BY MAN RAY

LES CHAMPS DELICIEUX, PARIS 1922 (*hors commerce*)

REVOLVING DOORS 1916-1917 10 planches (*Editions Surréalistes Paris*)

MAN RAY PHOTOGRAPHS 1920-1934 PARIS (*James Thrall Soby*)

FACILE with Paul Eluard 1935 (*Ed. G.L.M. Paris*)

LA PHOTOGRAPHIE N'EST PAS L'ART 1937 (*Ed. G.L.M. Paris*)

LES MAINS LIBRES Drawings illustrated by the poems of Paul Eluard 1937 (*Ed. Jeanne Bucher Paris*)

ALPHABET FOR ADULTS 1948 (*Copley Galleries, Beverly Hills, California*)

SELF PORTRAIT 1963

SELF PORTRAIT

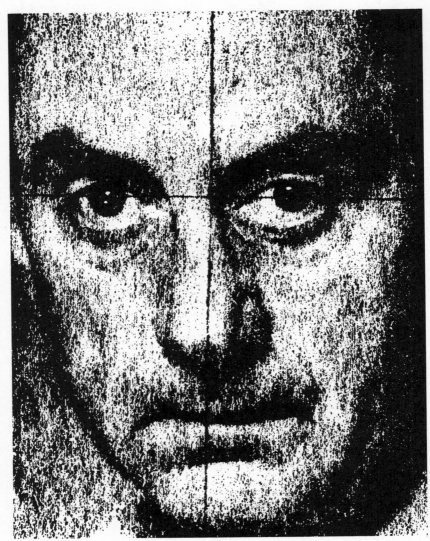

Self-portrait, Hollywood, 1947

SELF PORTRAIT

man Ray

With Illustrations

McGraw-Hill Book Company

*New York St. Louis San Francisco Bogotá
Düsseldorf Madrid Mexico Montreal
Panama Paris São Paulo Tokyo Toronto*

This edition reprinted by arrangement with Little, Brown and Company,
Inc., in association with the Atlantic Monthly Press.

FIRST MCGRAW-HILL PAPERBACK EDITION, 1979

1234567890 DODO 7832109

Library of Congress Cataloging in Publications Data

Ray, Man, 1890-1976.
 Self portrait.

 "An Atlantic Monthly Press Book."
 1. Ray, Man, 1890-1976. 2. Artists—United
States—Biography. I. Title.
N6537.R3A2 1979 709'.2'4 [B] 78-11750
ISBN 0-07-051248-5

For Juliet

MAN RAY, n. m. synon. de *Joie jouer jouir*

MARCEL DUCHAMP

Picasso, you and I are the greatest painters of our time, you in the Egyptian style, I in the modern.

HENRI ROUSSEAU

ILLUSTRATIONS

(*Illustrations listed in chronological order rather than order in which they appear in book*)

NEW YORK

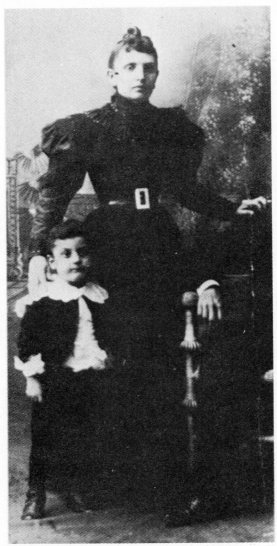

Man Ray with his mother, Philadelphia, c. 1895

My mother told me I made my first man on paper when I was three.

Later I learned that I myself just missed being born. Eighteen and innocent, mother was horrified by the advances of my would-be father, and they separated. After a year they met by chance, both unhappy and miserable, on the streets in Philadelphia, and she agreed to join their lives and possibly bring me into the world.

The earliest recollection I have of my introduction to paint is at the age of about five. We lived in a two-family house in a quiet dead-end alley. There were several children around to play with, including a younger reluctant brother whom I bribed or forced by threats to participate in all my forays and experiments. This I felt was necessary to divide the moral responsibility and the guilt when discovered. One afternoon the house painters had gone, leaving the shutters freshly painted a bright green, standing against the wall to dry. My mother with the neighbor upstairs had gone out to do their shopping for the evening. I had an idea. Approaching the shutters, I placed my hands on them and then carefully smeared my face with the paint. Persuading my playmates to do likewise, I took up my position behind the front door. When our mothers returned and pushed open the door, we sprang out and shouted *Boo!*

One mother screamed and the other nearly fainted. When they recovered, we were all roughly scrubbed with hot water and a very obnoxious laundry soap. I still recall the naphtha smell, not at all as agreeable as that of fresh paint. Our clothes, which had absorbed a good deal of the paint, were thrown away. Looking back, I consider this a waste, as I have since, many years later, as a modern painter, used paint-stained rags as a basis for paintings. The real punishment for this adventure came later in the evening when Father returned and was informed. He gave us a methodical, cold-blooded whipping.

We moved to Brooklyn, New York, when I was seven and a cousin gave me a box of colored crayons for my birthday. The battleship *Maine* had just been blown up by the Spaniards in Cuba, and the papers were full of pictures of this magnificent vessel. I made a careful copy of one with its turrets and guns and colored it with my crayons in a most arbitrary manner, using the whole spectrum at my command. While everyone admired the faithfulness of the detail, there were some reservations about the authenticity of the colors. At the time I could not refute the criticisms but I felt that since the original pictures were in black, I was perfectly free to use my imagination; besides, it was my way of expressing my patriotism.

The next few years all my spare time was spent in drawing and painting, mostly copying anything from chromos of Venetian sunsets to Japanese prints. My regular schoolwork and homework was neglected, although I seemed to excel in English composition without any effort, and my teacher complimented me on the extent of my vocabulary. I read a great deal, mostly poetry, and influenced my younger brother, who began to write; at the age of ten or eleven, he produced a sonnet which I thought the equal of Keats. (Poor brother, he was frail and ailing, crippled after a stroke of polio — the name hadn't been invented as yet, nor the cure; his great fear was that he would be unable to enjoy the sports and pleasures of life like the rest of us. However, he grew up, married, had children, and became a successful businessman.) I even taught him to play tennis and he became more and more at-

tached to me and less distrustful of my motives. At one time I thought I'd like to learn to play chess; I mastered its intricacies from a book, by myself, and proceeded to teach my brother, hoping to have an opponent. He learned the game without enthusiasm, but his mind was already turning to more practical and direct contacts with life. As far as I know, he never continued writing, nor ever read a book again.

Meanwhile, my main interest in painting was becoming a source of worry to my parents; while showing pride in my accomplishments, they could see no secure future in this dilettantism, and endless were the arguments about what would be a serious occupation.

The desire to paint grew stronger, in spite of this, although my parents had communicated some of their misgivings to me. I continued to draw in secret, showing my work less and less. I had not yet tried to paint in oils; after several visits to museums this seemed to me insurmountable at the time, but I had already developed the attitude that whatever was difficult or impossible was most desirable. Systematically, I prepared for my new venture. I had very little pocket money and dared not approach my mother, although she was more amenable than Father, for additional funds. There was a well-furnished artists'-materials shop nearby, quite odd for the prosaic neighborhood we lived in, which I patronized now and then for a pencil or eraser. Of course, they sold stationery and other articles more in demand, but my eyes lingered with desire on the open pigeonholed wall cabinet crammed with oil colors. With the few coins at my disposal, I purchased one tube of the less expensive colors and while the clerk's attention was distracted for a few moments, I abstracted and slipped into my pocket two or three additional tubes. By repeating this maneuver, in a short time I achieved a complete set of colors at very little expense. The brushes were a more serious problem, but I managed to acquire two or three in a more legitimate manner. My conscience did not trouble me, as I felt I was doing this for a very noble cause. I considered the painting of a picture the acme of human accomplishment; even today, the conviction still persists. At least I consider all artists as

privileged and sacred beings, whatever they produce. I may develop this theme at greater length in a more appropriate and recent stage of my development.

But to return to pilfering: I had become quite adept at it. Fagin would have been proud of me. In fact, I became a sort of Fagin myself. I coached two or three of my comrades, sending them out on forays to shops with open counters, but with instructions to take only objects that were colored. One day my mother opened an unused drawer and under an old shirt discovered a huge stock of colored pencils, unused, spools of silk thread, their colors arranged in spectrum sequences, and bottles of red, green, and purple ink. I confessed, without incriminating my disciples, I'm proud to say, and Mother insisted on leading me back to the shops to make amends. However, I craftily declared the loot had come from roving pushcarts in the streets and that it would be difficult to locate them.

Looking back, I cannot help admiring the diversity of my curiosity, and of my inventiveness. I was really another Leonardo da Vinci. My interests embraced, besides painting, human anatomy, both male and female; ballistics and mechanics in general. For the first, I used my brother, two younger sisters, and casual playmates as guinea pigs. One outraged little girl complained to her mother and I received a thrashing, which I almost enjoyed; was I a budding sadist and masochist?

I had acquired a small iron cannon. One could buy an ounce of gunpowder in a sporting goods store, and, loading the cannon with it, rammed down with wads of wet paper, I succeeded in producing a bang loud enough to bring all the neighbors to the windows. I rescued a half-dead mouse that a cat was playing with, loaded my cannon, attaching the mouse's tail to the last wad of paper, and lit the fuse. I was disappointed after the explosion to see that the mouse had moved only a few inches, but I am sure this was the first attempt ever made to put a living creature into space.

It was quite the thing to build your own wagon with a soapbox, a plank of wood and four wheels one could buy at the candy and toy shop. I decided to outdo all the others. In addition to the standard equipment, I got a small barrel and a

piece of stovepipe, and constructed a fairly realistic model of a locomotive — a coat of black paint and some absorbent cotton for smoke stuck in the stovepipe completed the illusion. I allowed a couple of my most intimate pals to push it around to the envy of everyone. One day, after school, I went into the back yard where the object was stored, and found it in a hundred splinters with an ax beside it. After some moments of stupefaction, I picked up the ax; rage filled me; I must find the perpetrator and tomahawk him. It was Mother who had done it; the street, with its trucks, was too dangerous. I wept and remonstrated that I kept the thing on the sidewalks, but she was firm and showed no remorse; it took me a long time to forget and I believe I never forgave her.

She nevertheless showed a certain respect for me in matters of art and taste. Once she took me with her to the milliner's to advise her in selecting a new hat. I was consulted if a new piece of furniture was to be acquired, or new wallpaper to be selected. A lampshade fell apart and I offered to make a new one. My idea was to make something unusual, original, and in addition, indestructible. I acquired a sheet of flexible brass at the hardware store, tracing the shape from the undone paper shade, then drew an elaborate pattern of scrolls and flowers on the brass. I must have seen somewhere an oriental lamp of perforated metal which gave out a mysterious and romantic light. With a nail and hammer I began puncturing little holes, following my design; but after a while this became too tedious — accordingly, when I was alone in the house I went to my mother's sewing machine, and, removing the spool of thread, began stitching the design, as if it were embroidery. It went much faster, but the needle broke often; by the time I had completed the work, I had consumed all the spare needles, not to mention throwing the machine out of gear. The lampshade was greatly admired; I never explained my technique and Mother had trouble with her sewing machine when she tried to use it.

My interest in animals was limited to an occasional dog or cat in the house, which I used as a model for drawing. Horses, too, attracted my attention, but it was with the desire to ride

them. There was a huge brewery in a side street, to which the trucks returned at sundown; one of the drivers let me take his massive Percheron to the stable a few blocks away. Or rather, the horse took me to the stable. I sat astride near his neck holding on to his mane, and the animal unerringly returned to his stall. When the Wild West Show came to town, one could hire a pony with a real Western saddle and ride around the field. After putting my foot in the stirrup, I had difficulty in hoisting myself. With a friendly kick in the pants, the attendant asked if I had lead in my ass. The pony walked leisurely around the track; nothing could induce him to break into a trot or gallop. I lost my interest in horses. Years later, when I saw my first horse race, it did not seem to me as if the jockeys had any control of the animals; they were stubborn, willful beasts that could run when they felt like it. I learned the rudiments of card games and dice throwing, besides shooting marbles and spinning tops, but winning or the stakes involved did not excite me; I decided I did not have the makeup of a gambler. Perhaps it was the fear of losing; any activity with others that involved chance or skill became repugnant to me.

At the age of fourteen I entered high school and here my real troubles began. Besides the usual classes in history, mathematics and languages, there were two sessions per week in drawing, one freehand, the other mechanical. I forget their names, but the instructors in each were as different from one another as a lamb and a sheepdog. The freehand teacher was an artist in every sense of the word, with his mild gray eyes, silky Vandyke beard and lisping voice. Evidently a frustrated painter, as are many art teachers, he was the butt of a rowdy, delinquent class which considered the session as an escape from the more serious work in school. Even the rest periods, intended more or less as a preparation for the following subjects, did not offer such an opportunity for snickering horseplay and spitball throwing. The teacher's voice quavered almost on the verge of tears as he tried to explain the laws of perspective and composition. As well try to teach chimpanzees

the niceties of ballet dancing. I felt sorry for him, and did my best to console him with my attention and proficiency. Of course, I was easily at the head of the class, carrying off all honors at the end of the term. My drawings were pinned up on the walls and I was held up as an example to follow. This did not endear me to the others; I too suffered from their pranks. I was teacher's pet.

The mechanical drawing teacher was a hardheaded thin little man, graduate of the Massachusetts Institute of Technology, who ate raisins and nuts for lunch at his desk while looking over his papers. He digressed philosophically as well as talking on his subject. The blackboards were decorated with diagrams in colored chalks interlaced with mottos such as, *I think, I can, I will.* More respect was shown the teacher than in the other class, but there was still very little interest, and the students went through with the drudgery because it added up points for the term. I liked him immensely; he combined everything that was practical with a wonderful sense of the graphic, and my admiration for him was complete when he designed our graduation pin in gold with Michelangelo's head of David in bas-relief surrounded by a circle enameled with our school colors. Not only did I devote myself to his prescribed course, but I'd rush up during the rest periods to his office, where he put at my disposal all his papers and drawings executed during his college years, so that at the end of my high school course, I came out with a complete technical training in the fundamentals of architecture, engineering and lettering. This was to stand me in good stead later on when I decided to earn my living and be independent. I would even come up after school hours and help him with his routine work on the school papers.

As has been said previously, my other studies suffered from this concentration on art. History especially was my bugaboo. I was the lowest in the class, its disgrace, and the despair of the teacher. All the others had passed with the required marks for graduation. The teacher in history could not understand me. I seemed intelligent. My notebooks, written in a beautiful, even script, were illustrated with gay colored maps of Caesar's

campaigns, with drawings of Roman and Greek temples, armor and coins. To save face he kept me in one afternoon, submitted a list of written questions, asking me to look up the answers at once, and write them out on a fresh sheet of examination paper. I passed with the required number of marks.

Upon the recommendation of the teachers in drawing, it was announced on graduation day that I had been awarded a scholarship in architecture at an important university. Now my parents were really delighted and proud of me. I'd gotten some sense into my head. Myself, I was reconciled to being an architect, as it seemed I could combine art with the respect of society for a more practical vocation. I thought of all the beautiful cathedrals and monuments of France, Italy and Greece I'd pored over in books and from which I had made detailed drawings. Locally, I had admired the classic front of the Brooklyn museum; the elegant tower of Stanford White's Madison Square Garden, and the daring architecture of the modern Flatiron Building in New York.

School ended with June and I had the whole summer to myself before enrolling in college in September. All was quiet in the family — there was a truce in anticipation of the new career I was about to undertake. But vacation, freedom, meant drawing and painting for me. On sunny days, with my paint-box, I took the elevated train to the end of the line and found myself at once in the outskirts of Brooklyn — open country, barns, horses and cows grazing in the fields. Here in solitude I thought of myself as a Thoreau breaking free of all ties and duties to society, and, as I painted, it seemed to me that my thoughts and feelings flowed through my arm onto the canvas. But afterwards I would realize that my canvases had failed to communicate what I really felt.

Throughout the summer I painted indoors and outdoors, scraped off the few panels and canvases to be used again, spreading my colors thinly, and as the day approached for my entry to college, my hesitations and misgivings increased. Finally I announced at home that I would abandon my awarded scholarship, and go to work — earn my living. I did not see fit to add that I would continue painting in my spare

time. I'd had enough of schools. Following the first shock of consternation and incredulity, my parents calmed down. After all, my decision might relieve them of further responsibility; anyhow, it would be one less mouth to feed.

Now began the period of job-hunting. I had noticed in my trips on the elevated railroad that each station had a news-stand with an attendant. I made my application and was soon assigned to a station after a slight briefing. At the end of one week, I collected my pay and never returned to my stand. No inquiries were made by the company.

I answered an advertisement for an apprentice to learn engraving. This was a branch of the arts that I had never envisaged exploring and my curiosity was aroused. I presented myself at an office in an old grimy building under the Brooklyn Bridge in New York, with a portfolio of my drawings, both freehand and mechanical. A grizzled man wearing an apron, his hands blackened, looked them over carefully, then informed me that my work was not exactly in line with what they were doing, but I showed aptitude, and if I was willing to take lessons, I could start right away. Nothing was said about salary: I thought it wiser to leave the matter to any sense of fairness my future employer would show.

I was led into a workroom reeking with acids, where three or four workmen sat at tables piled high with what looked like umbrella or cane handles. I was given a vacant stool along-side one of the workmen who was told to initiate me. He picked up one of the handles which was covered with a coat of some chalky preparation, then with an etching needle quickly scratched some flowers and leaves. He explained that this was a silver handle, and that after the drawing, it would be dipped in acid and cleaned. He showed me a shiny silver handle nicely etched — the finished product.

Engraving, etching to me meant Rembrandt, Goya, Whistler. However, going home that night, I decided to stick it out; I was sure I could master the art and earn money, which was the immediate problem.

By the end of the week I was turning out twenty pieces per

hour, nearly all different, never following any one pattern as did the others. I improvised designs, clusters of cherries and grapes with a bee or a butterfly now and then for variety. Although it was important to earn money, I was not letting myself become a drudge. Saturday noon, as we walked through the office for our salaries, the boss kept me a while for a little talk. He liked my serious application and promised that in a few months he would pay me on the basis of piecework. It seemed I'd grow out of my apprenticeship sooner than was customary. Then he handed me three dollars. I did not return to work the following week.

My next job was in an advertising office on Union Square, 14th Street. The boss was a natty, dynamic young man, continually on the go, getting contracts and making lots of money. My work consisted of preparing layouts and lettering, leaving spaces for the more experienced and high-salaried artists to fill in with faces and figures. Without any previous pencil sketching, one of these men could start at the bottom of the paper with his pen, working upwards, and produce in a single unwavering line a sexy and glamorous figure. I admired and detested him. He was always half drunk, with a wet cigar in his mouth, and an endless repertoire of dirty stories. I listened with mixed feelings. Sex had been bothering me the last two or three years. Before the age of puberty and out of curiosity, I had investigated a couple of little girls, and with a bribe of a book or a stick of candy had even succeeded in playing some games of *touche-pipi*. Later on, there had been a couple of sporadic infatuations, with kissing and petting, which left me miserable. I had not yet seen a naked woman in the flesh.

I had gloated over reproductions of Greek statues and Ingres's nudes, had made drawings of them ostensibly as exercises in art, but inwardly knowing full well it was the woman that interested me equally. Now, with my evenings free, it occurred to me that it might be a good idea to join a life-class. I enrolled in an institute uptown; but to my surprise, I was obliged as a beginner to start by drawing from antique plaster casts. We were all set to work on a statue of Apollo — even in

plaster I was denied a female subject. During several evenings, I plugged away at my work without enthusiasm, and when interest waned completely, I made desultory sketches of the students around the edge of the paper. When the instructor came around to criticize, and sat down in front of my drawing, he shook his head. My drawing had no life in it. I agreed, silently. To be sure, if I hung around for a couple of years, I might improve and qualify for a silver medal, he said rather sarcastically, but the sketches around the edge of the main drawing showed some interest and some liveliness. Why didn't I quit and go on working by myself; do the things that interested me? Acting on this sound advice, I did not return to the class. I regretted only the deposit I had made for the month. I applied at another night school where I was allowed to enter the life-class immediately.

A huge naked woman was posing on a platform. About twenty students grouped around the model were busily wielding charcoal, erasers and pieces of chamois. I was assigned to an empty stool with a chair in front, upon which I placed my portfolio as the others did. Now and then a student would hold up his piece of charcoal measuring the proportions of the model, or with a plumbline verify the pose. It must have been quite an advanced class, for their drawings were ethereal and elegant, but what mystified me was their knowledge of anatomy. With all my experience in various kinds of drawing, I had never tackled this subject. I was to discover the secret very soon. I began by sketching in heavy black lines the general pose, a style entirely different from all the other drawings, and in an hour felt I had completed my drawing. The others had been working on theirs for days. I went over my lines again, changing and correcting, until my drawing was a complete mess of black charcoal out of which emerged a strange primitive-looking figure.

The instructor was reputed to be one of the greatest living authorities on anatomy, had written books on the subject, illustrated with his own drawings. When he came around to me and sat down in front of my work, with a cigar in his mouth, he was silent for a few moments. Shifting the cigar to one side

of his mouth, he spoke: What is this, a horse? Fervently, silently, I agreed. Then, taking up a piece of charcoal, he quickly sketched a head alongside of my summary indication explaining its roundness by geometric planes. Running a finger down the arm on my drawing, he stopped at the elbow, and drew in details of the sinews and joint. Likewise further down, he drew the knee joint and the shape of the kneecap, all of which were invisible on the model. I admired his dexterity, and understood how the students had learned their anatomy. With a few words about getting my nose down to the grindstone and not trying to be an artist until I had mastered a few fundamentals, he went on to the next pupil, whom he praised without reserve, adding no corrections to the clean drawing.

I had a friend about my age who aspired to being a musician, but who, to appease his parents, was studying medicine. We had long talks about the relative values of music and painting, he maintaining the superiority of his art over mine, in that it was more mathematical, more logical and abstract. I partly agreed, but intended later to paint abstractedly. I did not yet see how, but knew it would come, after I had mastered the fundamentals of my art, and one of these was anatomy. He must be learning anatomy in his medical courses. How did they teach it?

Well, for one thing, he said, they had a dissecting room where they studied corpses sent in from the morgue. I thought immediately of Leonardo da Vinci, who acquired the bodies of executed prisoners or of unidentified women who had died, and of the revolutionary discoveries he had made about human anatomy. To be sure, I had dissected a frog once in a science class, but that was kid stuff. I asked whether I could get into that dissecting room. He said he had access to it when the students were gone, and would take me around on Saturday afternoons. When I first entered that room I was almost overcome by the stench, mostly of disinfectants. My friend informed me that the corpses were kept almost a week, as one could not rely on a regular supply. There were a dozen tables covered with stained old sheets vaguely outlining the bodies. My friend drew back one of the sheets, uncovering a man most

of whose flesh had been removed, exposing his muscles, like one of those artifically constructed models. A curious detail I noticed was that his sexual parts were missing. Jokingly I asked whether they had been removed for prudish reasons. Oh no, when a fresh corpse arrived, it was the first operation performed by the students, the organ to be slipped later into another's coat pocket or his desk. I had brought a sketchbook intending to make some studies, to be transferred later in the life class to my drawing, to surprise and perhaps please the anatomy teacher with my zeal. But it wasn't very easy to work, there were no chairs in the room, and any space on the table available was too messy. I abandoned the idea and contented myself with examining two or three other bodies, one a woman who was no more interesting than the first model in the life class. After all, there were surely many books on anatomy; I'd look them up.

The next model in the life-class was male, with all his attributes intact, his joints and muscles more clearly defined. For a week I forgot my preoccupation with the other sex devoting myself to the study of anatomy in the most abstract sense. My drawing might have interested Michelangelo, but not the teacher. With a few ironic remarks about my imagination and some corrections on my drawing, he advised me to take a week off, study the old masters in the museums. In all my visits to the galleries, I had never been impressed with the older schools, but sought out what few impressionist pictures had crept in.

I did take a week off, but switched to the portrait and still-life class. The instructor was a well-known successful painter whose still-lifes of fresh fish brought two thousand dollars. An imposing man with a gray pointed beard, bristling mustache, wide black ribbon on his pince-nez, some kind of decoration on his lapel, and a high satin stock bearing a large emerald, he was known for his aversion to the nude both in school and in paintings. Accordingly, the day of his visit, the students carefully draped the legs of the stools with rags. But he had at least one agreeable quality; he permitted us to do a portrait or still-life composition in one sitting. This was a great

relief from the other classes where one had to plug away a week on the same subject.

With the unexpected closing of the advertising office, I lost my job. After some weeks of desultory search, I was hired as a letterer and layout man by a large technical publishing house. The firm specialized in engineering and machinery. The office was situated on the twelfth floor in a high building, harmoniously furnished in golden oak, brand-new, with large windows overlooking the Hudson River. I was assigned to a flat-top desk, with all the materials in place for my work. Next to me was a young man of about my age, clean-cut and efficient in his work, with whom I soon became very friendly. He smoked cigars, as did our chief and the most important draftsman; all the others smoked pipes. I had been smoking a pipe, but soon switched to cigars to follow my companion's example. This was not an extravagance, my salary was about double of what I had earned before, and a decent cigar cost five cents. Sometimes, after the day's work, my new friend and I remained in the quarter, the most interesting of New York, with its theaters, movies, and big hotels. We would have a snack and take in a movie. One evening we passed a theater that was playing a musical comedy, *The Chocolate Soldier*, based on Bernard Shaw's *Arms and the Man*. I had read most of Shaw's plays as they came out; I had a very literary cousin who had passed on the books to me, and I had been deeply impressed with them. We bought a couple of cheap seats in the gallery, but they were badly placed; we could hardly see the stage. I spoke to an usher, offering him some money if he could change our seats. The theater was not packed and he led us to an empty box near the stage. There were no seats in it, but a divan reserved for a spectator who might find herself ill and in need of a doctor. We saw the play stretched out on the couch, hidden from the audience, in the greatest luxury. No comments later from my friend, but I was ravished. On another occasion I suggested the Metropolitan Opera, but my friend begged off. That night he was seeing his girl, whom he was marrying soon. I went alone, stood in line for the gallery

and stood through *La Tosca.* It was very hot, my feet ached after a while, and I regretted *The Chocolate Soldier.* It is for this reason that in the following years, and today also, I choose the spectacles first for the comfortable seating the theater has to offer. There was the rival Manhattan Opera House whose enterprising director presented the modern works. I saw *Salome, Electra, Ariadne and Bluebeard,* Isadora Duncan dance; I also went to symphony concerts in Carnegie Hall Saturday afternoons, did not care much for Beethoven, Brahms and Mahler, but was enthusiastic about Bach. My musical friend, whom I saw from time to time, considered Bach unemotional and too rigorous; perhaps Bach moved me because of my own precise training in mechanical subjects; he was a kindred spirit who inspired me to greater efforts in my line.

I was not neglecting my interest in painting, with these new distractions. During the day at my desk, overlooking the river, I watched the liners leaving their docks en route to France and wondered if I could ever get to Paris, that Mecca of art. The chief of the office in making his rounds once stopped in front of me and asked gently what I was daydreaming about. I said I didn't feel well. I did look rather pale, he observed, I should get out in the country weekends.

My weekends were devoted to painting and browsing in art books. During my lunch hour, I would run up to exhibitions at the art galleries on Fifth Avenue, nearby. There was one called "291," its number on the avenue. It was run by the famous Alfred Stieglitz, who had started a secessionist school of photographers. He talked at length about modern art to anyone willing to listen to him. I listened fascinated, but at times it seemed a bit long-winded. The first show I saw at his place was one of watercolors by Cézanne. I admired the economical touches of color and the white spaces which made the landscapes look unfinished but quite abstract. So different from any watercolors I had seen before. I remember other shows: primitive African sculptures, Brancusi's gleaming, golden bronzes and his smooth simple pieces in wood and marble, Rodin's unanatomical watercolor sketches of nudes, action pieces which pleased me immensely and justified my abandon of academic principles. The stark-black charcoal lines of Picasso with here and there a piece of newspaper pasted on seemed very daring — rather incomprehensible, though. There were shows of American painters also, Marin Hartley, Arthur Dove, who had spent some time in Europe and been impregnated with the modern spirit. Their work, however, seemed very American and lacked the mystery I felt

in the imported work. They seemed brash and humoristic by comparison. Stieglitz was all for Americanism, and later when he moved to another gallery, he called it An American Place, showing mostly American painters.

I became a regular visitor and listener; we got to know each other quite well. He asked me to bring my work around, and I was sometimes invited to lunch with a couple of older painters whom I suspected of coming in for this purpose. Stieglitz's luncheons were famous, for he took us to the Holland House on Fifth Avenue, or to Mouquin's on Sixth, one of the finest French restaurants in New York. I wondered what it cost; he always signed the check; I never saw him with any money in his hand, which confirmed my faith in his altruistic efforts. There was no commercialism about 291; all money from sales was turned over integrally to the artist. At the same time Stieglitz worked incessantly at his photography, to prove that it was art, both by his publication of a deluxe photographic magazine, and by his own examples. He made portraits of anyone who happened to be in the gallery, when he was in the mood for working or if the subject appealed to him, whether it was the colored elevator man or one of the painters who frequented the place. He never made a portrait for money as far as I know; once a wealthy woman asked him what he would charge to do her portrait; he replied, one thousand dollars. I was surprised and my opinion of him came down a peg. The woman replied she would have to consult her husband. When in a day or two she phoned with her husband's approval, Stieglitz replied that it would now be fifteen hundred dollars.

On one of my visits, when no one else was in the gallery, he set up his old camera on its rickety tripod, asking me to stand in front against the wall. The gallery was small, but quite light with its neutral gray walls and muslin-screened skylight. He told me the exposure would be rather long, but to keep looking at the camera; I might blink my eyes, it wouldn't matter nor show. He produced a hoop stretched with cheesecloth, uncapped his lens, and began waving the hoop over my head, moving about like a dancer, watching me closely. It lasted about ten seconds. I have since seen photographers with more modern

instruments shooting at one hundredth of a second, perform similar gymnastics, but before making the exposure. With Stieglitz, it was simultaneous and synchronized.

Although the photographs of Stieglitz were free of anecdote and cheap sentiment, they remained intensely figurative in contrast to the painting and sculpture he exhibited. I could not help thinking that since photography had liberated the modern painter from the drudgery of faithful representation, this field would become the exclusive one of photography, helping it to become an art in its own right; hence Stieglitz's interest in the two means of expression. And so there was no conflict. Despite my respect for Stieglitz's efforts, and my aroused interest in photography, painting remained my guiding passion. But I had done nothing yet that I cared to show. With all these distractions and preoccupations, my job suffered somewhat: prolonged lunch hours, continued daydreaming at my desk, the speed with which I left the office on the dot of five P.M. One day the chief informed me that for reasons of economy the firm was obliged to release some of its men, naturally those who had been engaged more recently. I took this with a grain of salt, but inwardly welcomed the release. I had saved some money, and thought I could easily get work whenever I wished; with my capacities, I had only to put my hand to the plow.

I still lived with my parents in Brooklyn; with my contribution to the household I had attained the dignity of having my own room properly transformed into an artist's studio with its easel, accessories and a couple of portraits in oil on the wall. The florid design of the wallpaper annoyed me, but I did nothing about it. Someday I would have a real studio with simple gray walls and a skylight, like Stieglitz's gallery, only bigger. I had met a young painter in the museum, copying old masters, earning some money by selling a copy now and then. Joseph admired more than any other painter the nineteenth-century painter Géricault. By watching him, and with a few explanations he gave me, I learned quite a bit on the mixing of oil colors. My desire to paint was aroused more than ever, although my days of copying were past — I would do original works.

However, I needed work and money again. Soon I entered the drafting rooms of a map-and-atlas publisher. I mastered the work quickly, and attracted attention not only with my ability as a mapmaker but with a talent for embellishing my drawings with ornamental borders and lettering. After a while I was relieved of the tedious, mechanical work, and assigned to the more artistic production. I had my evenings free and looked about for something to occupy them, something related to painting.

Then I heard of a social center uptown where one could join a night life-class. The center's premises proved to be a brownstone house in a residential section. Entering on the ground floor, I found myself in a room like a restaurant, with a mixed crowd sitting around drinking coffee served by a small dark woman dressed in gypsy clothes, wearing long golden earrings. I sat down at one of the tables and presently she came over. When she had brought the coffee I had ordered, I inquired about the life-class. It was upstairs on the next floor; I could join whenever I pleased, there was no fee but members made contributions to pay for the model. Presently I went up and found myself in the typical drawing class — the nude model on a raised platform surrounded by a mixed group of all ages busily working away in various media: pencil, charcoal, watercolor, and oil. All seemed to be in a hurry to finish their studies, in contrast to the slow plodding of the schools I had attended previously. I sat down near a man with a beard who jabbed away with charcoal on a drawing that bore no resemblance to the model. On my other side sat a young girl in a loose dress evidently made from a Paisley shawl, feverishly smearing her paper with pastels.

After a while, a voice up front said, Rest; the model abandoned her pose and sat down, stretching and yawning like a cat. Her face was like a cat's with elongated green eyes. She was a magnificent, voluptuous blond with an ivory skin; every movement she made expressed languor and sensuality. I felt I'd be content to watch her and not do any work.

(The center had been founded by sympathizers in memory of the execution of Francisco Ferrer, the Spanish anarchist,

and was financed by a well-to-do New York writer. Besides the art class there were classes in literature, philosophy, and a day school for the children of members who wished to bring them up in more liberal surroundings than the public schools afforded. All courses were free; some well-known writers and painters volunteered their services as instructors; in fact, everything was free, even love. Most of the conventions of society were frowned upon.)

When she resumed her pose it was a different one. One had to make a drawing and even a color sketch in twenty minutes. This was indeed a revolutionary experience for me, who had dawdled for hours over a drawing, not really knowing what I was aiming for. I went home that night with my head in a whirl, immense possibilities opened before me both in art and in love.

During the next day I impatiently awaited the closing of the office and journeyed to the center, where I first had a sandwich and coffee, then ran up to the art class. I had brought the necessary drawing materials with me and set them up on a chair ready for work. The same members were there, but it seemed no professional model had been available for the evening. One of the girl students then volunteered to pose, went into another room and came out in the nude. She was rather thin and bony; I regretted that the pretty one next to me had not volunteered.

We set to work, I sketched quickly and freely; with my experience acquired in academic surroundings, my drawing had a more traditional look than the work of the others. During the second pose, a tall, distinguished-looking man came in. His face was sallow and slightly pockmarked, with a thin nose. It was Robert Henri, the well-known secessionist painter, whose work I had seen in galleries, and admired, more or less, for its bold, slashing strokes and heightened color: evidently inspired by Franz Hals and Manet. He was considered a rebel in art circles and among the critics, but regarded with respect, probably because of his pronunciamentos in the school he ran under his name. Passing around from drawing to drawing, he made gen-

tle, encouraging remarks, but never touched the drawings nor criticized adversely. Stopping in front of my work, he put his hand to his chin and was silent for a few moments. Then he spoke: This was the sort of thing most people would understand and like; however, we should try to assert our individuality even at the risk of being misunderstood. He went on, I did not quite follow the rest of his talk, but he ended up patting me on the back, and saying not to mind what he said; he was against what most people were for, and for what most were against. Other evenings he would talk without paying much attention to the members' work and I found his ideas more stimulating than any direct criticism. Once he was accompanied by a handsome tall red-headed woman rumored to be his mistress. I would have liked to see her in the nude, but she did not volunteer to pose. There was a thirteen-year-old girl who came in occasionally to draw. One evening when we did not have a professional model she was asked to pose, and, without hesitation, she took off her clothes and stepped onto the platform. Her figure, quite stocky, with firm, fully developed little breasts, resembled one of Renoir's nudes. She aroused no irrelevant thoughts in me; my sketches looked like primitive sculpture.

A new instructor came in that night, George Bellows, famous for his brutal prizefight paintings and his prized conventional society portraits. Making the rounds, he took my drawing and placed it in front of the class. He spoke at length about initiative and imagination; everyone looked and listened attentively, including the model standing nude amongst us. What a picture, I thought; it would need a Manet to paint it.

The young girl created quite a hubbub in the center some time later. She was the oldest child in a day class for children conducted by a brilliant young student of philosophy, Will Durant, who fell in love with his pupil. With special dispensation, and consent of the parents, he married her. I heard no criticism in the liberal center concerning the conventional procedure.

I was becoming familiar with some of the members; we had coffee and talked. One new friend was Loupov, a sculptor, who

also painted and wrote poetry, besides being interested in social problems. Within its own circle the spirit and talk of liberalism continued. One of the evenings when a model had not been available, he brought his seven-year-old daughter to pose. Of course, she could not be required to hold a pose for twenty minutes, and was allowed to move about as she pleased. She was a beautiful child with large blue eyes and golden hair; although nude, she was natural and unaffected in every gesture. It was a new experience to draw a subject in action, to try and record its nature. Little did I suspect that this child would play an important part in my life in the years to come. Towards the end of the session, a woman came in; the mother of the little girl. She was in her early twenties, her hair the same color as the child's; her faced looked drawn. She helped her daughter to dress and led her away.

My interest, however, was centered on the young girl who sat next to me in the class, Nancy; I accompanied her home more and more often, a few blocks away. One bright night after a heavy snowfall, I suggested we walk through the park nearby. It was deserted; I put my arm around her waist and pulled her close to me. She tried to disengage herself, but I held her tightly and we wrestled; we both fell to the ground but held on to each other, rolling and laughing. When we stood up I brushed the snow off her, ending up with a kiss on her cold face. She looked coyly at me and asked why I did it. From then on I began to lose interest in Nancy; I decided she was cold all over.

I made a more direct approach one night: asked her point-blank to be my lover. She was not a child, moved in liberal circles, knew of the liaisons of her sister and friends. She replied calmly, wished she could, liked me very much, but was ill, was seeing a doctor, had something wrong with her menses. Besides, had never had an affair with a man. I did not say it, but thought sadly: neither had I ever gone to bed with a woman.

My Sundays were unoccupied and I painted, sometimes in the park, or a still-life at home, but what I wanted most was to paint a nude. This was inconvenient in the center at night. Occasionally I saw Joseph, the man who admired Géricault,

and suggested that we form a life-class Sunday mornings in my room. It would have been too scandalous to have a nude model all by myself, in my parents' home; besides, the expense would be prohibitive and if we could unite three or four to share the hiring of a model there would be no difficulty. The copyist knew two boys who painted and would bring them around to discuss the matter. We made a date and I was introduced to the two candidates. One was an anemic young man who had studied in an academy and was perfecting himself in the drawing of pretty faces and figures; he hoped to become a successful commercial artist. The other was a stocky, dark-skinned Italian who roamed the streets and the park with a sketch pad under his arm and a small box of watercolors. He had some work with him and showed it to me. They were colorful little studies whose subjects were indecipherable; they reminded me of the watercolors by Cézanne I had seen at Stieglitz's gallery. But he had no job nor any money. I offered to pay his share of the model and would like to have one of his sketches. Joseph told me afterwards he did not think much of the man's work, it was not serious. Remained the problem of getting a model.

As none of the others knew of any offhand, I volunteered to take care of that. It just happened, during the following week, we had the voluptuous blond at the Ferrer center. At the end of the session I asked her to pose at my place on Sunday, telling her of the formation of my little group. She agreed, stating her price, adding it would be convenient for her since she too lived in Brooklyn. I could hardly wait until Sunday, when everyone came in according to plan.

I had warned the family of my new enterprise, but neglected to say that the model would pose in the nude. My room had two doors, one giving directly on the landing, the other leading to the rest of the flat. When everyone was set and the model began to undress, I turned the keys in both doors. She took a pose, I suggested another and a third, just to see her move; she was nearer to me than she had ever been in the art center, and a hundred times more desirable. Joseph had set up a large canvas on a folding easel and prepared his palette very profes-

sionally, the aspiring commercial artist began sketching on a watercolor pad with his colors beside him, the Italian just sat and looked, doing nothing, while I began to work simply with charcoal on paper, just to get the feel of things. Later I would paint. After about ten minutes, I stopped. My emotions had completely unnerved me, I was getting nowhere with my drawing; couldn't concentrate.

After a while the commercial artist asked me for a glass of water for his colors. I unlocked the door leading to the flat and went into the kitchen. The family sitting around all looked at me silently and with curiosity. When I returned I locked the door again quite audibly, in case someone should take it into his head to come in. With mutual consent, we relaxed from time to time, smoked and talked. So passed the two hours we had agreed upon; I had made several new starts, but had produced nothing. Nor had the Italian, who hadn't even tried. The other two had quite finished their work; the backgrounds could be put in without the model. She dressed, I paid her and offered to see her home. Joseph winked at me. We left by the outside door, and took the trolley to her place, which was a few blocks from the stop. I told her the effect she had had on me, how beautiful she was, that she had inspired me tremendously; however, working with her in front of me was out of the question. I would paint from memory or imagination, when I was alone. When we reached her door she smiled and said good-by, then shivered a bit, observed it was getting chilly, she needed a new coat, had seen quite a nice one in a certain shop for fifty dollars. I was silent, embarrassed; if I had had the money I would have given it to her at once, or better still, bought the coat and laid it at her feet.

When I got home Mother asked me why I had locked the door to my room. I replied angrily that we did not wish to be disturbed; she replied with an observation on the secretive habits of artists; then I blurted out the truth. She gasped; to think that a son of hers would so disgrace her home — bringing in strange nude women. I observed there had been only one woman and four men, thinking, no doubt, thereby to calm her limited and outraged sense of morality. However, I made

no further arrangements to continue our Sunday sittings, informed my companions that due to objections on the part of my parents, it was all off. Which they understood.

I continued working at home by myself in my spare time, using Dorothy, a young sister, as a portrait model. She was quite a beauty with raven black hair, white skin and big black eyes. Once, while sitting for me wearing a dressing gown, I asked her to slip it down from her shoulders so that I might include her bosom. If the rest of her was as lovely as her face, it would make a stunning picture. She refused, although pleased with my compliments.

I continued my trips to the Ferrer school, but attended the life-class less often. There were always new faces, people dropping in out of curiosity or in sympathy with liberal ideas. I met new writers and painters; we sat in the café and talked. Sometimes Marie, the gypsy woman who served, would join us; she knew everyone and introduced me to newcomers as a talented young painter. One night, a short man with a long face and gray eyes came in and sat at my table. We were introduced by Marie. His name was Halpert, a painter just returned from Paris where he had studied with Matisse. Several years older than me, he talked patronizingly and like a man of the world. I listened attentively as he told me of his exploits in Paris and of the work he had brought back with him for an exhibition. He did not paint like Matisse, had been more impressed with the work of a painter I had never heard of: Marquet. He was glad to get back to the States, regretted only the little French girl he had left behind. Did I know any nice girls in New York? No, I replied in an offhand manner, only a couple of professional models whom he could meet if he attended the life-class upstairs. He looked at me as if I had said something rude and tactless; he was through with schools and professional models, besides he painted only landscapes and still-lifes. Anyhow, we became quite friendly, he once asked me condescendingly about my work.

I asked him to come out to my place a Sunday afternoon, I'd appreciate his advice and criticism. He came; I introduced him to the family, then showed him some of my work. He made

some encouraging remarks but suggested that I break away from schools and academic influences if I wished to become a significant painter. My sister served tea and cakes; she looked older than her age, having applied some rouge to her cheeks and lips. Halpert did not take his eyes off her. The following week when I met him again he handed me an envelope which he asked me to give to my sister. On my way home that night I tore it open and read the note asking her for a rendezvous, saying how beautiful she was, that he would like to paint her. I destroyed the note and said nothing to Sister. When next I saw him and he asked if there was an answer to his note, I pretended I had lost or mislaid it. A few days later she received a letter from him in the mail. Evidently he mentioned his first note, as she asked about it; I made the same excuse, adding sourly that I was not a postman. There were recriminations, Mother got wind of the affair and at once put her foot down; she wasn't having her daughter going around with artists; one in the family was enough.

I heartily agreed with her, but for my own reasons. For days the home atmosphere was irrespirable; I wished I could get away. Halpert asked after my sister, said he was really in love with her, his intentions were honorable, he wished to settle down and marry. I said she was only sixteen although she looked older, and was not allowed to go out yet. Having thus disposed of the matter, to my secret satisfaction, I directed my efforts to placating my sister with little gifts and added attentions. She had been thrilled, attracting a mature man, an artist besides, and while I did not hope to replace him, I could have her to myself for a while. I was the dog in the manger.

But I was resolved to quit home, and the opportunity soon presented itself. Some weeks later Loupov informed me that he had rented a studio on Thirty-fifth Street, where he worked during the day, and that I could come in any time and work also. I thanked him and appeared the next Saturday afternoon. It was a hall room with a small skylight on the top floor of a rooming house for theatrical folk. Loupov was modeling some clay on a stand. There was a narrow couch at one end and a sink in a corner. A rickety easel and a couple of chairs com-

pleted the furnishings. The floor was wet and dirty from the sculpture work. I asked Loupov whether he lived here. No, it was just for work, he said, since he could not use the flat where he lived with a friend. Wasn't that his wife, I asked, who had come to the center one night, for the little girl who had posed? They were divorced, he replied, but I ought to meet her; she was French and very intelligent, very interesting. I made no comment, but my mind was working. Since he did not come here at night, couldn't I come and sleep here? I suggested it to him, offering to share the rent. He accepted at once, gave me a key, and the next night I moved in, with a small bag I had brought with me. I had told my folks that I'd been invited to stay at a friend's for a few days and not to worry. Each day I brought a few more personal belongings including my paint-box, until I had all that was necessary for sleeping and work-ing. It wasn't very comfortable, but I experienced a great sense of freedom. I saw Loupov only on Saturday afternoons or at the center. But traces of his work were all over the place and it got more and more messy. I did very little work myself, as Loupov's work seemed to fill up the place in a short time: sculptures, drawings, oil paintings; I did not feel like working at night and continued my visits to the Ferrer school.

One night Halpert said he was going to visit an art colony on the Jersey side, next Sunday, would I like to come along? I said yes, and we agreed to meet at the ferry after lunch. I went around to the hall room early Saturday, after my work. When I opened the door Loupov was lying on his back on the couch; on top of him, also on her back, was a young woman. I made as if to withdraw, but he told me to stay. They both laughed; he explained this was a project for a sculpture, they were re-hearsing the pose. After introductions, I remained a while, then returned home where I slept that night. I felt I must have a place entirely to myself to be happy, to avoid conflict.

The next day I met Halpert as arranged and we took the ferry to the Jersey side and a trolley to the top of the Palisades. It was open country without any houses. We walked up a road for about half a mile and came to a clump of woods. We fol-lowed a narrow path for another ten minutes, with silence all

around us except for the twittering of a bird now and then, and came out on an open hillside with a panoramic view of a valley. In the foreground, scattered here and there, stood a few simple and picturesque little houses with fruit trees in between. To the right, among taller trees, could be seen more substantially built rustic stone houses. It certainly looked like my idea of an artists' colony.

I asked who lived in the wooden houses in the orchard. It appeared that an old Polish blacksmith had put them up himself and rented them in the summer to painters. This interested me, and I suggested we look in on the Pole. He occupied the largest house, a two-story affair. A little old woman was feeding chickens and upon our inquiry she called the old man, who came out of the house. He was tall and robust-looking, a week's stubble on his face, with a drooping mustache. The shacks were all rented for the summer, except one that had four rooms and a kitchen — good for a family with children. Halpert was interested, he wanted a place to work for the summer but could only come out occasionally. However, he agreed to share the rent with me, adding that he knew a writer who might take a room to work in and contribute something. We paid a month's rent (twelve dollars) and could move in whenever we liked. I went home that day with my head whirling with projects. I'd move in completely, abandon home for good, even the city except for my trips to the office where I earned my living. It was spring — the days were getting longer — I could always manage to put in an hour or two painting after work.

Another big event occurred that year which was to mark a new departure in my work: the Armory show of modern painting in 1913. All the European schools of the most extreme tendencies were represented, but it had been organized by two American painters. Aside from showing some of my work at the Ferrer center the year before, I had produced nothing that could make me eligible for this show, but it gave me the courage to tackle larger canvases. I went about methodically organizing what was to be my new way of life. First, I removed my things from the place on Thirty-fifth Street, telling Loupov

about my new home. He thought it a good idea and promised to visit me. It was somewhat more complicated with my parents, but they were less and less surprised by my eccentricities; and when I promised to spend two or three nights at home every week and said they could come out to see me — it was beautiful country — they relented. Mother prepared some sheets and a blanket and shed a few tears as if I were going to some distant land. The shack was furnished — that is, it contained a couple of springs with mattresses, some chairs and a table.

I went out by myself the following Saturday afternoon and had until Monday morning to get settled. There were no shops, the nearest village being about a mile away. My landlord supplied me with milk, bread, and eggs which I could fry on a small kerosene stove. His wife offered to kill and roast a small chicken, all for a price, of course. Cold clear water came from a well nearby. This, and the ten-minute walk through the woods, were to me the symbols of my escape from the sordidness in the city. And so near — I was lucky; once again, as in previous years, in my trips to the outskirts of Brooklyn, I thought of Thoreau, and hoped some day to liberate myself from the restraints of civilization. Halpert did not show up this weekend, for which I was grateful; I enjoyed my solitude immensely. At nightfall I lit an oil lamp, and prepared my bed. Before turning in, I stepped out into a moonless starry night; a few dim lights shone in some nearby windows; now and then a dog barked or an owl hooted in the woods. I slept soundly and was awakened early by the crowing of a cock. All else was quiet. I opened the door and let in the first rays of the sun, also a black cat, poured myself a glass of milk, also a saucerful for the cat. Then I went for a walk to explore my surroundings. I had made a few watercolors during the week, pinned them up on the wall, which I thought gave the place a more lived-in appearance. The room I had chosen for myself had a window facing north, as befits an artist's studio; Halpert could have his choice of the other three rooms, east, west and south. It did not occur to me that he might have a preference. He arrived the following weekend, carrying paints and canvas, ac-

companied by another man, lanky, sandy-haired and bespectacled, whom he introduced to me as a poet who might take one of the rooms. Halpert took another room that had the second bed, but suggested that my room should be used as a common studio, it being the largest. I agreed willingly; we moved my things into one of the remaining empty rooms. He then suggested that I take down my watercolors; the studio should be kept neutral. Undoing one of the packages, he placed a glazed black vase on the table which was to figure in a still-life he planned to paint.

The poet was charmed with the place and agreed to take the remaining room; he, too, would come out only on weekends, as various interests kept him in town during the week. He left after a while saying he'd return next Saturday with a folding cot and a few supplies. We continued getting ourselves comfortably settled. Halpert said he could cook; later, when we brought some provisions, he would make a meal *à la Française*. For today's meal, we contented ourselves with some eggs, bread and coffee. I hadn't thought much about preparing meals; during the week, on my way out from work, I stopped in a self-service place for a sandwich or a hot dish. Likewise, going to work in the morning, I had my coffee in town.

We arose early Sunday, it was a beautiful June morning; after our coffee, we set up our folding easels outdoors and worked until noon. Now it really looked like an art colony. The Pole's wife came down to ask if we needed anything; I asked her to roast that little chicken for us, which she did to a turn, bringing with it a bowl of fresh ripe strawberries and some cream. Then we had coffee again, which made a perfect meal for me; Halpert regretted that we had no wine, which was considered indispensable in France; he'd gotten so used to it.

The following Saturday afternoon the poet appeared perspiring and out of breath, with his belongings in a bag and his folding cot on his shoulder. He had carried them from the trolley station. A mandolin hung on his back. Besides writing, he was a musician and a chessplayer. Now I got his name: Kreymborg. We got an old kitchen table and a chair from the landlord; Kreymborg laid out some books and papers. I was very

pleased. We might develop into something more than merely an artists' colony: Ridgefield, New Jersey — our colony was within its boundaries — could become an advanced cultural center embracing all the arts. We put our chairs out in the sun, talked, smoked and got acquainted. By the way, he'd seen Halpert in town — he was not coming out this weekend. My feeling was not exactly of relief, but I did not regret his announcement.

The next morning, after a light breakfast, Kreymborg went to his room and I to mine before starting to paint. My bed was covered with a sort of crazy quilt I had designed as a wall hanging in my Brooklyn room. It was composed of rectangles of black and gray samples of cloth. On it lay the black cat, sleeping peacefully. What a perfect harmony of tones, I thought — it would make a stunning still-life. I went into the studio to get my paint things; my eyes caught the black vase Halpert had brought. I took it back to my room and placed it on the bed alongside the sleeping cat. It was now a symphony in black; it would be the title of my painting. I worked all day at it, using bold and simple strokes, as Halpert painted, but with larger and more clearly defined forms. If he should think I was imitating him or was influenced by him, he could only be flattered. As for me, I had never worried about influences — there had been so many — every new painter whom I discovered was a source of inspiration and emulation. If there had been no predecessors, I might not have continued painting. Sufficient that I chose my influences — my masters.

When Halpert turned up the next week and saw my painting, he frowned. He recognized the vase he had brought for his projected still-life and considered my work an act of piracy. I apologized, never having looked at it from that angle, but, after all, he hadn't made the vase any more than the landscape before which we both sat a couple of weeks ago. I don't think he was mollified, anyhow he never painted his still-life. In fact, he did very little work; he seemed to regard his excursion as a relaxation from the more important work he was doing in town in preparation for his forthcoming show in the fall.

The next day we had visitors: half a dozen members of the

Ferrer center appeared, including Loupov and his wife, from whom he had said he was divorced. He introduced me — Donna was her name — and I asked her to take a walk with me; we left the others sitting in front of the house. She was beautiful with her golden hair and gray eyes, and had the wistful, strained expresion on her face I had noticed at the center the night she came for the child. She spoke perfect English with a charming French accent. After some general talk, she began telling me about herself. Yes, she was divorced from Loupov, but they remained on friendly terms, both taking turns caring for the child. It was difficult for her, Donna, as she was staying at the house of a couple; the man made passes at her when they were alone; the woman suspected her and was jealous, although they were both liberals and preached freedom in all matters. She was tired of the city and the people around her; she would like to get away. It sounded so sad; I was extremely moved and wondered how I could help her. I said I, too, had come out here to escape from the city, to live peacefully and work. Look, I said, I had the house all to myself all week and could give her my room, I'd sleep in one of the other rooms. She took my hand and thanked me, but wondered whether the others would approve. I explained, they came out for a day or two, and not regularly; it was my place; the others were really my guests. She accepted, when did I want her to come? Today, I said fearfully. Simultaneously, we threw our arms around each other and kissed. She said she felt as if we were old friends, Loupov had talked to her about me: I was intelligent and interesting. When we returned, the others were still sitting in front of the house, in the late afternoon sun. They looked at us with curiosity; Halpert made a facetious remark.

Loupov informed us they had been discussing the possibility of founding a liberal colony in our spot. He had always wanted to publish a magazine devoted to the arts. Besides poetry and painting, we might do our own printing. He had already spoken to a young printer in town, who offered to help with the production. In fact, the printer had a press which could be shipped out and installed in our shack. The idea met with everyone's

approval. I saw myself as the art director. Loupov would take care of all details and invite a couple of writers who were sufficiently known to add prestige to our venture.

As he prepared to leave with the other visitors, Donna announced she was staying a couple of days as our guest. Halpert raised his eyebrows but the others took it quite naturally. When they had left, Halpert became quite merry and said something to Donna in French. Then he announced he would cook dinner for us, having brought some provisions and a bottle of wine. Donna offered to help but he refused, saying she was our guest and it would be a pleasure to serve her. From time to time, he'd make an observation in French to which she replied rather shortly. The meal went off gaily; what with the bottle of wine and the conversation interspersed with French, I imagined myself transported to Paris.

When came time for retiring, I was rather perplexed. My bed was wider than the others; should I ask Kreymborg or Halpert to share it with me, and one of them to give his to Donna? Halpert jokingly suggested that Donna and he take mine, and I take his. I persuaded him to give up his bed and put up with me.

There was a coolness all around the next morning; the two men made me feel as if I had encroached on their rights as seniors. The men left early in the morning; I did not go in to work until later. Donna and I walked and talked, embracing occasionally, becoming better acquainted. We were very happy; the future held out limitless possibilities. Projects for painting filled my thoughts; with the man-woman problem solved, I seemed to know more clearly the directions my work would take. For the time, however, I must not neglect my means of a livelihood. We went into town together, I to my office, Donna to pick up a bag with her things where she had been staying. We met after my work, ate in a restaurant, and took the ferry to the Jersey shore. As we sat holding hands on the short ride, time ceased to exist, prolonged itself into an eternal honeymoon. The final walk through the woods to the cottage completed my sense of having attained a full life.

RIDGEFIELD, N. J.

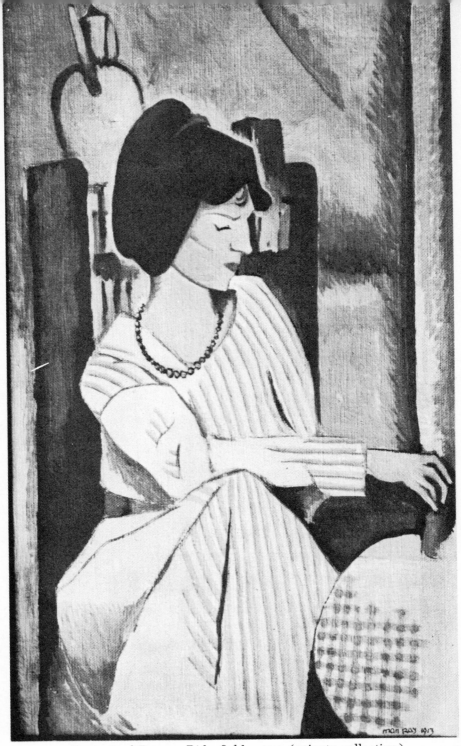

Portrait of Donna, Ridgefield, 1913 (private collection)

Donna and I had the whole week to ourselves, until the others came, but I had no misgivings.

Going to work all day and leaving Donna alone in the country had worried me; she was sure to get bored. But she reassured me; she loved the isolation, and found plenty to do around the house, besides she was writing: free verse and prose. So we would have another contributor to our magazine. On my way home I would stop at the markets downtown for food and sometimes a bottle of red wine which she liked. She cooked well and quickly, and made delicious salads. A bit of cheese and some coffee completed the meal, then we sat outside in the twilight, I smoking my pipe.

One night that week Donna retired early — she was not feeling well. Later, when I came into our room with an oil lamp she was fast asleep. Her head on the pillow made an interesting composition; I decided to paint her. I brought in a small canvas, my box of colors, and prepared my palette. The light was dim, but I knew my colors and could adapt them to the circumstances. The painting was finished in an hour, and I bent over to kiss her. Unconsciously, she put her arms around me. I went to bed.

The next morning my first thought on awaking was to look at the painting. It was a surprise: the face was a beautiful

lemon-yellow. In the light of the oil lamp, I had mistaken the tube of yellow for white. However, I decided to leave it so; it looked as intentional as was the stylized drawing. Donna thought the painting very original. Others who saw the work later also complimented me and said it should be exhibited. Encouraged, I took it up to Stieglitz, whom I continued to visit from time to time. He, too, liked the painting. Unfortunately he was not buying art, but sent me to a well-known publisher who was a collector. I was received at once on pronouncing Stieglitz's name, showed my little painting; without further ceremony the editor wrote out a check for one hundred and fifty dollars. Thus had this painting produced a second surprise. Forty years later came a third surprise: the painting appeared in the collection of the Whitney Museum.

During the week, Loupov phoned me at the office to say that the printing press would arrive at the Ridgefield railroad station Saturday afternoon, and to hire a local truckman to bring it to the house. He would arrive with the printer to set it up, besides having invited a couple of writers to discuss the future of the proposed magazine.

Everyone duly arrived: Halpert, Kreymborg, then Loupov and the printer, finally two new faces, Max Eastman, editor of the liberal magazine, *The Masses,* William Carlos Williams, a poet who practiced medicine in a town nearby.

The local truckman soon came jogging up the hill in his one-horse wagon. He grumbled somewhat at the weight of the press — several hundred pounds; I calmed him with a drink of beer and the promise of an additional fee. Planks were laid down from the wagon to the ground, and everyone gave a hand to the unloading. The press slid down, then was rolled into the common studio. On examination, however, it was discovered that it had been damaged in transport, and was useless.

Kreymborg advised me to put in a claim with the insurance and railroad. Which I did: after a while, I received a check in compensation. The idea of a new magazine was not abandoned, but as most of us would be in town by the end of the summer, it was decided to publish it there with an ordinary

printer. Kreymborg suggested that the check I had received be used for this purpose, but since I was staying on in Ridgefield, I decided to keep it for something I would publish myself locally as had been originally planned. The others might contribute if they wished. This proposal did not meet with enthusiasm. Kreymborg finally found backing for a poetry magazine published in New York which was called *Others*. I never could figure out whether the title was intended to express detachment from me, or that the contributors were new poets.

Halpert and Kreymborg continued coming out weekends, but the atmosphere became more and more strained. Their resentment at my obstinacy, and success with Donna, expressed itself in small ways. They acted more like guests, leaving all the cooking and washing-up to us, even hinting that we were occupying more than our share of the house. We were unhappy; I looked for a solution, hoping at the same time they would leave for good. However, they had paid up until the end of September, which indicated they would stay on.

At the end of August, one of the smaller houses on the property was vacant and I rented it. The landlord cleaned it up, repainted it in light, simple tints, without any wallpaper or other decoration, and we moved in. It was a sweet little house with a gabled roof, bedroom, living room and kitchen. A simple stairway led up to an attic under the roof. The rent was ten dollars per month. Besides the beds and an oil lamp which we brought from the other place, there was no furniture. The old Pole, ex-blacksmith, was a jack-of-all-trades; with some planks, he built a table and a couple of benches. I acquired an oil stove; we set it up on fruit crates which served as cabinets. Donna draped them tastefully with some printed cottons. There was a built-in closet with glass doors in the kitchen, painted brick red, which looked very handsome when filled with dishes. Refrigerators did not exist yet, an icebox was out of the question, as there was no delivery of ice in the community, but outside the house was a well, an ideal place to keep butter and milk let down in a pail on a string. Water was cold, pure and plentiful. The landlord built a porch with some planks, corrugated

iron roofing, trunks of young trees for posts, outside the bedroom window, facing west on the slope of the hill. I screened it with netting against the mosquitoes. The whole valley lay before us, with distant blue hills — a continual source of inspiration for landscape work. The hill opposite was dotted with detached simple houses in different tints. I made several studies of the village of Ridgefield. It was a walk of about a mile to the post office where we got our mail.

By the end of September we were alone, the others had gone and we knew no one in our vicinity. The quiet was interrupted now and then by the quarreling voices of the Pole and his wife when they got drunk. We were at the end of the world. One Sunday afternoon in October, as we sat outdoors in a warm Indian summer's haze, a group descended upon us. It was Loupov with a young woman, followed by a red-haired young man whom I recognized as Manuel Komroff, having met him in the life-class at the center. He was accompanied by a distinguished-looking woman. She was introduced — a successful English watercolor painter; the girl we knew also, from the center; she had posed for us one night. They were all very hot and perspiring from the walk. The girl asked if she could take a shower.

I laughed and suggested we go around to the back of the house where I would douse her with pails of water from the well. Without hesitation, she took me up on this, running around the house and everyone followed. I brought up two pails of water from the well; when I came around she was standing nude under an apple tree, head up, her long hair loose, like some Joan of Arc listening to the spirits. What a picture, I thought, for some painter with symbolical leanings. Or an Eve in the garden of Eden waiting for Adam. And Adam came; I threw a pailful of water at her, she screamed with the shock of the cold well water. The rest of us looked at each other aghast. What if some neighbors heard her and came upon the scene? She shook herself, her teeth chattering, but motioned to the other pail of water. This time I approached and gently poured the contents over her shoulders, not wish-

ing to wet her hair. Donna had gone in to fetch a towel, which I took from her and began drying the girl. I rubbed her slowly, thoroughly, avoiding her intimate parts although the desire to touch them was very strong, then gave her the towel to finish the act.

Loupov and Donna remained outside in conversation, while we went into the house — the girl, Komroff, and the English-woman — and I showed them some of my work. The woman, although a conservative painter of portraits, was interested in my work, and bought two small watercolors for twenty dollars. Komroff asked if there was a small house for rent on the property; I supposed the one we had left was now vacant, and directed him to the owner. He went up with his friend and soon came back announcing he would be our neighbor; it would be pleasant to have some kindred spirits nearby in this charming but lonely setting.

When everyone had left, Donna told me that when she and Loupov had been divorced, all their household goods had been put into storage; he now agreed to let her have whatever she needed to furnish our home. She went into town a few days later and soon a truck arrived with the effects. At first I was averse to having anything around that was connected with her former life — I had particularly told her not to bring any beds, even if superior to our present ones. Besides a sturdy round table and some chairs, there were two cases, one containing some French crockery and a magnificent antique polished brass jug very much like one of Brancusi's golden birds recently exhibited at Stieglitz's gallery. This I mentally reserved for a future still-life. The other case was full of books, yellow paper-backed insignificant-looking volumes in French. Donna began removing them carefully one by one, stopping now and then to turn the pages of one, reading some lines to herself, then translating into literal English a poem by Mallarmé; another by Rimbaud and a paragraph from Lautréamont's *Chants de Maldoror*, works that were to be adopted ten years later as slogans by the Surrealists in Paris. Then there was Apollinaire, whose *Calligrammes* played havoc with typography, who de-

fended the young Cubists. And Baudelaire, with his odes to his mistress, his translations of Poe, bringing his genius to the French.

My mind was in a turmoil — the turmoil of a seed that has been planted in fertile ground, ready to break through. I seethed with projects to paint; I must find more time to myself. There were so many immediate distractions: my job, chopping and storing wood for the approaching winter, getting warm clothes.

I made an arrangement with my employer, whereby I would come in to town only three days a week. This reduced my income, but not my usefulness to the company. Instead of dawdling and dreaming half the time in the office, I turned out as much work as in a whole week — I was a fast worker — and met all the demands made on me. With the occasional sale of a small painting I hoped to make up the difference. Donna was not so optimistic, but I had other projects in mind besides painting. She had been writing — some short pieces in prose and poetry — and I suggested we do a book together, a deluxe portfolio, limited edition, with my drawings and her writings which I would, with my training in calligraphy, letter by hand. This could be reproduced on fine paper by a process similar to lithography, with which I was familiar. The insurance money I had collected for the broken press would pay the costs. Only twenty copies were to be printed, to sell at ten dollars each.

Although I felt that Donna's writings in English were rather awkward at times, they were sincere and fresh like the paintings of naïve artists; I calligraphed them as they were. Why couldn't one be naïve in writing, I thought, as well as in painting? Hadn't Stieglitz published some of the first writings of Gertrude Stein, wherein she pretended to write in the same spirit as some modern painters painted? Donna wrote things in French also, which I did not understand. At one time she began giving me lessons, in preparation for the day when we would be able to sail for Paris. She soon gave this up, however, being outraged by my pronunciation and my lack of aptitude.

The winter of 1913-1914 passed uneventfully as far as outside appearances were concerned; inside our little house there was great activity. I started a series of larger canvases, compositions of slightly Cubistic figures, yet very colorful, in contrast to the almost monochromatic Cubistic paintings I had seen at the international show in the Armory.

One day I received a note from Kreymborg asking me to meet him in town. I was to bring a small painting with me, as he would introduce me to a friend who was interested in the younger painters. The friend was an occasional poet, Hartpence by name, who was looking for a situation, preferably in an art gallery. He took us to an old-fashioned beer saloon on Forty-second Street and Ninth Avenue. The owner, a large, round-faced man, stood behind the counter; I was introduced to Mr. Daniel; we ordered beer, then Hartpence suggested we try the sandwiches of the house. Three huge rolls, covered with caraway seeds, lined with slices of ham and Swiss cheese, were put before us. They were delicious. Daniel, through Hartpence's coaching, was buying paintings; I was asked to show what I had brought with me. Daniel held the work at arm's length, squinting at it, brought it closer examining the texture, shook his head knowingly and asked how much I wanted for the painting. I left it up to him — he gave me twenty dollars. Afterwards, Hartpence told me he was working on Daniel to persuade him to open an art gallery, with himself as the director; if he succeeded, he would arrange for me to have a show when I had enough paintings. I was grateful and asked him to visit us in Ridgefield, which he promised to do as soon as spring came around. The future looked very bright indeed.

The winter, however, was severe. We burned wood in our stove; our landlord lent me a two-handled saw with which we cut down a tree in the woods nearby, which was private property but unguarded. The exercise was good for us. A few times we were snowed in; when I opened the door in the morning I was faced with a six-foot snowdrift which I did not bother to remove, except to fill a kettle for hot water. We generally had enough food in the house for two or three days; it was pleasant to be cut off from the rest of the world.

Came spring, it was pleasant to walk through the damp greening woods to the cottage, carrying a bag of provisions from town, eager to get to my easel. One warm late afternoon I came upon Donna washing her hair over a basin outdoors; it was a charming picture and I immediately made a watercolor. With the warmer weather, people began coming out, generally on Sundays.

We still knew no one of the local inhabitants, but they seemed to know all about us. There was a feeling of antagonism in the air. Of course, we were artists, bohemians, living in sin probably. At the post office the clerk refused to give Donna my mail; she got hers under her maiden name: Lacour. I went down to remonstrate, said it was her author's nom-de-plume, and was asked to show our wedding certificate. Even some of the liberals who came out to see us treated us as if we were on a lark that would soon end and Donna would be free again. One man, a young poet, asked her to come into town to live with him.

Loupov came out with Donna's daughter and left her with us for some days. She had been put in a school up the Hudson, run by the sister of Isadora Duncan. Esther was the youngest of the pupils studying the dance; she had the grace and the poise of an accomplished ballet girl. I was delighted to have her with us, it gave a domestic touch to our home, and seemed to insure its permanence. I offered to do what I could to help with her upbringing; it would be agreeable to have a ready-made daughter in the family. It was enough of a burden to give birth to works of art. Then, in order to set at rest all speculations of our friends and eliminate the disapproval of others, we agreed to get married.

I obtained a license in the village and the next Sunday afternoon that we had visitors I asked them to walk down to the village to act as witnesses for us. We drank a few toasts, and started off in very gay spirits. It was warm, we wore no coats; our shirts open at the neck; the women, too, wore nondescript country clothes. Halfway down the road we met a procession of people on foot, headed by a bearded man, his fat wife leaning on his arm. We stopped, I introduced myself and judged

he was the rabbi of the community. He replied in the affirmative, adding that they were returning from a funeral. Would he marry us, I asked. His wife nudged him violently; some of the others scowled at us as if we were making fun of them, but he replied gently that it was not convenient right there in the open, besides they were quite tired; he could give me his address and we might come to his home during the week. I thanked him, saying I had my witnesses only for the day; we continued to the village.

The justice of the peace was away on Sunday; we were directed to the home of the local minister of the church. I do not remember the denomination; he told us he could not perform a civil ceremony, only one according to the usual church rites. We accepted and he married us with Bible and all. A ring was borrowed from one of the witnesses. During the week we had a visit from the minister asking us to join his parish. I thanked him, saying I would see later on, we were too busy at the time. To show my good will, I gave him a watercolor which he accepted with thanks.

All immediate problems being well settled, we organized our time on a regular program. Three days in town to assure a steady income, small but adequate, the rest of the week at home, painting, reading, loving, planning for the future, which we hoped would be in France. Visitors came on Sundays to break the continuity of our life, sometimes agreeably so; at other times it was a relief when they left. Hartpence and his friend Helen came regularly. They were both outdoor people, loved the country; but what endeared them to me was their interest and enthusiasm about my painting. She was a tall handsome girl, full of vitality in contrast to him, who was rather anemic, suffering from some stomach ailment.

One Sunday afternoon a new group descended upon us, led by Hartpence and Helen. Three couples besides our friends; they came looking for places to live in, away from the city. A tall, distinguished-looking man whose name I do not remember, who was supposed to write, but drank mostly, as I found out later. His wife, Rose, was a handsome woman who did

write. A poet, Orrick Johns, and his wife, the painter Peggy Bacon; he had lost a leg in an accident. Robert Carlton Brown, a poet and writer who associated himself with the Imagist school then forming. Later he invented a new system of reading on tape that unrolled under a magnifying glass, calling it "The Readies." He also became famous with a serial that appeared in the papers: "What Happened to Mary." A line in one of his poems stuck in my memory, it was about a fat woman who carried herself as if every ounce was worth a thousand dollars. Bob Brown with a small capital had made a killing in Wall Street in a couple of weeks. He bought one of the larger stone houses in the community, whose owner had died; Johns persuaded the old Pole to move out of his house into a smaller cottage; he and Peggy settled down to write and paint. As for Rose and her husband, they found a romantic little shack in the woods, covered with bark and the gables ornamented with twisted branches and roots. It was on the property of one of the more substantial stone houses, but quite invisible among the trees and ferns. As soon as he moved in, Brown gave an enormous housewarming party on the roof, which had been converted into a flat terrace. About a hundred people came; there was dancing and drinking until early morning, and a few fights. Bob seemed to get along especially well with Rose, but her husband was drunk and too feeble to protest.

I hadn't noticed anything in particular, but Donna told me later that several guests had made passes at her. She seemed quite annoyed that I showed no signs of jealousy, and suggested I had been too busy with Bob's wife — she'd been watching me. I replied shortly: no harm had been done and we were still together, which was what mattered. However, she sulked for a couple of days, now and then giving little talks on promiscuity and fidelity — she'd had enough of liberal ideas. I assured her of my complete devotion, how happy I was with her, how much she meant to me and what a source of inspiration she was, above all; no other woman could replace her in every respect. We made up and agreed to have as little to do with our neighbors as possible.

Having persuaded Daniel to sell his business of running a

beer saloon and open an art gallery, Hartpence had urged me to work hard, to have enough paintings for a show when the time came. I had redoubled my efforts and by July had produced a dozen presentable works. These were fair-sized canvases, but I started a larger one, three by six feet, on a specially prepared canvas to make it look like a fresco painting, which was first to fill a space in our living room. I had been reading about Uccello; the reproductions of his battle scenes had impressed me with their power although I did not see in them the solution of perspective problems with which he was credited. He was supposed to have awakened his wife at night to impart to her his revelations. Later, Leonardo da Vinci had put perspective on a more scientific basis, in fact, had declared that perspective was the basis of all art. During my earlier architectural studies, I myself had been fascinated by the problems of perspective, and had devoted much time to them, which stood me in good stead at the publishers, who now and then had to produce a picture of a project not realized. In my painting, however, I never forgot that I was working on a two-dimensional surface which for the sake of a new reality I would not violate, or as little as possible, just as I had abandoned any attempts to reproduce academic anatomy.

These matters were well taken care of in our time by photography, which had liberated painting. So I reasoned. My large painting progressed with these thoughts as a background. Composed of elementary human forms in alternating blue and red, and gray horses also simplified, as must have been the Trojan horse, I kept in mind the idea of the fresco; the work in oils was more somber as befitted the subject. Although there was a suggestion of volumes in the series of paintings I was doing that year, I decided, after finishing this series, to work in a more two-dimensional manner, respecting the flat surface of the canvas.

In August war broke out in Europe. We figured that our plans to go abroad would have to be postponed — perhaps for another year or so. I was finishing my large canvas; Donna said it was prophetic, that I should call it War. I simply added the Roman numerals in a corner: MCMXIV. In town the impact of

the war was more visible. It was a field day for the newspapers with their accounts of battles and atrocities; Wall Street was booming; speculators were reaping fortunes in a day. During my lunch hour when in town I walked around the streets near the stock market, filled with gesticulating employees shouting to men in the open windows of the offices, transmitting orders to buy and sell. It was like a great holiday, all the profits of war with none of its miseries. Walking home in the evening through the silent wood, I felt depressed and at the same time glad that we had not yet been able to get to Europe. There must be a way, I thought, of avoiding the calamities that human beings brought upon themselves. Wasn't it enough to wage the slow battle against nature and sickness? Donna wrote a poem of a pacifist tendency which I incorporated in the portfolio I was preparing, illustrated with a drawing of my large canvas. She wrote other poems, calm and lyrical, dealing with nature and love, which I also included and ornamented with drawings. By the end of the year it was finished and printed on the best paper I could find. I designed a cover; we bound the twenty copies ourselves.

Autumn came with its red and gold coloring; it was a beautiful Indian summer again. Hartpence suggested we go on a camping tour for a few days into the wild country up the Hudson. He knew the land and helped outfit us for the hike. Rose and her husband liked the outdoors and asked to go along. We were three couples, each one with a blanket rolled around the shoulder and knapsacks with provisions. We started down the road towards the trolley that would take us to the landing where the riverboat left for Bear Mountain, whence we would strike across the hills. Hartpence and Helen led the procession, I followed with Rose who had taken my arm, Donna and Rose's husband bringing up the rear. Hardly had we gone a hundred yards when Donna called to me and, as I turned, she turned also and began walking back to the house alone. I hurried after her, thinking she had forgotten something, leaving the others, who stopped to wait for us. In the house Donna decided she

would not go on the trip; I was entirely too chummy with Rose, who was a woman out for trouble. I could join the others alone, as for herself she was leaving for the city, leaving me free to seek adventure. This was too sudden and too drastic; I did not know how to cope with the situation. I called back the others and explained as best I could while Donna sulked in the bedroom. She had removed her camping equipment and was packing a bag with her clothes. Helen and Rose went in to talk to her. Hartpence giggled and observed that it was an outburst of the Latin temperament, not serious; then we all assured Donna that our intentions were honorable, that we would scrupulously observe our respective status as from the start. There had to be a certain amount of friendliness if we were to live together for several days in the wilds. Finally Donna relented; we resumed our journey with me alongside her.

When the boat docked at Bear Mountain we struck out on foot uphill through thick woods into the Ramapo Hills. It was called the Harriman Park, rather sterile country with here and there an abandoned farmhouse; not a sign of life. Hartpence said there were copperheads and rattlesnakes. He'd brought cauterizing supplies and some whisky in case something happened. We shivered at every rustle in the bushes. Once a long black snake lay ahead across our path, but it was harmless and disappeared.

Towards sundown we came to a cozy little clearing with a brook nearby; we stopped and unloaded our packs. Hartpence collected some twigs and dead wood, expertly building a fire, and sent me down to the brook with a kettle for water. As I bent down, I heard a rattle nearby; I straightened up and banged the kettle against a stone; there was no further sound. After a meal of canned beans and corn washed down with black coffee, we gathered pine branches for beds, rolled ourselves in our blankets and slept soundly until sunrise. There was dew on the ground and our blankets were damp; we spread them out on the ground in the sun while preparing breakfast. Rose and Helen went down to the brook and bathed; Donna joined them a few minutes later. We watched the nude figures moving about

through the branches; I thought of Cézanne's paintings, and made a mental note of the treatment of figures in a natural setting, for future works.

After a breakfast of bacon and eggs, we collected our material; as I lifted my blanket, a snake slid away from underneath. I told Hartpence this was the second time I had encountered the reptiles; he laughed and replied that they had a preference for certain body smells. Donna frowned as if it were a reflection on herself; she had no sense of American humor. We were running out of food; Hartpence said there was a small town about ten miles farther which we could make by lunchtime if we moved briskly. It was getting warmer with the rising sun and we were perspiring, so we stopped often. Hartpence must have miscalculated, for by three in the afternoon we were still in wild country with no sign of any habitation. After another hour or two of slow progress we saw a thin column of smoke rising from a clump of woods.

Directing our steps towards it, we came upon a camp in a clearing, consisting of two tents, a large automobile, a man and woman sitting comfortably in camp chairs in front of a table with drinks, and another man wearing a chauffeur's cap preparing a fire in a camp stove. After introductions all around, we were offered drinks and invited to stay for dinner. Our host was a retired businessman from Long Island, taking a vacation. Although seeking solitude they were glad to meet people unexpectedly and made us feel very welcome. The dinner was sumptuous, with fried chicken, vegetables and fruit, ending up with coffee, cigars and brandy. There was even a box of chocolates to take with us. We refused an invitation to camp nearby and have breakfast, we were on our way to the next town. And so we continued a short distance until we found a suitable spot to camp in. The next morning we reached the town after a short hike and laid in a stock of provisions — eggs, bacon and some canned goods — and continued into the open country to have breakfast. After cracking a couple of eggs which turned out to be bad, we used the rest of the dozen as missiles with a tree trunk as a target. We contented ourselves with some bacon and coffee and were soon on our way again.

We came upon an abandoned orchard, the ground strewn with ripe red apples with which we gorged ourselves and filled the knapsacks. This was all we ate as we trudged along leisurely during the day.

Towards evening we came upon another camp, different from the previous ones. It was a large tent with a couple of horses tethered nearby. A small Japanese man was preparing some food on a folding table. Two men came out dressed in khaki shirts and breeches. They were government surveyors who were doing the country around, and they received us with enthusiasm and with marked gallantry towards the women. Rose particularly put forth all her charm; we were invited inside the tent for drinks. Besides the two cots, the inside was stocked with much equipment and stores. In the rear were a dozen cases of whisky — anti-snakebite liquor they called it — and we became thoroughly inoculated. Then tables were set outdoors for dinner, and once again we were treated to a splendid meal which terminated with Pêche Melba. The Japanese cook and servant wore white coats for the occasion. Thanking our hosts, who pressed us to camp nearby, we continued our trip while it was still light. In a short time we came upon what looked like an abandoned barn: the inside was filled with bales of hay. There was a ladder leading to a loft strewn with fresh hay, which we adopted at once as our sleeping quarters. Presently we heard steps and a voice called up to us. It was a farmer, who told us roughly to get out. Hartpence talked to him, promising to leave the place as we had found it, but he was afraid of fire and wasn't having his place burned down. He expressed no concern for our own skins, I remarked. To reassure him we promised not to smoke and put all our matches outside. O.K., he said, and left us. There were still lots of nice people in the world, I thought. Sleeping with Donna in sweet-smelling hay was a new and delightful experience, but in the morning we were taunted by the others — we had kept them awake with strange noises. Donna replied that less aesthetic noises had come from them. Everyone laughed, enjoying her repartee. Our breakfast consisted of the rest of the bacon, some apples and coffee. There was a town another ten

miles farther on, with a railroad station where we could take a train back to our homes. All agreed we had been extremely lucky and pampered; we might not be so fortunate in the future, there was always the problem of food, and the weather might turn for the worse. It was getting chilly at night; our blankets were not warm enough; in short, we decided to return. After four or five hours of walking, we arrived at the railroad station, obtained some food at a local shop and waited for the train due in a couple of hours.

Hartpence and I took a walk in a nearby forest, discussing future art projects. I told him I would make some imaginary landscapes inspired by my trip — I would no longer paint from nature. In fact, I had decided that sitting in front of the subject might be a hindrance to really creative work. He approved in general, but observed that man could not detach himself from nature, in the long run we had to return to nature, man himself was nature. Walking slowly through the narrow path, stepping over dead branches and brambles, I suddenly felt a sharp pain in my ankle. I let out a cry, thinking I had been bitten by a snake. Hartpence made me lie down, took out his pocket knife and the flask of whisky from his hip pocket, removed my shoe and sock. Telling me not to move, he said he'd make an incision and suck out the blood. On examining the wound, however, he said I'd been pricked by a thorn, and simply poured some liquor on it, explaining that a snakebite left a different mark with the fangs. I felt somewhat ashamed and asked him not to mention the incident to the others.

What I carried away as most significant of our excursion was this last talk with Hartpence. After the imaginary landscapes I would paint as inspired by the trip, not only would I cease to look for inspiration in nature; I would turn more and more to man-made sources. Since I was a part of nature — since I was nature itself — whatever subject matter I chose, whatever fantasies and contradictions I might bring forth, I would still be functioning like nature in its infinite and unpredictable manifestations. I could not visualize what form the future would take, but I was sure it would resolve itself as did the work of

nature. The urge to live and to work would find the way. So I reasoned.

Veterans of last year's experience, Donna and I faced the coming winter with confidence, making ourselves as comfortable as possible, dividing our time into a well-ordered routine. Our portfolio of drawings and poems finished, I carried them into town one by one and was able to dispose of them among friends, adding to our income. By the end of the year I had completed my series of romantic expressionistic paintings of figures in the woods as well as a few landscapes inspired by the camping trip and the country around where we lived.

Then, with the beginning of the next year, I changed my style completely, reducing human figures to flat-patterned disarticulated forms. I painted some still-lifes also in flat subdued colors, carefully choosing subjects that in themselves had no aesthetic interest. All idea of composition as I had been concerned with it previously, through my earlier training, was abandoned, and replaced with an idea of cohesion, unity and a dynamic quality as in a growing plant. This I felt more than actually analyzed, which was adequate justification for the new trend; the emotional impulse was as strong as ever.

Donna and the visitors who saw the new work had very little to say about it; they had praised my more romantic period; one or two, including Hartpence, thought I was undergoing a brainstorm provoked by the foreign painters I had seen in the big Armory show the year before. Of course, no one suggested that these foreigners were influencing each other. If there was influence, as there had to be influence if one were to continue the traditions of art, at least I showed initiative in choosing my sources of influence; my preferences, I thought. It was a consolation when in the spring a well-known painter came to my door and invited me to an exhibition of modern American painters that he was organizing for one of the smartest and most conservative galleries on Fifth Avenue. I sent in my MCMXIV, the large canvas of men and horses, and also one of

my new still-lifes. All one needed do was produce; there would always be a demand for the work in some quarter or other.

The show produced a little flurry in art circles; the critics were none too gentle with American painters who were undergoing European influences; however, to me, it seemed the show was very American: it had freshness, a bit of humor here and there and an earnest attempt at injecting new life in the oil-wallowing productions that filled the galleries at the time. Besides, the influence came not only from abroad; Stieglitz had already opened new horizons which disturbed the somnambulists.

Finally Daniel sold his saloon and opened a luxurious gallery at Fifth Avenue and Forty-seventh Street, then the most exclusive district of New York. It was definite — my show would be hung in the fall.

The spring and summer passed quickly. Besides putting the finishing touches to my paintings for the coming show, I decided to do something in the way of preparing reproductions of my work for catalogs and the press. The few reproductions that professional photographers had made of some paintings were unsatisfactory. Translating color into black and white required not only technical skill but an understanding as well of the works to be copied. No one, I figured, was better qualified for this work than the painter himself. I had never shared the contempt shown by other painters for photography; there was no competition involved, rather the two mediums were engaged in different paths. This was confirmed when I met accomplished photographers who were also painters, practicing the two means of expression at the same time without the one encroaching upon the other. I admired and envied them.

Some painters, confessed they were simply overawed by the camera, had never touched one; it seemed to require devilish dexterity and great scientific knowledge. The camera intimidated me, too, but as usual, when something seemed beyond my reach I was restless until I resolved to make it my next conquest. Hadn't da Vinci and Dürer fumbled with optics and devices for facilitating their work? They probably would have used the camera without compunction to save themselves

many hours of laborious drawing. In my case, the work was done; there was no question of using the camera in connection with it except as a means of recording the result. I acquired a camera, a set of different filters which I was told were necessary to interpret colors into black and white, and the appropriate plates for reproduction. Following the instructions which came with the material, I took my plates to town to be developed and printed. The results were surprisingly satisfactory. It was much simpler than I imagined. Later I would set up a darkroom and explore the mysteries of developing. I had enough prints made to prepare several duplicate albums of my paintings, to be presented to Daniel, Hartpence, Stieglitz and others who might be interested. All this took me away from my painting for a while, but I had enough for my coming exhibition. Besides I needed a rest — or rather a diversion, after two years of concentration on painting.

That summer there were other distractions, with visitors, and contacts with some of the literary neighbors. Bob Brown's wife had left him, Rose had left her drinking and unproductive husband. Bob's mother, a grand and vital lady who had helped him with his writing, came down to stay with him and gave the place a more serious look, although we had some gay evenings together. Our nearest neighbors, the poet Orrick Johns and Peggy Bacon, would come down of an evening and we would discuss poetry or listen to his latest poems. One night after we had gone to bed a violent thunderstorm broke, with continuous flashes of lightning. Donna was terribly afraid of lightning; I got up to close the bedroom window giving on our porch, but we could not fall asleep again because of the blinding flashes and racket. With each illumination the landscape stood out as in daylight, but with a quality of intense moonlight. I was seriously considering setting up my camera at the window and letting one of the flashes make a photograph. Just out of curiosity, not that I would ever want to be a pictorial photographer. I might use the picture as a source of inspiration for a painting later. Of course, the work would be something entirely different. However, I was snugly tucked in bed; with the monotonous drumming of the rain on the roof I dozed off

when suddenly Donna began shaking me: there was a persistent pounding on the door. I arose, lit the lantern and went to the door, which I unbolted and opened a few inches. At first, I saw nothing in the dark, then a flash of lightning illuminated a hallucinating scene which remained impressed on my retina as if it were a photographic film. A one-legged man, stark naked, with the water running down his body, was wiggling his foot to balance himself. It was Johns the poet. I opened the door wider, holding up the lantern between us to see him more clearly, and he asked to come in. With two or three hops like a bird he entered: I gave him a chair. He had been drinking, I could see, and he asked if I had anything to drink. No, I hadn't; he talked for a while, I replied shortly, I had nothing to say to people who were drunk; even when sober he had never shown the slightest interest in my work; my interest in others had to be reciprocated, which seldom happened with writers, whom I forgave less readily than I did out-and-out Philistines. Discouraged, he finally left; I watched him hopping up the path to his house, fearing he might fall down, but he was remarkably agile in spite of his condition. Perhaps it was the gentle cool July rain that helped him maintain his equilibrium. I regretted not having been able to photograph him.

It gave me an idea: I'd rig up a curtain on a hoop in back of the house, open to the sky; whenever it rained in the summertime, we'd take showers. Our bathing facilities were quite primitive: a large basin, water warmed up on the oil stove, and a rough sponge. When Donna bathed standing in the basin near the stove in the winter it was like one of the sketches by Dégas or Toulouse-Lautrec. It was in pure French tradition. I made a couple of sketches in the same manner. I thought of taking some photographs to be used later for the sketches, but it seemed too roundabout, I could draw so quickly and get the result immediately, without bothering to interpret a photograph.

Visitors continued to descend upon us: one Sunday afternoon two men arrived — a young Frenchman, and an American somewhat older. The one was Marcel Duchamp, the painter whose Nude Descending the Staircase had created

such a furor at the Armory show in 1913, the second a collector of modern art, Walter Arensberg. Duchamp spoke no English, my French was nonexistent. Donna acted as my interpreter but mostly carried on a rapid dialogue with him. I brought out a couple of old tennis rackets, and a ball which we batted back and forth without any net, in front of the house. Having played the game on regular courts previously, I called the strokes to make conversation: fifteen, thirty, forty, love, to which he replied each time with the same word: yes.

In November, I sent about thirty paintings, unframed, to the new Daniel Gallery, which would be devoted mostly to young American painters. It was too late to order frames, besides Daniel hesitated before the expense, unless I was willing to use a simple wooden molding. But I had already conceived a substitute; I was averse to frames. First, we hung the pictures as they were to be shown, then strips of wood the same thickness as the canvas stretchers were nailed to the wall close around them. The pictures were removed and cheesecloth stretched over the walls and tucked inside the strips. Then the paintings were put back in their original spaces, making them flush with the new wall and giving the effect of their having been placed in the gallery permanently. In fact, they looked as if they had been painted on the wall. For the catalogue, I labeled the works under general titles such as Studies in Two Dimensions, Inventions, and Interpretations.

With one or two exceptions, the art critics' reactions to my first one-man show were deprecatory or outrightly hostile. One had explained to Hartpence that he had to follow the policy of his paper, which drew a substantial revenue from advertising space taken by the more conservative galleries — since we had not advertised in this paper, the implications were obvious. Another critic whom I met later, who had given me a long write-up of a patronizing nature, interspersed with humorous remarks, advised me not to read criticisms but to measure the amount of space they covered and be satisfied accordingly. One visitor asked for a photograph, which appeared later in a book on the history of art to date. I do not remember the name

of the author, but in writing about the work he said that he did not know the name of the painter, and did not care, but judging from the work, this artist must be a degenerate, a drug addict. Daniel, or rather Hartpence, did not seem to mind these attacks, he expected them and promised to stand by me whatever the reception of my work.

Nothing was sold; at the end of the show, the paintings were taken down ready to be shipped back to me. It seemed I'd have to resign myself to another year of effort and economical scraping. About a hundred yards up the road from the cottage was a small café run by a Swede where we'd stop in for a beer or to use the telephone. A few days after the show closed, as I was puttering around one morning, the café owner came running down to call me to the phone — it was urgent. It was Daniel — a collector from Chicago was in town — the famous Arthur J. Eddy. He was over seventy, a big corporation lawyer, tall and white-haired, with racing stables in California and Florida, champion fencer of the United States, he'd had his portrait painted by Whistler. He had brought the first Renoir into the country and had written a book on Cubists and Post-Impressionists. He had also ridden the first bicycle in Chicago. A pioneer in his own right.

The famous collector had turned around my paintings as they stood face to the wall, picked out half a dozen and offered two thousand dollars for them. I said I'd come in at once. When I told Donna she advised me to hold out for more — Daniel was probably getting double the amount. I pointed out that this was a lifesaver for us — we could move into town and be spared a third winter in the country. Hadn't we had enough of this back-to-earth life? However, when I came in to the gallery I told Daniel that since he had put prices of five and six hundred dollars on the paintings, Eddy should pay more — with Daniel's commission, there wouldn't be much left for me. Daniel told me this would make me, I should not think of money now — as for himself, he would forgo his commission — this was too important for the future. Inwardly I was very excited and accepted without further fuss. I had never had so much money and a vision of a studio in town with possibilities

of more time for painting along new lines filled me with joy. I rushed back to Donna and told her we were moving into town immediately. No more woodchopping or melting snow for water, for me — we'd get a new outfit of clothes and eat out for a while. Donna was thrilled but tried not to show it — she was always defending me against those who might exploit me — I was too easy-going. I loved her for this — it was a token of her devotion to me.

NEW YORK AGAIN

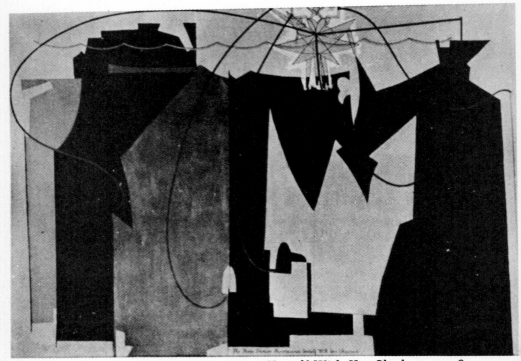

The Rope Dancer Accompanies Herself With Her Shadows, 1916
(Museum of Modern Art, New York)

I found a regular artist's studio on Lexington Avenue oppo-
site Grand Central — on the fifth floor of an old brick building.
It had a skylight and had been occupied by a well-known painter
— Glackens. There was hot water and steam heat and a bath-
tub. They were building the Lexington Avenue subway and
the racket of concrete mixers and steam drills was constant.
It was music to me and even a source of inspiration — I who
had been thinking of turning away from nature to man-made
productions. After attending to our immediate needs and get-
ting comfortably settled, I bought rolls of canvas and a large
stock of colors. We ate in restaurants and went to the movies.
Towards the end of the month we received an invitation from
A. J. Eddy, who was in town again, to have dinner with him.

We had a fine dinner at Mouquin's, with champagne; Eddy
tried out his French on Donna, and we laughed a good deal.
After coffee and brandy, we went to the studio to look at some
of my work that had not been shown at Daniel's. I made the
mistake of first showing Eddy some drawings for future proj-
ects — a complete departure from my Romantic-Expression-
ist-Cubist period. The new subjects were of pseudo-mechanis-
tic forms, more or less invented, but suggesting geometric
contraptions that were neither logical nor scientific. Eddy did
not react. The deliberate coldness and precision of execution

seemed to inspire him with equal coldness. I tried to explain that with my new surroundings in a busy and changing city it was inevitable that I change my influences and technique. He asked if I hadn't something left over from my work done in the country. I replied that some of the paintings in my exhibition which he had not acquired already indicated the new directions my work would take, but I brought out a couple of landscapes done after my camping trip. He revived: this was what I should continue, what he had been attracted by in the works he had acquired; then asked the price for the two. I stated some astronomical sum, feeling that I could expect no further support from him in the future; that he might even go around condemning my new work — and I knew I would never return to the older style. He did not take the landscapes.

After a few months the novelty of our new surroundings began to wear off and we became more susceptible to the inconveniences. Donna complained about the five steep flights and the kitchenette which was merely an extension of the studio over a lower adjoining roof, difficult to heat in the winter. It had no steam radiator. The rumble of trucks and machinery over the temporary wooden sidewalks in the street, night and day, wore on our nerves. We began looking for another place. I held on to my three-day-a-week job, painting the rest of the time.

The studio was small and served as our main living room. I had started a large canvas which I rigged up with ropes and pullies, to be drawn up into the skylight when not being worked on. The subject was a rope dancer I had seen in a vaudeville show. I began by making sketches of various positions of the acrobatic forms, each on a different sheet of spectrum-colored paper, with the idea of suggesting movement not only in the drawing but by a transition from one color to another. I cut these out and arranged the forms into sequences before I began the final painting. After several changes in my composition I was less and less satisfied. It looked too decorative and might have served as a curtain for the theater. Then my eyes turned to the pieces of colored paper that had fallen to the floor. They made an abstract pattern that might have been

the shadows of the dancer or an architectural subject, according to the trend of one's imagination if he were looking for a representative motive. I played with these, then saw the painting as it should be carried out. Scrapping the original forms of the dancer, I set to work on the canvas, laying in large areas of pure color in the form of the spaces that had been left outside the original drawings of the dancer. No attempt was made to establish a color harmony; it was red against blue, purple against yellow, green versus orange, with an effect of maximum contrast. The color was laid on with precision, yet lavishly — in fact, the stock of colors was entirely depleted. When finished, I wrote the legend along the bottom of the canvas: The Rope Dancer Accompanies Herself with Her Shadows. The satisfaction and confidence this work gave me was greater than anything I had experienced heretofore, although it was incomprehensible to any of our visitors who saw it. In fact, until we moved out of the studio the painting was invisible to most, hanging up high near the skylight. But already some of my recent work was incomprehensible, invisible to people even when placed on their eye level. I began to expect it and even derived a certain assurance that I was on the right track. What to others was mystification, to me was simply mystery.

Speaking of mystery reminds me of a visit to the studio one day of a distinguished young man with a carefully combed blond beard. Willard Huntington Wright was his name, a very intellectual art critic. Later, he became more famous as S. S. Van Dine, writer of mystery novels. He was organizing an exhibition featuring his brother MacDonald-Wright, and Morgan Russell, two American painters who had started an art movement in Paris before the war — the Synchromists. I was invited as a guest artist, and sent in a large canvas, one of the last I had painted in the country. It was highly stylized in my recent flat manner — dominated by a black figure that could be either man or woman. There was a large attendance at the opening, the Synchromists' canvases were huge and occupied the best places while mine had been hung off to one side in a corner. It peeved me somewhat — a guest should be entitled to more

considerate treatment, I felt. Stieglitz was there, standing in front of my canvas. When I came up to him, he was full of praise and said he got the hermaphroditic significance of my work. He chuckled and I was pleased and comforted.

Before the next winter set in, I found a cozy little flat on Twenty-sixth Street near Broadway. The ceilings were low, but there was more floor space and only two flights up; the windows looked out upon an old churchyard and across was Madison Square. Though it was in the heart of the garment district with the workers milling about at noon, the place had quite a provincial air. At night it was deserted and quiet as the country. We could run across to Fifth Avenue and browse in the basement at Brentano's among the art books and magazines, the French quarter towards Seventh Avenue had little French restaurants where one could get a full course meal with wine for sixty cents. I began working on the series of pseudo-scientific abstractions, but before transferring them to canvas, I traced the forms on the spectrum-colored papers, observing a certain logic in the overlapping of primary colors into secondary ones, then cut them out carefully and pasted them down on white cardboard. The result was quite satisfactory and I felt no immediate need of transferring them to canvas. I would show them as is in my next exhibition, wrote a long rambling text to accompany the compositions, which bore fanciful titles such as The Meeting, Legend, Decanter, Shadows, Orchestra, Concrete Mixer, Dragon-fly, Mime, Jeune Fille, and Long Distance, with the general title of Revolving Doors because they were mounted upon a stand and hinged so that they could be turned and seen one at a time. It was a relief not to paint for a while; I made several other compositions with whole pages from newspapers, and cut ovals and rectangles out of various other kinds of paper, putting them simply under glass. While these works did not have the finished and imposing quality of oil paintings, I considered them equally important.

Once in a while I'd run up to visit Duchamp, who was installed in a ground-floor apartment which looked as if he had been moving out and leaving some unwanted debris lying around. There was absolutely nothing in his place that could

remind one of a painter's studio. He was making rapid progress with his English and we could exchange ideas. His proficiency no doubt was due to the fact that he had taken on some pupils to teach them French; I'm sure he learned much more English than they did French. Although he had made the resolution not to paint any more, he was not idle.

Besides devoting much time to chess, he was at the time engaged in constructing a strange machine consisting of narrow panels of glass on which were traced parts of a spiral, mounted on a ball-bearing axle connected to a motor. The idea was that when these panels were set in motion, revolving, they completed the spiral when looked at from front. The day the machine was ready for the trial I brought around my camera to record the operation. I placed the camera where the spectator was supposed to stand; Duchamp switched on the motor. The thing began to revolve, I made the exposure, but the panels gained in speed with the centrifugal movement and he switched it off quickly. Then he wanted to see the effect himself; taking his place where the camera was, I was directed to stand behind where the motor was and turn it on. The machine began again to revolve slowly, then gaining speed was whirling like an airplane propeller. There was a great whining noise and suddenly the belt flew off the motor or the axle, caught in the glass plates like a lasso. There was a crash like an explosion with glass flying in all directions. I felt something hit the top of my head, but it was a glancing blow and my hair had cushioned the shock. Duchamp ran around to me, he was pale and asked if I had been hurt. I expressed concern only for the machine, on which he had spent months. He ordered new panels and with the patience and obstinacy of a spider reweaving its web repainted and rebuilt the machine. While few understood his enigmatic personality and above all his abstinence from painting, his charm and simplicity made him very popular with everyone who came in contact with him, especially women. Walter Arensberg, the poet and collector, was devoted to him. Duchamp brought him around to my place one day; he bought one of my recent compositions of papers arranged in the form of a portrait but without any features.

We were invited to an evening at his duplex filled with his collection of moderns. There was a mixed crowd; Picabia from France, various women and Duchamp, who sat quietly in a corner playing chess with a neurologist. George Bellows, the painter, walked around with a disdainful and patronizing air, evidently out of place in the surroundings. He picked up an apple in a bowl; after eating it, he threw the core across the room into the fireplace with the skill of a baseball player. The neurologist having finished his game with Duchamp, also moved about looking at the Braques and Brancusis, then proceeded to give an impromptu talk on modern art. He had us painters all classified into categories: the rounds, the squares, and the triangles, according to which forms predominated in our works. Afterwards, Donna thought the evening had been very silly — she wouldn't go to any more gatherings. However, I had enjoyed myself — there had been great variety; it was rare to find oneself in such a heterogeneous group. Besides, there had been some talk of founding an independent salon for painters, without a jury; something that had never existed before in New York.

This soon materialized — Duchamp was on the committee — and the Grand Central showrooms were hired for the occasion. With the payment of two dollars, each one could hang what he pleased. The galleries were filled — this was really in the American democratic spirit. Duchamp had no painting to show but sent in a porcelain urinal signed Richard Mutt, which was immediately censored by the rest of the committee. Duchamp resigned — the no-jury program had been violated. Stieglitz, to voice his protest, made a beautiful photograph of the bowl. Some lectures were scheduled, among them one by Arthur Cravan, a supposed nephew of Oscar Wilde, who had become notorious for having fought Jack Johnson, the Negro champion, in a supposedly fixed bout in Spain. Cravan arrived half an hour late, carrying a valise, and drunkenly mumbled some excuses to the assembled society. Then he opened the bag and began throwing out his soiled linen. Two guards rushed forward and grabbed him, but some painters intervened and had him released — he was doing no harm. Indignant ladies

who had come to seek culture left hurriedly. Art was a serious thing not to be trifled with. At the opening, I again met Stieglitz in front of my painting, The Rope Dancer; he thought it very significant — it vibrated, in fact it was almost blinding. Some of the painters whose works hung nearby were dissatisfied with the hanging — my painting made theirs look dull and insignificant — it was a publicity stunt, they argued.

After Christmas I had my second show at Daniel's. There were only nine or ten items, pure inventions. One panel particularly, called Self-Portrait, was the butt of much joking. On a background of black and aluminum paint I had attached two electric bells and a real push button. In the middle, I had simply put my hand on the palette and transferred the paint imprint as a signature. Everyone who pushed the button was disappointed that the bell did not ring. Another panel was hung by one corner which, inevitably, visitors attempted to redress only to have it swing back at an angle. I was called a humorist, but it was far from my intention to be funny. I simply wished the spectator to take an active part in the creation. The most worried one was Daniel — I was supposed to be one of the young promising painters — two or three collectors had shown interest in my earlier work, had bought it — why couldn't I continue along those lines — after all, he was in business and the overhead of the gallery was enormous. I was acting as if I were on a lark — didn't I need to sell? It was only through Hartpence's intervention that he didn't throw me out. Of course, I needed money, living in town was more expensive than in the country and I had spent whatever I had made out of painting. My only resource was still the part-time job I held on to. To encourage me, Daniel offered to buy a picture every month — the older ones that were still available. I hadn't told him I'd destroyed a number of them.

But I couldn't go back; I was finding myself, I was filled with enthusiasm at every new turn my fancy took, and, my contrary spirit aiding, I planned new excursions into the unknown. Donna was also worried; our rent was eating a large chunk out of my income and we decided to look for cheaper quarters. The logical place was Greenwich Village, which had

become the artists' haven — mostly starving artists. We seldom had gone downtown, not caring much for the bohemian atmosphere, but there were plenty of apartments and cubbyholes available. One day Donna had gone down to investigate an advertised apartment, and came back furious — she had been insulted by the owner, who wasn't renting his place to illegitimate couples. Donna's clothes, while not exactly bohemian, were not drab and conservative, which might have antagonized him. I finally located a small flat on Eighth Street between Fifth and Sixth Avenue, run by a pleasant Italian woman whose tailoring shop was on the floor below. The rent was cheap — the quarter hadn't suffered the invasion of real estate operators who followed later in the wake of artists, transforming the brownstone houses into expensive modern flats for tenants who sought atmosphere and could pay. We fixed up the flat ourselves, painting furniture, making couch covers and curtains of raw silk dyed in tea, which gave a warm cozy look to the place, in short, it was more of a place to live in than the other places we'd had in town. But there was no room for painting; at least, I hesitated to mess up the flat with my materials. The easel stood in a corner with a painting permanently in place as a decoration.

But a solution presented itself — our landlady offered me an empty attic room for a few dollars more and here I set up my materials. I was planning something entirely new, had no need of an easel, brushes and the other paraphernalia of the traditional painter. The inspiration came from my office, where I had installed an airbrush outfit with air-pump and instruments to speed up some of the work which involved the laying down of large areas of color. This could be done much more quickly and smoothly than by hand. Where precise forms had to be contoured, stencils were cut out which protected the areas not to be sprayed. It was a process commonly used in commercial work. I became quite adept in the use of the airbrush and wondered if I could use it for my personal painting. I remained in the office after hours to make a few studies from my own drawings, and would return home late for dinner, much to Donna's annoyance. Finally, I installed a rented compressed air tank in

my attic, bringing home the spray guns to work with. But I became just as invisible as if I had stayed at the office; most of my spare time was spent in the attic. I worked in *gouache* on tinted and white cardboards — the results were astonishing — they had a photographic quality, although the subjects were anything but figurative. Or rather, I'd start with a definite subject, something I had seen — nudes, an interior, a ballet with Spanish dancers, or even some odd miscellaneous objects lying about which I used as stencils, but the result was always a more abstract pattern. It was thrilling to paint a picture, hardly touching the surface — a purely cerebral act, as it were.

I felt somewhat guilty leaving Donna so much alone; after the first excitement of working with the airbrush had passed and a number of works been realized, I relaxed, became more human and tried to make up for my neglect. A friend or several came in now and then, although I hadn't many. But there was always Duchamp, the painter Stella and the musician Varèse. These brought with them a European atmosphere which enabled Donna to exercise her French. There was a luncheon now and then with other French people with very gay and animated conversation to which I felt a stranger. Donna afterwards translated the salient remarks, most of which were quite Rabelaisian. I felt more and more like an outsider. When we were alone I taught her to play chess which she learned quickly but which we soon abandoned, as every game ended with a quarrel. She hated to lose. I've met other players since who acted similarly.

Once, with the money I received from Daniel for a painting, we went shopping. I decided that we'd begin to pay a little more attention to our persons and start with the purchase of coats for the winter. I acquired a magnificent one for myself, in a big department store; then we went to the women's department. Donna tried on a number of garments but none seemed to please her. She put on her old coat and we returned home. When she removed her coat, a new one was underneath. I gave her a good laying-out, not because of the moral issue involved; but suppose she had been caught; no amount of money saved was worth the taking of such a risk. She laughed at me and

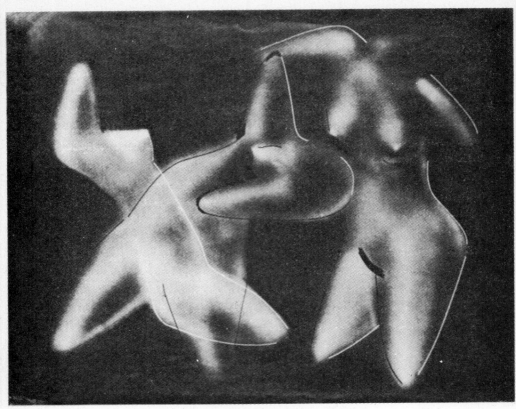

Airbrush painting, 1919 (lost)

said I was a poor timid creature. After further refreshing our wardrobe, I decided I'd carry a cane to complete my appearance; I found a used one in a thrift shop; it had a silver band and I carried it jauntily in the crook of my arm. One Saturday afternoon we went to a concert in Carnegie Hall. I sat in an aisle seat and as the place filled up someone I knew passed by slowly, looking for his seat. I reached out with my cane and caught his arm. The top detached itself from the silver band, followed by about twelve inches of steel. Terrified, I unhooked the cane and pushed the top back; no one had noticed it. It was a sword cane with a fine Toledo blade. I left it at home and abandoned the idea of carrying canes. Looking into a shop window one day I was attracted by a leopardskin and brought it home to Donna. At first she was doubtful about wearing it; I argued that primitive and savage art was influencing the moderns in all countries; to wear this would make her

look more original; free from the silly fashions of the day. How I ever thought up such an argument is beyond me, I who had resolved never to allow any primitive motive to influence my work. Perhaps I subconsciously associated the scarf with her sometimes primitive and even savage nature. To please me she wore it for a while, then converted it into a cushion.

The few acquaintances I had came less often to the flat — our domestic atmosphere bored them probably. I met some new people by occasional visits to some local cafés; one was situated below Marshall's chess club on Fourth Street. I joined the club to spend one night a week there and try to improve my game. There were pretty girls who brought one coffee; the place was a mixture of sociability and serious players. One of my first opponents was a young man with a decidedly Prussian appearance: saber cuts on his face, a monocle in his eye and a bantering, cynical expression over all. He'd click his heels when we met, and again when he left. He beat me easily and mercilessly at chess, but did not disdain to give me some points and show me my errors. He was always on the alert for an intrigue with women, yet I never saw him with one. He said he had only one use for them — prepared for the next adventure by a long and methodical abstinence. I invited him up to the flat; he clicked his heels, bent stiffly from the waist to kiss Donna's hand and spoke to her in French with a strong German accent. I showed him some of my work which might as well have been blank canvases, and when I tried to explain some of my ideas, he tried to demolish them with cold logic. The only thing he seemed to approve about me was Donna, implying surprise that she should have picked such a nitwit for a husband. Later she told me he had come up during the day when I was at work, had courted and tried to seduce her. But she was faithful — that was one bourgeois quality she adhered to — didn't I feel the same way? I reassured her, advised her not to admit him again; neither would I bring him around. I saw him at the chess club, or rather downstairs in the café flirting with the girls — chess was too easy for him, it seemed. Sometime later I heard he had shot himself. I meditated on this: the man must have been in great difficulty and too proud to admit it or to seek

help. I remember I did lend him a dollar at one time — fifty cents for a taxi on another occasion.

My third show at Daniel's opened in November. It looked very sober with the ten quiet airbrush paintings framed under glass. To please Daniel I included a few earlier oil paintings which had not been shown previously. He watched with anxiety as I set up the stand in the center of the gallery — the support for the ten spectrum-colored paper compositions, Revolving Doors. He asked me to give him some clues on all these new-fangled productions, so that he might be able to explain them to critics and prospective collectors. Hartpence, who accepted my work without question, advised that I give no technical details, let the spectators make their own deductions, that I speak in general abstract terms, make it sound mysterious. Mystery — this was the key word close to my heart and mind — and everyone loved a mystery; but did he not also want the solution? Whereas I always began with the solution.

The reaction to my work soon manifested itself. There was a hue-and-cry from the critics: I was painting with mechanical, commercial instruments. I had vulgarized and debased art. Crowds came out of curiosity but nothing was bought. Hartpence told me not to worry; others, more important, had suffered similar attacks before me. Daniel was completely bewildered, threatened to give up the art business, as if it depended entirely on me. Again, he repeated his admonitions, asking me if I was interested in selling my work. I replied by pointing out that he had a dozen other painters in his stable who were toeing the mark whatever their advanced-guard pretensions; let me be the black sheep in the fold — it got him publicity. He replied that business was not so good even with his most conservative painters. All the more reason, I said, that he should tolerate me, since I wasn't so much worse as an asset. Then jokingly, if he knew so well what would sell, I had a suggestion for him, that is, *he* paint the pictures and *I* sell them. If it hadn't been for Hartpence, I'm sure he would have crossed me off his list of painters, but Hartpence was really the guiding spirit of the gallery, Daniel merely the money man. I spoke to Stieglitz of my troubles; he smiled and said I should have come

to him in the first place — what did I expect of a saloonkeeper?

Meanwhile, the firm downtown where I worked had been prospering. Extra draftsmen had been hired to cope with incoming orders; I had charge of half a dozen, distributing the work and putting the final artistic touches to maps and atlases. A timeclock was installed which the employees dutifully punched as they arrived in the morning and left at the end of the day, all except myself who sauntered in late in the morning and left whenever I had assured myself that the others had enough to keep them busy until the next day or whenever I planned to come in again. My own contribution was never behind time; I never looked at the clock. My employer called me in to his private office one day; he said I set a bad example to the others; he offered me a full-time job with increased pay, asking me to punch the clock. I said I couldn't as I had other things to do as well, at home. I was sure he would not fire me, I was too indispensable. Why couldn't he treat me simply as a free-lance consultant, be free to come and go as he did. I even agreed to punch the clock if he did. This was too preposterous. Of course, I would have welcomed an increase in my revenue, and suggested that he do so at once. The conversation ended here, but I was kept on. However, when the end of the year arrived, each employee found a bonus in his pay envelope, except myself. I bided my time; thought of looking for another place or finding work to do at home, in my little attic. Then I'd be much freer.

Donna and I often went for dinner to a homey little Italian restaurant in a basement on Third Street. One night, two Spanish-looking young men sat near our table; we somehow got into conversation. The younger introduced himself as Luis Delmonte, just up from his uncle's farm in Cuba. He worked in an office as a clerk. After the meal we shook hands and said good-bye, promising to meet again. That night Donna seemed preoccupied; said very little. I left early the next morning, planning to return earlier in the afternoon to finish up a work I had started in the attic. When I returned, Donna was stretched out on the couch reading a book. The place was immaculate, she had done a thorough job of housecleaning as if we were

to receive some special guests. As far as I knew we had no date; this was to be our night in by ourselves. But there seemed to be no preparations for dinner; the kitchen was also clean, with everything put away. I then noticed that she was carefully dressed and made up. I looked at her inquiringly; she spoke. Luis had slipped a note to her as we said good night at the restaurant, asking her to meet him somewhere — she did not say where — and have dinner with him. Then she was silent. I, too, was silent for a time; this had never happened before, we'd always been together except for one or two times when I had spent a night at my parents' in Brooklyn. I did not know how to cope with the situation. Should I lock the door and make a violent scene? Throw up to her her sermons on fidelity? I decided to let her go, and without any recriminations. Knowing her character, I felt any opposition would be of no avail, would make matters worse; at best might end in silent or deceitful antagonism. My pretended indifference might disturb her; I recalled the closing advice of a master in a chess book I had been reading: to practice masterly inactivity.

I went up to my attic, puttered about for a while but could not concentrate on the work in hand. When I came down again Donna had gone. Towards eleven she had not returned, and I went out. After walking about aimlessly for an hour I arrived at the chess club and tried to interest myself first by watching a game in progress, then by sitting down to play with a member. After a half-hour's play, I resigned; my position was hopeless. Another member invited me to play; I knew him as one of the masters, a tall imposing Russian who had just escaped from his country, which was in the hands of the Bolsheviks. The club was quite deserted that night, two or three tables only were occupied. I thanked him but declared that it might be boring for him. He said it did not matter, he'd give me any odds I wished. I declined odds saying it changed the character of the game, but it was an honor to play with him; I'd rather lose to a master than win from an inferior player. He observed that I had the right spirit, but insisted on some kind of odds, namely to mate me before the thirteenth move. Intrigued, I sat down and we played. On the twelfth move, after fifteen minutes of

play, he mated me. I thanked him for his patience, and the lesson he'd given me; was about to rise, but he motioned to me to remain seated, set up the pieces in a position several moves back, something I had never been able to do. He saw a variation of the ending, and began moving the pieces for both sides, saying the moves he made for me were the best or forced, and his pieces kept hemming me in until the final mate. I felt foolish, in fact, he called this variation a comical mate. But he hadn't finished; once again he set up the pieces in a previous position in the game, began sacrificing his most important pieces including his queen and mated my king again. This he called a reckless mate. So he continued through a couple of more variations, seeming to ignore my existence, reveling in his own resourcefulness. Then he invited me to begin a new game with the same condition: that he mate me before the thirteenth move. We played. Whatever I did he kept pushing his pawns into my territory without my being able to stop him, until finally one pawn reached the last square, becoming a queen and mating me again. Now, this, he said, was a tragic mate. In the mood I was in by now, tragic was the right word. Tragic mate, indeed; why that's me, or perhaps it might be Donna, I feared. My master looked at his watch; it was three in the morning. I rose, thanked him and said my name. Soldatenkov, he replied. I was to see and hear more of him later on.

I let myself into the flat; Donna had not returned and I went to bed. I fell asleep a couple of hours later. I was awakened in broad daylight by the noise of a key turning in the lock; Donna entered, looking just as she had left, carefully dressed and made up; her mouth was grim. It was ten in the morning and she started to make some breakfast, just as if nothing had happened. We sat facing one another silently; I waited for her to speak. Then she began by describing Luis: he had left his uncle's ranch in Cuba to try and make his way in New York; he was still a boy but also a man, he understood women. Each word was like a blow in my face. She went on saying she loved us both, for different reasons, that nothing would be changed in our relations but that she must be allowed

more independence. I did not believe my ears, it seemed so out of character, she who had preached monogamy to me for years, who was jealous if I merely looked at another woman, was jealous even if I showed an interest in another man who had created something. I said all these things to her, adding that I would hold her to her word, and whatever she had applied to me, applied to her as well. She would have to make up her mind at once and choose one man exclusively. If she did not, I would take the necessary measures.

She listened calmly, then asked how much time I would give her to make her choice. At once, I repeated, then exhorted her to take into consideration our six years of being together happily — that it could continue indefinitely — that she had been a source of inspiration and contentment for me which I doubted another woman could replace — that she was risking a tried experience for an uncertain future, and so on. She wept, threw her arms around me, said I had been neglecting her, seldom told her I loved her and she did not know what had come over her, but she needed demonstrative affection. I kissed her and we finished our breakfast. I remained home all day, spent an hour in my attic, came down with a drawing for a new work to show her. We went to dinner uptown to a French restaurant and drank a bottle of wine. Donna was very affectionate that night; I was convinced she had made her decision, at the same time wondering what she was trying to prove. It was a base thought and I banished it.

I went to my office the next day and when I returned I found Donna again dressed up as if to go out. She was quite nervous, then spoke: Luis had come in during the lunch hour and made a scene; said he must see her that night and would stop at nothing if she did not come. If necessary, he would kill me. I laughed and observed that it would not get him anywhere and it certainly wouldn't get him Donna. He'd be in prison and probably be executed. It gave me an idea: I could kill him and probably get off scot-free. Donna replied jeeringly that I didn't have the guts. I replied cuttingly that she was not worth the risk. She left; I made no effort to retain her.

I went to the Pepper Pot, the café below the chess club, to

eat something. Duchamp was there and I sat with him, until the club opened. A tall black-haired girl was playing the piano. Presently she came over to us and sat down. She did not take her eyes off Duchamp and I realized she was madly in love with him. I was introduced to Hazel, she was from Boston, but had left her family to seek some excitement in Greenwich Village, made her way with her piano playing. Duchamp was noncommittal and presently rose; the two of us went up to the club. He sat down at a table where a member had set up the pieces, evidently waiting for him. I watched the game for a while, then Hazel appeared. She stood beside me, then asked if I would like to play a game. We sat down at a table and played silently for a while. Then she asked whether I knew Duchamp well; he was such a strange man, had responded to her advances at first, was very affectionate, but had long periods of indifference. I replied that he was a mystery to many people which no doubt was due to his preoccupation with artistic matters; besides he had not yet mastered the language completely. But she spoke French very well, she said. I replied offhand that it needed more than a common language for people to get together, but I did not elaborate the subject. She was too young and too simple to understand, I thought.

Duchamp and I left the club about one A.M.; I walked him to the subway, dreading to return to a deserted flat. He told me he was installed in his new place at Sixty-sixth Street; worked at night when all was quiet and he wouldn't be disturbed. But first he would have a bite to eat; would I join him? We went into an all-night lunchroom. I took some coffee and told him something of my domestic upheaval. As he ate his scrambled eggs and apple sauce, he made little comment — his face showed no change of expression and he offered no advice. However, he invited me to come up with him to his place.

It was in a commercial loft building full of little enterprises: printers, tire vulcanizers, and nondescript shops. We climbed the stairway to his floor, walked through winding corridors until he stopped at a door and opened it. Again, the interior presented the same abandoned aspect as his first place; nothing suggested a painter's studio. It was quite large; there were

steam radiators, and it was very warm. In the middle of the floor stood a naked bathtub with pipes running along the floor to the sink plumbing against a wall. The floor was littered with crumpled newspapers and rubbish. Attached to the ceiling were several paintings, his brother's, the then unknown Jacques Villon, which he had brought over with him. Against the walls stood some other paintings, a study by Duchamp of his sister Suzanne, also a painter. On a small easel was a glass and metal construction by a friend, Jean Crotti, who later married Suzanne and was thus integrated into this family of artists.

In the far corner near the window stood a pair of trestles on which lay a large piece of heavy glass covered with intricate patterns laid out in fine lead wires. It was Duchamp's major opus: The Bride Stripped Bare By Her Bachelors Even. A single unshaded bulb hung from the ceiling to furnish the only light. On the walls were tacked various precise drawings covered with symbols and references: studies for the glass. Duchamp lit his pipe and sat down in front of the glass. One section of it bore an irregular mirrored surface seen from the back, on which a delicate series of ovals had been traced. With a razor blade he began scraping at the unwanted silver. It was tedious work; after a while he paused, put his hand over his eyes and sighed: if he could only find a Chinaman to perform this drudgery. I supposed he meant a slavey. I was sorry for him; wished I could help him. I suggested that there might be a photographic process that would expedite matters. Yes, he replied, perhaps in the future photography would replace all art. I thought so, too, but not for the same reasons perhaps. In the present generation painters were trying to paint more freely, but my efforts the last couple of years had been in the direction of freeing myself totally from painting and its aesthetic implications. Duchamp was accomplishing this in his own way, in fact he intimated that he would stop painting altogether after he had finished the glass, if ever it was finished. He'd been on it for months — for years. It was still invisible — his work — it was purely cerebral, yet material; the equivalent of a thousand

works by others, but could not be exploited nor add to the prestige of the creator as in the case of the others.

I was very much impressed, even moved. Before leaving him I offered to bring my camera and photograph the glass as it lay on its trestles. We shook hands; his grasp was warm and firm.

Returning to the deserted flat, I slept a few hours and rose early. It was Saturday; I always went down then to the office to clean up things and collect my pay. At noon everyone left for the weekend. The employer carried a new fishing rod and was off to his suburban home. I said I'd close up the place, having a few little things to finish. When alone, I sat down at his desk and wrote a note on the firm's stationery. I said that for personal reasons I was leaving for good, not to expect me back, nor try to contact me. Leaving it open on his blotter, I placed my personal key on it and left. As I passed the timeclock I punched a blank card among the others, and pulled the door shut behind me. Leisurely I walked up Broadway towards Eighth Street. It was a long walk; I had plenty of time to figure my next move. Arriving at the house, I walked up the first flight of steps and stopped at the landlady's door. Through the glass panels I saw her sitting near the window sewing. I went in and told her that the attic was too small for me. I had some important work to do and required larger quarters. She owned the brownstone next door — did she have anything for rent? Well, not exactly, she said, except a basement in the rear which she used for storage. But she could clean it up, it was roomy and had a large fireplace. She named a low figure, I paid a month in advance and asked her to have it ready in a couple of days.

Then I went up to my place. Donna and Luis were there. Also Esther, now a beautiful girl of fourteen. She came down from school generally on Saturdays to spend the day with us. She held up her face to be kissed, Luis held out his hand, which I ignored. He left soon, Donna accompanying him to the door. Returning, she said it was too bad I hadn't been able to come for lunch; but she could prepare something for me if I wished. I had eaten, I said, and proposed a walk in the Village. Esther

liked to wander through the quaint streets, or go to a local movie. Donna was tired and told me to take her out alone. Esther was very loquacious, and related all the gossip of the school, about the other girls and their dancing — the oldest was in love with the ballet master. The school was a lovely place, situated on the Hudson, with beautiful country around where they took long walks, but it got boring sometimes. She wished she could go to school in town, not see the same people always. Father promised to get her out soon. He was calling for her later to take her back to his place for dinner. She did not care much for his friend, a woman who designed clothes and was very rich. She had a daughter of about sixteen who was not very nice to herself, Esther. We had some ice cream in a little Italian shop, and I brought her back to the flat.

Later, her father arrived; we conversed a bit. He was sculpting but hadn't landed any commissions; how was I doing with my painting? So-so, I replied, but wasn't relying on it — I always had my job to fall back on. He said I was lucky to be able to do something besides. However, he had several projects and one day he hoped to strike it rich. Presently he took Esther away and I remained alone with Donna. She said she had asked Luis to come for lunch to meet me and talk the whole matter over quietly, reasonably. I looked at her for a moment, then said it wasn't necessary, everything was settled, I'd arranged all for the best — to avoid further discussion. Since she hadn't been able to make up her mind, or rather since she had made it up to please herself, I was leaving, leaving the flat to her. But where would I go, she asked. Next door, I replied, at least for the time being; I had rented another place. But this was beyond my means, she objected. That, too, I had provided for, I said, today I threw up my job; since she did not worry about the future, neither would I. It was freedom for me from now on, freedom from one employer and from one woman. I was going to enjoy myself, not be dependent on one other person. She did not believe me, said I was hiding something, perhaps had a mistress who was going to keep me. I was flattered. Then I asked permission to stay in the place until Monday. In a strained voice she asked me to stay.

I spent most of Sunday in the attic, finishing up a project and putting all my things together ready to be moved out. When I came down to the flat in the afternoon Donna had gone. I collected a few more personal objects and necessities, putting them in a valise; also a couple of paintings, including the one on the easel, and carried them up to the attic. Then I took a turn around Washington Square, ending up at the Pepper Pot. Hazel came over and sat with me; poured out her heart, had to talk to someone; I was Duchamp's friend, she had confidence in me. I told her to be calm, not to run after him, let things take their natural course. She said, perhaps I had never been in love. I wondered: perhaps love had come to me too easily, as it had to Duchamp; I took it for granted, was spoiled. Presently Duchamp arrived; we went up to the club. Later, I walked with him to the lunchroom.

While eating he informed me that he had met a woman who collected contemporary works of art, and was planning to found a museum of modern art. Since she was financing the project she'd be the treasurer and had asked him to be the honorary president. He had proposed me for the vice-presidency. I was thrilled. The future looked bright — my sacrifices would be compensated. I accepted his proposal wholeheartedly. He asked about my domestic situation; I told him what I had done and gave him my new address. He nodded approvingly, adding that he'd arrange a meeting with the founder of the new venture. I returned to the flat; Donna was not in. It looked more empty than ever without my paintings — as if I were in a stranger's home.

Rising early next morning I went down to the landlady — who already had someone in the basement removing the various objects that cluttered it, placing them temporarily in the vestibule. I picked a number of things that I thought I could use, asking her to leave them — some chairs, a table and a bedspring and mattress. There were also a couple of old dress forms on stands which I kept — they seemed to furnish the place with a substitute for human company. I also kept an old sign that hung on the wall: NOT RESPONSIBLE FOR GOODS LEFT OVER THIRTY DAYS — thinking to change the wording later,

something like LEFT OVER GOODS NOT RESPONSIBLE FOR THIRTY DAYS. I never made the change, being satisfied with simply imagining the transformation.

Remained the things to be moved down from the attic; I led the helper next door — we had begun carrying the material down, when Donna appeared on the landing below. She asked me to come inside and reproached me with having removed the paintings. I said I did not care to have my works in Luis's place. She replied it was her flat — I'd given it to her with all that was in it. Oh, the bitch, I thought, she still values my work, there is still a spark of consistency in her. I was flattered, softened somewhat. On my way up again from the basement to the attic, I brought back the painting that had stood on the easel. She looked at it, then said it had been painted under her influence; I'd probably never do anything as good again. I smiled, did not answer, then asked her if she could let me have a couple of sheets and a pillow.

Once installed in my new quarters, my next problem was to find some source of income. Relying on my painting was out of the question, Daniel was getting more and more shy. I had my camera and had become quite adept in reproducing paintings. But they were my own, the thought of photographing the work of others was repugnant to me, beneath my dignity as an artist. I had made several attempts at portraiture with Donna and Esther as models, had been quite pleased with the results. This was the solution: I'd begin by photographing anyone that came by, and make up a portfolio of specimens. Since my painting had evolved to a degree where I would never consider painting a portrait, there was no question of a conflict between painting and photography. In fact, my painting might gain by this precise separation of subject matter.

One morning during the week there was a knock at my door. It was Donna, she wished to talk to me. First, she looked all around the place — the door where my coat hung on a nail, then at the unmade bed, as if seeking signs of a woman's presence. Speaking, she was worried about Esther who was coming as usual on Saturday. Esther must not feel there was any change; would I come up for lunch and act as usual, not say anything to disturb the atmosphere. I asked if Luis would be there. Of course, she replied. Then she added that Esther was

such a beautiful girl, was growing up into womanhood with quite a keen mind, understood everything, that I should treat her as a grownup. So, I thought, Donna wants to keep me in the family by any means; very well, I'd play her game. I was very gay at the luncheon on Saturday, and told them of my new job — I was a photographer, hadn't much to show yet but would make up an album of portraits of my friends. Donna said I ought to do a portrait of Luis, he was so handsome. Yes, I replied, but first I would do a series of women, I might even become a specialist in women. It was a bigger market; I was interested in photography as a means of making a living, I added. After lunch Esther and I went for a walk, leaving the others in the flat. Once in the street I invited her to see my new studio. It looked very professional with the camera standing on its tripod, my airbrush instruments laid out on the table, the compressed air tanks in a corner. On one wall hung the cloth like a tapestry — the one composed of squares of wool samples in sober tints which I had brought back from Ridgefield.

Esther remarked a painting on the wall which had hung in the flat. She said she had noticed its absence upstairs. I said I had borrowed it temporarily until I selected something to replace it. Then I suggested she pose for my first serious portrait. I placed her in front of the camera and busied myself with the preparations. She looked at the couch and said I was not very neat; I should not have a white pillow showing — did I sleep here sometimes? Sometimes, I replied, when I worked late and did not wish to disturb her mother. She looked at me, then asked simply, was there any trouble between us? I told her she was a big girl now, understood things; Donna and I were not getting on very well and we had decided to see each other less often. And Luis: she asked. Oh, just a friend who came for lunch on Saturdays. Then I told her to sit quietly — went over to arrange a lock of her golden hair and chucked her playfully under the chin, saying she must show her beautiful large eyes. They opened wider than ever. I made a couple of exposures and we went out. After a short walk around the square I took her back to the house; Father was calling earlier than usual — they were going to dinner and the theater. No, I wouldn't come

up, I had an appointment with a person who was interested in my painting — very important. She looked at me with questioning eyes and asked me if I was unhappy. I took her into the hallway, put my arms around her, said I did not know exactly what I felt, she had been too young to understand what happened when her father and mother separated; these things happened all the time, it was of no real importance in a lifetime; I only hoped I would have her for a lasting friend, whatever came. There must have been a note of emotion in my voice — she put her arms around me and kissed me, ran up the steps calling back to me that she would speak to Mother. I called back for her not to do that.

Duchamp had asked me to come to the apartment of the proposed founder of the new museum, to discuss their project, the following Monday. When I arrived I was ushered by a maid into a room lined with books and modern paintings, mostly Expressionists. Here and there stood a piece of sculpture on a pedestal. Presently, Duchamp arrived; shortly after, the hostess entered: Katherine S. Dreier. She was a large, blond woman with an air of authority. I was introduced and she announced that tea would be served. I fingered my pipe in my pocket, but decided not to smoke. The place was gleaming, immaculate, with no sign of an ashtray.

Miss Dreier opened the session by declaring that first a name had to be given to the new venture. After a few suggestions, I had an idea — I had come across a phrase in a French magazine that had intrigued me: Société Anonyme — which I thought meant Anonymous Society. Duchamp laughed and explained that it was an expression used in connection with certain large firms of limited responsibility — the equivalent of incorporated. He further added that he thought it was perfect as a name for a modern museum. I was grateful to him, because for a moment it seemed that Miss Dreier would object. The name was adopted unanimously.

The tea tray was wheeled in and tea was served with all the formality of an English interior. Miss Dreier said she had secured a large floor in a brownstone house near Fifth Avenue;

Duchamp and I were to decorate it, that is, make it look like an art gallery. Circulars would be printed inviting people to become members at a fixed fee, to help support the enterprise. We should all make an effort to obtain subscribers. As vice president, one of my duties would be that of publicity agent. I wondered how, then said I could make photographs for the press and for catalogs.

So, I was a photographer, she said. I explained that I was a painter and used photography to reproduce my paintings. Perfect, she replied, we would print postcards of the works exhibited; it would add to the income. Well, I thought, here was an opportunity to earn some money. Of course, she expected my services to be free — a contribution to the welfare of the museum. I agreed, but observed thàt the actual printing of the cards in quantity would be done by a commercial firm, figuring mentally that I might reserve some of the cost for myself — at least to pay for the material. She understood this, then suggested that I photograph her room and the more important works in her collection.

Returning to the subject of members, I tactlessly observed that they would expect special privileges to induce them to join. She replied testily that the act of joining our group would be a privilege in itself — if I did not think so, then I was not qualified to hold the office I had been invested with. She added, however, that there would be lectures by well-known painters and writers, catalogs with illustrations, perhaps musical concerts, all free to members. We took our leave, after agreeing to meet in the new location the next day, to decide on the installations. I also fixed a day to bring my camera and photograph her room and the important works. As I walked down the street I said very little, but felt that if it hadn't been for Duchamp, Miss Dreier would never have accepted me as a collaborator.

We went downtown to the chess club, stopping for a snack at the Pepper Pot. There was hardly anyone in the club on Sunday; we left early. I suggested to Duchamp that I pick up my camera, which I had never taken out of my place, and photograph his glass as I had offered to do on my first visit to

him. It would be good practice for me, in preparation for the work I was to do for Miss Dreier. As I had already noticed, there was only a single unshaded bulb hanging over his work, but from experience I knew this did not matter in copying still objects; with the camera fixed steadily on its tripod and a long exposure, the result would be satisfactory. Looking down on the work as I focused the camera, it appeared like some strange landscape from a bird's-eye view. There was dust on the work and bits of tissue and cotton wadding that had been used to clean up the finished parts, adding to the mystery. This, I thought, was indeed the domain of Duchamp. Later he titled the photograph: *Elévage de Poussière* — Bringing up Dust or Dust Raising. Since it was to be a long exposure, I opened the shutter and we went out to eat something, returning about an hour later, when I closed the shutter. I hurried back to my basement and developed the plate — I always did my developing at night, not having a darkroom. The negative was perfect — I was confident of the success of any future assignments.

Having gone to bed quite late, I was still asleep the next morning when I was awakened by a knocking on the door. Slipping on my old robe, I opened; it was Donna. I returned to bed, very tired, she sat down on the edge. What had I been telling Esther, she asked, who had taken her to task like a grownup, told her to be more considerate of me and not cause me any pain. Using her own words, I told Donna that Esther was a young woman now — she winced at this as if it were a reflection on her own age — Esther had a keen mind, did not have to be told things. Donna threw herself on the bed hugging me and weeping; she loved me, why couldn't I accept the situation — I was free to live my own life as I desired it — she would not interfere — she would do all she could to arouse Esther's affection for me. The contact of Donna's body aroused my old desires and I took her, brutally. She relaxed and smiled at me through her tear-stained face. She looked radiant. Arising, she adjusted herself, then told me she needed some money to pay a bill during the day; Luis's salary was not munificent right now; he expected an allowance from his uncle. I gave

her some bills and she left. I was still tired and thought, as I dozed off; if there had to be a cuckold, it would be Luis, besides, I had a paid woman.

I slept until noon, then went out. There was some rubbish in the vestibule with a broken lampshade on top. I carefully removed the paper, took it back to the room and hung it up by one end. It formed a pleasing spiral. This would be one of my exhibits in the new museum — my contribution as a sculptor. Looking at a dress form in a corner, I mentally removed the cloth-covered torso — the stand itself would serve as a support. I would also send in my latest painting — an airbrush composition of gear wheels, which had been inspired by the gyrations of a Spanish dancer I had seen in a musical play. The title was lettered into the composition: it could be read either DANCER or DANGER.

In the afternoon, Miss Dreier, Duchamp and I met in the brownstone house. Duchamp suggested that the walls be done in shiny white oilcloth; I proposed blue daylight bulbs to preserve the colors in the paintings. All this was carried out very quickly; by the end of the month the place was ready and all the works brought in to be hung. I was kept busy with photography for the museum and for Miss Dreier personally, in spite of my resolution not to reproduce the work of other painters. I still kept in mind my goal of becoming a portrait photographer; I must find some subjects, step out and meet people. When I wasn't developing films at night or going to the club, I'd wander around the village investigating some of the other night cafés. One was particularly gay, with music and dancing.

There I met a young woman with bobbed hair and boyish figure; she said she was a sculptor. I told her I was taking up photography and was looking for suitable models — would she care to pose for me? She looked at me and I hastened to add that it was only for a portrait — a head. She agreed; we made an appointment for the next day. Did I dance, she asked. I had never danced, it seemed an accomplishment I could never attain. She offered to teach me. And she did, very easily. There was nothing to it. I had a sense of rhythm, she said — that was

all one needed. I was elated — all the arts that had seemed beyond me were now within my grasp; photography, dancing, everything was possible.

She kept her appointment and I made several studies of her head. Her name was Berenice Abbot. Later, when I had a number of portraits to show, I took them up to Stieglitz for his opinion; he liked especially the one of Berenice and advised me to send it to a forthcoming photographic show. He was on the jury and my print received a prize.

I met a number of other people who sat for me, mostly writers and painters. I never asked for money and gave my prints away freely. Naturally, I did a number of studies of Duchamp. Edgar Varèse, the modern composer, sat for me. He was quite a handsome man, very popular with the ladies. Joseph Stella the Italian painter had joined our Société Anonyme, ingratiated himself with Miss Dreier, saw to it that I photographed his paintings for the exhibition to open soon, and incidentally wanted a portrait of himself. He was very fat. Some of my portraits may have looked like caricatures but in his case whatever turned out was a perfect likeness. He was very vain, considered himself a Don Juan and acted as if he was always involved in some escapade. I went to see him one day, he opened the door a few inches and excused himself — he had someone with him. I heard later that he was living with a widow with several children; no one had ever seen her.

I was sleeping late one morning after a prolonged spree of dancing and drinking (I was adding the latter to my list of accomplishments in the era of Prohibition); a loud knocking on the door awoke me. It was Donna — she hadn't seen me for more than a week, had to speak to me at once. I did not open the door, saying I was tired. She banged furiously shouting that she knew I had a woman with me, and if I did not open she would break in. I knew it was possible as the locks on the doors of these old buildings were flimsy. Standing behind my door, I was suddenly seized with a violent attack of cramps — would have to run to the toilet in the vestibule. I told her to go back to her place, that I'd come up in a few minutes. She left

and I ran out to relieve myself. Then I dressed quickly. I was trembling with rage. This would be final, I decided — passing the shaving mirror I saw a distorted face with disheveled hair — it was well so, I thought — then ran up three steps at a time and without knocking put my shoulder against the door. It flew open; Donna was sitting on the couch. In a choked voice I asked her what she wanted, before she could answer, I pulled out my belt and began lashing her. She fell on her face moaning; I continued striking her back a number of times, then stopped and told her to explain the marks to Luis. I'd be waiting for him if he wanted further explanation. I was still shaken when I got back below, but took my sword cane, which stood in a corner, pulled out the blade, and stared grimly at the needle-point. Yes, this could be final, I thought. Luis did not show up; I neither heard nor saw either of them for another week.

Then Donna appeared one morning, very contrite — she spoke gently, but with no reference to our violent scene — simply to ask me to come up for lunch Saturday, for Esther's sake. I made conditions: that there be no more hypocrisy, since Esther understood; that I be received openly as a friend and a guest — if I were to make any progress with Esther, I added insinuatingly, who still looked upon me as her second father. Otherwise, I'd move away, which I should have done at once, disappear. Donna's brows contracted; she promised to behave, adding that years of habit could not be wiped out in a day. I thought of suggesting an immediate divorce, but put it off as something to be dealt with by itself, a mere formality. The Saturday lunch was glum, very little was said; I left shortly with Esther. I led her to the basement to show her some prints of herself. She was fascinated, more with the process than with the results; expressed the wish to do something like that when she got out of school. I put my arm around her, stroked her hair, planted a light kiss on her forehead and told her that her place should always be in front of a camera, not behind one, she was too beautiful to hide in a darkroom. However, I added, if ever I became a successful photographer, she could work with me, I'd teach her, but she must promise to

be my model also; my favorite one, I added. She smiled — if ever she were my model she'd want to be the only one, she said. Then, irrelevantly, that she disapproved very much her mother's ways. The girl was certainly very bright.

Miss Dreier and Duchamp were already in the galleries of the Société Anonyme when I arrived in the morning before its opening. We were meeting for a final verification; Miss Dreier was upset. Everything seemed to be in place except one item. Hadn't I brought The Lampshade with me, she asked, and pointed to a corner. There stood the support, but no paper spiral. Of course I had, I replied. I couldn't understand. What shall we do, it's listed in the catalog, she continued. The janitor was called in; he had cleaned up the gallery earlier. Oh, the paper wrapping for the stand, he said; he'd crumpled it up and removed it with the other rubbish. I reassured her, saying I'd have it replaced before the opening of the show in the afternoon. Going to a tinsmith, I traced a pattern on a sheet of metal, which he cut out. I picked up a can of quick-drying flat white paint and a brush and carried all back to the gallery. Twisting the metal into a spiral form, I hung it on the stand and gave it a coat of white paint. It looked quite like the original paper spiral and was dry in a couple of hours. With satisfaction, I contemplated the substitution, taking pleasure in the thought that it would resist any attempt at destruction. Other contraptions of mine have been destroyed by visitors; not always through ignorance nor by accident, but willfully, as a

protest. But I have managed to make them indestructible, that is, by making duplicates very easily.

It was a satisfaction to me that Miss Dreier bought my Lampshade for her collection, and, although I have not heard of it since the dispersal of her collection after her death, I have duplicated it a dozen times for other exhibitions. I have no compunction about this — an important book or musical score is not destroyed by burning it. Only a collector who was acquiring the object for speculative reasons would hesitate to add it to his collection.

The new museum was well attended; Miss Dreier went ahead with her projects; first, some lectures on art by selected painters. I was one of the chosen speakers. I had never talked in public and looked forward to the ordeal with misgiving. For days I ruminated on my approach to my subject; could not decide where to begin; made no effort to jot down some notes as a guide. On the appointed evening I took the bus up to the gallery; on the way a vague idea outlined itself. The gallery was filled with people, Miss Dreier introduced me and I stood before this many-headed beast which seemed ready to devour me. Finally I fixed my attention on one person in front of me as if it were a tête-à-tête, and began politely to thank the organizers for the privilege of addressing such a select gathering. My talk, I said, would be very short as I was accustomed to expressing myself in paint rather than in words. Then I told a story: the other day I had come into the gallery to photograph a painting and set up my camera. There were people moving about who very considerately avoided passing between my instrument and the painting towards which it was directed. All except one person who ignored my presence and passed several times in front of the camera and even lingered a few moments in front of the painting I was copying. I said nothing, knowing that since I was giving a long exposure, anything that was in movement in front of my camera would not show on the negative. However, when I developed my plate that night there was nothing on it — it was a failure. Perhaps I hadn't calculated my exposure properly, or it might have been the individual who had stopped too long in front of the camera.

I hung up the plate with some others, to dry. The next morning I examined the negative more carefully — there was something on it — it seemed to be entirely covered with fine writing. I made a print and read the text; it was an essay on modern art. The only explanation I could think of was that the visitor who had lingered in front of the camera had transmitted his thoughts to the sensitive negative — a sort of telepathy. I would now give my listeners the gist of the essay. . . . The audience hung on my words as if I were relating a mystery story.

I do not exactly remember the words, but I broke into a tirade against dealers, collectors and critics, defended the integrity of the artist, questioned the motives of those who were out to please, who were confusing issues; then I ended abruptly by condemning exhibitions in general, without making it clear whether I was quoting from the essay or expressing my own opinions. The audience broke out in applause and I was pleased; at least I hadn't bored them.

Miss Dreier rose majestically, came up to the platform beside me and thanked me, then, turning to the audience, announced she would now speak seriously on art. I slunk back to a chair.

My larder being temporarily replenished with proceeds from photographic work and Miss Dreier's purchase, I sought distractions in the Village and through invitations to my studio, the latter as a means of obtaining subjects for portraits. One day it was two handsome young women, writers, Mina Loy and Djuna Barnes, the one in light tan clothes of her own design, the other all in black with a veil. They were stunning subjects — I photographed them together and the contrast made a fine picture. Another young woman came in from time to time; it was Elsa Schiaparelli, whom I also photographed but not so successfully. She was exotic-looking, Italian and related to a famous astronomer. She was unhappy, separated from her husband, and looking for something to do. She soon left for France with some knitting that was different from the usual sort of thing, and became the well-known couturier. Years

later in Paris I had the satisfaction of doing her portrait which was a triumph.

Her ex-husband came often to the Pepper Pot, where there were always some pretty girls. One evening the place was full with a mixed crowd. Soldatenkov, the chess master, sat at a table with his beautiful young American wife. Suddenly there was a commotion, dishes crashed on the floor, a table was overturned and Soldatenkov had Elsa's ex-husband by the throat against a wall. The latter in passing had made a flippant remark to the Russian's wife.

When we players adjourned to the club, he (Soldatenkov) introduced me to her. Later I invited them to come to my place and be photographed. A date was fixed; they came and posed. In my room was a chess table with one of my first designs for a set of unorthodox pieces, simple geometric shapes. The master inquired whether they were intended to be chess pieces and when I nodded, he at once proposed a game. It took him about ten minutes to beat me. I was pleased and asked him if he did not think this design was practical — might be accepted by players. He replied that the pieces did not matter, he could play with buttons, or even without pieces. Then he proposed turning his back, that I announce my moves to which he would reply. I did not accept the challenge and decided that chessplayers were not susceptible to form, unless they were also artists. However, he liked my photographs and gave me a substantial order.

With all these diversions, I found little time to paint, besides, I was not in the mood, there was no immediate urgency. Then Duchamp came to me with projects; he had conceived an idea for making three-dimensional movies. Miss Dreier had presented him with a movie camera, and he obtained another cheap one — the idea was to join them with gears and a common axis so that a double, stereoscopic film could be made of a globe with a spiral painted on it. There was a young mechanic living in my building, out of a job. He drank and quarreled continuously with his wife, Eileen, a fiery little red-headed Irish girl. We paid him in small installments; he finally managed to join the two cameras together. Then he disappeared,

leaving his wife alone. Duchamp decided to develop the film himself; I helped him. First, we obtained a couple of shallow garbage-can covers for tanks, a round plywood board was cut to fit, then waterproofed with parafin. To wind the film on these, Duchamp drew radiating lines from the centers and hammered four hundred nails along them. After taking fifty feet of film, we waited for nightfall and in the dark managed to wind the film onto the labyrinth of nails. I had already poured the developer into one of the trays, the fixing liquid into the other. We immersed the board into the first and timed the development, then transferred it to the fixer tank. After about twenty minutes we turned on the light. The film looked like a mass of tangled seaweed. It had swelled and was stuck together, most of it not having been acted on by the developer.

A slight moaning came from the bed. Eileen had been with us, suffering from an acute toothache. She refused to get up; I promised to bring back some medicament; Duchamp and I went out to eat. He was imperturbable; if we could save a few feet to verify his experiment, he'd be satisfied. I was depressed, after all the effort. Duchamp went on to the chess club and I returned to my place with a sedative for Eileen. All through the night, she kept me awake; I did all I could to console her, got up several times, wrapped a lighted bulb in a towel for her face, held her close in my arms; her body was like that of a little girl; at times I could not tell whether her moaning expressed pleasure or pain. She left in the morning.

Duchamp came in towards evening; we did save some film, two matching strips which, on examination through an old stereopticon, gave the effect of relief. To carry on the experiment, capital was needed as well as several other adjustments to make it practical for public presentation; the project was abandoned.

Duchamp was in correspondence with the young group of poets and painters in Paris: the Dadaists, who asked for contributions to their publications. Why not get out a New York edition of a Dada magazine? We went to work. Aside from the cover which he designed, he left the rest of the make-up to me,

as well as the choice of the contents. Tristan Tzara, one of the founders of Dadaism, sent us a mock authorization from Paris, which we translated. I picked material at random — a poem by the painter Marsden Hartley, a caricature by a newspaper cartoonist, Goldberg, some banal slogans, Stieglitz gave us a photograph of a woman's leg in a too-tight shoe; I added a few equivocal photographs from my own files. Most of the material was unsigned to express our contempt for credits and merits. The distribution was just as haphazard and the paper attracted very little attention. There was only the one issue. The effort was as futile as trying to grow lilies in a desert.

We were out late one night after the chess club, during the Prohibition era, making the rounds of various cafés and carrying our own liquor. Towards morning Duchamp stood in the middle of Fifth Avenue trying to hail a passing taxi, waving a bottle. None would stop; I led him back to my place and we fell asleep. I was awakened the next morning by a knocking on the door. Duchamp slept soundly, his head covered by the blanket, just a white wrist showing above the covers. I opened, it was a sculptor who had come to see me about having some photographs made of his work. He looked towards the bed and apologized for disturbing me. I told him to return later in the day. With an embarrassed air he withdrew.

When Duchamp rose we went out to lunch. He told me he was leaving for Paris soon and I promised to make every effort I could to join him, perhaps in a couple of months. I might be able to scrape together enough for the trip by then. How, I did not know — photography was still a meager source of income — I gave away most of my prints. Now and then a painter or sculptor asked me to photograph his work, in which I was totally uninterested.

And Daniel showed the same lack of interest in my painting. No plans were made for a future exhibition; besides, I had nothing new to show.

I saw very little of Donna now; Esther had been sent to another school farther out and lived there, coming in once a month. It would be a good thing, I thought, if I went away for a while. I knew a couple who had taken a place for the summer

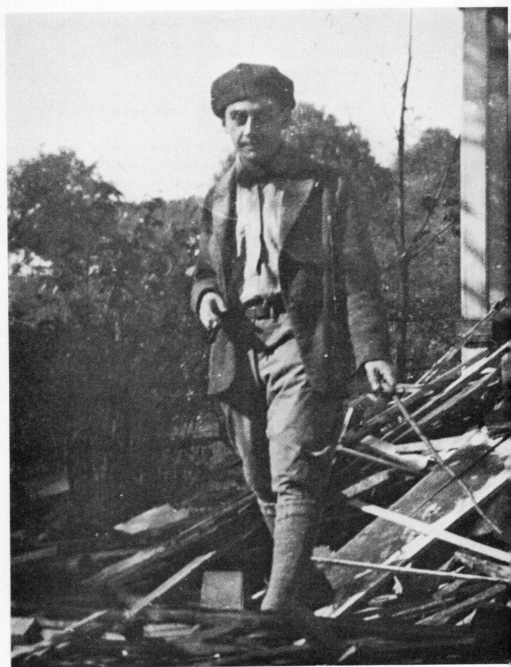

Man Ray, 1920

in Provincetown and went up on weekends to ready it. They invited me to join them on one of the trips. Provincetown was just becoming popular as an artists' colony. The place was dotted with the easels of landscape painters. I was brought to a house where I met Bob Chanler of the millionaire family. He painted society portraits and elaborate screens which brought ten thousand dollars. There was lots of whisky and a chess table. We played a couple of games and he beat me. One of the guests, Clem Randolph, the famous author of *Rain,* told me afterwards how glad she was that I had lost, Bob would have been insupportable the rest of the day if I had won. I returned the next day depressed by artists' colonies.

I made other excursions on weekends, but they left me more restless than ever; I must go farther — to Paris.

One day I visited Stieglitz, confided to him my situation and asked his advice. He told me he'd had a visit the previous day from a collector of paintings, a retired coal baron from Toledo, Ohio, who had acquired some of my work at Daniel's, and who spoke very highly of me. Mr. Howald was setting up an apartment in town; why didn't I contact him, ask him for an advance? Stieglitz gave me his address. That night I wrote a letter to Mr. Howald offering him a choice of one or several paintings if he would finance my trip to Paris. I received a reply in a few days, inviting me to lunch. Mr. Howald was a florid gentleman with a white mustache, very distinguished-looking, not very talkative. I did most of the talking; at the end of the meal I repeated my request. How much did I require, he asked. I had no idea; left it entirely up to him. He took out a checkbook, wrote out a check and handed it to me; it was for five hundred dollars. He planned to be in Paris the next year, he said — hoped I would have produced some good work by then — and would make his choice. I thanked him and told him he needn't wait so long, but could go to Daniel and pick out something from what I was leaving, some of the earlier things, similar to what he had already acquired, and which had pleased him. If there were any implications of irony in my proposal, I was sure he would not notice them; I did not wish to deceive him, for I was also sure that my future work would be less and less

acceptable to him. (His deception was greater than I had imagined, when he did arrive in Paris the following year — when I was definitely installed as a photographer — I thought to please him by doing his portrait; but he told me a painter should stick to his painting. Besides, I'd been in Paris long enough and should return home soon, he disapproved of expatriates. I showed him a number of paintings I'd made in Paris, for I continued to paint; but he made no move to select any.)

That night I made the rounds of my favorite haunts in the Village, celebrating my good fortune; later I lay awake planning my departure. The next morning I booked passage on a boat that was leaving within three days. I already had my passport, having obtained it a month before to convince myself that I was going away. The next two days were spent selecting what I would take with me. I destroyed some paintings that I did not think much of, which I regretted later, but still retained about thirty items good for an exhibition in Paris if the occasion presented itself. I picked up an old theatrical trunk and a large packing case to hold my things. This constituted all my baggage. My clothes were on my back, with some linen in a handbag.

The last night was spent in further celebration in the cafés. I joined up with a young couple who were acting in a play with the recently founded Provincetown Players on MacDougal Street. She was a sister of Edna St. Vincent Millay, and we danced. While dancing with her I told her of my good fortune; she was very envious and would have liked to come along. Others had joined our party, there were half a dozen of us. We stayed out all night and I was led back quite tipsy, in time to get my things together. My friends put me on the boat an hour before it sailed. I fell asleep in the bunk, not waking up until late the next night with the boat well out to sea. In the morning the sea was rough, many passengers were sick, but I felt very good and took a walk several times around the deserted deck, balancing myself with the rolling of the vessel.

It seemed to me that I was still dancing.

PARIS

The boat docked at Le Havre on July 14, 1921, the French Independence Day. After a two- or three-hour train ride through the Normandy country with its green fields, rare farm workers and no billboards or advertising, except here and there on the side of a barn a faded, indecipherable painted sign blending with the landscape, we pulled in to the St.-Lazare railroad station in Paris. The bustle with the porters, customs officials and voyagers seemed to be a preparation for the three-day festivities of the holiday. Everyone was anxious to get through with the formalities; I went through in no time with my hand-bag and was told to return in a few days to clear my trunk and case of paintings with the customs. Duchamp met me at the station — I had cabled him the date of my arrival — he had reserved a room, in a hotel in quiet residential Passy, that had just been vacated by Tristan Tzara, founder of the Dada movement, who had gone away for the summer. The hotel bore a sign, *Hotel Meublé*, which, in my ignorance of French, sounded very distinguished to me. Climbing the slippery waxed stairs, I was assailed by a strong odor of urine and disinfectant. In the next days, whenever I was asked my address I gave it, adding, the Hotel Meublé, until I noticed several other hotels bearing the same sign — in other words, Furnished Hotel.

Late in the afternoon Duchamp took me to a café in the boulevards where the young writers of the Dada movement met regularly before dinner. Half a dozen men and a young woman sat around a table in an isolated nook. After introductions some attempt was made at conversation. Jacques Rigaut, who spoke a few words of English, interpreted questions and answers. It was rather summary, yet I felt at ease with these strangers who seemed to accept me as one of themselves, due, no doubt to my reputed sympathies and the knowledge they already had of my activities in New York. André Breton, who was to found the Surrealist movement several years later, already seemed to dominate the group, carrying his imposing head like a chip on the shoulder. Louis Aragon, writer and poet, also bore himself with assurance and a certain arrogance. Paul Eluard, the poet, with his large forehead, looked like a younger version of the portrait of Baudelaire I had seen in a book. His wife, Gala, a quiet young woman, who ten years later became the wife of Salvador Dali, spoke some English and I encouraged her in order to make conversation. The young medical student Fraenkel, with his slanted eyes and high cheekbones, looked impassively Oriental. Philippe Soupault, poet, like an impish schoolboy with his twinkling eyes and curly hair, seemed ready for some mischief. Rigaut was the handsomest, the best-dressed of the group — my idea of a French dandy, though his lips had a rather bitter twist. In the years to follow we became very intimate and participated in many escapades, until one day I learned that he had committed suicide. He left no explanation.

Curiously enough, at the time of my first encounter there were no painters in the group. Francis Picabia had been vaguely associated with it for a while, but had broken away; at the time of my arrival, he was at odds with the writers.

We left the café together and went to a little Hindu restaurant nearby for dinner. My friends ate the various dishes of curry and rice with a certain disdain, as if nothing could replace French cooking, but made up for it by ordering innumerable bottles of red wine, becoming very gay and loquacious.

The other diners in the place drank water and were silent.

Coming out of the restaurant, we directed our steps towards Montmartre. The streets were full of people, and the sound of trumpets and accordions filled the air; at the next corner, strung with colored lanterns, couples were waltzing around a small bandstand decorated with tri-colored bunting. Suddenly, Soupault ran up to a lamppost, embraced it, and climbed up. From his perch he harangued us with what sounded like Dada-istic poetry. He descended and we walked on, but soon he left us and ran in to an open doorway. Stopping at the door of the concierge, he knocked violently. After a minute's conversation, he came out slowly, shaking his head. A few doors farther down he repeated the action with the same result. I was completely mystified. Rigaut informed me that Soupault had inquired whether Soupault lived there and had received a negative reply. We finally reached the boulevard in Montmartre, where a huge and noisy amusement park had been set up along its wide center as far as the eye could reach. Elaborate merry-go-rounds, scenic railways, steam swings, midget autos bumping each other, candy booths and sideshows outdid each other in the general cacophony. My friends rushed from one attraction to another like children, enjoying themselves to the utmost, ending up by angling with fishing poles with rings on the ends for bottles of wine, or cheap champagne. I looked on, bewildered by the playfulness and the abandon of all dignity by these people who otherwise took themselves so seriously: people who were having a revolutionary influence on the art and thinking of the new generation. Once I ventured on the dizzy swings with the Eluards; we were violently thrown upon each other and I wondered fleetingly whether they sought a physical extension into the realm of strong sensations. Returning late to my hotel room, my brain in a whirl and exhausted with the day's events, I felt I had been catapulted into a new world. My first efforts would be directed towards a mastery of the language.

After the holidays I went down to the customs to clear my paintings. First the large case was opened. It contained half a

dozen canvases — Cubist, the inspector said knowingly, and passed them. But there was also a strange object — a long narrow box under glass containing various materials, wire, colored wooden strips, a zinc washboard and a title at the bottom: Catherine Barometer. It looked like some scientific contraption. An interpreter was called in, and I explained that as an artist I used this as a guide for my color combinations, not wishing to enter into an exposé of what constituted a Dada object. It was passed. We came to my trunk, very heavy. It was lifted up on the platform by two men, and I couldn't find the key. One of the porters went off and returned fifteen minutes later with a bunch of keys. None of them fitted. I told them to force the locks. The trunk contained my airbrush paintings, all under glass, and various objects. The paintings passed after the inspector had been assured that they were in no way intended for duplication or commercial exploitation. He then picked up a jar filled with steel ball bearings in oil. It bore a label: NEW YORK 1920. This, I explained to the interpreter, was a decoration for my studio which I intended to set up in Paris. Sometimes artists didn't have any food, it would give me the illusion that there was something to eat in the house. Another object made of odd pieces of wood and cork I explained as a primitive idol made by the American Indians — a fetish. Far West, said the interpreter, proud of his English. With a gesture, the inspector dismissed the lot. I got an open taxi, the things were placed inside somehow, I took my seat alongside the chauffeur and we rode to the hotel. He kept up a monologue while driving, in which I gleaned a word now and then such as American, to which I replied with a monosyllable, *Oui.* He drove like a cowboy on a bronco, whizzing through the streets, honking his horn at crossings, bawling out pedestrians; I trembled for all the glass in the back. But we arrived safely and with the aid of the hotel porter got all the things into my room.

I had no plans the first few weeks, and wandered aimlessly through the streets of Paris, familiarizing myself with the transportation facilities of buses and subways. The city fascinated me, even the most sordid quarters seemed picturesque. I

tried to explain this to myself; was it because there were no wooden houses? Then there were the trees, every important street was lined with them surrounded by grillwork at their bases. No buildings were over eight floors, the last being a mansard. One felt taller, more important, after being belittled by the buildings in New York. I made vague projects to visit the museums to see the originals of paintings I had pored over in books in my student days. For the time, however, I concentrated on the outdoors. Plenty of time for the other.

But for years to come I was so preoccupied with my work and with the activities of the Dadaists and Surrealists that time and interest were lacking for museums; it was only ten years later, on an afternoon off, that I wandered into the Louvre for an hour. I hurried through, stopping now and then before what were once my favorite Ingreses, Manets and Uccellos. My feelings before these works were not the same as they would have been ten years earlier, but I was impressed with the power and assurance one could not sense in the reproductions. I felt I had attained some of this conviction in my larger works and wondered what these painters would think if they could see them. Would they have been outraged as their contemporaries were outraged with their own works? It was to be expected, as I had found, that certain contemporary works were taken as a personal affront by those steeped in tradition.

In adapting myself to my new surroundings, Duchamp was very helpful as my guide and adviser. I asked his opinion on the advisability of joining a school in French, which he thought a good idea, but added that if I could get myself a French girl, I'd probably learn much faster. He gave me a few useful lessons, mostly in pronunciation, which was more important than grammar. This worked like magic. I had not been able to make myself understood when trying to order a coffee or a cup of chocolate, pronouncing the French word with the accent on the first syllable as in English; in French it is the last syllable that is always emphasized, in fact, if only the last syllable is articulated one is understood.

One day I was invited to lunch at Francis Picabia's. I had met him casually on one of his trips to New York but there was

Dada group, c. 1922. *Above, l. to r.:* Paul Chadourne,
Tristan Tzara, Philippe Soupault, Serge Charchoune. *Below,*
l. to r.: Man Ray, Paul Eluard, Jacques Rigaut, Mme. Soupault,
Georges Ribemont-Dessaignes

always the language barrier. At this time he was feuding with
the Dadaists, publishing his own paper, *391,* a sequel to Stieg-
litz's *291* to which he had contributed in New York. A small
man, with high-heeled shoes to increase his stature, he was of
great charm and intelligence, in his writing as in his painting.
In his salon stood a large canvas covered with phrases and
signatures of visitors. Pots of paint stood on the floor, and I
was invited to sign. Afterwards, the canvas hung for years in
a famous night club, the Bôeuf sur le Toit, frequented by writ-
ers, musicians, painters and high society. I offered to photo-
graph the canvas, which led to commissions to photograph his
paintings. My funds were running low and I had to resort more
and more to my photography. After Picabia, other painters
gave me some work, but it was sporadic.

Duchamp was returning to the States soon, he was living in
a small flat lent him by a friend who was absent, but suggested
I take a small unoccupied room in it; he'd speak to his friend.
This would be rent-free. However, I kept my hotel room until
his departure and the return of the friend.

One day, Breton, Eluard, and Aragon came to see my paintings; Soupault was planning to open a gallery and I could have the first show.

The thirty-odd works were transferred from my hotel room to the gallery — which was situated near the Invalides, where the marble sarcophagus of Napoleon lies in state, and which I have never visited. (From photographs his coffin is symmetrical at both ends; I meant to drop in one day and ask the guide which end was Napoleon's head. I'd bring along the Dadaists as tourists and hoped to create some confusion, institute research. It would be a nice Dada gesture.) My friends prepared the exhibition in their typical manner. A catalog was printed with the heading *Good News*, followed by a short biographical sketch in which it was stated that it was not known where I had been born, and that after a career as coal merchant, several times millionaire, and chairman of the chewing gum trust, I had accepted the invitation of the Dadaists to show my latest canvases. Then followed a series of paragraphs signed by the members extolling my merits in characteristic Dada terms. Tristan Tzara closed the eulogies with the words: *New York sends us one of its love fingers* [title of one of my paintings; Love Fingers], *which will not be long in tickling the susceptibilities of French painters. Let us hope that this titillation will again indicate the already well-known wound which marks the closed somnolence of art. The paintings of Man Ray are made of basilic, of mace, of a pinch of pepper, and parsley in the form of hard-souled branches.*

Evidently my exhibition was the occasion and pretext for the group to manifest their antagonism to the established order and to make sly digs at those who had seceded from their movement. Although at odds with the Dadaists, one of the first to appear at my show was Picabia, in a huge open Delage car. It was a raw December day; he was wrapped in sweaters and woolen scarves, but wore no hat. Shaking my hand with Spanish urbanity and ignoring the others, he gave a certain distinction to the opening. The gallery began to fill — I was surprised at the turnout, and hopeful. The prices on the works were kept low; if I sold well, it would enable me to get a

Erik Satie, Paris, 1924

start; I'd produce a new series of works more unusual than anything I had done previously. There was a great deal of conversation which escaped me, but much hand-shaking and compliments.

A strange voluble little man in his fifties came over to me and led me to one of my paintings. Strange, because he seemed out of place in this gathering of younger men. With a little white beard, an old-fashioned pince-nez, black bowler hat, black overcoat and umbrella, he looked like an undertaker or an employee of some conservative bank. I was tired with the preparations of the opening, the gallery had no heat, I shivered and said in English that I was cold. He replied in English, took my arm, and led me out of the gallery to a corner café, where he ordered hot grogs. Introducing himself as Erik Satie, he relapsed into French, which I informed him I did not understand. With a twinkle in his eye he said it did not matter. We had a couple of additional grogs; I began to feel warm and lightheaded. Leaving the café, we passed a shop where various household utensils were spread out in front. I picked up a flat-iron, the kind used on coal stoves, asked Satie to come inside with me, where, with his help, I acquired a box of tacks and a tube of glue. Back at the gallery I glued a row of tacks to the smooth surface of the iron, titled it, The Gift, and added it to the exhibition. This was my first Dada object in France, similar to assemblages I had made in New York. I intended to hold a drawing for it amongst my friends, but during the afternoon it disappeared. I strongly suspected Soupault of having made sure it would fall to him. The show lasted two weeks, but nothing was sold. I got panicky, but reassured myself with the thought that famous painters had struggled for many years before recognition. Besides, I had my photography to fall back on.

My next step was to give up my hotel room and move into a room Duchamp had offered me. Picabia gave me work photographing his paintings, which at the time were not taken very seriously by the art world, although I thought them very important and was reconciled to my hackwork by a good cause. He gave me a number of introductions which brought in more orders, and also sent me to a well-known dealer in modern

Cadeau, Paris, 1921

paintings with whom I left my series of Revolving Doors collages. Nothing came of this, however; after a month I withdrew them and decided not to bother with the art world as far as my painting was concerned. More and more dealers and painters came to me for reproductions of paintings, which I performed conscientiously and mechanically. I used the bathroom at night for my developing and printing.

Duchamp was working on a series of black-and-white spirals of which he wished to make a film embellished with anagrammatic phrases. On Sundays we went out in the suburbs to his brother, Jacques Villon, for lunch; and afterwards set up the old movie camera in the garden and filmed the spirals on an upright bicycle wheel, as it revolved slowly. He called the film *Anemic Cinema,* a pretty anagram. Sometimes we played chess or Villon would show us his paintings. He was already in his forties, had not sold anything, and made his living by making colored etchings of the work of more successful painters. We had a bond in common, I felt.

My French was improving although limited to essentials and flavored with an atrocious accent. So far my contacts were all French; I had not met any English-speaking people. One day I learned that there was a quarter in Paris where expatriates of all nations gathered in the cafés — Montparnasse. I took the subway one night when not working and found myself indeed in the midst of a cosmopolitan world. All languages were spoken including French as terrible as my own. I wandered from one café to another, noticed that the groups were quite well segregated — one café was patronized almost exclusively by the French, another by a mixture of various nationalities, a third by Americans and English who stood up at the bar and were the most boisterous. I preferred the first two, where the clients sat at tables and changed their places from time to time to join other friends. All in all, the animation pleased me and I decided I'd move into this quarter, away from the more staid parts of the city I was familiar with.

Duchamp returned to the States, his friend returned to the apartment, and I moved out taking a room in a hotel in Montparnasse. I acquired the habit of sitting around in the cafés

and made new acquaintances easily. The Dadaists came around often to visit me in my hotel room, overcoming their aversion to what they considered too arty and bohemian a quarter. Tristan Tzara returned to Paris and took a room in my hotel. We became close friends. There were rivalries and dissensions among the avant-garde group but I was somehow never involved and remained on good terms with everyone — saw everyone and was never asked to take sides. My neutral position was invaluable to all; with my photography and drawing, I became an official recorder of events and personalities. Picabia gave me an introduction to Jean Cocteau as someone who knew everybody in Paris, was a social idol, and a poet, although despised by the Dadaists.

I made an appointment with him by phone and was received the next morning. He was freshly shaved and powdered, wearing a silk dressing gown. He looked quite aristocratic and very engaging. He liked Americans he said, especially their jazz music. The room was full of knickknacks, photographs and drawings, and I walked around examining them, reading signatures of well-known people. Suddenly the air was filled with music; he had put a Charleston on the phonograph in a corner. I turned around; he smiled and picked up a pair of drumsticks with which he beat out an accompaniment on the edge of the phonograph. Before leaving, I invited him to pose for his portrait in his surroundings. We made an appointment; the photographs were a great success, and were distributed among his friends. From then on he began bringing or sending people to my hotel room, mostly the modern musicians and a young writer he was promoting, Raymond Radiguet, who soon produced a best seller, *Le Diable au Corps*. No one paid for the prints but my files became very imposing and my reputation grew.

Before abandoning entirely the idea of trying to do something with my painting, I made one more effort, since I still had the works I had brought over with me. The Salon des Indépendants was opening soon; no jury: anyone could exhibit upon payment of a fee for his wall space. I sent in two of the contraptions that I had not exhibited in my one-man show; the

Catherine Barometer, and a painted panel still-life with simulated wood-textures and real strings and knobs. The critics ignored these works; some visitors lumped them with the usual bid for publicity by the Dadaists. Years later both these works entered private collections and have often been exhibited and admired as pioneer Dada works.

It was my last effort (for years to come) to enter the art world though I did take part in expositions arranged by my avant-garde friends, and had one-man shows sponsored by them. Besides my photographic activities, I produced enough works for these purposes.

I now turned all my attention to getting myself organized as a professional photographer, getting a studio and installing it to do my work more efficiently. I was going to make money — not wait for recognition that might or might not come. In fact, I might become rich enough never to have to sell a painting, which would be ideal — anyone who expressed appreciation or enthusiasm for my work could have it for the asking. And I put my philosophy into practice at once — I began giving my works to any who expressed the regret they did not have the money to buy them.

PAUL POIRET:
THE PORTRAIT THAT WAS NEVER MADE

It was Gabrielle, Picabia's wife, who arranged my meeting
with the fabulous Paul Poiret in his dressmaking salons in
Paris. He was famous also as a collector of the works of the
more advanced painters, but my object was to interest him in
my photography. I had brought over my first efforts, the series
of portraits of friends, enlarged from smaller negatives with-
out retouching, a rather daring technique at that time, frowned
upon by any self-respecting professional photographer but con-
forming to my own ideas of realism. I hadn't the slightest no-
tion of how Poiret could use me; I might first offer to do his
portrait.

La Maison Poiret was a fine old converted mansion set back
in a garden with an imposing iron grille and gate facing a
quiet, tree-lined street. There was also a tradesman's and em-
ployees' entrance on the St.-Honoré side, a business street
lined with art galleries and antique dealers' shops. I chose the
former entrance as being more in keeping with my mission. A
doorman in uniform at the gate directed me inside when I
mentioned Poiret's name, and as I crossed the gravel walk of
the garden, I observed the original arrangement. Brightly
painted chairs and little tables were scattered about, with a
raised platform at the farther end. Over the whole floated an
inflated canopy in bright yellow, like a blimp held down by

ropes. I'd heard this was a café-cabaret at night where popular singers and musicians entertained smart society.

Walking up a few marble steps, I entered the vestibule and through the glass doors saw a sumptuous salon full of mirrors and brocade curtains, with seated women elaborately dressed in shiny silks and satins watching the evolutions of a mannequin in a dress whose folds somewhat hampered the movements of her legs. I entered with my portfolio under my arm, wondering whom to address. Several saleswomen were consulting with clients; when one passed by I stopped her, asking in English how I could reach Monsieur Poiret — I had an appointment with him. She replied in a strongly accented English, directing me to the floor above. Mounting the wide, heavily carpeted stairway I found myself in a large empty salon with no one there, as rich in its appointments as the one on the floor below. On the walls, however, were works by contemporary painters and on a pedestal in the center a magnificent stylized gold bird by Brancusi. This different atmosphere reassured me; it was more in keeping with my world.

Presently a door opened and a man came out formally dressed in a cutaway frock coat and striped trousers, carrying a bolt of cloth. Again I asked for M. Poiret; he motioned me to the door and I went into an office filled with bolts of silks and brocades scattered around a desk behind which sat Poiret himself. An impressive man, carefully dressed, in a canary-colored coat, above which sprouted an oriental-looking beard. A full face, unsmiling eyes, gave the impression of one not to be trifled with, and who was accustomed to the best things in life. And yet, there was something informal about him, something human as well as epicurean. Although intimidated somewhat, I approached the desk, catching my foot in some cloth heaped on the floor. Recovering, I told him that Madame Picabia had said he'd be interested in seeing my photographs. He replied in fluent English, which was a relief, putting me more at my ease. I thought, what a magnificent portrait he would make just as he sat there, surrounded by the trappings of his house. I would suggest it to him, but first I must show him my work and see his reaction to it. I handed him my portfolio,

which he began to look through slowly, lingering now and then at a print. He liked my work, he said, then asked what he could do for me.

Instead of following my original idea of asking him to sit for me, my mind became a blank; I said, simply, I didn't know. A slight expression of impatience crossed his face; he asked whether I had ever done fashion photographs. I was afraid of this, admitted that I hadn't but hastened to add that I should like to try, it was difficult because I had no studio. With an inclusive gesture, he pointed out that here was his house, the rooms, the dresses, the girls — photographers generally worked on the spot, which he preferred. I confessed I did not even have a darkroom in which to finish my work. There was one in the attic, he said, used by photographers who came to work for the magazines. Reaching in a drawer he brought out some keys and laid them on the desk. There was one for the darkroom, one for the front door, another for the other side of the building, and I could work whenever it was convenient outside of business hours, say, during the lunch hour between twelve and two, or any time after six, even at night. He'd like to get some original pictures of his mannequins and gowns, something different, not like the stuff turned out by the usual fashion photographers. He would speak to the mannequins, impress upon them that this work was not the ordinary showing of gowns, but portraiture as well, giving more human qualities to the pictures; he was sure they would be interested and willing to collaborate. I was charmed with the man's intelligence and good will, but did not reply at once; something worried me. Finally I told him that I had no lights, which were necessary on gray days or at night. Poiret pushed a button on his desk; soon one of the salesgirls appeared. He introduced me, telling her to present me to the mannequins and to help me in every possible way in my photographic work, then told her to send up the janitor. When the latter appeared, Poiret asked what I needed in the way of lights. I said that a couple of strong bulbs in reflectors on stands would do. The two conversed a while, then Poiret said I could come to work in a week; the lamps would be ready. I thanked him, picked up my portfolio and left.

It was noon; downstairs everyone was preparing to go to lunch. The girl who had come to the office was waiting for me; she led me to a back room where several mannequins in negligees were getting ready to dress and go out. They were beautiful girls with every shade of hair from blond to black, moving about nonchalantly in their scanty chemises, stockings and high-heeled shoes. I was introduced, my role explained, while I tried to look as if I did not see anything. The girls were cool, almost forbidding. All except one black-haired, wide-eyed girl with whom I spoke in English — she did not look as French as the others. I told her I was an American; she, too, was from New York, studying singing and making her way by modeling. I said I was on an assignment from Poiret himself to make photographs and would like her to give me part of her lunch hour to pose. She agreed readily and hoped the pictures would appear in one of the fashion magazines; it would be a great help for her. I assured her I'd do my best to get them published. The others did not understand our conversation, and paid no attention to us anyhow. I was highly pleased with myself, entering this new world with perhaps many possibilities, and left my mannequin, promising to be back in a few days. As I passed out of the main gate I saw M. Poiret in a large white convertible driven by a chauffeur in livery. He sat in the back flanked by two gorgeous women, one blond, the other red-haired. I began to think about lunch, too, and took the bus back to my quarter.

The next week, one day before noon, I wrapped up my large secondhand camera with the dozen glass plates in their holders — the material I had used for the reproduction of paintings — and journeyed to Poiret's.

It was near noon and again all the lunch-hour bustle was repeated. I sought out the salesgirl who was to help me, inquiring if my lights were ready; I had come to work. She went to get the janitor who soon appeared bearing a seven-foot wrought-iron Venetian stand with an improvised tin reflector on top enclosing a large bulb. Plunking it down in the middle of the salon, he left and in a few minutes returned with another similar contraption. He beamed proudly at me and the

lamps as if he had constructed the whole thing himself. The girl inquired if all was satisfactory; I told her to thank the janitor for me — it was perfect. I lifted one of the stands to place it approximately where I might want it, but it was very heavy; the janitor helped me. Then he plugged in the wire, but the light was rather feeble for such a large bulb. On closer examination I saw that the reflector was so constructed that it had no value whatsoever. I made a remark to the girl, who spoke to the man. He lifted his hand in a gesture bidding me to have patience; went to the other lamp and plugged in the wire. There was a bright little flash for an instant and both lamps were out; the fuse in the house had melted. The man raised his shoulders in a helpless gesture, palms out, and said something to the girl. She translated: the house current could not take the two lamps; I'd have to limit myself to one lamp at a time. Blowing fuses was already a common experience with me; I'd have to make longer exposures with the limited light. But an idea occurred to me; I could use one of the stands as a prop and support for a pose, cutting off the incongruous reflector at the top in the composition. The wrought iron went very well with the other rococo details of the salon.

However, I asked the girl, if possible, to send me a blond mannequin wearing a light-colored dress, figuring this could be photographed with a shorter exposure. In the meantime, I set up my camera on its rickety tripod. I was ready when the mannequin came out. She looked none too pleased, as I was obviously cutting into her lunch hour. However, by assuring her through my girl aide that it would take a few minutes only, she relaxed and became more gracious. The fuse having been replaced, I lit up one lamp, placing the model alongside the other stand. She looked very trim and smart, her small blond head contrasting with the voluminous satin dress built up in complicated folds, one of Poiret's innovations of the period. I gave as long a pose as possible before she began to waver, afraid it would be underexposed. I changed the pose for a second shot, thanked the model, motioned to her that that would be all; she rushed off.

I now asked the salesgirl for the American model, saying she

could go to lunch; I could manage from now on. She thanked me and went into the dressing room. Presently, the model came out wearing a close-fitting gown in gold-shot brocade, gathered around the ankles in the hobble skirt style of the day. I apologized for encroaching on her lunch period, but she smilingly reassured me, saying she hadn't acquired the French habit; one hour would be sufficient for her lunch. Besides, she was on a diet, because of her voice. I would try to make something very original with her, I said. Suggesting that we go to the salon above, with its paintings and sculpture, I picked up my camera and she offered to help me. I gave her the batch of plate-holders, which she hugged to her bosom with one arm while with the other hand she lifted the dress high, almost to her knees. It made a charming picture as she moved up the stairway. I regretted not having the facilities for taking a snapshot of the movement, and followed her with the camera. The room upstairs was flooded with sunlight from the windows; I would not need any other light. I had her stand near the Brancusi sculpture, which threw off beams of golden light, blending with the colors of the dress. This was to be the picture, I decided; I'd combine art and fashion. While getting the camera ready, a couple of details bothered me, such as wrinkles in the dress which hadn't been ironed out; also her shoes showing at the bottom looked shabby and shapeless. Then, some stray wisps of hair hung untidily from the nape of her neck. The general effect, however, was good enough; with judicious posing in the given light, I managed to minimize these minor defects. I was quite pleased with myself for having noticed the details and thought that with a little practice fashion photography would have no mysteries for me. And my model was being very co-operative; she deserved the best I was capable of. I made a couple of exposures; with the good light there could be no doubt about the results.

Looking around for a new background I noticed the open door of Poiret's office, the floor littered with brilliant-colored bolts of material. I had an idea. I explained to my subject that Poiret expected something original from me and different from the usual fashion pictures. Pointing to the disorder on the

floor, I asked her to lie down on the pile, taking a pose completely relaxed. I had a practical reason for this: the office was darker, would require a longer exposure and she was less likely to move in that position. She looked at me with an amused but doubtful expression, then went in and dropped on the pile, with her arms over her head, which she turned towards me with a coy expression. It was ravishing, divine (as they say in fashion circles). There was line, color, texture, and above all, sex-appeal, which I instinctively felt was what Poiret wanted. After focusing my camera, I walked over to her, bent down to adjust a fold in the dress, caught my foot in a bolt of cloth and fell flat on the girl. She made no abrupt gesture; I quickly rolled over to the side and arose apologizing profusely. She looked at me with a smile; perhaps she did not believe it was an accident, I thought, and went back to the camera. The girl tranquilly rearranged herself while I busied myself with my instrument, working quickly and seriously, making a couple of exposures. Then I gallantly assisted her to her feet. I was sure, I said, this would be the most successful picture.

I asked her to put on something different for another picture; she came back in a smart tailored suit, a small hat on her head, changing her personality completely. Taking a couple of shots near a window, with the trees showing outside, I said this would be all for the day, as I wished to verify the results before going any further. Thanking her, I suggested she come to dinner with me some evening (when I got my first pay, I added to myself). She would be delighted, but it was difficult because she went to school five nights a week studying French. In any case, I said, I'd be back in a few days with the results and to make some new pictures.

That night, as soon as it was sufficiently dark in my hotel room, I pulled the curtains, laid out my two trays on the table, and by the light of my candle in a little red lantern, developed the plates, one by one. They were not too bad as far as exposure went, but nothing came out on the two shots of the reclining figure; in my distraction, I had forgotten to pull the slides of the holders before making the exposures. The next day I made the prints, which turned out better than I had ex-

pected. I spent some time rehearsing all the necessary manipulations of camera and slides so that I would not make any stupid blunders, and returned to Poiret for more work, so as to have a good selection to show him. In the meantime I would ask him to pose for me, picturing him at his desk surrounded by several mannequins in his creations. But M. Poiret had not come in that day; was laid up with indigestion. Amongst other interests, I'd heard of his prowess as a cook; he gave magnificent dinners at home, donning the apron and cap of a Cordon Bleu chef. His wine cellar was famous, too. He had probably outdone himself. Disappointed, I asked my helpful salesgirl to let me do one or two pictures, since I had brought my material. She produced my favorite model wearing a stunning city outfit that molded her figure perfectly. I suggested we do this outdoors, in the cabaret garden. After a couple of shots, one alongside a bronze deer near the steps, another among the tables and chairs, she said she had an urgent visit to make during her lunch hour and would like to leave soon. This was satisfactory with me, as my own plans had been upset by the nonappearance of Poiret; I did not feel in the mood for working. How did the first pictures turn out, she asked. Fine, I said, except the reclining ones, where something had gone wrong with the camera and there were no results. Perhaps we could do it again someday; and I'd be careful not to fall on her. She laughed and said it was lucky the camera didn't click when I tripped and fell. She went inside, while I wrapped up my material. I left by the tradesmen's entrance where the bus stopped. A young man smartly dressed in a brown suit, rather tight at the waist, stood at the entrance, smoking a cigarette. I waited at the curb for my bus. The American young lady appeared, still wearing the suit she had posed in, and took the young man's arm, while he kissed her on the cheek. Then she noticed me, smiled with a nod of her head and they walked off. Her companion turned to look at me — she had evidently told him who I was. With my bundle in a black cloth under my arm, I felt like a delivery boy. I experienced a slight pang of envy, but thought my time would come one of these days, when I, too, would have a girl leaning on my arm.

Rayograph, 1946

Again at night I developed the last plates I had exposed; the following night I set to work printing them. Besides the trays and chemical solutions in bottles, a glass graduate and thermometer, a box of photographic paper, my laboratory equipment was nil. Fortunately, I had to make only contact prints from my large plates. I simply laid a glass negative on a sheet of light-sensitive paper on the table, by the light of my little red lantern, turned on the bulb that hung from the ceiling, for a few seconds, and developed the prints. It was while making these prints that I hit on my Rayograph process, or cameraless photographs. One sheet of photo paper got into the developing tray — a sheet unexposed that had been mixed with those already exposed under the negatives — I made my several exposures first, developing them together later — and as I waited in vain a couple of minutes for an image to appear, regretting the waste of paper, I mechanically placed a small glass funnel,

the graduate and the thermometer in the tray on the wetted paper. I turned on the light; before my eyes an image began to form, not quite a simple silhouette of the objects as in a straight photograph, but distorted and refracted by the glass more or less in contact with the paper and standing out against a black background, the part directly exposed to the light. I remembered when I was a boy, placing fern leaves in a printing frame with proof paper, exposing it to sunlight, and obtaining a white negative of the leaves. This was the same idea, but with an added three-dimensional quality and tone graduation. I made a few more prints, setting aside the more serious work for Poiret, using up my precious paper. Taking whatever objects came to hand; my hotel-room key, a handkerchief, some pencils, a brush, a candle, a piece of twine — it wasn't necessary to put them in the liquid but on the dry paper first, exposing it to the light for a few seconds as with the negatives — I made a few more prints, excitedly, enjoying myself immensely. In the morning I examined the results, pinning a couple of the Rayographs — as I decided to call them — on the wall. They looked startlingly new and mysterious. Around noon, Tristan Tzara came in to see if we might lunch together. We got on pretty well in spite of the handicap of language — he spoke a little English — after all, his use of language was a complete mystery to the more academic critics; it would have been a mystery in any language. He spotted my prints on the wall at once, becoming very enthusiastic; they were pure Dada creations, he said, and far superior to similar attempts — simple flat textural prints in black and white — made a few years ago by Christian Schad, an early Dadaist.

Tzara came to my room that night; we made some Rayographs together, he disposing matches on the paper, breaking up the match box itself for an object, and burning holes with a cigarette in a piece of paper, while I made cones and triangles and wire spirals, all of which produced astonishing results. When he proposed to continue with other materials, I did not encourage him, as I felt somewhat jealous of my discovery and did not care to be influenced by his ideas. He must have sensed this, as he never suggested working with me again, although

his enthusiasm did not diminish. Later that year, when I conceived the idea of doing an album of some prints, in a limited edition, which I called *Les Champs Délicieux*, he wrote a fine preface.

Shortly after this diversion I went to see Poiret with my fashion prints. I slipped in a couple of the Rayographs, figuring that as a patron of modern art he might be interested in them, and it would take me out of the class of mere photographers. I went directly upstairs to his office, was about to knock on the door, but stopped, hearing loud voices inside. They were English voices; a woman telling Poiret she was dissatisfied with her gown, it did not fit, wasn't even smart. He shouted that he knew his business, he was Paul Poiret, and that if he told a woman to wear a nightgown with a chamber pot on her head, she would do just that. The woman came out and brushed by me. Poiret saw me and motioned to me to come in. Some women don't know what's good for them, he said. I smiled appreciatively. He sat down at his desk, relaxed a moment, then asked what I had to show him. I handed him the folder, and he examined the prints one at a time, nodding his head. When he came to the blond in the pale satin dress, he lingered a little longer and said it was very smart — I might have the makings of a fine fashion photographer. I could have told him it was perhaps because I was more interested in the girl than in the clothes, but I kept my mouth shut. Then he saw the two Rayographs, and asked what they were. I explained I was trying to do with photography what painters were doing, but with light and chemicals, instead of pigment, and without the optical help of the camera. He did not quite get it; I described the process as I had worked it in my darkroom. He nodded and said it was very interesting, handing me back the folder. He liked my work. I could come and make more pictures whenever I wished.

I asked if he'd keep these first prints, then, hesitating, could he give me an advance to buy more materials. He looked at me in surprise: these were for the fashion magazines, he never paid for photographs and photographers considered it a privilege to work in his house; these should be taken to the maga-

zines. I stammered, saying I had no contacts, did not know how to go about such matters, and thought this was his personal order. Again that look of impatience he had shown in our first interview, then, extracting the two Rayographs, said he liked new experiments, would pay me for these, and took out some 100-franc notes from his pocket. I thanked him and told him to keep all the pictures; I'd make duplicates and take them to a fashion magazine. Promising to get to work soon on a new series, I left, quite elated. I had never received so much money for my more commercial work. Poiret was one of those rare businessmen: generous and imaginative. If I did nothing else, my next job would be his portrait. In the meantime, Tzara had been spreading the news about my new work, and people began to come in to see it.

An editor of a literary and art magazine took some prints for publication, Cocteau asked me to make a frontispiece for a deluxe book of poems he was bringing out; it had to be a Rayograph. For a while I forgot Poiret until an editor of a fashion magazine called me to say he had seen my photographs at Poiret's; would I come to see him? That night I made duplicate prints of the fashion pictures and went to see the editor the next day. He received me very cordially, took all my photographs, but offered very little for them. This was free publicity for Poiret, he explained, and he was paying me more than usual only because it was exceptional work; I was a very fine artist, he said.

Now that I had made contact with a fashion magazine, I meant to return to Poiret to make some more pictures, especially his portrait, to recompense the man's generosity.

But the next few weeks I was very busy; had no time for him. More writers, painters and musicians came to see my Rayographs, bringing me books and sketches, inviting me to concerts of modern music. I was flattered and incidentally made portraits of them which added to my renown. There was no question of payment, of course. As Gertrude Stein said to me, we were all artists, hard up.

I was obliging in other ways: an artists' model came one day asking me to make some nudes of her. She posed profession-

ally for painters; it would be a great convenience to have photographs of herself and not have to undress every time she presented herself to a new painter. I agreed, on one condition: that she bring a second model with her as I would like to make some compositions for myself that had a little more variety than a single static nude. I thought of the paintings of Botticelli and Ingres, whose nudes were most effective when grouped on a single canvas, as in the latter's Turkish Bath. The girl was living with a friend who, though not a model, could be persuaded to pose with her, she was sure; it would be less embarrassing for her friend. The day was fixed for the sitting; in effect, the two nudes were more at ease than if they had been alone; at my suggestion, they even took some intimate poses with arms around each other, making for rather complicated anatomical designs. I managed to produce a series of very delicate prints, with hardly any modeling, like drawings, which were much admired. Only the girls were disappointed when I gave them some prints. They thought these were unfinished — they lacked the usual photographic detail.

On one of the days when I had less to do I phoned Poiret, telling him I'd like to do that portrait of him in his office, surrounded by his mannequins wearing his typical creations. But he was in the midst of preparing his new collection and we'd have to postpone the sitting until after the opening, when we could photograph the new clothes. Might I come to see him for a moment, I asked, to show him something that might interest him personally? He told me to come around after lunch. Knowing his interest in so many arts, I brought my pictures of the nudes; he admired them very much, saying, A nude is always in fashion, pity the women cannot wear transparent clothes. Years later, I thought of this when I was photographing some filmy garments for the magazines; it had been impressed on me that I was to get as much sex-appeal as possible into the pictures. I did, too, and the pictures were never used. Poiret invited me to an intimate dinner at his house. There were a couple of painters, a well-known singer who performed in his cabaret, two or three composers. He had donned his white chef's cap and apron and was officiating in the kitchen. There,

I thought, was another portrait I should do of him, a living picture of the great French culinary tradition.

By now I was being solicited by other dress houses and fashion editors to work for them — and kept more busy than ever. Poiret's star seemed to be waning, he was less publicized, but continued to make desperate efforts to maintain his prestige. When the big decorative arts exposition opened in Paris in 1926, I was commissioned by editors to photograph the couture section. The dresses were shown on seven- or eight-foot sculptures of slender mannequins, highly stylized. Poiret had an important part in the show, but it seemed more retrospective. The other designers were making simpler clothes; women were going more and more for closely bobbed hairdos, flat chests, and less sumptuous materials. However, I made a number of striking pictures of Poiret's mannequins which were used in the magazines. I felt I had been of some use to him. At the opening, he was so surrounded by his admirers that I could not approach him. He had installed three ornate barges on the river: a theater, a nightclub, and a modern home which included a perfume organ. With his lavish ideas he was ruining himself, or rather his backers.

I sent Poiret some complimentary prints of his presentation at the fair, inviting him to my studio to sit for his portrait, but received no reply. Shortly afterwards, it was announced that he was bankrupt and the salons were closed. But soon came news that he was opening a new shop on the Avenue des Champs-Elysées, at that time the still uncommercial Fifth Avenue of Paris. I received an invitation to the opening; on approaching the place I was disappointed, did not go in. It looked like any other business enterprise, with none of that Old World, sedate air which had characterized his first place. It did not last long; Poiret disappeared.

One day, a young doctor whom I knew came and asked me to have lunch with Poiret and himself. He had been treating Poiret for some ailment. The man was quite alone and unhappy; it might cheer him up to talk over old times with another artist. I accepted the invitation. Dr. D—— told me that Poiret was now painting and writing his autobiography. Mem-

ories came up of his generosity to me; he had helped me get started, perhaps I could now do something for him, when he needed help. I would finally do the portrait of him, get it into the papers as publicity for his book. We met in the heart of the central markets, Chez Monteil, a well-known restaurant where all the big produce and meat dealers came for lunch, after the trading of the morning.

I was shocked by Poiret's appearance. He looked haggard, without his carefully groomed beard, wearing a small mustache like any other Frenchman. Having previously associated him with the *Arabian Nights,* I could not reconcile myself to the fact that he came of local stock.

The lunch was very complete, with oysters, chicken, salad, assorted cheeses, fruit, coffee and brandy, besides the very fine wines. Our conversation was not very animated. Poiret said he was doing now what he had always aimed to do finally, painting and writing, a one-man job, without relying on others for inspiration or other support. It sounded vague to me. For my part I was leading a double life, I said, the isolated creative one of the artist, and the busy social life which my photography forced me to live. I hoped someday to devote myself exclusively to my own needs and desires. But I would not regret the past. Poiret did not regret the past, he said, but all activity in collaboration with others had to end tragically. He was indeed a disillusioned man, I thought; his present activity being a refuge, where in my case I had begun with the artist's instinct and at the same time adopted a more collective activity, for self-preservation. How many who had devoted themselves exclusively to their art had ended tragically. Our conversation lagged, we were getting bogged down. I looked at Poiret and wondered how I could photograph him with that mustache. Ever since I had begun to make portraits I had developed an aversion to mustached men. I could always discern character in a clean-shaven face or through a beard, but this appendage was like a disguise, like a high collar or a fresh haircut. I looked from Poiret to Dr. D——, who wore a beard very much like the one the other had, only it was black instead of reddish gray.

When we separated, Poiret invited us to come out to his

place in the country, an hour's drive along the Seine River; come out for lunch Sunday, he said. We promised to do so. Walking back to my quarter with the doctor alone, he said it was very sad about Poiret, but we had cheered him up; he seemed to like me very much. I said I wished I could do something for him; would bring my camera out with me, do a portrait of him at his desk or easel and try to get it published. I also suggested that the doctor should pose for me. He was flattered; we made an appointment for the week after our visit to Poiret.

On Sunday morning, I picked up Dr. D—— in my car and we drove out of Paris along the winding road following the Seine. It was a fine day with small white clouds dotting the blue sky and people fishing, picnicking and walking leisurely along the banks of the river, just like in a painting by Henri Rousseau, or Georges Seurat in his *La Grande Jatte*. Arriving at a quiet little village, my friend directed me through it, then along a dirt road with mounds of gravel at regular intervals, waiting to be spread out. This was Poiret's private road, he said; he was afraid it would never be finished. We arrived at a small isolated house of gray concrete in the style of the new architecture beginning to appear in France, of which le Corbusier and Mallet-Stevens were the innovators.

When we rang the bell a little girl opened the door. Poiret came out of the kitchen wearing a coarse blue apron like those worn by Normandy waiters. He had a large spoon in his hand. He introduced us to his little daughter who brought in a tray with a bottle of port and glasses. Excusing himself, he returned to the kitchen. An appetizing odor came in from there and we moved closer to have a look. Poiret pulled a large black pot halfway out of the stove, and lifted the cover, disclosing two beautiful browned pheasants. In other pots on the stove were various vegetables simmering. Our mouths watered; Dr. D—— said Poiret certainly knew how to whet one's appetite. Meanwhile, the young daughter was setting the table. She was very efficient; there was no other help around, it seemed. Presently, we sat down; after nibbling at some hors d'oeuvres, our host brought in a roast bird on a large dish and set to carving

it. He told us to pour the Burgundy which stood on the table. It did not last through the meal; another bottle was brought in. The second bird, too, and we drank all through the meal. Lifting his glass, he looked at the doctor, saying it was bad for him, but the latter said nothing to restrain him. The conversation became more animated, but always decorous because of the young girl. I had rarely been so loquacious, telling about my sitters, the writers and painters I had met and making everyone laugh, not with my stories but with my reckless handling of the French language in which I thought I had made great progress.

After coffee and a glass of fine armagnac, my favorite brandy, Poiret suggested a walk to see his unfinished project. We reached the top of a hill with a panoramic view of the surrounding country, showing the river winding through woods and small villages. The hill itself was a slightly concave plateau within which lay a long concrete skeleton of architecture, with gaping openings for windows and doors in the roofless walls. This construction was begun in the days of Poiret's affluence. It was to be his country seat, with many guest rooms, a swimming pool in the center of an enclosed patio and gardens of exotic plants. There would be weekends with painters, writers and musicians, as well as his mannequins to add to the decoration. But, with financial troubles and a vain effort to restore his prestige, he had to abandon the project, occupying the small house that had been finished for the caretaker.

As we stood there, the sky became overcast, the sun disappeared, and the unfinished mass of gray looked like some prehistoric ruin, lacking the details which might have made it appear more modern. My camera was in the car, but while I was considering the possibility of taking some pictures, it began to rain. We returned to the cottage. It was too dark to photograph indoors; again I had to abandon the idea of taking some pictures of Poiret. He brought out some of his paintings and we made polite and flattering remarks. They were not particularly thrilling or interesting to me, but must have been a satisfaction to himself, as paintings generally are for their authors. I could never understand painters who deprecated

their own work, or were dissatisfied with it. I doubted their sincerity. To me, any painting is a faithful record of an experience at the time it is made and should not be criticized.

The rain diminished in an hour, but it was getting darker. We took our leave so we could be back before nightfall. Poiret said we must come again; he very seldom had guests and since he had given up his social contacts, he was more sensitive, was more easily bored and irritated by most people. On the way back, Dr. D—— regretted I had not taken any pictures, especially of Poiret himself; it would have boosted his morale.

Dropping my friend at his place, I reminded him of our appointment; he promised to be at the studio. When he arrived I had already made some preparations for the sitting. There was an antique gothic chest in a corner of my studio. I pulled this out in front of my lights. I had an assortment of velvets, satins and brocades which I used sometimes as backgrounds. These I scattered around the chest, and over. Then I brought out a white cotton coat, a sort of smock I wore in the darkroom, which I had him put on. From another corner of the studio I brought out one of those canvas and wire dress forms on an iron stand used by seamstresses for their fittings, but which I had used in various compositions of photography and paintings, giving them a mysterious note. For a time it had stood near the door and amused me when it made a visitor start as he came in, as if it were an actual presence. Dr. D—— watched me with curiosity during these preliminaries, then asked if I was going to make something Surrealistic. Yes, I said, I could take this liberty with him, as he was a bit of a Surrealist himself, having attended some of the reunions and treated the members in his capacity as a doctor. I added that his beard had given me an idea, too, the picture would be exotic. Placed in a chair behind the chest as if it were a desk or table, he looked like some important couturier, wearing the white coat of a designer in the workrooms of a famous house. His beard suggested Poiret in his heyday. I took a number of poses, until I thought I'd gotten something of the Poiret expression and atmosphere, and let the sitter go, telling him to come in a few days later to see the results.

The pictures did not turn out to be Surrealistic at all; rather they were of a self-important-looking dressmaker surrounded by the trappings of his enterprise. It might have been Poiret for those who did not know him personally too well. I did not show Dr. D—— the complete prints, but made enlargements of the head alone, good, straight-forward photographs. He was extremely pleased and flattered with the results, said he would have something to live up to; I had made him look like an important medical authority or a great scientist. The beard helped, I replied, jokingly. But what about the Surrealist setting, he asked. I spoke evasively, saying the pictures had not come out as I had expected, they looked too documentary, lacking any atmosphere of mystery. However, I would work on them, it would take some time and certain optical modifications to produce the desired results. This was too mysterious for him; he did not pursue the subject.

This sitting took some of the load off my conscience of never having photographed Poiret. I even thought seriously of giving him a print as a joke. He might enter into the spirit and allow me to publish it as a portrait of himself in the old days. He surely had a sufficient sense of humor to enjoy the hoax.

But I never saw Poiret again. We did not go back to his place in the country. I heard he was living in a small room on the Champs-Elysées, quite destitute.

I forgot him, with all my other preoccupations and absences from Paris; the prints of Dr. D—— were filed away with so many other records of my busy and varied existence.

One day the papers announced the death of Poiret. It was dramatic; he had been discovered on the bed in his room, surrounded with dress materials, paintings and manuscripts. The walls were covered with scrawls bearing the names of a number of people, accompanied with maledictions, people who, he wrote, had abused, robbed and ruined him.

Going through my files, I drew out the prints of Dr. D——, selected one that was nearest to my conception of Poiret in the first years of our acquaintance, and sent it with a short note and fictitious date to the editor of an illustrated weekly. It ap-

peared in the next issue with an article on the man's life and accomplishments.

Dr. D—— came by with the paper, asking for an explanation. I told him the whole story, requesting him to keep it confidential. After all, I said, what did it matter, no one would be the wiser; besides, I owed Poiret a debt, and had taken this way of paying it off, a bit late, to be sure.

Dr. D—— agreed not to say anything about the hoax; the picture had done double duty, since he had a portrait of himself by me. It was a stroke of genius on my part, he concluded.

I was dining one night with two charming young women and asked him to join us. It would complete the party. During a gay evening, one of the girls became ill; something she had eaten, she said. We took her to the doctor's office. The girl fell in love with him; and with his beard, as she confided to me later. The beard had done double duty. And the doctor kept the secret of the Portrait That Was Never Made.

THE TRUE STORY OF KIKI
OF MONTPARNASSE

I was sitting in a café one day chatting with Marie Wassilieff, a painter who eked out a living by making leather dolls which caricatured celebrities. She was one of the institutions of the Quarter, friend of all the painters, and her Cossack dancing was the life of our improvised studio parties. Across the room sat two young women, girls under twenty, I thought, but trying to look older with heavy make-up and the hairdo then in fashion among the smart women, short cut with bangs low on the forehead. The prettier one had curls coming down on her cheeks in the manner one associated with the girl friends of Parisian apaches. She waved a greeting to Marie, who told me it was Kiki, favorite model of the painters.

Presently, the waiter came to take our order, then moved on to the girls' table. The waiter would not serve them since they wore no hats and a violent dispute ensued. Kiki shouted some words in argot which I did not understand, but which must have been quite insulting, then she added that a café was not a church, besides all the American bitches came in without hats. The waiter left, and the manager came up and tried to reason with her. She was French, he said, and her appearance might lead to a misinterpretation of her presence. She might be mistaken for a whore. Kiki looked around in a rage as if trying to find something to throw at the man. She arose, shouting that everyone knew her, she'd never set foot in the place again

Kiki, Paris, 1924

and get everyone to boycott it. Then she stepped up on the chair and across the table, jumping down as gracefully as a gazelle. Marie invited her and her friend to sit down at our table; I called the waiter and ordered drinks for the girls, putting authority in my voice. He apologized — didn't know they were our friends — but had his orders not to serve unaccompanied women. Kiki's anger vanished as quickly as it had flared and she began to recount her latest experiences posing for painters. She'd been posing for Utrillo for three days. During the rest periods he drank red wine, got quite tipsy, and offered her a glass, but when she tried to look at the work in progress he pushed her away. She could see it when it was finished. When finally she was allowed to walk around the easel, she saw that he had painted a landscape. She visited Soutine the other day as a friend, and knowing that he had hardly anything to eat — no money — she brought a loaf of bread and a herring. On entering she was overcome by foul stench, for on the table were some rotting vegetables and a side of beef — a still-life he'd been working on for several days.

Often, I saw Soutine strolling in front of the café terrace until he spotted an acquaintance at a table who might pay the price of a cup of coffee. One summer day the collector, Albert C. Barnes of Philadelphia, was in town and managed to escape the surveillance of his dealer and advisor, jealous of any outside interference. Barnes met Zborowski, a go-between between artists and collectors, who was poor himself and had no official gallery. He'd help out one of the painters from time to time with a few francs for a painting, especially Modigliani and Soutine. Zborowski took Barnes to Soutine's studio, with the result that Barnes bought up the entire output of the painter. Soutine, his pockets bulging with francs, rushed down to the café, got himself well inebriated, climbed into a taxi, and ordered the chauffeur to drive to the south of France. He was gone for a month.

After some further desultory conversation, we went to a nearby bistro frequented by painters, and had ourselves a

sumptuous meal, sumptuous because of the amount of wine we consumed. It was my treat, a rare event for the girls, who now considered themselves on an equal footing with the other fortunate diners, shouting and laughing, exchanging good-natured and suggestive insults. After dinner I suggested a movie, to which all agreed. It would be an agreeable change from the cafés; there were no nightclubs in Montparnasse at that time. Marie and Kiki linked arms with me, calling me their rich American friend — could I take them to America? In the cinema I sat next to Kiki who, like the others, was completely aborbed by the film. I, however, hardly looked at the screen and sought Kiki's hand in the dark. We held and squeezed hands throughout the program. Walking back, I explained that I was a painter but could not work directly from a model — it was distracting, she especially would be too disturbing, she was so beautiful. I was already very much upset and troubled. She laughed and said she was used to that — all the painters made passes at her. I continued to explain that my method was different from the others — I would photograph her, which was the work of an instant, then study the results by myself and work from them, calmly. No, she said, she would not pose for photographers, they were worse than painters — the one she had recently posed for tried to work faster than his camera; she liked sentiment and poetry. Besides she posed only for friends whom she knew well, she was interested in painting and would someday paint also. Here Marie took pity on my rudimentary French, and vouched for my integrity, my sincerity, giving me an unmistakable look of complicity.

Kiki still demurred, she did not want photographs of herself all over the place. But she posed nude, I insisted, and the paintings were always on exhibition, sometimes with her name as the title. Well, she replied, a painter could always modify the appearance of things whereas a photograph was too factual. Not mine, I replied, I photographed as I painted, transforming the subject as a painter would, idealizing or deforming as freely as does a painter. Deforming? — then she said that she had a physical defect which she did not care to show. I looked at her — from the perfect oval of her face with its wide-set

eyes to her long neck, high firm bosom, slim waist, small hips and shapely legs below her short skirt, I could discern no defect. I wondered. I could imagine nothing that would require surgical intervention, nor anything that a skillful artist couldn't correct. I assured her that I and my camera would ignore any defect — that only her beauty would be recorded — I could make my instrument obey me; if necessary I'd keep my eyes shut during the operation. Yes, said Marie, Man Ray is a magician. Kiki agreed to pose for me, we fixed the day and she came up to my hotel room.

Since my student days I had not looked at a nude with the disinterested eyes of a painter, if I had ever done so even then; I was nervous and excited wondering whether I could keep my wits calm. Kiki undressed behind a screen that shielded the washbasin in the corner, and came out, modestly holding her hand in front of her, exactly like Ingres's painting of *La Source*. Her body would have inspired any academic painter. Looking at her from head to foot I could see no physical defect. She smiled shyly like a little girl and said that she had no pubic hairs. I told her that was fine, it would pass the censors. She had tried everything, she said earnestly, pomades, massage, nothing worked. I got her to take a few poses, concentrating mostly on her head; then gave up — it was just like the old days in the life-classes; my mind wandered, other ideas surged in. I told her to dress and we went out to the café.

She began telling me about herself. Born in a small town in Burgundy and brought up by her grandmother with a brood of other children, at the age of fifteen she came to Paris, where her mother lived, but she had had to fend for herself until she landed in Montparnasse and became a model. A painter had adopted her, but he'd left Paris recently and kept writing for her to join him. But she couldn't leave; she liked the Quarter and the friends who were kind to her. Someday she'd go back to the country, live quietly and raise pigs. Now she wanted to enjoy herself. It was just as simple as that. She shared a hotel room with another girl but had to stay away when her friend's beau came around. It wasn't always convenient. I was encouraged and hopeful and told her she could come to my room

whenever she pleased — I had no one — in fact, she could bring her things and stay permanently. I wasn't the rich American she imagined, but I'd share whatever I had with her. She thanked me; said she'd think about it and let me know soon. In the meantime, we made an appointment for another sitting for the next day. After dinner I told her I had work to do and went back to the hotel to develop my plates, eager to see the results of the first sitting. The next morning I made some prints on proof paper exposed in printing frames to daylight. I was satisfied with the results — they really looked like studies for paintings, or might even be mistaken at a casual glance for reproductions of academic paintings. My experience, and experiments with optics, had enabled me to obtain such effects. (In fact, one of the principal accusations against me by sticklers for pure photography, later, was that I confused painting with photography. How true, I replied, I was a painter; it was perfectly normal that one should influence the other. Hadn't I, in my series of airbrush paintings, done before I had taken up photography, produced works that were mistaken for clever photographs? In the true Dada spirit I had completed the cycle of confusion. I know this phrase will make scientists smile, thinking I mean circle of confusion, and that the alliteration will seem affected to readers; I, who have always attempted, above all, to avoid alliteration.)

I showed Kiki the prints when she came; she was duly impressed, probably more with the fact that I had kept my word not producing a vulgar photograph than with the merits of my work. Presently she undressed while I sat on the edge of the bed with the camera before me. When she came out from behind the screen, I motioned to her to come and sit beside me. I put my arms around her, she did the same; our lips met, and we both lay down. No pictures were taken that day; we stayed in bed all afternoon. She told me she loved me and would come to live with me. The next day she moved in with her few belongings. So began a liaison that lasted six years, exactly the length of my first marriage.

Although I was called out often on assignments, people also came to my room; it was arranged that Kiki should not be

around in the afternoons; we'd meet at the café before dinner unless I had an invitation for the evening in connection with my work, or a meeting with the Dadaists, later the Surrealists. She was somewhat worried about these absences, but so was I — as to how she spent her time away from me. This was a healthy sign, I thought, it proved that we were in love. I gave her some money to shop around, which she used to adorn herself very colorfully. We had full meals every day, something she hadn't been used to, having subsisted previously on bread and tea; she began to put on weight, which did not bother her, and was delighted when some pubic hairs began to appear. One night at a gay party at Foujita's, she impersonated Napoleon; putting on a hat sideways, she lifted her dress up to her waist and stuck a hand into her bosom. Her white thighs (she wore no drawers) were a perfect replica of the emperor's white breeches. Everyone roared with laughter and applauded.

When I moved into my own studio on the rue Campagne-Première in Montparnasse, I arranged it to receive visitors and handle the increasing amount of work. The washroom was converted into a darkroom, the balcony was the bedroom where Kiki had to remain quietly when I was receiving, or leave during my appointments. I decided to give a housewarming party, inviting all the people I knew in the Quarter as well as more distinguished people from other parts of town. Most of the Dadaists came too, and each guest brought a bottle. Tzara found a pail and emptied a dozen various liquors into it. By two in the morning the festivities were in full swing accompanied by an infernal uproar. Rigaut, as usual immaculately dressed, pursued one girl after another; at one moment he was hanging by one hand from a hook high up in the ceiling, which he had reached from the balcony. I was particularly attentive to two young girls, daughters of a famous general, whom I anticipated as future models or clients. Suddenly, I received a resounding whack on the side of my head, and turned around to see Kiki with blazing eyes, addressing a torrent of invectives to the girls and myself. I made for her, but she ran nimbly up the stairway to the balcony. Rigaut held me

back and calmed me. All in all, the party was a huge success, social distinctions had been wiped out, and in a couple of hours all the guests, drunk and happy, had left. I made up with Kiki and felt that we loved each other more than ever. The next morning I was awakened by the doorbell. It was the concierge standing there with a paper in her hand. It was a letter addressed to the owner and signed by the tenants, demanding my immediate expulsion. I had the right, she told me, to have a party and make noise once in a while, but the tenants had to be forewarned. I apologized, promised that it would not occur again, and gave her some money. As a foreigner, I did not know all the rules. The petition was squelched.

I now decided that it was not practical having Kiki around the studio; besides, I planned to install lights on the balcony and make it the place for sittings, leaving the studio free for other visitors and prospective clients. The studio should be an exhibition gallery where I hung my photographs and other creative efforts. Nostalgically, I hung up some of my paintings also, so that the place would not have a too commercial atmosphere.

In those days it was easy to find studios and apartments; To LET signs were visible everywhere. Kiki discovered a charming little flat in a courtyard back of the cafés, where some painter friends had their studios. These friends had wives or mistresses, which reassured me, and we moved in. There was heat and a bathroom, which was rare in Paris. Kiki spent a good deal of time in the bathtub out of sheer luxury. Nearly always, when I dropped in during the day, I'd find her in a dressing gown or simply nude. If I announced that I had invited some friends for lunch or dinner, she went shopping and in no time had cooked a meal and set the table. The food was always delicious, good Burgundy dishes, plenty of wine, salads and carefully chosen cheeses. And as we sat around afterwards with glasses of brandy, she would sing us some popular Rabelaisian songs in a clear, perfectly tuned voice, accompanied by meaningful gestures and subtle facial expressions. Since she had been with me, Kiki no longer posed for painters; time often

hung heavily on her hands. I would ask her to take care of the studio whenever I had to go out for a while on some assignment: to answer the doorbell or the phone.

Once, looking up a phone number in my address book, I found some curious alterations. Wherever a woman's name was inscribed, the letters had been deformed to make it illegible and the numbers changed so that they could not be deciphered. I said nothing, but a warm feeling came over me. Kiki had been domesticated. To please some of her girl friends, she sent them around to be photographed, but warned me not to try anything with them — I might catch a disease. I did get sick once and blamed her, as I had not touched any other girl. She came up with certificates from two different doctors testifying that there was nothing wrong with her. I consulted a doctor friend, who explained that one could get infected in several ways as, for instance, from a toilet seat. Kiki wanted a baby with me, but was disappointed. I never had been a father and wondered if it was my fault. I did not pursue the investigation any further, and am still wondering.

Kiki solved her own problem of what to do with her spare time. One day she came into the studio carrying a painting. It represented a little girl, very much like a Kiki, of about eight years old, but filling up most of the canvas, seated in a field, with a woman much smaller beside her. She said it was a childhood souvenir of her upbringing in Burgundy. The painting was naïve but boldly brushed in, the drawing heightened by strong pencil lines, the colors bright and fresh. I offered to buy the picture, telling her I'd take everything if she continued to paint. Kiki went to work with a will, producing all kinds of subjects: rural scenes with peasants, circus scenes and strong men at fairs, portraits of painters and girl friends. One day Hans Richter, the Dada moviemaker, came in with Eisenstein, the Russian director. In a short sitting she made a portrait of the latter, which he bought. Another time Bob Chanler was in town and brought Clem Randolph with her baby to be photographed. I made the picture with the baby feeding at Clem's naked breast. When Kiki saw the print she melted sentimentally, carried it off and made a painting of it. At the flat one

day I saw another curious work — a country scene with cows, their horns twisted the wrong way, like a Chagall painting, but in the foreground were pasted cut-out chromos of dogs. She admitted she did not know how to draw a dog and had resorted to this expedient. And she had never heard of collages.

An exhibition was arranged for Kiki at a local gallery. Robert Desnos, the poet, wrote a preface for the catalog. All Montparnasse turned out for the opening — it was a great success, both artistically and financially — most of the pictures were sold. But Kiki did not continue; had none of the instincts of a career girl; could never turn her talents to profit. And there were other distractions that claimed her exuberance.

Despite its cosmopolitan population, Montparnasse until now had been a closely knit community with its cafés, studios and intrigues. It was like a provincial town with its inhabitants; but mostly painters, sculptors, writers and students. Casual tourists were few, most of them infesting the other end of Paris, Montmartre, with its all-night clubs and champagne. One day an enterprising ex-jockey with backing opened a night place in the heart of Montparnasse. He called it the Jockey. In an old one-story building, situated at the other end of the street where I had my studio, the outside walls were decorated by the American painter, Hilaire Hiler, with stylized figures of Indians and cowboys, the inside plastered with old posters. For the opening a group of the better known habitués were photographed in front of the club, all in more or less affected poses: myself holding a useless little Kodak, Tristan Tzara with his monocle, Jean Cocteau and his black-and-white knitted gloves, Pound in his false-bohemian getup. But the main attraction, besides other singers and the American jazz band, was Kiki and her naughty French songs, delivered in an inimitable deadpan manner. She passed the hat around afterwards, browbeating the consumers into making generous donations which she divided amongst the less favored performers. When not singing she sat at my table, or we danced on the few feet of crowded floor. One night a character of the Quarter, known as the Cowboy, because of his dress, a Russian in reality, came up to our table and invited Kiki to dance. I knew French etiquette

in popular dance halls: it was not considered good form for an accompanied woman to refuse such an invitation from a stranger as it might lead to a brawl. But the Cowboy was drunk and I arose to place myself between him and Kiki. He tried to push me aside; we grappled and rolled on the floor, each holding on to the other so that no blows were struck; Kiki shouted for me to finish him off. A couple of waiters separated us and put the Cowboy out, while I went to the washroom to brush myself off. When I returned a minute later, Kiki was no longer around — she had gone outside. I followed and saw the Cowboy sitting on a bench holding his head, which was bleeding. Kiki stood by, still shouting her indignation to the people standing around. In her hand was a box camera I'd given her with which she had hit the Cowboy. The camera was always with her — she had made some interesting snapshots with it which I had enlarged. When she had grabbed it from behind the counter and rushed out, no one could imagine the use she would make of it.

There were other incidents, and attempts by tourists to take her to the night places in Montmartre when the Jockey closed, but it was soon learned that she was incorruptible, had her steady man, and sang for the fun of it not the money. When she returned home she became again the simple country girl, in love with me and the domestic setup. When another engagement kept me out late and I could not get to the Jockey, she'd be home waiting to entertain me with the day's gossip. It was in her nature to suspect my other activities. On one occasion, I dressed for an important dinner with some prospective sitters. She helped me, putting the cuff links in my shirt, and admired my appearance in my dinner clothes, put her arms around me and kissed me tenderly, telling me not to come home too late. The dinner was in one of the most fashionable restaurants, and we then went on to a night club. I asked the wife of my host to dance; she told me first to go to the washroom and arrange my clothes. I looked at her in surprise; felt my bow tie, pulled down my waistcoat, all seemed in order. When I looked in the mirror in the washroom, there was a perfect imprint of a beautiful pair of red lips on my collar. I re-

versed the collar, folded back the tabs the other way and re-turned smiling to my hosts. (This probably gave me the idea to photograph an isolated mouth, or paint a huge pair of lips floating in the sky, which was called The Lovers.) When I re-turned home and undressed, I reversed the collar again, show-ing it to Kiki the next morning and asked her to plant a kiss next to the first one, to prove it was her mouth.

I did take Kiki with me sometimes to the cafés of my more intellectual friends, or to their homes. She was perfectly at ease and amused everyone with her quips, but got bored if the conversation became too abstract for her. Unlike the wives or mistresses of the others, who tried to keep up with the current or kept silent, she became restless; I took her back to her be-loved Montparnasse. Someone once asked me whether she was intelligent: I replied shortly that I had enough intelligence for the two of us. Kiki told me some of my most intellectual friends had propositioned her.

One day she brought a couple to my studio, who wished to be photographed. They were Americans touring Europe, look-ing for talent. The man was tall and handsome, the woman somewhat older than he; they seemed affluent. They were en-chanted with Kiki, her singing and personality, and suggested taking her to the States where they were sure they could get her a contract in the theater or the movies. All expenses would be taken care of. She would be placed first with a French fam-ily in Greenwich Village. We discussed this for a few days; Kiki was all for it, but I was doubtful — I had no faith in her practical sense when it came to matters of money and busi-ness. The couple reassured me, they'd be her agents and handle all details, in fact, they would see that Kiki remained the Kiki of Montparnasse with all her ingenuousness; that was the whole point of the enterprise; they'd protect her. I was per-suaded, gave my approval, and preparations were made for the voyage. Kiki was outfitted in a new wardrobe — she strutted about in her new clothes playing the grand lady to perfection, although it seemed somewhat out of character to me. There were tearful farewells at the boat train with promises to write every day. I gave her a couple of addresses of friends, includ-

ing my sister. Not knowing how long Kiki would be away, I gave up our little flat and took a room in a hotel next door to my studio. This was more convenient in my temporary bachelor status.

There were a few picture postcards of New York from Kiki, a rambling, incoherent letter expressing her bewilderment in the city, the kindness of the people she met, and much homesickness for Paris and myself. Then a couple of weeks of silence. One morning there was a cable — an S.O.S. asking me to send her the fare for her return. I complied at once and received a wire telling me when her boat would arrive. I took the train to Le Havre and met her as she landed. We stayed in town overnight. Her story was simple: going over, the couple had quarreled, the woman becoming jealous of her, because she thought her companion was being too attentive to Kiki, which was true. On their arrival, the couple separated, and the man offered to put Kiki up in his flat. She refused; went to stay with the French family as orginally planned. However, he did arrange a meeting with the Paramount people who had studios on Long Island at that time, and gave instructions for her to meet him there. When she arrived, she got lost in the maze of buildings, could not make herself understood, and finally, disgusted with the casualness of the arrangements, took the train back to New York. After that, her one thought was to return to Paris. She was happy now, was not interested in a career; would stay with me forever. In the train on the way back to Paris, we sat silently holding hands as in the movies on our first encounter. Kiki received the welcome of a prodigal daughter. Montparnasse made a holiday of it; she ran from café to café, ending up at night at the Jockey, resuming her undisputed position.

A few days later I was sitting at a terrace with some friends, waiting for her to join me for dinner. When she arrived she was very agitated and without any preliminaries accused me of having had an affair with one of her acquaintances during her absence, then gave me a resounding slap. I arose and with dignity walked away, she following. I returned to the hotel with her and asked her quietly where she had gathered her informa-

tion. There was no doubt about her sources, she said, and continued to call me names. I hit her so hard that she fell on the bed. Rolling over, she ran to a table near the window, picked up a bottle of ink and threw it at me, but it hit the wall making a splash that would have delighted any contemporary action-painter. She then broke the window with her fist, opened wide the casement, screaming murder, and threatened to jump if I approached her. The maid came in, followed by the proprietor, who ordered us to leave at once, demanding indemnity for the damage to the room. When they left we fell into each other's arms, Kiki weeping and I laughing. We moved to another hotel.

There were other explosions from time to time, always in public when there were witnesses about; when we were together alone, she was as gentle as a kitten. It was typically French to require an audience in making a scene. One such happening had more serious consequences for Kiki, and I was not the cause. She was in the South of France at Villefranche on the Mediterranean, where I was to join her shortly. She frequented a bar that was full of American sailors on leave from a battleship anchored in the harbor. There were other girls around for more practical purposes, who looked upon Kiki's presence with disfavor. She was the mascot of the American navy and distracted its attention too much. She got into an argument with one of the girls one night, which ended with her throwing a glass of liquor in the girl's face. Immediately, there was a free-for-all fight and the place was reduced to a shambles. When things calmed down, the sailors took up a collection which largely covered the damage. But the perfidious owner complained to the police, demanding the expulsion of Kiki from the town — she was hurting his business.

Two officers appeared at her hotel the next morning and requested her to follow them. She demanded an explanation, whereat one of the men seized her by an arm, calling her an ugly name. She picked up her handbag and swung it into his face. Striking an officer now was the charge — that was sufficient cause for arrest. Kiki was thrown into jail awaiting judgment when the court convened. I received a wire from Thérèse,

who was her close friend, to come down at once. Taking the next train, I arrived in Nice, where she was being held. A lawyer was found with whom I went into consultation. The case was grave, he said, Kiki was liable to three to six months' detention. She would come up before the judge, but not before a couple of weeks. There was only one way out: for her to plead guilty, backed by a certificate from a doctor testifying that she was being treated for some mental aberration and had come down from Paris to rest, with me, her protector, paying the bills. She was not a prostitute. I wrote to a doctor friend who at once sent me the necessary papers. I visited her in prison; she was in good form — everyone in charge was kind to her and she was allowed an hour's exercise every day in the yard, where she played handball. I brought her some delicacies which she welcomed, but said she would come out thinner. Living with me had made her too fat.

Her time finally came to appear before the magistrate. He sat behind his desk, reclining in his chair, gently stroking his white beard. After a few cases of petty larceny or prostitution, Kiki was brought in. Without make-up, she looked like a little frightened country girl. She looked over the audience; I raised my hand slightly and she smiled weakly. The lawyer spoke as planned, stressing her neurotic condition, referring to the doctor's certificate, and saying that her friend had come down to bring her back to Paris. The magistrate then made a long-winded speech about respect for the law, the gravity of the offense of striking an officer performing his duty; then, turning to her, asked if she pleaded guilty. In a small voice, she replied in the affirmative, adding mechanically that she was very sorry. The law was the law, the magistrate continued, it provided a definite punishment for this case; he sentenced her to six months in jail. I gasped, while the old sadist stroked his beard, then he spoke again; he was sorry only for her friend who had been put to so much trouble, for his sake he commuted her sentence — let her off on parole.

I took her back to Paris and soon the episode was forgotten, except that she turned out a series of paintings of jaunty-looking sailors standing at bars or sitting with girls. During that

summer she expressed a desire to visit the grandmother who had brought her up. Kiki had lost weight, looked tired, so I packed her off to her home town in Burgundy. I received affectionate letters from her with descriptions of the country, its peaceful, idyllic life, urging me to come down. But I was kept in my studio — many people came through during the summer months — I had much work to do. I wrote her to stay as long as she liked. A short time afterwards, I received a voluminous envelope from her. It was the story of her childhood, the other children and her troubles in school and with the holy Sisters of the town. The style was direct, artless, yet with certain perceptive qualities and implications — an awareness of the stupidity and hypocrisy of the provincial folk, their farcical charity and morality.

When she returned, I urged her to continue writing and make a book of it — her arrival and life in Paris — it would be her memoirs and we'd get it published. She went to work with a will, as easily as she sang or painted, writing regularly until the book was finished. I read the manuscript — it was not literature; it was a self-portrait of Kiki, true to life, shockingly but delicately frank at times — or one could read easily between the lines in the more reserved passages. There was a short chapter on myself in which she wrote of my artistic activities — my preoccupation with the bits of paper, hardware and cotton which went into the making of my Rayographs. Referring to my portraits, she observed a certain lack of logic on my part. I had criticized her penchant for bright, gaudy colors, yet I had photographed some of the Negro cast from the *Blackbirds* musical that was taking Paris by storm. Therefore, I did like color, she argued. Except in referring to me as her lover, the rest of the chapter was discreet, as were other references to me in the book.

A publisher was soon found: the editor of a local magazine that promoted the artistic and economic interests of Montparnasse. Broca was the son of a famous doctor, but had gone bohemian; a drinker, a drug addict and subject to hallucinations — all of which I learned later when Kiki had left me. This came about gradually, while they were collaborating on

the editing and printing. She began frequenting the other night places that sprang up in Montparnasse. Her singing was in demand everywhere; her presence attracted the tourists who were now flooding the quarter. There were no scenes nor explanations between us. She appeared sometimes at the studio to consult me about the book; I acted reserved — we were now simply good friends. When the book came out, she brought me one of the first copies in which she had written a touching inscription. We met often at the café and had a drink together. She came to the studio now and then for one of my photos of her. She obtained a part in a lavish musical, where she sang some of her songs in a bohemian setting. A record company invited her to make some recordings — she made one and never returned. She needed a live audience to encourage her. One day she appeared trembling, saying that Broca had had one of his fits, had tried to kill her, and been taken away to a sanatorium. He died shortly after.

Edward Titus, then husband of Helena Rubinstein of the beauty products enterprises, ran an English bookshop in the Quarter. Kiki's memoirs had created a stir in Paris and he offered to get out an edition in English. Kiki received an advance, the book was translated; Hemingway wrote a glowing preface. The memoirs were gobbled up by the English-speaking community, but the book's entry to the States was banned as indecent. Yet it did not contain a single four-letter word — in the original French, it did not contain a single three or five-letter word.

Kiki was now living with her accordion-playing accompanist who seemed to have other means of adding to his income. They had money and a car. She would drop into the studio from time to time — once she brought a beautiful young Frenchwoman, a close friend — she always had some girl with her who admired her and acted as a sort of chaperone, a deterrent to any man that became too importunate. Evidently, Kiki had told her the most flattering things about me. I invited the girl to sit for me; she was completely conquered. Kiki was delighted with the success of her matchmaking.

The last few years before World War II, I saw little of her; I was away from Paris a good deal, had a studio in another quarter, seldom visited Montparnasse. When the invasion of France came, I returned to the States. Ten years later I was back in Paris, settled in a studio not far from my old haunts. One day I walked through the Luxembourg gardens to Montparnasse, to see what changes had taken place. Everything seemed exactly as I had left it, that is, the streets, the buildings, the cafés. But the faces were different. I went into a café-restaurant for something to eat. There were half a dozen tables; I recognized a couple of the old habitués — a painter and a sculptor with whom I exchanged some words of greeting. Then I heard a voice and laughter coming from the other side of the partition between the restaurant and the bar. It was the voice of Kiki exchanging some banter with the proprietor. I walked around and faced her. She uttered a scream and threw herself into my arms, almost bowling me over. She was very heavy, but her face was still the clean oval of former days without any sagging flesh — and as usual, made up as if for the stage. I took her back to the table and we had some red wine. She carried a large bag with some old shoes and clothes. No, she said, she couldn't have lunch, she was on her way to some charitable institution to deliver her package between one and two, the visiting hours.

Kiki was alone now, living in a small room in the Quarter, not doing anything in particular. She was quite ill, suffering from dropsy, she said, patting her swollen belly. She'd go into the hospital soon and take serious treatment. I offered to help her in any way, but she said she needed nothing. I gave her some money, telling her to come to me any time and to let me know when she entered the hospital. She came around once or twice to my studio and then disappeared. Then I read in the papers that she had died in the hospital. All Montparnasse went into mourning. A large collection was taken up and she was given a magnificent funeral. There were pictures of old friends laying flowers on her bier; the magazines came to me clamoring for photographs, but I was angry — why wasn't she

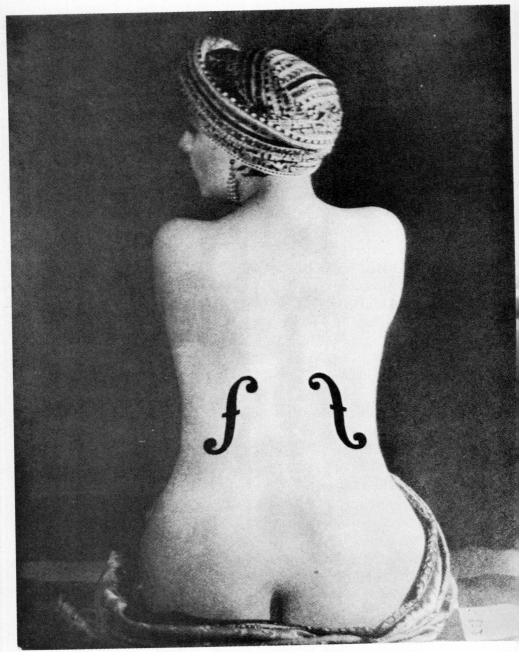

Violon d'Ingres, posed by Kiki, 1924

helped while still alive? And now the undertaker, the florists, and the journalists were making the most of it, like maggots on a carcass.

I have resented the death of many friends: not blaming the inhumanity of society so much — in many cases it was mainly the individual's fault — as feeling that the departure of a being who had been close to me was a sort of evasion, a betrayal.

CONTACTS WITH THE ARISTOCRACY

My first introduction to higher society occurred while I was still in my hotel room. I received a visit from a tall imposing woman in black with enormous eyes emphasized with black makeup. She wore a high headdress in black lace and bent her head slightly as she came through the door, as if it were too low for her. Introducing herself as the Marquise Casati, she expressed the wish to have herself photographed. But it would have to be done in her salon surrounded with her favorite objects. We made an appointment; in the meantime, I informed myself about her — she was famous in aristocratic circles, but considered rather eccentric. Her Italian villa had been the scene of elaborate festivals, with the trees in her garden painted gold, and she had received her guests with a twelve-foot, live python twined around her. (Later, in her pink marble villa near Paris, I saw the dead snake realistically twined around a tree trunk in a huge glass case.) She had been a friend of the Italian poet D'Annunzio.

At the time of our rendezvous she occupied a suite in a hotel on the Place Vendôme. She received me in a silk dressing gown, her red-dyed hair in disorder and her huge eyes carefully made up. The place was littered with precious knickknacks. I set up my camera and lights, and she sat down at a table on which was an elaborate bouquet of flowers — of jade and pre-

cious stones. When I turned on my lights there was a quick flash and everything went dark. As usual in French interiors, every room was wired and fused for a minimum of current. The porter replaced the burned-out fuses, but I did not dare use my lights again. I told the Marquise that I'd use the ordinary lighting in the room, but that the poses would be longer and she must try to hold them as still as possible. It was trying work — the lady acted as if I were doing a movie of her.

That night when I developed my negatives, they were all blurred; I put them aside and considered the sitting a failure. Not hearing from me, she phoned me sometime later; when I informed her that the negatives were worthless, she insisted on seeing some prints, bad as they were. I printed up a couple on which there was a semblance of a face — one with three pairs of eyes. It might have passed for a Surrealist version of the Medusa. She was enchanted with this one — said I had portrayed her soul, and ordered dozens of prints. I wished other sitters were as easy to please. The picture of the Marquise went all over Paris; sitters began coming in — people from the more exclusive circles, all expecting miracles from me. I had to get out of my hotel room — find a real studio.

The Comte de Beaumont, a tall aristocrat, patron of the arts and theater, invited me to one of his sumptuous costume balls and offered me a room in his house to set up my camera and photograph the guests in costume as they filed in. He asked me to wear a dinner suit or tails, so as not to look too professional. The pictures were for himself and his guests — there would be lots of orders, but I was requested not to seek any publicity. I took the suggestion too literally, first in the way I dressed, then in not following up my subjects after the prints were made, but waiting for whatever countesses and duchesses took the trouble to get my address and come around for prints. To the people I knew more intimately I did hand out some prints, like Picasso in a toreador costume, or Tristan Tzara in a tuxedo, kissing the hand of the masked and top-hatted Nancy Cunard. I wore a dinner jacket, but my starched shirt and collar and tie were also black, as was my mask. When the count approached

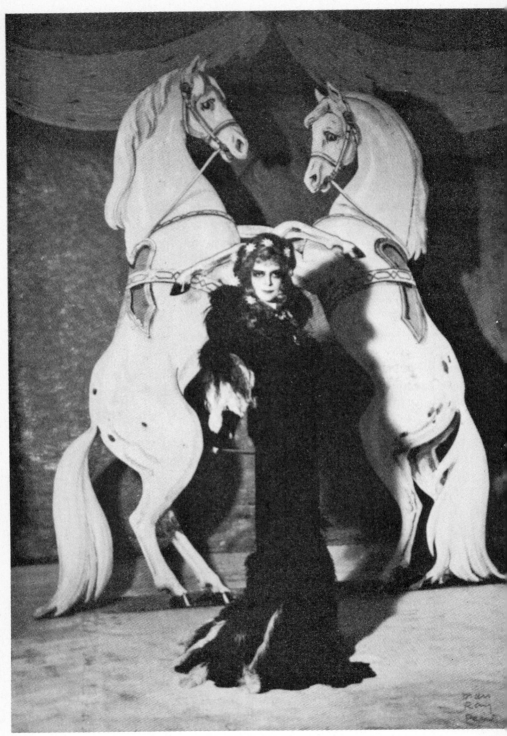

La Marquise Casati at the Beaumont Ball, 1927

me, I frightened him by flashing my dark studs red — a concealed battery in my pocket lit up electric bulbs. After all, I was the photographer — but very anonymous. De Beaumont was delighted with my act, and came often to my studio afterwards with projects for movies and decorations, but somehow nothing much materialized. I was too busy. I did give him some portraits of the smarter ladies, which he worked into a film he produced — it was called *Of What Young Girls Dream*. A young *cineaste* who directed the film introduced shots of revolving crystals, abstract optical effects similar to my Rayographs, but I would have nothing to do with such a hybrid production.

One day de Beaumont appeared with a very aristocratic-looking elderly lady, the Comtesse Greffuhle. She was interested in photography and wished to see some of my work. I gave her a portfolio to look at, but did not manifest much enthusiasm. Too many people came around taking up my time without any benefits to me. The Countess dabbled in photography — would I give her some lessons? I replied politely that now and then a pupil or apprentice stayed with me awhile and learned while helping me. She said she had a setup for photography in her château and would be pleased to have me out for lunch. She'd let me know the day and send me instructions on how to get out to her place. I saw her to the door, where stood a liveried chauffeur alongside an old Delaunay-Belleville car, immaculate with its round brass radiator and headlights shining like gold.

A few days later I received a note from her, written by her major-domo in a beautiful calligraphic script, inviting me for lunch the following Sunday. Every sentence in the note began with, *Madame la Comtesse* . . . , giving me instructions how to get to the château, about forty miles east of Paris. A car would be waiting for me at the railroad station. I was also invited to bring a portfolio of my work, as a number of influential friends would be present. I replied, accepting the invitation, and took the train the following Sunday. The same car and chauffeur I'd seen in Paris were waiting for me at the station. We drove through the country for about ten miles until we ar-

rived before a high iron gate. Through the bars I saw about forty Russian greyhounds running or lying about. I was impressed. The chauffeur honked with his rubber bulb — a man came out and ceremoniously opened the gates. We drove for another ten minutes through a wooded path and arrived at the château. I was ushered into the drawing room, a dozen elderly people sat around.

The Countess introduced me — I didn't get any of the names — and asked me to show my work. The prints were passed around, producing various comments, but the work seemed to bewilder the assembled guests. It did not look like the photographs one was accustomed to see in silver frames on pianos and tables. Meanwhile, the Countess took me around, asked me to admire the rubbed-down eighteenth-century paneling of the room. It had been transferred intact from her house in Normandy. I made an inappropriate remark, regretting that so much effort wasn't devoted to more contemporary work. She smiled and said it was natural for a young man to be concerned with his own period. Besides, she added, she used what she had, times were hard; there was no money for indulging oneself, the upkeep of her property — the third largest in France — was enormous; in the old days there were three thousand people on it, producing everything that was needed for themselves as well as for the château — thank heaven, they still had their own power plant to produce electricity.

Presently lunch was announced; we went into the dining room and sat down at a round table. There were two or three dishes of meats, fowl and venison, very little else — some cheese. The servant, as he poured the wine, murmured in our ears the year and name of the vintage. After lunch we went out on the terrace and walked around the grounds, the Countess and I together. There was a large pond ahead, black with wild duck. I picked up a stone and threw it into the flock — a thousand birds rose in the air. There was something to photograph, I said. Yes, she replied, with our modern cameras, but she possessed only an old plate camera on a tripod. Thinking to give her a first lesson, I explained that the instrument did not matter — one could always reconcile the subject with the

means and get a result that would be interesting, even if it appeared wanting to academic eyes — didn't Goya paint with a spoon when he had no brushes at hand? And what about Titian who said that he could produce the flesh of Venus with mud? One should be superior to his limited means, use imagination, be inventive. She suggested that we go in and get to work. She would do my portrait; I would direct her. I offered to do her portrait first, but she objected — did not think she was a good enough subject. I had already studied her and saw possibilities for a very distinguished portrait.

We walked through long dim corridors lined with glass cases of hunt trophies — boars' heads, antlers and birds. Passing a door, she said the count was confined to his bed and could not join us. We came to a stairway and climbed up a couple of flights. She led me into a high-ceilinged chapel with stained-glass windows. Her friend the Cardinal of Paris had given them to her. There was a piano or small organ and the place looked as if it might be her studio, but there was nothing to indicate that any work was done here — all was spotless, carefully in order. She led me to another wing, opened a small door which gave into a tiny room. A large white sheet hung at one end, intended as a background, I thought. Yes, this was where she did her photography. She produced her old camera, a large affair on a wobbly tripod. The room was rather dim — I asked her if she had any lights. She came up with a bare bulb and some tangled wire, which she attached to the back of a chair. I told her it was rather weak for photographic purposes; besides, it should be higher than the model to obtain proper lighting. She bade me stand against the sheet and busied herself with the focusing.

To steady myself for a long exposure, I put my hand back against the sheet, but it met empty space. I lost my balance, fell backward pulling the sheet down with me and landed in a bathtub. The Countess was concerned — asked if I was hurt, but I got up without trouble; we continued the sitting, me sitting on the edge of the tub. After a couple of exposures, she called her steward who took me to another small dark room. He brought up some water in a pitcher, some chemicals and

two trays. By the light of a candle in a red paper lantern, I developed the plates. The exposure was satisfactory, but I had moved — it was nothing comparable to the exciting portrait of the Marquise Casati with her three pairs of eyes. During the following week her man brought me the dried plates to print, at the same time inviting me to a cocktail at her town house. She asked me also to bring some of my more imaginative work — those mysterious Rayographs.

I arrived in the rue d'Astorg before a high wall with an imposing door; was admitted to a spacious garden with the house at the other end. Many of the old families have houses like this in Paris — it is like entering directly into a far distant part of France. The Countess received me amongst a group of guests similar to the ones on the previous Sunday. After some desultory talk, my new work was passed around. It was examined with curiosity but without comment. The Countess, however, was enthusiastic; speaking to me apart, she commented on the mystical quality of these prints and wondered if I could produce similar effects in a film. She had a project in mind — her friend H. G. Wells was an ardent spiritualist; with a scenario by him and with my photography, a fascinating film on spiritualism could be produced. It should be made in Egypt with the sphinx and pyramids as a background. She was sure she could find a producer to finance it.

It always irritated me when someone, looking at my work, immediately conceived the idea of applying it to his particular interests. It happened often, especially with advertisers and editors of fashion magazines or with interior decorators. While expecting and accepting this attitude in my less esoteric work, in more creative productions I hoped to meet the same deference accorded to a work of art, a painting or a drawing. I explained to the Countess that I had never thought of my work as something bordering on the mystical or supernatural; had been considering films to see it in movement, but it would have to be according to my own ideas, my own scenario. I do not know whether my words had the effect of a rebuff or whether she decided that I was an impractical dreamer incapable of any collaboration. I sincerely hope it was the latter, for her

sake, although for myself I would be pleased with the first interpretation. She was a sweet, well-meaning lady. Later, upon making further inquiries about her, as I sometimes did about the people I met, I learned that in former days she had had one of the most exclusive literary and political salons in Paris, was famous for her beauty and influence, and that Proust had used her as a model for one of his characters.

The Vicomte Charles de Noailles was a fervent collector of modern art. Of one of the most illustrious families of France, his background centered on a palatial house in Paris filled with works of old masters, Goya, Titian, and so on. For the more recent acquisitions he had some of the rooms remodeled in a more contemporary spirit. Prominent decorators produced interiors of bronze and white leather; the garden had a stage for plays; the iron fence around was lined inside with mirrors. When the installations were terminated, he came to me asking me to make a series of photographs of the new arrangements. In my studio hung a six-foot replica of the spiral lampshade, a sculpture in sheet metal that was a favorite theme with me. He bought it, but it did not figure among the paintings and sculptures when I came to make the photographs. In fact, none of the recent acquisitions were to be seen, which must have pleased the decorators immensely, who have always considered their work complete works of art and frown upon the introduction of paintings. I admit that in a sense I too was pleased, not having to photograph the works of art of others. Later, the walls were gradually covered with paintings.

Besides the interiors, I photographed the garden and its theater, but to give it an occupied air I contrived a setting for the stage that might have been a scene from some Dada play. An accommodating friend stretched out on a table and was covered with a sheet as if he were a corpse in a morgue. Nearby on a stepladder stood another figure, also draped from head to foot in a white sheet. Noailles accepted my improvisations good-naturedly. I made a series of portraits of his beautiful wife, Marie Laure, which were much admired. I became a regular guest, at lunches and dinners. The huge ballroom

could be converted into a movie theater; Noailles often gave previews of new films for a few select guests, after dinner. To inaugurate the transformations, he announced a fancy dress ball for the summer, giving those invited time to prepare their costumes. The theme was Futurism or The Future Age, which permitted every sort of fantasy. Months and much money were spent in preparation. I was among those invited, but put off until the last day the designing of a costume.

Finally, the costume I concocted for myself consisted of a shiny rayon clothesbag whose four corners I cut off for my arms and legs. A little cap out of which stuck a whirling toy propeller completed the outfit. In my hand I held an egg beater. The costume was more Dada than Futurist. At the ball it looked pretty shabby alongside the elaborate ones, ranging from aluminum space-suits to the sharkskin gown and head-dress of the hostess. However, I was not too displeased with myself and pitched into the champagne supper later at night with the conviction that at least I was as original as the others, if not as expensively got up. And then I felt that I was making an effective protest against the extravagance around me, effective because of the disapproving looks some of the guests directed towards me. I did, however, give credit to the democratic spirit of my hosts in inviting me. Also, since I was grateful to them for not asking me as a photographer, I made up for it by inviting Marie Laure to come and pose for me in her costume.

The Count and Countess Pecci-Blunt gave an elaborate costume ball in their house and garden in Paris. The theme was white; any costume was admitted but it had to be all in white. A large white dance floor was installed in the garden with the orchestra hidden in the bushes. I was asked to think up some added attraction. I hired a movie projector which was set up in a room on an upper floor, with the window giving out on the garden. I found an old hand-colored film by the pioneer French film-maker, Mélièis. While the white couples were revolving on the white floor, the film was projected on this moving screen — those who were not dancing looked down from the windows of the house. The effect was eerie — figures and faces in the

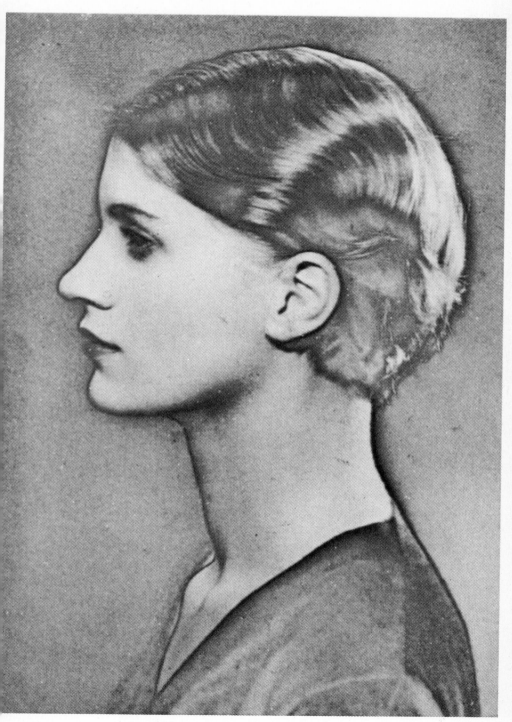

Lee Miller, 1930 (solarized photograph)

film were distorted but recognizable. I had also set up a camera in a room to photograph the guests.

In keeping with the theme of the ball, I was dressed in white as a tennis player, bringing as assistant a pupil who studied photography with me at the time — Lee Miller. She too was dressed as a tennis player in very smart shorts and blouse especially designed by one of the well-known couturiers. A slim figure with blond hair and lovely legs, she was continually being taken away to dance, leaving me to concentrate alone on my photography. I was pleased with her success, but annoyed at the same time, not because of the added work, but out of jealousy; I was in love with her. As the night progressed, I saw less and less of her, fumbled with my material and could not keep track of my supply of film holders. I finally ceased taking pictures, went down to the buffet for a drink, and withdrew from the party. Lee turned up now and then between dances to tell me what a wonderful time she was having; all the men were so sweet to her. It was her introduction to French society.

Near the end of the festivities, there was a pause and silence — a large white base had been set up at one end of the garden, as if for a sculpture, and several white figures grouped themselves on and around it. Their faces, too, were white, giving the effect of a classical Greek statue. The participants were Marie Laure, Cocteau, and some painters and writers. I was asked to make a picture of the composition. Looking over my film holders, I found one film that I was sure had not been exposed. This would be rather precarious; I went about carefully preparing the shot. First, I had all the available projectors trained on the group as there was not enough light otherwise. Several press photographers gathered around to profit by the arrangement — there were no flash bulbs in those days. I made my exposure; it came out well. I had never before relied on a single shot to obtain a satisfactory result and from now on I resolved to reduce the number of exposures I would make of any subject. I thus saved myself a great deal of unnecessary work. Photography need not be a hit-and-miss affair any more than painting, in which the painter limits himself to one canvas per subject. The procedure is slightly different: in pho-

tography all corrections are made in advance, whereas in painting, during and after a work in progress.

Other incidents with the foreign and transient individuals impressed themselves on my memory. One day I was summoned to the Ritz Hotel to photograph the Aga Khan. His aide-de-camp received me, led me to a room and told me to set up my material; the Aga was dressing for the occasion. This was to be an important document to send to his subjects in India. I had a vision of Oriental splendor with silks and turbans, pearls, emeralds and rubies. The Aga came down without any headgear, wearing a yellow woolen sweater, doeskin trousers and — a pair of boxing gloves on his hands. He explained that since he spent so much of his time in Europe and England, his subjects would be most impressed to see him in a Western outfit. I said I would have liked to see him receiving his annual gift seated on a large pair of scales, balanced with his weight in pearls. I'd read about this in the papers. He was a heavy man, took a stance, not that of a boxer; I made an exposure. The light was rather dim and I suggested we go out into the courtyard. Here I proposed that he put up his gloves, but he thought it would not be sufficiently dignified. I made a couple of exposures and said I was finished. He would need many prints, he said, a thousand, maybe. I replied that any photo-finishing house could do this from my negative, missing a large order.

The aide-de-camp came around a few days later, for the prints, which he admired. He dabbled in photography himself — would like to have some lessons. They were going back to India soon and he could arrange to have me out there, where, besides being an instructor, I would find plenty of material for interesting photography. I replied that I seldom took a camera out of my studio, and then only for portraits, which were my specialty. I was fascinated by his glittering wrist watch held by a white linen band and asked where he got the latter. In London, he said, he had half a dozen and laundered them himself. Next time I went to London I acquired some for myself. They were very smart.

The Maharaja of Indore came to the studio to be photographed, also in Western clothes — sack suits and formal evening dress. He was young, tall and very elegant. I got a substantial order from this sitting. He asked me to go out to his stables and take pictures of his favorite horse. An appointment was made with the trainer and I appeared with my finest cameras. The trainer trotted out the horse; I spent an afternoon shooting from every possible angle, in motion and in repose. I worked harder than I ever had with a human portrait. The Maharaja was leaving for India; the prints were to be submitted to the trainer and forwarded. When I showed him the results he was disappointed. He said I did not understand horses, had missed the particular points of the beast and he could not send them. I sent the prints myself directly to the Maharaja. I received a glowing letter from him, with a check. Perhaps he was as ignorant of the fine points of the animal as myself.

Next year, the Maharaja was in the South of France with his young bride. He had taken an entire floor of a hotel in Cannes, for himself and his retinue. I was invited to come down and make pictures. During his last visit to my studio he had been intrigued with a contraption that stood in a corner. It was a phonograph on an empty valise. On the floor against it was a felted ball worked by a pedal — the kind that goes with the bass drum in jazz bands. To the phonograph was attached a cymbal. I had demonstrated by putting on a record, accompanying it with the improvised battery. No doubt I had gotten the idea from my first visit to Cocteau. The Maharaja loved jazz and dancing. I arrived in Cannes before noon, was assigned to my room in the suite and joined the newly wedded couple for lunch in the hotel. The Maharanee was an exquisite girl in her teens. She wore French clothes, and a huge emerald ring. The Maharaja had bought it for her that morning while taking a walk.

The first thing he asked me was whether I had brought my jazz outfit with me. I hadn't thought of it, I said, but could easily rig one up on the spot. After lunch I went shopping in town but the only musical shop had no musical accessories for

professionals. The Maharaja said we would drive into Nice — there were plenty of shops. He ordered the car. When we came down to the lobby a huge black Bentley was waiting for us. A chauffeur and footman in tan-and-gold uniform stood by. It was pouring rain. With a wave of the hand he dismissed them; got behind the wheel, motioning me to join him. The interior was upholstered in green leather. With his fingertips on the wheel he drove through the dense traffic and downpour at about fifty miles an hour, chatting all the time. We were in Nice in about fifteen minutes. We found a musical instrument shop, and the needed accessories, returning to the hotel in time for tea in the suite. I set up my empty valise as a bass drum with a Victrola on top and attached the battery. A record was put on and the young couple danced while I played the accompaniment with drumsticks, cymbals and foot-pedal thumping the valise. At night we had dinner in the hotel while an orchestra played. There was more dancing; I asked the Maharanee for a dance. With my arm around her waist, she felt like a child, but moved like a woman — a European woman; she danced divinely.

The next day after lunch the couple retired for a siesta. I was asked to bring my camera to their suite before teatime. We'd begin with some informal pictures — I could stay as long as necessary to make a series of photographs that would be a record of their honeymoon. I checked my material carefully before the sitting. The camera was a small insignificant instrument, the oldest and cheapest one in my collection, purposely chosen so that I would not have too professional an air. I brought no lights, relying on the daylight that came through the windows. First, I had to play some jazz to which the subjects danced, then they sat down holding hands. I made a few exposures, after which I suggested that they pose separately for individual portraits. The Maharanee was very relaxed — she smiled at me, not at all impressed or stiff as she might have been in the more elaborate setup of a studio. When I tried to make an exposure, the camera jammed.

I cursed myself for not having brought another camera, and fumbled for a while, then announced that we'd have to post-

pone the sittings until I could have the instrument adjusted. The Maharaja went to a cupboard, opened the door; on a shelf was an array of shiny new cameras of the most recent models, both for stills and for movies. He told me to help myself. I explained that the more modern the instrument, the more time I required to familiarize myself with it. My camera was like an old shoe, I was used to it and would have it in working order the next day, I said. We had some drinks, played a few more records, and I left to dress for dinner.

We drove to a swank restaurant and night club on the coast, where a table had been reserved for a dozen people, including a couple of aides-de-camp, a secretary, the English tutor and some other members of the retinue. The table was loaded with flowers, the food and wine were of the best, the musicians stood around playing for us and asked if we had any favorite airs we'd like to hear. The Maharaja preferred dance music. After dinner we danced and drank champagne. Later a waiter passed around with a bunch of small keys — one for each guest. He told us that he would bring a padlock and that the key which opened it would win a prize. When the padlock was passed around each one tried to force his key into it, amidst much laughter. My key opened the lock. Another waiter appeared bearing a large radio, still the smallest made at that time, and set it before me. I was rather embarrassed, having kept my baggage down to a minimum, besides never having had a radio nor any use for one. But I received congratulations all around as if I had broken the bank at roulette, and I felt that my prestige had risen. The machine was carried back to the car and installed in my room. The next morning I had a hangover; did not leave the room and busied myself with putting my camera in order.

We had a sitting in the afternoon which went well, with several poses of the lovebirds holding each other as if dancing, although I knew that in the final prints it would appear simply as if they were embracing. They did not kiss — one of the Oriental customs they still observed. It occurred to me that I might suggest more intimate poses, as if there were no one present; I would assure them of my professional discretion and hand

over or destroy the negatives, after giving them the prints. However, I dismissed the thought as too presumptuous. We continued our séances for a few days; I returned to Paris with my load of film, worked during a week printing them and sent off the batch to Cannes. It was soon returned with large orders chosen from the most satisfactory poses.

In my studio I installed the radio, which played while I worked, except when I had a visit from one of my Surrealist friends. The Surrealists disapproved of music — there were no musicians in the group — since they were considered of an inferior mentality. The radio cured me of my jazz prowess; I became a listener, abandoning my phonograph and battery accompaniment. Later, when I received another radio from a friend, I gave the old one to a Surrealist poet who became very attached to it but pretended that he listened only to the news; would turn it off abruptly when I was around. When it broke down, he begged me to find a repair man to put it in order again.

Lady Cunard was very enthusiastic about my portrait of her. She kept sending and bringing people to me. One day she appeared with Monsieur Olivier, or rather she came ahead of him to prepare me for the portrait I was to do of him. He was considered one of the most important diplomats in Europe, although only the head man of the Ritz Hotel. His knowledge of protocol and his tact were infallible — he knew how to place people who were not friendly with each other at widely separated tables — could bring together others who wanted to meet. He would send me many sitters, she said, if I made a good portrait of him. After the sitting Lady Cunard offered to take Monsieur Olivier back in her car. He thanked her and said that his own car was outside. I did not think he showed good tact.

On another occasion she brought her friend George Moore to be photographed. He was an elderly gentleman with a chubby, rosy face and silvery white hair. Looking around the walls at some of my prints, he frowned and observed that he did not care much for this modern photography. According to

him the only worthwhile, artistic photographs were daguerreo-
types. I said I agreed with him but that a daguerreotype was a
unique piece, like a painting, which could not easily be dupli-
cated, whereas today, with progress in photography, many
prints could be made of a successful work, which was what
most people expected. He said I was too commercial — I re-
plied, so were the old-timers, so were some of the best painters.
He reddened somewhat, more than his habitual color, turned
to Lady Cunard saying he was afraid that he and I did not see
eye to eye, or words to that effect. Then he made for the door
followed by her ladyship looking helplessly at me. Of course, I
should have shown more tact; agreed to make a daguerreotype
of him. I would have found a way even if the materials were
no longer available. Years later, I photographed Lady Cunard's
daughter, Nancy, and made prints on a silver bromide paper
that gave the effect of a daguerreotype. But this paper had come
on the market only recently. I hoped George Moore saw it and
revised his opinion of me before he died.

Augustus John, the English painter, was brought to sit for
me. With his wide felt hat and beard he made a very pictur-
esque subject. But he was slightly in his cups that day, his ex-
pression was rather stern; when I sent a print to his hotel, I
was told he tore it up. Frank Crowninshield of the old *Vanity
Fair* came in one day and, going through my files to select pic-
tures of celebrities, picked out portraits of Cocteau, Stravinsky,
Gertrude Stein, and others. He came upon the portrait of John
and stopped in admiration. Never had he seen a face with
character so well portrayed. It was forceful and noble, he said.

Sometimes a sitter made an unusual request. One woman
wished to be photographed nude to please her husband, an-
other to help her get one. A man, to show his virility. Another
lady had been told she had the most beautiful back in the
world.

Sometimes I was asked to photograph a person on his death-
bed. I complied — it was repugnant but presented no prob-
lems, because there was no danger not only of the subject
moving, but of his being consulted on the results — as when

one photographed a baby. One Sunday morning Cocteau woke me up, asking me to come at once to photograph Proust on his deathbed. He would be buried the next day. Proust's face was white but with a black stubble of several days. It was impressed upon me that the picture was not to be released to the press — just a print for the family, one for Cocteau and a third, if I liked, for myself. Later on, the picture appeared in a smart magazine — bearing the name of another photographer. When I remonstrated with the editor, he promised to print a rectification in the next issue. When it appeared, it said simply that I claimed the work as mine.

One night I happened to be in a club where the entertainers were men dressed as women. One particularly attracted my attention. He was got up as a Spanish duenna with black lace mantilla, high comb, Spanish shawl and long black gloves. I invited him to pose for me; the picture looked quite authentic. When an editor of a fashion magazine saw it in my studio he inquired who it was. I replied offhand that it was the Duchess of Arion, of Spain. He printed it dutifully with that caption. The impersonator was thrilled and showed it around to his envious companions.

Titled people from many countries came through my studio — they were quite simple and human, put on no airs with me and generally manifested an interest in my various activities. Some, now and then, would buy a print of my more creative work. I was often invited to dinner and cocktails. Only the English seemed more aloof, were interested only in my portraiture; acted more businesslike. Perhaps my American accent rebuffed them, or it may have been their accent seemed stiff and formal to me. I made a few lasting friendships amongst them, but these were not of the nobility. As elsewhere, I could communicate only with those who were interested in the same subjects as I.

Although France has been a republic, if intermittently, for one hundred and seventy years, most of the noble families still hand down to their descendants their titles, recognized more

as a courtesy than as a mark of any special privilege. It is considered a form of polite social usage to observe these titles, especially in correspondence. In countries where royalty and titles have been replaced more recently by democratic régimes, class distinctions have been more rigorously abolished as far as such titles are concerned. However, the desire for some sort of distinction is still rooted in human nature, something to set one apart from the mass-produced living created by the industrial age, whether in the hope of acquiring a superior standing or out of pure snobbery and the illusion of enjoying privileges limited to a few. Industrialists and advertisers have understood this desire, especially in a country like the United States without any traditions of nobility. Here, then, wealth has become the criterion, backed up by slogans and substitutes for letters of nobility. Products and localities are embellished with such terms as personalized, distinctive, custom-built, exclusive, gracious and king-size, adorned with coats of arms and escutcheons, indiscriminately applied to alcohol, tobacco, automobiles, hotels. The consumer's distinction is then measured by the choice of his patronage and by what he can afford to pay. Breeding and background need not be taken into consideration except among small and close groups.

In democracies with aristocratic traditions or in countries where royalty and nobility are still respected, there is little striving for either distinction or conformity, rather there seems to be a premium on personality — on individuality. This explains all the iconoclastic movements that have affected the arts in such countries during the twentieth century; and it accounts for my having spent half of my life in France.

AMERICAN AND ENGLISH WRITERS

Prejudiced as I was in favor of the European school of lit-
erature — which accepted me on a broader basis than my
English writing visitors, whose interest in me occasionally man-
ifested itself only after I had been recognized as a member of
the local avant-garde movement — my contact with American
and English writers was a more casual affair. As already ex-
plained, it was principally the relation between photographer
and sitter. Although I read their work with interest, I could not
help comparing it with what seemed to me the more meaty and
poetic writing of my French friends. Fortunately, evaluations,
criticisms and analyses of prewar English writing have been
adequately recorded in print. I can only give a meager account
of my actual contact with the physical person — a sort of word
portrait that completes my photographs. And this, to be sure,
as it occurred at the time of the contact.

My first visit to Gertrude Stein in the rue de Fleurus, shortly
after my arrival in France, caused me mixed sensations. Cross-
ing the courtyard, I rang a bell; the door was opened by a small
dark woman with long earrings, looking like a gypsy. Inside, I
was greeted with a broad warm smile by Gertrude Stein, mas-
sive, in a woolen dress and woolen socks with comfortable

Gertrude Stein, 1922

sandals, which emphasized her bulk. I had brought my camera; it was understood that I was to make some pictures of her in her interior. Miss Stein introduced me to her friend Alice Toklas, whom I had taken for her maid, although, in her print dress trimmed with white lace, she was too carefully groomed. Miss Stein, too, wore a flowered blouse fastened at the neck with a scarf held by a Victorian brooch. Both sat down in chintz-covered armchairs blending with their dresses, while I set up my camera. The room was filled with massive waxed Italian and Spanish furniture on which stood knickknacks in porcelain, with here and there a small vase containing posies, all of which was discreetly set off by a neutral wainscoting. At one end of the room, between two small windows, hung a large black cross. But above, all around the room were paintings by Cézanne, Matisse, Braque, and Picasso on a light water-stained wall. At first glance it was difficult to reconcile the effect of these with the more traditional setting below. The intention, no doubt, was to prove that the two different elements could cohabit. If anything, what were considered revolutionary paintings seemed to blend with the older stuff. This was emphasized by the Cézannes and Braques which hung above the ornamental fireplace and had acquired some of its soot. I wished these had kept their original brilliance for my photography.

In another corner hung the portrait of Gertrude Stein by Picasso, a good likeness — I had her sit alongside it for a double portrait. Like many of his more conventional works, it looked unfinished but the hands were beautifully painted. I have no objection to unfinished works, in fact I have an aversion to paintings in which nothing is left to speculation. Certainly, my photographs left nothing to the imagination, that is, my straight photography; I was already trying to overcome this deficiency in my freer work which I pursued on the side. This aroused the interest of a few who closely followed all the newer trends in expression; in general it left others indifferent, those who had no imagination. I must include among these most of my sitters, intent on getting an important-looking image of themselves.

My portraits of Gertrude Stein were the first to appear in

print, to give her small circle of readers at the time an idea of how she looked. Perhaps I was impressed by the staidness of her personality but it never occurred to me to try any fantasy or acrobatics with her physiognomy. She might have welcomed the notoriety, as in her writing; and she might have thought more of me as a creative artist. Besides the classics on her walls, she took an interest now and then in some striving young painter — tried to help him, but soon dropped him so that generally he passed into oblivion. It reminds me of a famous gourmet in France who was approached by a manufacturer of margarine to write a phrase extolling the merits of his product. The gourmet wrote: Nothing can replace butter! Gertrude Stein was mature and hardened; nothing that came after her first attachments could equal them. This attitude was carried to the extreme regarding other writers — they were all condemned: Hemingway, Joyce, the Dadaists, the Surrealists, with herself as the pioneer. Her bitterness really showed up when the others got universal attention before she did. In her own circle she always held the floor; if anyone tried to usurp it, that person was shortly called to order. One day at a small gathering, she and two of us were engaged in conversation at one end of the room; in an opposite corner Alice and a woman carried on a lively dialogue. Gertrude stopped short, turned her head in their direction and shouted belligerently for them to lower their voices. It was more than effective — there was a dead silence.

I visited often during the next ten years, she came to my studio for other sittings, and invited me to lunch — Alice's cooking was famous. One of the last sittings, with her hair cropped after an illness, pleased her especially. She looked rather mannish, except for her flowered blouse and the brooch she always wore. In exchange for some prints she did a portrait of me in prose.

By now she had publishers and a public. Requiring photographs for her publicity she ordered a dozen prints which I sent with a modest bill. Soon I received a short note saying that we were all struggling artists, that it was I who had invited her to sit for me, and not she who had solicited me, in

short, not to be silly. I did not answer, thinking that she felt I was indebted to her — in any case, I had told her in a previous note, when my pictures of her were reproduced in magazines, that I would do what I could to help her. But I, too, was getting known and had the reputation of being a very expensive photographer, perhaps because I sent out bills more often, when I thought sitters could pay something. It wasn't so much the money I was after — there were plenty of clients who never quibbled and paid enough to make up for those who did not, but I felt more and more that I was being kept from more creative work; I expected a sacrifice from those who were concerned with themselves alone. The flattery and glory that came from portraiture that was often drudgery left me cold. Sometimes, when a prospective client found my price high, I replied ironically that if he or she would like a portrait of myself, it would cost nothing.

Gertrude Stein lived well during her long stay in Paris, whether she already had money from her family, or occasionally sold a painting from her collection — she certainly did not make enough from her writings. When success finally came, she managed her contracts for books and lectures very efficiently — whereas I had started with nothing but my own efforts. I granted that she had made an important contribution to contemporary literature, had been especially helpful to starving European artists, but had profited all she could from her initiative. On one occasion when a collector wished to buy a painting from her, but observed that she was asking more than a work of similar importance brought in the galleries, she replied, Ah, yes, but the latter was not from the Gertrude Stein collection. I read some of her writings, of course — once she read a passage to me, which was more impressive than reading it myself, and I suggested she make recordings. Joyce and the French poet Eluard had made some records to which I listened with pleasure. She never sent me any of her books, on publication — I had been rather spoiled by French authors from whom I received many autographed copies — whereas English and American publishers sometimes sent me a subscription blank, if they happened to have my name and address.

Hemingway, a tall young man of athletic build, with his hair low on his forehead, a clear complexion, and a small mustache, was often seen at the bars and cafés in Montparnasse. It was Robert McAlmon, a young American poet and writer I'd met in Greenwich Village, and now married to Bryher, a rich young English girl, who brought him around to me for a portrait. Bob started a publishing affair called Contact Editions for young, unknown writers whom established publishers would not handle. He was getting out Hemingway's book of some short stories: *In Our Time*. My first portrait gave the man a poetic look, making him very handsome besides. We became friendly; one night he took me to an important boxing match; I wasn't interested in sports myself, but seized the occasion to try out a new hand movie camera I had acquired. I brought an assistant along with another camera, with the idea of getting two different points of view of the fight, and also that one might take up the shooting on a pre-arranged signal after the other's film had run out. Ernest and I were in the fourth or fifth row, while my assistant was in front near the ring, for closeups. When the first round started, the latter raised his camera and had hardly run off a few feet when the manager rushed over and yanked it out of his hands. I discreetly raised my camera and started it rolling. Before I had run off the thirty feet of film there was a dramatic knockout — in the first round. Pandemonium broke out in the hall, Hemingway joining in the shouting and arm-waving. The next day I went to the manager's office to claim my assistant's camera. The manager returned it, first confiscating the film. No pictures were allowed, he said. I returned to my studio, developed the film in my own camera and furnished the illustrated weekly with pictures of a sensational knockout. It was one of my few scoops, I who boasted that I never took a camera out of my studio. I would never be a reporter; it was just another sport — I could never be a Johnny-on-the-spot. Hemingway loved boxing; when he had no one else to spar with, he took on Joan Miró, the Spanish painter, more than a head shorter than himself. When he had no one at all, he'd put a pair of baby boxing gloves on his little boy Bumby's hands, and box with him hold-

ing him in his arms. I made other pictures of Hemingway, his wife and the little boy. He was going down to Pamplona for his first bullfight; I lent him my camera, showed him how to use it, and he came back with pictures of the festival and bullfights which were printed up in my studio.

We had a little party one night in my place — a few American and French friends. During the evening he went to the toilet and came out soon, his head covered with blood. He'd pulled what he thought was the chain, but it was the cord of the casement window above, which came down splintering glass on him. He was bandaged up. I put a small felt hat jauntily on his head partly hiding the bandage — the wound wasn't very serious — and took a picture of him. There have been other pictures of him wounded, before and after this one, but none which gave him the same look of amusement and indifference to the ups and downs of his career. I can imagine the smile on his face, a little more grim perhaps, just before his death recently. For many years afterwards, our paths got wider and wider apart; in fact, we never met again, he the great adventurer and I the confirmed sedentary one.

When Ezra Pound came into my studio he immediately flopped into an armchair with his legs stretched out, his arms hanging loosely, his black tie flowing, and his pointed red beard raised aggressively, as if to take possession of the place. I knew him as a kindhearted man, always ready to help others, but dominatingly arrogant where literature was concerned. It worked very well with the English-speaking community, but I never heard him mentioned in European circles. Perhaps the basis of his writing was too erudite for other races in that they required an English erudition to be appreciated. However impressive it might have been, I was too ignorant to feel any impact from his work; as for any revolutionary content, I was too steeped in the violent and often gratuitous productions of my French friends, who generally hid their erudition to obtain wider circles of reaction. My immediate contact with Pound was as a photographer — I made his portrait to add to my files, and to the growing collection of English writers on the

walls of Sylvia Beach's bookshop: Shakespeare and Company. When he came around again to see the prints he brought his father with him, on a tour through Europe. A pleasant gentleman, who immediately was attracted by one of my paintings on the wall. When he expressed a desire to buy it, Pound discouraged him; it was under heavy glass and would be too inconvenient to carry around. Pound had never looked nor commented upon my work, so I classed him at once among the many other egotists who came to me. I did not regret not selling the painting, as it has since found a place in an important collection, satisfying any egotism that I myself may possess.

James Joyce's *Ulysses* was about to come off the presses; Shakespeare and Company sent the writer to me to have press photos made. Miss Beach also wanted some good portrait prints made for friends. I fixed a fee for this, not much, expecting to receive a copy of this encyclopedic work. I could have asked for it or bought it, but neglected to do both. The book was cheap then; no one could tell whether there would be a demand for it. Anyhow, I went to work on Joyce because his fine Irish face, although marred by thick glasses — he was between two operations on his eyes — interested me. I had read some short pieces by him in the *Little Review*, which had held my attention. I told him so, with the idea of putting him at ease — he seemed to consider the sitting a terrible nuisance. However, he was very patient, until after a couple of shots when he turned his head away from the lights, putting his hand over his eyes and saying that he could no longer face the glare. I snapped this pose, which has become the favorite one, although in certain quarters it was criticized as too artificial, too posed. Later, one evening we sat at the café; Joyce had been drinking and was very gay, singing snatches from operas in a loud voice. I could see where he'd handed down this talent to his son Giorgio, who became an opera singer. Joyce invited me to dinner at his favorite restaurant in Montparnasse, the Trianons, the most expensive, and the wine flowed freely. I talked about photography and painting, but he stared blankly through

James Joyce, Paris, 1922

his thick glasses and said very little. Every now and then he'd hum a tune between the glasses of wine. The meal was copious and delicious. Reading *Ulysses* later, it seemed to me that here, too, there was an immense background of erudition, of literary knowledge — one would have had to be as well-read as Joyce to appreciate the liberties he had taken with the language, the departures he had made from conventional writing.

William Carlos Williams, the poet, turned up in the studio one day. Except for coming across his well-turned poetry in the little magazines, occasionally, I had lost contact with him since my days in Ridgefield, New Jersey. Now, years later, he had managed to take a vacation from his professional duties as doctor, and turned up in Paris making the rounds of the American literary group. Someone had directed him to me to be photographed. He was very good-looking; there was no problem and the results were automatically satisfactory. He ordered a number of prints which I sent to his hotel, one of the more expensive places on the Left Bank. Judging from this, I included a modest bill and received a check. Two decades later, living in California, I received an invitation from a bookshop where Williams was signing his latest book, an autobiography. We shook hands, my wife was very much impressed with his presence and thrilled with the inscription. There was a reference to our meeting in Paris in the book, commenting on my high prices. Not that it did me any harm, but I was annoyed that he hadn't found something more significant to talk about.

There were sporadic appearances of magazines in English: the short-lived *Broom*, backed by Harold Loeb; *This Quarter*, from the bookshop of Edward Titus, and *transition*, run by Eugene and Maria Jolas and Elliot Paul, who became famous with his *The Last Time I Saw Paris. Transition* lasted the longest. My reputation and my appearances in the French periodicals induced them to use some of my more creative work. But only in certain issues, in keeping with their attempts at being iconoclastic, whereas with the French I had become a more permanent contributor. The feeling of transition seemed to

dominate all the American efforts abroad, as if it were a stepping-stone to a return to home on more solid ground. With many it worked well; they attained their final consecration in the States.

Two Americans settled in England, Curtis Moffat, a painter, and Ted McKnight Kauffer, a well-known poster designer, were very assiduous in sending me sitters from London. Besides many members of English society, I photographed the writers — T. S. Eliot; Havelock Ellis, his patriarch's head at odds with his baggy tweeds; Aldous Huxley, posed so his bad eye would not show; Virginia Woolf, whose ascetic face was framed in a severe arrangement of her hair — I had to put some lipstick on her mouth, to which she objected at first, but I explained that it was for technical reasons and would not show in the picture. When she left, she forgot to remove the rouge.

Besides writers more or less recognized by the literary circle in Paris, there were the lone wolves, those who produced intermittently, did not seem to care whether they were accepted or not, and others who were already established on the market and were too busy with themselves. Visitors to my studio included my first photographic subjects from Greenwich Village: Djuna Barnes and Mina Loy, proud and handsome as ever, but whom I did not photograph again, the wistful Edna St. Vincent Millay, on a short visit, who sat for me, Matthew Josephson and Malcolm Cowley, eager to absorb the Paris atmosphere but prudently keeping a foot on American shores. On the English side, there was Richard Aldington and Hilda Doolittle, H.D. as she was known, both early Imagists, and the vital Mary Butts absorbing all she could in her short life. Sinclair Lewis, already a sensation in America, was brought in one day — he was in his cups — I sat him in front of a huge oak screw from a wine press which I had acquired recently in an antique shop with the idea of using it for a composition. It seemed very appropriate for Lewis; when I sent him the print he did not tear it up, told me it was the portrait he liked best of all that had been taken of him. He came around for another sitting, quite sober, bringing his wife Dorothy Thompson.

There was a strange character, Aleister Crowley, whom I'd

heard of in connection with various suspect activities in London and New York. We were sitting in the café with some friends; he took me aside to speak more confidentially. He knew many wealthy women who came to him for horoscopes. We could work together, he said — why not tell those that wished to be photographed that I required their horoscope in order to portray them properly; on his side he would tell a prospective client for a horoscope that he needed a portrait of her to complete his analysis. As I did not need the extra business, the proposition was not adopted.

One of the most intriguing outsiders was William Seabrook, whose exotic books on voodoo practices in the West Indies, cannibalism in Africa and adventurous trips to Timbuktu were creating a stir. When I first met him, I found him sympathetic because of his complete indifference to the celebrity he was enjoying, which brought him substantial returns. Unlike Hemingway, whose adventures were so much raw material for a literary career, he was more a journalist intent on reporting the customs of less known quarters of the globe. In earlier days he might have been a sort of Marco Polo. There was no literary pretense about Seabrook. If, as he was accused, he had embroidered his tales, it was no different than the tendency of all journalist-adventurers. Besides, it improved his books, and made for better reading; only fact-hounds would object. It is rare to read facts that sound like fiction — most writers strive for the reverse effect.

Seabrook carried his curiosity about exotic subject matter into his personal life, only here it was more erotic. As he observed, it must have been as the result of a childhood pampered by five doting aunts that he conceived the desire to torture women in a more or less benign manner. One afternoon he phoned me asking me to do him a favor and spend the evening from eight to twelve in his studio. This was a luxurious duplex in a hotel in Montparnasse. It was a well-known stopping-place for notorious and famous people like Isadora Duncan and Bob Chanler. Seabrook had just received the press, who had interviewed him; had been invited, with his charming wife, to a banquet in his honor that night. Would

I sit in the studio until his return and watch over a girl he had chained to the newel of the staircase? Oh, it was nothing secret, he said, the press had seen her and he had explained she was a sort of mascot. I was embarrassed, said I had a date with a young American girl, Lee Miller, I was dining with her. Seabrook said I could bring her along, order dinner in the room and be comfortable. I accepted the role of baby-sitter and came around with my date, thinking she'd be amused seeing an unusual slice of life in Paris. When we came in, Seabrook and his wife, Marjorie, received us graciously and introduced us to the girl.

She was nude except for a soiled, ragged loincloth, with her hands behind her back chained to the post with a padlock. Seabrook produced a key and informed me that I was to release the girl only in case of an emergency — a fire, or for a short visit to the bathroom. She was being paid to do this for a few days, was very docile and willing. I was to order dinner from the dining room, anything we liked: wines, champagne, but under no circumstances have the girl eat with us. She was to be served on a plate with the food cut up and placed on the floor near her, as for a dog — get down on her knees to eat. The chain was long enough. When the Seabrooks left, I rang for the waiter, who came in without blinking, and ordered a large meal. The food and wine arrived presently, the table laid out for three. When the waiter had departed, I opened the padlock and invited the girl to sit with us. Perhaps she would like to go to the bathroom first? Her hands and face looked untidy. Oh, no, one of the conditions of her engagement was not to wash. We sat down, I and my companion trying to be as natural and casual as possible. As the meal progressed, and with the wine, we relaxed; the girl began telling us some of her experiences with men who had unusual obsessions. There was, for instance, a German businessman who came to Paris every year, for a week. Among his bags was one containing an assortment of leather straps and whips. He whipped her, one lash at a time, methodically, selecting a different whip for each stroke, and placing a hundred-franc note on the table after

each stroke, until she could hold out no longer and would call quits. It was grueling, but watching the pile of notes grow helped her endure more than she thought herself capable of. Then she could stay in bed for a week, take it easy. Seabrook was a gentle man, made no such demands on her, but was content to sit for hours with a glass of whisky, just looking at her. When he went to bed he chained her to the bedpost and she slept on the floor like a dog. She believed he was impotent. She could not understand Marjorie's humoring him.

We cleared the table and played a game of cards. Before midnight, I chained the girl up again, and when the Seabrooks returned everything looked as before. He was quite pleased. I had not forgotten to place a dish with remnants of food on the floor beside her. When we left, my companion told me she had met a man who liked to whip women — it was nothing new for her. Nor for me either, I thought; I had whipped women a couple of times, but not from any perverse motives. Seabrook was so pleased with the docility of his hired girl that he took her with him when he went down south for the summer. She agreed to perform the various duties of cook and housemaid. However, when I saw him again he told me that it hadn't worked out well. The girl had become arrogant, had treated Marjorie as if she were the housemaid, and been generally dictatorial, even holding on to the purse strings. He could get rid of her only by paying her a large sum.

Seabrook had recourse to my services on several other occasions. One day he asked me to design a high silver collar for Marjorie, and whether I knew of a silversmith who could execute it? I had a man who had made my silver chess pieces, and set to work designing the collar. Measurements were taken of Marjorie's neck; the collar was to follow the line of her chin so that she had to keep her head up high and not be able to turn it. My silversmith made a very pretty job of it: two hinged pieces of dull silver studded with shiny knobs, that snapped into place, giving the wearer a very regal appearance. This was heightened by her abundant black hair and a severe black dress. She was to wear the bauble at home to please Seabrook's

penchant for fetishism, and because it became quite uncomfortable after a while. She also wore it at a social function once; it was a sensation, few suspecting its real function. He made her wear the collar thereafter whenever they went out to dinner and took a certain pleasure in watching her at the table eating and drinking with difficulty.

In the Thirties, Marjorie went to New York to see about the publication of a novel she had written, a rather unconventional story with overtones as in D. H. Lawrence's Lady Chatterley, but without the censorable words. She took her silver collar with her; Seabrook wrote me a note saying it had created a furor. They were both in New York later, when I came over on an assignment to do some work and to attend the opening of the Fantastic Art show at the Museum of Modern Art. We made a date for lunch and I was asked to come a little earlier to see something interesting. They had rooms apart, Seabrook's being a large studio-like place. In the middle on the floor sat a statuesque woman, like an odalisque, quite nude and decorated with strings of pearls, bracelets and rings. He introduced her as his secretary, but she did not move nor speak. He informed me that she was condemned to silence for twenty-four hours but functioned otherwise like any normal being. Presently she was allowed to get up and dress. The four of us, Marjorie having come in to lunch with us, then walked down Fifth Avenue. The secretary was taller than any of the others; in a dark gray tailored suit she looked like an efficient young businesswoman.

But there was something peculiar about her; she walked with difficulty, the heels of her shoes were abnormally high. Turning to me at a moment when Seabrook's attention was diverted, she said in a low voice that she would tell the bastard what she thought of him, when her time was up. Seabrook was now drinking more heavily than ever and finally had to go into an asylum for a year's cure. When he came out, he wrote a book of his experiences and the methods employed in such institutions: a book, very cool and objective, that caused a flurry. I did not see him again; he had separated from Marjorie, had remarried, and was living in an isolated house outside the city. Here, I heard, he continued some of his weird practices, had

built a cage in which he kept another secretary for twenty-four hours. It seemed that his last wife was not so tolerant of his habits; there were scenes and he took to drinking heavily until he died.

PAINTERS AND SCULPTORS

Although in the beginning I complied with demands by artists to photograph their works—I realized that besides being a means of gaining my immediate subsistence it gave me access to their personalities. And, incidentally, by doing their portraits at the same time, my understanding of these creators was considerably aided. I had always wanted to know the human side of creators whose work had interested me, and their biographies were as fascinating for me as their works. Anecdotes of the old masters and their ways of living were important to me. I had never agreed with those who maintained that it was sufficient for them to look at the works.

I saw more and more of Francis Picabia; besides photographing his works, I made a number of portraits of him. He liked especially to be photographed behind the wheel of one of his great cars. He was pleased, too, that I continued to see him, although I frequented the Dada group from which he had detached himself. In the spring after my exhibition, he invited me to drive down south with him for a short vacation. He drove very fast. The first night we put up at a cheap hotel in a little town. There was no comfort, the room was cold and we were up early in the morning as he planned to arrive at our destination before nightfall. I was rather annoyed with this

Francis Picabia, 1922

haste and austerity, wishing on this first trip through France to take in some of the beautiful country that flew by. We lunched frugally at an inn filled with local workers, which was also a deception, I having expected to regale myself at one of the renowned stopping places. But when the landscape began to change, with budding plane trees along the road, the gray-green olive trees, red-tiled stone farm houses surrounded by black poplars, and quaint towns with vestiges of Roman ruins, I forgot my disappointment. And when the blue Mediterranean came into sight, I was thoroughly captivated.

The last lap of our trip was around the Corniche bordering the sea. It was a narrow road barely wide enough for two cars to pass each other, cut in the cliffs several hundred feet above the sea. There was no protecting wall on the outside: the side on which we rode, with the wheels a few inches from the edge. There were hairpin turns which explained the term — they were hair-raising. Some had to be negotiated in two maneuvers while I looked back to advise Picabia how near he could back

the long chassis to the edge of the precipice. He handled the car with ease, assuring me he had been in tighter places during the war as chauffeur for a general. I envied his skill and resolved to learn to drive, perhaps have a car of my own some day. It would add to the series of accomplishments which had seemed beyond me: painting in oils, photography and dancing.

We finally reached a straight road bordering the sea; the sunset intensified the red cliffs and the sea was almost purple, the sky green by contrast. For the first time I saw palm trees and cactus plants in their native habitat, with here and there clusters of parasol pine trees. It was inspiring enough to make one wish to return to landscape painting. Perhaps I would, I thought, at least it would do no harm to turn out a few landscapes, although my integrity as a Dadaist might suffer. But I had already compromised myself with my photography in spite of some efforts to pull it out of the bread-and-butter or cheesecake limits. We rode through Cannes with its gardens and flowers, its promenade bordered with branches of the smart shops of Paris, and its imposing hotels, then drove inland a couple of miles to a quiet little town, Le Cannet, where we were installed in a modest hotel.

Picabia was going to Monte Carlo in the evening to play roulette and I went along. We had dinner in a fish restaurant in Nice and drove to the Casino in Monte Carlo. I exchanged a little money for chips, Picabia traded a much larger sum. After timidly playing only the black and red, I shortly lost my investment, and spent the next hour watching his play and the others'. Huge sums of money were being raked in and distributed; the players were tense as if their lives were at stake. Here and there one acted nonchalantly as if it did not matter whether he won or lost. But I lost interest and was bored, I could not understand how people who could afford to lose their money, who seemed to have plenty, could get a thrill out of winning a little more. As for those who could not afford to lose, how could they risk their peace of mind for a gain that would soon be futilely squandered? But, as I have already said, I had never developed a gambling spirit, was averse to any form of competition, gambling included. Picabia rose from his seat —

he had lost. We drove back to our hotel along the coast road by brilliant moonlight.

Picabia said he'd be busy the next day. He had a number of appointments, but would introduce me to a charming lady who ran an antique shop in Cannes. We went down the next morning and I was presented as a famous photographer who would be pleased to do her portrait. She was in her forties, rather blowzy; I was annoyed with Picabia's making the suggestion without first consulting me. True, he was my senior by about ten years and I was prepared to tolerate a certain amount of patronizing, but this, I felt, was exceeding the limit. I looked around the shop while he engaged in some bantering talk with the woman. One of his recent paintings hung on the wall amongst various old-fashioned prints and portraits. It was a portrait of a Spanish woman with the national headdress and enormous eyes, the whole superposing various nudes, giving the effect of a double exposure in photography. I could not help thinking that only an intimate relationship between them would have induced her to hang such a work among the more conventional objects. At the time Picabia's work was not taken seriously by the critics, while the avant-garde considered his latest development rather superficial — a let-down from his earlier Dada productions.

Presently, he excused himself and left me alone with the lady. She invited me to her flat for lunch, which was served by a maid who discreetly disappeared at the end of the meal. We sat around for a while drinking coffee and brandy; she was amused with my conversation which was more or less incoherent as I had drunk much wine and was reckless with my French. After a while she complained of a headache, said she'd lie down and have a siesta. I followed her into the bedroom where she stretched out on the bed, covering her eyes with her hand. I was invited to lie down also, if I wished to relax. I was dizzy and said I'd go out into the fresh air. Taking her hand I kissed it gallantly in European fashion, thanked her for the lunch and promised to bring my camera to do her portrait. She turned her back to me and I left.

I strolled along the promenade by the sea and felt better,

then wandered over to the main thoroughfare with its more popular shops. Passing a store for artists' materials, I went in and bought a couple of small canvasses and some tubes of color. The yachts skimming along the sea had given me an idea — I'd interpret the regatta against the blazing sun, realize my desire to paint a picture more or less from the scene before me. Taking a bus back to the hotel I set to work at once. Without brushes, painting directly with the tubes, I sketched in the boats, the sails black against the sky, and the sun in swirls of pure colors behind them. It was very impressionistic, joyful yet somber; it might have been traced back to that unhappy Van Gogh whose colors expressed so much tragedy. However, my monochromatic effect was more austere — there could be no mistake about my intention to avoid making a pretty picture. The next day, Picabia came into my room and was surprised that I had already produced something. He praised the painting and said he'd like to have it — would give me a painting in exchange when we got back to Paris. And he kept his word, except that instead of allowing me to select something, he had picked out what I was to have, probably a work he considered of less importance, but which pleased me, as it was of the late Dada period, more personal and perhaps less marketable. Later, after his death, this period was the one more sought after by collectors. My painting was not visible in his flat; it was many years after that I came across it; the director of an annual salon of painting invited me to a cocktail at his place in Paris, and there on his walls hung my Regatta. When I inquired how he had come by it, he said he'd picked it up one day in Cannes in an antique shop. The antiquarian did not explain how she had acquired it. Later, again, after the director's death, I saw the painting in a collector's house. I marveled at how inanimate objects survived human beings.

Picabia finally installed himself definitely in the South of France, to escape his matrimonial and tax problems. He had built himself a comfortable villa but soon new complications arose. Still pursued by the tax people, separated from his wife, he had taken up with the governess of his children. He sold his house, bought a houseboat and, it seemed, living on the water,

did not have to pay taxes. I came down often to the south under my own power, having acquired a car and learned to drive; on one occasion, I visited him on the boat which was docked at Golfe Juan, a few miles from Cannes. He invited me to join him the next morning for a trip to St. Tropez about fifty miles further along the coast. The boat would leave at 8 A.M. I arrived at the dock at five minutes past eight and saw the boat several hundred yards out to sea. Golfe Juan was a small town of fishermen; I stood irresolute for a few moments, then jumped into my car and drove full speed to Cannes where the big yachts and motorboats for skiing were anchored. Leaving the car on the dock I approached one of the motor boats and asked the owner to take me out to sea and try to intercept a boat that would be passing on its way west. We agreed on a fee and set off. There was a tremendous churning of the water and the launch shot ahead. In a few minutes we were far out, and there in the distance was Picabia's boat cruising leisurely towards St. Tropez. We pulled up alongside, Picabia standing at the gunwale with a worried look, wondering, no doubt, if we were officials pursuing him for some infraction. I stood up and waved — he stared at me in astonishment. I laughed and asked whether I was too late for the party. After paying off the motorboat, I climbed aboard the houseboat and shook hands with Picabia and Olga. He complimented me on my resourcefulness but made no apology for leaving without me. The cabin was neatly filled with two bunks and a galley for living purposes; a sailor up front handled the boat. After a steady, uneventful run, we arrived at St. Tropez about noon.

We were to meet a party of a dozen friends for lunch at the Hotel Sube on the quai. The table was set and there was great animation and laughter as Picabia recounted how he had rescued me at sea. After some preliminary drinks — the native pastis, a milder sort of absinthe tolerated by the law — we sat down to the serious business of eating. Hors d'oeuvres were followed by the main dish of bouillabaisse, a huge fish stew served in large pieces of concave cork bark stripped directly from the tree. This was accompanied by separate platters of lobsters in a rich red sauce, à l'Armoricaine, sometimes called

à l'Américaine, without reason. The aroma of spices and saffron filled the room. Picabia picked up a lobster claw and broke it, spattering the shirt of the guest opposite him. This one playfully picked up a fragment, swirled it around in the sauce and sprinkled Picabia with it, who retaliated with a similar gesture but projecting the red sauce on several other diners. These in turn followed suit until in a few moments everyone was decorated. Amid shouting and remonstrances we continued the meal. At the end the place looked like a battlefield, but all were in good humor, and those who were able to, retired to change their clothes. A few, like myself who were simply visiting, kept our stained shirts on.

Picabia, Olga and I went to a bar nearby to pay a visit to the owner whom we knew from Paris where he managed the Boeuf sur le Toit, the famous night club. He received us with pleasure, plied us with champagne, and we returned to the houseboat. Picabia was in a hurry to get back to his base, had an appointment before nightfall. He returned by car which a friend was driving back to Cannes, leaving Olga and myself to return by boat. I stretched out on a bunk and slept off the effects of the food and drink until we made port.

Picabia's good will towards me manifested itself on other occasions, but the results always seemed to fall short of my expectations. A woman appeared one day in my studio bearing a letter from him in which he asked me to do her portrait — she did not dare ask it herself. She was also interested in modern painting, would be pleased to look at my work. He also added that there was a fine gallery in Cannes and that he could persuade the owner to give me an exhibition. So, when I came down south again, I was to bring my work with me and the show would be arranged at once. I photographed the lady; she admired whatever paintings hung on the wall, but I made no effort to interest her any further. Unless she expressed a desire to own my work, I'd make no advances to that end.

In the spring I drove down to Cannes but instead of taking my paintings with me, I selected about fifty of my most representative photographs. Cannes would be filled with rich society vacationing during the Easter holidays; my painting would be

of no interest to them. I might get some sittings for portraits, and so brought my camera with me. When I arrived, I explained my attitude to Picabia, saying it was about time that photography should be presented as art, hung in galleries devoted to painting and sculpture, besides I considered Cannes and its people too superficial to be exposed to our sort of painting. Picabia agreed with me, saying that the dealer was not too well-informed on contemporary work, handled mostly old masters and better known moderns. He himself had been able to sell his own work only to friends or through social contacts. It would be interesting to see what effect a photographic show would have on the locality. The gallery owner seemed to have complete faith in Picabia's sponsorship and a date was fixed for the show to open within a week. The gallery would make appointments for sittings and take a commission, as well as pay all expenses. I busied myself preparing posters and catalogs. Picabia wrote a preface, in his manner, too cryptic and too highbrow for the public I anticipated. He wrote, among other phrases: *You listen with your eyes, which all painters should do; your paintings, your photographs neither laugh nor cry, I compare them to the philosopher lying in the sun, they are a far cry from the cannibalism of Paris!* . . .

Although he said I could use the preface or not, as I pleased, I used it. Never would I criticize or reject another's work, having endured enough of that sort of thing from critics whose motives I always questioned. The gallery was palatial with a frosted glass ceiling which admitted a diffused light. I fixed the photographs on the four walls in a single row well spaced, giving each one the importance needed to carry out my idea of presenting it as a work of art. The show looked very impressive; the owner was reassured and optimistic in this new venture and was certain I'd get many orders for portraits. Of course, one could not expect to sell the prints themselves as one would paintings or drawings, a photograph had no investment value. I did hope to sell individual prints, which was secretly the real object of the show, but I said nothing.

The exhibition opened the next day as announced by the invitations and the posters. I arrived early to receive the first

visitors. After an hour or so no one had entered the gallery. I fidgeted for a while, went into the office of the director to verify the date on the invitations — there might have been a mistake, but no, everything was as scheduled, all cards had been sent out four days before. Back in the gallery a couple of lone visitors attracted by the poster on the outside were wandering about. Presently Picabia's wife appeared, alone. Picabia was ill, she said, and kept to his bed. She apologized profusely for him. Two or three other visitors came in, strayed about and left; that was all. Later in the afternoon, a handsome, foreign-looking young couple came in. They spoke to me and asked if they could reach the artist. I introduced myself; they did likewise, giving a name with a title. They were on their honeymoon and wished to be photographed. We made an appointment in their hotel; the next few days I was busy finishing up the prints in a local darkroom. They were very pleased; ordered many prints and paid the price I asked without quibbling.

Now I became quite depressed, decided I needed a little distraction. I ceased going to the gallery, said I'd be gone a few days, and for them to make any appointment that might be solicited, for the next week. That night I put on my dinner jacket and went to a smart night club. I sat at the bar drinking whiskies and treating the hostesses that sat alongside me. One good-looking redhead was especially attentive to me; although she was almost a head taller than I, we danced quite comfortably together. During one of the dances I noticed another couple which we passed several times. The girl, looking over her partner's shoulder, smiled at me. Returning to the bar at the end of the dance, I asked the barman for a pencil and a piece of paper, scribbled a note asking for the next dance, then went over to the doorman in uniform and asked him to slip the paper to the girl who was sitting at a table with a party of five or six. He nodded and I gave him some money. He sauntered over to the table and quite openly held up my note for all to see, then pointed me out to them. They turned their heads in my direction, laughing and joking. Furious, and emboldened by my drinks, I walked over to the table to remonstrate, when coming closer to the doorman I saw that he wore an aviator's

uniform with wings. I apologized, offered him a drink; he thanked me, sat down and invited me to join the party. But I was too confused and returned to the bar — I was lucky that I hadn't been knocked down as might have happened. I consoled myself with the redhead, danced and drank with her until closing time, and found myself alone in a strange hotel the next morning, remembering nothing.

Continuing my spree the next night I went to another cabaret, wearing my dinner jacket again. However, instead of the black trousers that went with it, I donned a pair of white flannels. I had become clothes conscious, did not wish to be taken for a waiter who all wore black trousers, whether their jackets were white or black. My bow tie was red. There were a few curious looks directed towards me as I went up to the bar and ordered a drink. A lone girl sat on a stool near me, but after a cursory glance she no longer paid any attention to me. This was a challenge, I thought; I finished my drink, then asked her to come and sit at a table with me. She accepted and when the waiter (in a white jacket) came up, I ordered a bottle of champagne. As the cigarette girl passed by, I stopped her. My companion chose the most expensive turkish brand with rose petal tips. We danced; she became more friendly and inquired about my strange get-up. I replied that I was an artist who took liberties in dressing as well as in painting. She suggested that I might take some liberties with herself. After some further dancing and finishing the bottle, I motioned to a waiter, to pay my bill. The man came up, bowed to us stiffly, inquired who I was, and said he did not remember where we had met. Then I noticed that his white jacket was of the finest material and cut, his silk shirt pleated, and he wore diamond studs and a diamond ring. I apologized, said I had mistaken him for an acquaintance; he bowed again stiffly and walked away. The girl giggled and complimented me on my social relations, perhaps I was hiding my identity in my masquerade, she said. Decidedly, two nights in succession I had made a fool of myself; I should not drink so much. After getting the waiter, we took a taxi; the girl gave the chauffeur an address and we arrived at a villa hidden at the end of a garden. The taxi had pulled up

behind a large car, which I recognized at once as Picabia's. I retained the taxi, telling the girl we'd have to go to a hotel, as I did not wish to run into some friends. I pointed to the car. She was impressed, but said she was due back at the villa, with or without a client, others were waiting for her. I returned alone to my hotel.

During the Fifties after my return to Paris, I met Picabia at an exhibition that had been arranged for him. He was very ill; could hardly walk or talk and had shrunk to a small figure. His paintings consisted of a simple motive, largely brushed in, as cryptic as anything he had produced in the Dada period or more so since there was no provocation involved as in his earlier work. Certainly, not anything to excite collectors and dealers. One morning Olga phoned me to announce his death. I ran over to the flat and saw him on the bed. He looked very frail, his face pinched and swarthy with the Spanish character very marked. Returning to my studio I made a sketch from memory, which was used in a pamphlet published by his friends in homage to him. While the others had written what amounted to funeral orations, I had simply added a caption to the effect that while for others it was the end, for me it was simply an Intermission. I was referring to the name of the movie interlude in the ballet he had composed one year, and which he had named *Closed for the Season;* creating some confusion on the opening night.

The first time I went to see the sculptor Brancusi in his studio, I was more impressed than in any cathedral. I was overwhelmed with its whiteness and lightness. Judging from the airy columns of medieval churches, the interiors may also have been pervaded with light in the beginning, catching the colors of the stained glass windows projected on the white stone in an orgy of chromatics, far from the religious gloom which we accept after centuries of accumulation of dust and grime. Coming into Brancusi's studio was like entering another world — the whiteness, which, after all, is a synthesis of all the colors of the spectrum, this whiteness extended to the home-built brick stove and long stovepipe — here and there

Brancusi, Paris, 1930

emphasized by a roughhewn piece of oak or the golden metallic gleam of a polished dynamic form on a pedestal. There was nothing in the studio that might have come out of a shop, no chairs or furniture. A solid white plaster cylinder six feet in diameter, cast on the floor of the studio, served as a table, with a couple of hollowed-out logs to sit on. A few small cushions thrown on these made the seats more inviting.

Brancusi lived like a hermit, in his studio in the heart of Paris. Except for a few devoted friends, his work was practically unknown in Europe. He refused to exhibit — a sculpture was the result of years of patient finishing — a curve the result of endless rectifications, like testing the keel of a ship, not to be submitted to the casual gaze of the first comer, nor to facile, irresponsible criticism. I think it was Steichen, the painter and photographer living in France, who had won his confidence and persuaded him to show at Stieglitz's in New York. This was not without its disillusionments, beginning with the customs which refused to regard the sculptures as works of art, insisting they were dutiable as industrial products. There were also snickers on the part of those who saw a certain eroticism in the works.

Besides the desire to know the man in person whose works interested me, I came to Brancusi with the idea of making a portrait of him to add to my files. When I broached the subject he frowned; he said he did not like to be photographed. What would interest him was to see some good photographs of his work; so far, the few reproductions he had seen were a disappointment. Then he showed me a print Stieglitz had sent him, when his show was being held in New York. It was of one of his marble sculptures, perfect in lighting and texture. It was a beautiful photograph, he said, but it did not represent his work. Only he himself would know how to photograph it. Would I help him acquire the necessary material and give him some points? I'd be glad to, I said; the next day we went shopping, acquired a camera and a tripod. I suggested a photo-finisher who would do his darkroom work, but this, too, he wished to do himself. So he built a darkroom in a corner of the studio, all by himself, as he did everything else in the studio, even to

the moving of heavy pieces by means of crowbars and pulleys. Naturally, the outside of the darkroom was whitewashed so that it blended with the rest and became invisible.

I directed him in the taking of a picture and showed him how to finish it in the darkroom. From then on he worked by himself, not consulting me any further. Some time later he showed me his prints. They were out of focus, over or under-exposed, scratched and spotty. This, he said, was how his work should be reproduced. Perhaps he was right — one of his golden birds had been caught with the sunrays striking it so that a sort of aurora radiated from it, giving the work an explosive character. Looking at the sculptures themselves, I could not help thinking how much more imposing they appeared now, alongside his amateurish attempts in another medium . . . thinking, also, that he did not wish to attain greater efficiency, so that his sculpture would always dominate. It seemed to me that a certain cunning went with all his simplicity. Whereas I, in perfecting my technique in photography, had done so to the detriment of my career as a painter.

As the years went by, Brancusi became more friendly, less impersonal; and I became part of the small circle of visitors who were welcome when we pulled the string at his door, which rang a deep-toned gong he'd installed. Whether it was with Duchamp, Léger the painter, Satie the composer, or, especially, if I brought a pretty young woman with me, his face expressed pleasure on opening the door. One night we were a party of four or five whom he had invited for dinner. It was a rare thing with him, the height of hospitality. He thrust a leg of lamb on the cinders of his stove, laid the places on the plaster disc, around which we sat and drank small glasses of Rumanian firewater while waiting for the roast. When it was ready there was a huge dish of polenta, to go with it. There was also plenty of wine; we got very gay towards the end. The meal finished, Brancusi piled up the dishes and carried them to a corner sink, came back with a stiff steel brush and scraped the table clean and white again. Our clothes were more or less white with the plaster, but he said not to worry — it was perfectly clean stuff. He himself wore dirty white work pants

which did indeed look cleaner after the meal. More liquor was brought out and we drank. Then he produced a violin and played some Rumanian folk tunes accompanying them with a little dance. It was all so primitive in contrast to the subtle finely finished works which filled the studio.

One of the guests, the Baroness d'O ———, famous for her patronage of writers, painters and musicians of the advanced movements, began to complain that she was ill and wished to leave. Brancusi told her to lie down on the couch on his balcony — it would pass. She was a tall handsome woman in her forties. We watched her go up the stairs and continued our drinking and chatter. After a while Brancusi told me to go up and see how she felt. She was lying quietly and said she felt better, but still had a slight headache. I sat down beside her and began stroking her temples; when I stopped she seized my hand and told me to continue — I had a magic touch, she said. I became more emboldened and my hands wandered over her body which was lithe and firm. I lay down beside her while she pressed me close to her. The inevitable happened. When I came down again I said simply that the baroness was much better and would come down presently. The group was silent; no remarks were made about my prolonged absence. I was very grateful for the tact displayed. When the lady came down we asked Brancusi to play us another tune before leaving, which he did with great gusto, looking at me all the time as if he were playing for me alone.

In keeping with the character of his studio, Brancusi for a long time refused to have any modern appliances around — it was years afterwards that he compromised on a telephone which was kept hidden and which he did not always answer when it rang. He did all his shopping himself; if he fell sick, no one knew it unless a friend or compatriot happened by, when he would open the door a crack and then refuse any assistance, saying all he needed was rest.

Someone, moving out of Paris, gave him a large old-fashioned radio. He took out all the parts and studied them, throwing away the cabinetwork. Then, in a block of white stone a foot thick he cut a round hole for the loudspeaker and set it up

in a corner on a pedestal as if it were a sculpture. The sound that came out was crystal clear, equal to anything produced by modern hi-fi constructions. In an alcove there were all sorts of electrical tools for cutting, scraping and polishing, which were not visible, leaving the studio as immaculate as an art gallery — there was no sign of a work in progress — everything looked as if it had grown by itself and was completed.

Duchamp and I were having dinner with him one night — just an intimate affair prior to the former's departure on one of his trips to the States. To commemorate the event Brancusi set up his camera, saying he'd make a picture of the three of us. We sat down on a log with him holding the bulb by a long tube to the shutter of the camera in front of us. A week later, after Duchamp's departure, Brancusi handed me a couple of prints, asking me to mail one to our friend in New York, he himself hated to go to the post office. It was a nice little snapshot; I was proud to be in it, and hoped it would appear in print someday. I think I wrote a note with the print telling Duchamp he could release it if anyone wished to reproduce it. A few months later it appeared in the *Little Review*, edited by Jane Heap and Margaret Anderson, but had been rather mutilated in a stupid manner. Both Duchamp and I had been eliminated, with Brancusi sitting alone with the rubber bulb held in his crotch in a most suggestive attitude. I hadn't seen Brancusi for some time until one evening when half a dozen of us were seated at a table in a café. Brancusi turned his back to me, then swung around again and lifting his glass shook it threateningly at me, saying I had made a fool of him — had I seen the *Little Review*? I tried to explain, saying I had nothing to do with it, had simply sent the print to Duchamp as he had given it to me. It was no use, Brancusi would not be placated. He sulked for a long time but finally relented. We reached a new, friendly basis — he even posed for me and I made some stunning portraits of him. But he was more wary than ever of photographs and photographers. He seemed even to lose interest in his own attempts, letting his darkroom go to seed, the camera standing in a corner covered with dust, white dust, prints abandoned, crumpled and torn. When I said that I would

include my portrait of him in an album I was preparing for publication he forbade it. The only authentic portrait of him, he said, should be one image chosen from a moving picture film of him, and he would choose the image. I agreed to do whatever he said and brought my professional movie camera to his studio. I did a couple of hundred feet of him moving about the studio; we projected it slowly and he put his finger on the frame he approved. This was used in my book, although I would have preferred one of my more careful studies. However, it did not matter, I was quite used to my other sitters having preferences which differed from mine — I regretted only that I hadn't labeled the picture: Self-Portrait by Brancusi.

Steichen had returned to the States for good, abandoning his house in the country. Brancusi wished to recover a sculpture that had been left in the garden. It was a wooden trunk about thirty feet high, carved with zigzag notches, called the Column Without End. I came around to the studio with my car; he got in carrying a large coil of rope and a saw. The house looked very sad, as do all abandoned houses, with some old empty frames lying around and the garden overgrown with weeds. But the column stood proudly in the middle like some prehistoric totem pole awaiting a ritual. Brancusi tied one end of the rope around his waist, attached the saw to it, and began climbing, placing his feet in the notches. He stopped near the top and pulling up half the rope, looped it around one of the notches so that the two ends fell to the ground. Then he climbed halfway down and began to saw through the column. It was hard wood and took about a quarter of an hour to cut through. And no doubt, the pressure of the upper part must have made the sawing more difficult. But the cut was perfectly horizontal and the sculpture held in place as if it hadn't been cut. (It reminded me of that expert Chinese executioner who could cut the head off a condemned man without its falling, so that one would think the executioner had missed his stroke). Brancusi then climbed down, picked up one of the loose ends of the rope and walked to a tree nearby. He climbed this and attached the rope loosely to a branch. Getting down, he picked up the other end of the rope and walked over to a tree on the opposite side, go-

ing through the same maneuver. When he came down, he stopped for a while, looking at the column; scratched his head. He'd forgotten something. Then he went into the house and soon appeared with another length of rope. Climbing the column again, he attached one end just above the saw cut, letting the other fall to the ground. He came down, picked up the loose end and began gently tugging it. The sawed upper part moved and finally slid off the lower half, falling to the ground still sufficiently retained by the ropes attached to the trees. Brancusi then lay down on the ground alongside the lower part and began sawing it until it, too, fell free. There were about three feet more in the ground, he said, but it did not matter — it was the Column Without End, whatever its length. Next day he would send a truck out to bring the two pieces in. They could always be put together again. Someday he'd make one in metal. (He did, in fact, when the Rumanian government commissioned him to erect a similar one in gilt steel.) I had stood by the entire operation, fascinated; my offer to help had been refused, but I did get a nice picture of the column before it came down. I do not remember whether I made any pictures of the actual demolition, but any negatives must have been turned over to Brancusi as I often did at his request.

I visited him now and then until the first months of World War II, before the invasion of France. We never discussed the situation — politics were never brought up in the studio. Only once, when the possibility of the Germans entering Paris came up, Brancusi cut the conversation short by saying that if he found himself in a tight fix he'd commit suicide.

Ten years later when I returned to France, I found him exactly as I had left him, that is, the studio was the same, but he had aged and was feebler, worked very little. One day when I came to see him he was on the roof patching a broken pane of glass with some tar. I remonstrated with him — there were plenty of roofers who could do the job. He said it couldn't wait, workers were unreliable, never came when called, when they came, did a bad job. Next I heard he had fallen down while working in the studio and broken his hip. He was in the hospital for a long time, but had himself brought back to the

studio where a young couple of compatriots took care of him. When Brancusi died I went to the cemetery in Montparnasse. I stood in line with the many followers and threw a white carnation on his coffin before it was placed in the vault. A delegation appeared from the Rumanian Embassy with a large wreath. Some of the other mourners loudly booed these representatives of a country behind the Iron Curtain. It was very depressing. I resolved never to attend another funeral.

Henri Matisse intrigued me because his personal appearance bore no relation to his works. I knew an early self-portrait, in which he had given himself a green beard, that had aroused a storm in the postimpressionist period. Now he looked like a successful doctor in well-cut tweeds and his carefully trimmed grayish-red beard. Having made an appointment to do his portrait, I arrived at his studio in the suburbs of Paris. When I opened my bag to set up my camera, I found to my horror that I had forgotten the lens which was wrapped separately. I was about to retire with apologies when Matisse produced an old Kodak which he said contained a film that had been left there unused since the previous summer. He also produced a snapshot of himself working in a field, and hoped I could do something with this material. I had known of painters who had used photographs as a basis for painting — why couldn't a photographer use an amateur's print and make something new of it? I thought seriously about this and would work on the idea when I got back to my darkroom. Anyhow, I used his camera and exposed the film it contained. My mind was working, however; there was a roll of tape in my outfit which gave me another idea. Removing my glasses I taped them to the front of my camera so that one of the lenses covered the opening, but in such a manner that only a small portion of the glass showed. Then, focusing on my subject through the ground glass, I saw quite a pleasing image. The lens was of sufficient focal length to make the head fair sized although not too sharp. The black focusing cloth dropped over the front of the camera served as a shutter, like the cap on an old-fashioned studio camera. I made a few exposures with Matisse patiently posing,

even suggesting that I use the collection of violins in a glass case as a background. All the shots turned out well; Matisse was very pleased with the prints I gave him, but he did not order any additional ones. However, the experience was very gratifying — I acquired confidence in my ability to cope with any adverse situation. Probably what I did was against all the rules of professional procedure, but this, too, gave me a certain satisfaction.

Matisse did send around his daughter to be photographed; this was definitely an order. When I brought the prints to him in his Paris studio I was kept waiting in a room for about half an hour — he was busy with a dealer or collector. Presently two men came through, each bearing a canvas under his arm, followed by the painter who greeted me with a smile excusing himself for keeping me so long — he was being dispossessed, he said. I thought I'd like to be robbed similarly; he was getting probably a thousand times what I would make with my photographs. He liked my work, gave me a substantial order, saying that now that his daughter was leaving him to get married, he'd have a something to replace her. I wondered whether the money he was getting for his paintings consoled him for being deprived of them.

Some years later, preparing the album of portraits for publication, I invited him to come to my studio for a new portrait which I wished to include. It should be more serious, more recent than my first attempt. As I finished the sitting, André Breton, founder of the Surrealist movement, appeared. I knew that Matisse was not in high favor with the Surrealists — after his first iconoclastic works he had degenerated, they thought, painted to please people and counted on his reputation to obtain high prices for his work. He had never gone beyond his postimpressionist period but became more decorative, eliminating all the element of shock that characterized his earlier works. An interesting dialogue followed in which Matisse assumed a didactic attitude defining what good painting meant to him. Among other remarks he declared that a hand should have some anatomical quality in a painting, not look like a bunch of bananas. Breton did not agree with him and did not

contradict him, who gave the impression that he was talking like a school teacher. I saw that the men could not even come to grips with one another, as if they were conversing in two different languages. For my part, I smiled inwardly — if any painter had painted hands as if they were bananas, it certainly was Matisse. And toes also. This had been one of his first breaches with the academy. Was the man trying to hoodwink us?

There had been writeups on him telling how he labored on his canvases, how he changed them or discarded them to begin anew. But what had impressed me on first seeing the works of Matisse was their spontaneity. They did not seem to suggest a labored effort, rather a direct brush stroke, based, to be sure, on a conviction resulting from long experience and meditation — as valid as the more scientific drawing of the old masters. Whatever the bases of their work, this had been the way of all painters who had finally completed recognition. All talk about difficulties and struggles had been for an audience accustomed to thinking (if ever it gave thought to the matter) and even demanding that the artist's life be one long painful struggle generally ending in martyrdom. To me the artist was that privileged being who could free himself from all social constraint — whose only objectives should be the pursuit of liberty and of pleasure. If the artist suffered and struggled, then he had not freed himself from the constraint. Or was the problem purely economic? As for those who struggled for recognition, this was in no way related to their work — in my opinion the most significant work should remain a closed book for a long period. To appreciate such a work one had to be as profound as the creator. True, some creators have been so profound that their intentions have never been fathomed. Only their superficial qualities have come to the surface. When Matisse left he expressed his pleasure in the exchange of views; he hadn't talked for years, he said. Left alone with me Breton expressed disdain for the man and his work.

I visited Matisse in his studio in Nice in the Thirties. The room was filled with bird cages and a continual chirping. He was beginning his series of paper cutouts, pasted on large sur-

faces, very decorative (which expression he would have resented, I am sure, if I had ventured it). Whether I liked them or not was immaterial — I considered that the man had made an important contribution to contemporary art.

The quiet, self-contained personality of Georges Braque was a relief from the more ostentatious and temperamental qualities of other artists. The studio I first visited, perched on the heights of Montmartre, was filled with his work, which gave one the impression that he had no other life but his work. Tall, wavy-haired, he moved leisurely, but it was hard to imagine him confined to an easel, rather that his activity must be more physical, that he had come into the studio for a short while to check on the progress of his work which was developing by itself as a plant grows. Or he might have been a Normandy farmer who, with a certain amount of guidance, let nature take its course. I knew some of his early Cubist work which at first glance was indistinguishable from that of Picasso, but which in time I was able to identify as easily as their faces, as an expert would handwriting. Although both may have been obsessed with the same idea, their personalities remained intact, branching out in different directions. Braque's work had now taken on a more arabesque character, while Picasso had launched into a pseudo-classical manner. The early cycle of Cubism had been completed, not abandoned; each painter now sought to renew himself, to give evidence of new enthusiasms. While Picasso's work became more uncompromising, more mystifying and provocative, Braque's painting was subtler, seeking new color harmonies. He might be considered the real classic of today's painting. It was for this reason that his work found less favor with the more advanced group of painters, wary of any new tendencies in the direction of pure aesthetics and good taste. However, since there was a legend that Braque had been the original founder of Cubism, he has been treated with the respect due the innovator of a movement.

I came to him with my camera and he posed for me in his shirtsleeves, as he stood in the doorway of his studio without any attempt to verify his appearance. The man had no vanity

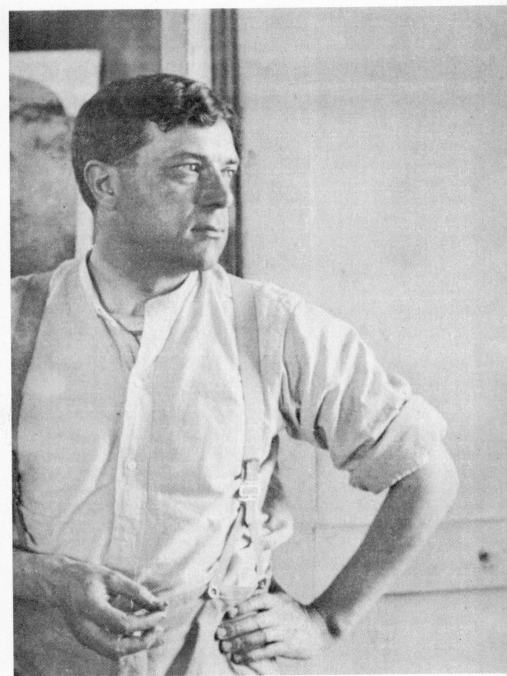

Georges Braque, Paris, 1922

nor self-consciousness. I assumed a similar nonchalant manner, made a couple of exposures, and thanked him, promising to show him the results in a few days. As a rule I had found men much more difficult subjects than women; whereas the latter were content with being made to look younger and prettier, the male was more exacting, expecting me to bring out qualities beyond the power of mere technical acrobatics, such as intelligence, authority, and a certain amount of sex-appeal. The conception of such attributes varied with each subject, making my task more difficult. Since they could be gauged only from the final results, it was too late to make any rectifications, even if I had known what to do about it. I lost a few possible friends by photographing them, but I lost some others because I had not invited them to sit for me.

As a rule, painters, musicians, writers, creators in general were pleased with my photographs, first because they were impressed with the magic of the medium wherein a few casual passes with the hands produced a miracle — whereas others, out of contact with the arts, preoccupied with their own vanity, whether they were anonymous businessmen or social lights like the Count Boni de Castellane, were disappoined with the results. The latter, however, did compliment me on the fine portrait of his little lap-dog on his knees. I wondered if the animal, if he had been able to voice his opinion, would also have rejected my work. I thought seriously at one time of specializing in animals and babies who could not be consulted on the merits of the pictures.

Braque was all praise for my portraits, ordered a number of prints. I refused to accept payment for them, which upset him. Then turning to the wall where a dozen small still-lifes were lined up, he asked me to choose one. It was my turn to be embarrassed, saying his acceptance of my work was sufficient recompense. He insisted so I chose one and left with the feeling of having gotten the best of the bargain. In the succeeding years, I saw Braque often, and made other portraits of him, using his magnificent head as a subject for some of my researches into more unconventional portrait photography, such as what has been called solarization, a process of developing

by which the contours of the visage are accentuated by a black line as in a drawing. Althought it is a purely photographic process, I was accused of retouching and tampering with the negatives. Nowadays it is common practice among amateurs who are fascinated by newer techniques, applying them indiscriminately whether they suit the subject or not. Whenever I deviated from orthodox practice it was simply because the subject demanded a new approach; I applied or invented techniques for emphasis of the points that seemed important. Only superficial critics could accuse me of trickiness; if ever I had any doubts of the value of my departure from the norm, such criticism convinced me that what I was doing was valid, that I was on the right track. Many so-called tricks of today become the truths of tomorrow. Besides, trickery is often the result of hard work.

André Derain, the painter, was entirely different from his contemporaries. Large and heavy, he sat at the bar of the Coupole consuming innumerable glasses of beer. His conversation was brilliant, tough and pungent. Once in a rage, whether drunk or provoked by another customer, he became violent — everyone fled and he proceeded to wreck the bar smashing glasses and mirrors. The next day he apologized and paid for the damage. In the early years of the century, he had been associated with the pioneers of the Fauvist and Cubist movements, but later returned to a more lyrical painting of landscapes, portraits and nudes. To me these seemed rather perfunctory, as if he had lost interest in painting, at least in the projection of any new idea, and was content to follow a lifetime habit of applying brushes to canvas, with the least possible effort. However, he had a following among collectors and dealers, who saw boldness, simplicity and volume in his work. He had also been one of the first to call attention to the beauties of primitive African art.

When I first became acquainted with him he had developed an absorbing hobby. Sitting at the bar with me one day, he asked me to step outside to see something. At the curb stood a

long low racing car, pale blue in color, with a small bit of windshield in front of the steering wheel; this was placed below the center of the dashboard in front of a large bucket seat, also centered. It looked like a custom-built job for him alone. The wheels had flat aluminum spokes, with trucklike tires, a forerunner of modern racing cars. Derain then lifted the hood, disclosing a long eight-cylinder aluminum block, ridiculously simple in appearance. More beautiful than any work of art, he commented. I agreed with him, but thought that without the sale of his paintings he would not have been able to afford such a monster. I was interested in cars myself, having acquired a small but fast sports car which I drove at seventy m.p.h. I expressed a desire to see Derain behind the wheel, and take some photographs of him in the car, and he invited me to lunch in the country the next day.

I climbed into an opening behind his seat and we were off with a tremendous noise from the exhaust pipes. Once out of the city limits, he pushed the pedal down; soon the speedometer was marking 110 m.p.h. The wind tried to take my head off; I leaned forward close to his broad back, saw nothing and was shaken like dice in a cup.

In about half an hour we arrived at Fontainebleau, had a copious lunch with a fine bottle of wine at a famed gastronomic inn, and drove leisurely back to Paris. On the way I asked him to stop and made some snapshots of the car with him at the wheel. When I came to his studio with the prints he said he was very much interested in photography and thought it could be a great help to painters. He then produced some photographs of nudes saying he studied them before starting a painting. Would I make some nudes of a model who was posing for him at the time? The prints he showed me were rather ungraceful postures of a squat figure. I said that photographing a nude was the hardest work, in fact, the more beautiful the model the more difficult it was to make something that did her justice. He did not want anything artistic, he said, just a documentary which could guide him, not something to copy. Some painters of the nineteenth century, Degas, Toulouse-

Lautrec, had had photographs made to study character and movement at their leisure. It had helped them also in making more informal compositions.

I told Derain to send around his model. The most distinguishing quality about her was that she was a female and very loquacious. She confided to me that Derain had an original way of working: she had to sit on his knee. With his left hand around her waist, he painted with the right — he had to feel his subject as well as see her. I photographed her mechanically — photography, after all, is nine tenths mechanics and requires closer calculation than to paint and the result is more "retinean," as Duchamp would say. Color can produce sensuousness and sensuality more directly than a black and white art. If these were erotic writings one would still need to conjure colored images in the mind to obtain the same effect that a painting of a nude produces directly. Never have I felt this as strongly as at a recent exhibition of nudes by Ingres. Chaste as they appear to us today, there was a time when they were censored.

Derain came to pose for a serious portrait of himself for my book. He told me to come to the studio and pick up a small painting he had set aside for me, but somehow I never got around to it, to my regret. He had a project for a film, and asked me to help him. There were to be nothing but closeups of heads to tell the story. After engaging a technician to help us solve certain problems, I tried to explain that there would be departures from the usual methods of shooting and even developing the film. Derain gave me a free hand to apply any of my methods I had been using in photography. He would simply make a working script and help with obtaining from the actors the dramatic facial expressions that would tell the story. The expert, after endless discussions, did not approve of our project. I reminded him that he had been engaged purely as a technical adviser. He ended up by saying that what we wanted to do was impossible. I might have been able to handle the work myself in the days of the silent movies, when I had made some short films using my own ideas and technique. Then it was still possible to make a film as a one-man job, but

with the addition of new techniques it was necessary to have collaboration. The idea of getting involved in a lot of hard work discouraged me, too; unless it could be effortless and a pleasure, as making a painting or a photograph had become for me, I would not engage myself in the making of a film. Inwardly, I resented the idea of doing any work even with only one other person. In the pursuit of pleasure, I was willing to collaborate with one other person.

Picasso gave me the impression of a man who was aware of all that was going on about him and in the world in general, a man who reacted violently to all impacts, but had only one outlet to express his feelings: painting. His short epigrammatic or enigmatic phrases which he let drop from time to time only emphasized his impatience with any other form of expression. And these words, almost exclusively concerned with painting, gave a clear indication, if one thought about it, of his philosophy and attitude to life.

My first meeting with him was for the purpose of photographing his recent works, in the early Twenties. As usual, when I had an extra plate, I made a portrait of the artist. It was nothing remarkable as a photograph, but showed the intense, intransigent look of the man, his black eyes sizing one up. He was a short stocky man, who never took any exercise, except that he liked to swim and walk with his dog. In town one could only see him right after lunch, before he took his walk — he avoided definite appointments as much as possible. He detested dates and fixed rendezvous. I was invited for lunch, and brought my camera to make some pictures of his Russian wife, Olga, the ex-ballet dancer, and his little son Paolo.

Later, when his domestic life broke up, he no longer worked in the apartment; it had been sealed off pending the divorce action until a settlement had been agreed upon. His lawyers were desperate as he made no effort to aid them in bringing about the legal separation. He did not paint for a couple of years, as any new works would have been attached during the proceedings. This was a great privation for him. He set himself

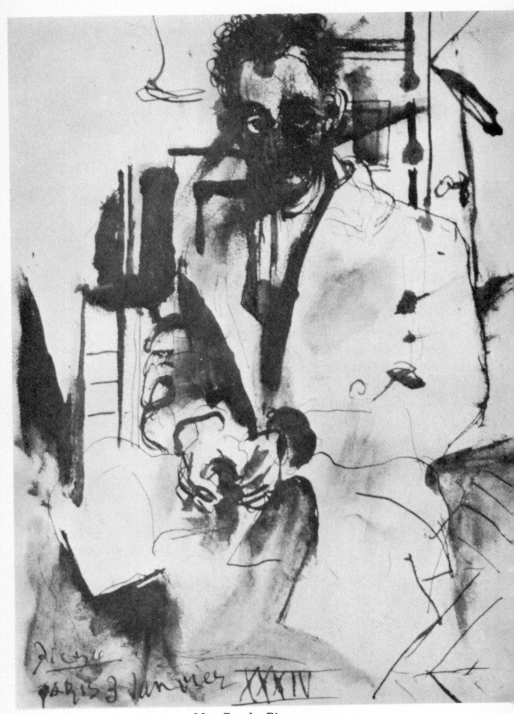

Man Ray by Picasso, 1934

to writing, covering pages with a passionate flow of incoherent phrases in Spanish and in a sprawling calligraphy that resembled his drawing. Like anything else he did, this was immediately reproduced in an art magazine, together with one of my latest portraits of him. When the editor of a smart American magazine wished to reproduce some of the manuscript, at any price, he refused. I was asked to intercede and he relented on condition that my portrait be included, for which I was to receive a handsome payment — he wanted no money. In due time my portrait of him appeared, but no manuscript. Upon inquiry, I was told that a translation had been made for English readers, but that it was so full of obscenities that it could not be printed.

Picasso promised to do a drawing of me for my forthcoming album of photographs. I came to sit for him in a room without any heat — it was in January — and I kept my overcoat on. He squatted down on a small stool with a quart bottle of ink on the floor beside him and a pad on his knees. Dipping his pen in the ink, regardless of the blackening of his fingers, he began scratching the paper. He worked away for half an hour or so, clumsily, like a student who was drawing for the first time. Knowing how quickly and surely he could work, I was rather surprised. He put down the pad and pen, and rising, proceeded to roll a cigarette, telling me to relax. When he resumed his work, he continued in the same uncertain manner, sometimes grumbling softly. He put a finger to his tongue and rubbed the drawing with it, repeating the operation. Presently, his fingers, lips and tongue were black with ink — he made a final dab and said that he did not know whether I could use the drawing — he didn't mind if I threw it away. I protested; said I would send it to the printer without looking at it — it was sufficient for me that he had signed the work — if he saw no objection to its reproduction, neither did I. The drawing was a mess from any academic standards — he could draw beautifully with a single line — but I liked the idea that he had struggled with this one — besides, it had much of me in it, standing there in my overcoat — a good deal of me — any unpracticed eye could see that, especially an unpracticed eye could see it. I used the draw-

ing in my book as a frontispiece with the same uncritical acceptance that Picasso showed towards my work and person; I thought, one does not question a signature on a check if the signer has a bank account — nor does one question the reputation of Picasso. Years later, when I was short of funds and sold the drawing to a collector, I'm sure he bought it because of the signature, or, I hoped, because it was me.

I knew Dora Maar in the Thirties, a beautiful girl and an accomplished photographer, some of whose work showed originality and a Surrealist approach. Picasso fell in love with her. One day in my studio he saw a portrait I had made of her and begged to have the print, saying he would give me something in exchange. I was pleased with his interest, gave him the print and forgot about the episode until a month later when he appeared in my studio with a roll under his arm. It was one of the first prints of his large etching, *Tauromachie*, bearing a personal inscription to me. Picasso never forgot anything.

He was now working in a large loft, in an old convent near the Seine. The war in Spain was at its climax. When news of the bombing of the town of Guernica reached us, he was completely upset. Until then, and since the First World War, he had never reacted so violently to world or outside affairs. He ordered a large canvas and began painting his version of Guernica. He worked feverishly every day, using only black, white and gray values — he was too angry to bother with the niceties of color nor with any problems of harmony and composition — painting out a portion he had done the previous day, not to improve it but to express another idea that had come to him — he was working on only one canvas. After he had expended his rage and stopped working on the canvas, he continued to make brutal drawings of women's heads weeping and heads of animals in their death agony. Years later when the canvas hung in a museum, it pained me to see an art instructor lecturing her pupils before the Guernica, calmly explaining how this vertical balanced that horizontal. And the drawings were exhibited as studies for the larger canvas, when in fact the sequence had been reversed. Picasso followed no accepted rules.

The three years preceding the last war, we gathered every summer on the beaches in the South of France, a happy family: I with my friend Adrienne, Paul Eluard the poet, with his wife Nusch, Roland Penrose with his wife to be, Lee Miller, and Picasso with Dora Maar and his Afghan, Kasbeck. We all stayed at a pension hotel, the Vast Horizon, back in the country in Mougins, above Antibes, lunching and dining on the grapevine sheltered pergola. After a morning on the beach and a leisurely lunch, we retired to our respective rooms for a siesta and perhaps love-making. But we worked, too. In the evening Eluard read us his latest poem, Picasso showed us his starry-eyed portrait of Dora, while I was engaged in a series of literal and extravagant drawings, to appear later in a book illustrated with the poems of Paul Eluard — *Les Mains Libres*. As for Dora, having photographed Picasso at work on his Guernica in Paris, she now abandoned her camera and turned to painting, contrary to what some biographer of Picasso has written: that a painter having seen Picasso's work, threw away his brushes and took up photography.

Drawing and painting for me were a relief from my photography, but I had no intention of substitution. It irked me when I was asked, according to my activity at the moment, whether I had given up the one for the other. There was no conflict between the two — why couldn't people accept the idea that one might engage in two activities in his lifetime, alternately or simultaneously? The implication, no doubt, was that photography was not on a level with painting — it was not art. This has been a moot question since the invention of photography, in which I had never been interested, and to avoid discussion, I had declared flatly that photography is not art, publishing a pamphlet with this statement as the title, to the dismay and reprobation of photographers. When asked more recently if I still held to my opinion, I declared that I had revised my attitude somewhat: for me, art is not photography.

I did not like to paint outside of my studio, so I acquired a permanent apartment with a terrace in Antibes, where I could retire to paint, whenever I could get away from my photographic work in Paris. Our idyllic meetings in the summer con-

tinued, but not for long; war clouds were gathering. Mussolini was getting obstreperous, threatening to invade the South of France and recover it as Italy's rightful territory. Then came the truce in Munich which put off war for a year. Besides, I had acquired a little house in the country near Paris, as I was neglecting my work with my absences from the studio. With the future so uncertain, I abandoned the idea of spending a good part of my time in the south. When I told Picasso of my plans, he offered to take over my flat in Antibes. I transferred my lease to him, and packed up some of my personal belongings, including paints and canvases. A composition of creased and folded papers, corks and bits of string hung on the wall, which I was about to remove, when he asked me to leave it, if I liked — he liked it. Decidedly, I thought, nothing I did was ever wasted — there was always at least one person in the world who was interested in it. To preserve a record of the said composition, before leaving I made a literal copy of it in oils, and called it *Trompe-l'Oeil.*

A few days later, with Picasso installed in the flat — I had taken a room in a hotel — I paid him a farewell visit. He was already at work. All the furniture had been moved out of the main room. Covering the largest wall, a canvas had been tacked up, and divided into about twenty squares, like a chessboard, on each of which he was painting a still-life, variations on one theme. During my visit his dealer from Paris appeared, to arrange for the next show in Paris. He looked at the still-lifes, but also glanced at the paint cans with a brush in each one, paints evidently bought at the nearest paint shop. Finally, he asked whether the paints were permanent. Picasso shrugged his shoulders saying he was not concerned with such matters — that was exclusively the affair of collectors and investors. This was not a pose; I had seen Picasso buy up the whole stock of the finest, most expensive colors in an art material shop. It was merely a question of availability, of not wasting time when the desire to paint possessed him.

Again this question of permanence: what a disillusionment my first view of some of the old masters had been. Whether it was a Rembrandt blackened with repeated varnishings, or a

Turner from which all the original flamboyant colors had faded or been removed by more or less careful restoration, leaving nothing but a shiny canvas in its frame to speculate on or with, permanence could only be a question of the painter's intention originally. I had made, as I suppose others have also made, preliminary sketches on which, instead of painting the colors, I simply wrote their appropriate names, in their respective areas. Words, phrases and dates had been incorporated in some of the old masters' works, as part of the painting, and the Cubists had introduced bits of newspaper, a torn label from a package of tobacco, or an irrelevant word as part of their compositions. I, myself, in the early days, had used words and figures as integral subjects for a painting, as one would use apples for a still-life. Of course, in present times the purpose was not to identify the subject, as some imagined, but to extend the boundaries of subject matter. Picasso, Max Ernst, Miro, Magritte, to mention a few, have felt this urge. Perhaps this is a new way of assuring permanence. Nothing can destroy the word — it will always remain on record, just as a book cannot be destroyed by burning it. To be sure, no one has found a way of duplicating a painting as a book or a bronze sculpture can be duplicated, unless he be a consummate copyist — it might knock the bottom out of the picture market, as the fabrication of diamonds would destroy their rarity and value. Painters have repeated certain of their most popular works, but the differences are easily discerned. There will always be a premium on the original, if it can be identified.

I did not see Picasso again until after my return to France in the Fifties. He had remained in the south and I was occupied with my affairs in Paris, when France was invaded, and I returned to the States. Fifteen years later, I visited him in his new villa near Cannes. When I phoned him on the morning of my arrival, he asked me to come up immediately as he had to leave for Nice where a film was being shot of him at work. I climbed up the hill to his place, and pulled the bell cord at the gate. We embraced affectionately and felt as if we'd seen each other recently. Nothing was changed. It was a huge house, built by some successful and pretentious champagne dealer.

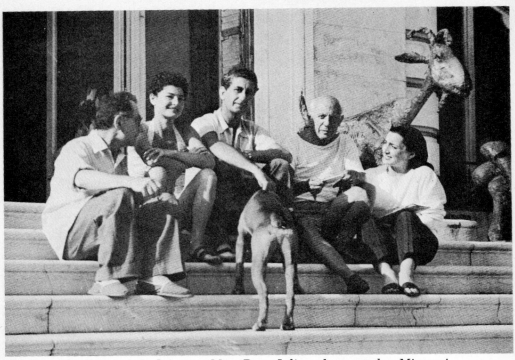

Cannes, 1956. *L. to r.:* Man Ray, Juliet, the matador Minouni,
Picasso, Jacqueline

The garden, carefully tended, was studded with Picasso's most
provocative bronzes which seemed to mock the baroque in-
tentions of the original owner. Inside the house, everything
had been painted white, making all the decoration invisible.
Unopened cases stood around, and canvases were turned to
the wall on which one unframed work hung casually: a por-
trait of his present wife, Jacqueline. Near the door giving on
the garden was an old sofa, in the middle of the room a bent
wood rocking-chair — the only seating available. On a large
table was piled pell-mell a collection of African sculptures.
Reaching into this charnel house of primitive art, Picasso pro-
duced a small gilt frame with a pastel of a reclining nude, ask-
ing me if I remembered it. I did not. He said I'd left it in the
flat in Antibes which I had handed over to him before the war.
The pastel was something I had made in an off moment, at-
taching no importance to it. Decidedly, Picasso never forgot
anything. (At this point, I suppose it would be good form on
my part to apologize for any seeming immodesty. However, I

must remember that I am doing a self-portrait and all self-portraits, except a few by expressionistic painters, have been self-flattering.)

During our short stay in Cannes, Picasso asked me and my wife Juliet to dinner. After a simple meal, without any fancy trimmings, he produced a bottle of vodka and some bottles of champagne. He never drank himself, but took a glass of champagne to celebrate the occasion, while Juliet concentrated on the vodka. Maya, his teen-age blond daughter by a previous mistress, put a dance record on the phonograph. Presently, Juliet began a solo dance, mimicking and clowning a serious ballet dancer. Picasso, leaning back in his chair in silent contemplation, reminded me of one of his early etchings showing King Herod watching Salomé dance. We spent another afternoon with him on the steps in his garden. There was Maya again and an old friend — a retired bull-fighter. I made snapshots of the group and we returned to Paris. Picasso does not come up to Paris any more.

I saw him again on one of my recent trips south — at a bull-fight in Vallauris, staged in his honor. We shook hands — he was surrounded by officials and photographers, but his penetrating gaze seemed to say, Until we meet again — in more intimate surroundings. The man does not seem to grow older; time can wait until we do meet again. Unlike many others who approached him — and he has been generous with others — I have never asked a favor of him, nor he of me, and if there was any suspicion of a service rendered, one or the other would reciprocate to annul the debt. Pride on my part, perhaps, great humility on the part of Picasso.

Not since my youth when I went to school or when I worked for a single employer, have I looked forward to vacation days. When I became my own employer, so to speak, it seemed to me I was always on vacation. Nor have I sought a new setting to refresh my thoughts. When I do go away, it is for a long period, a matter of necessity, or for something already in hand that demands attention elsewhere, or for a rendezvous, or to pick up some old familiar threads. And so, this August of 1961, I

am sitting at Meliton's café in Cadaquès, Spain, with my oldest friend, Marcel Duchamp, who first came to my shack in New Jersey in 1915. My mail, which I have just collected from the post office, lies on the table in front of me. On top of the little pile of letters is a book of poems by my not-so-old friend, Georges Hugnet. Its title is — *1961*. Upside down as seen from my seat it still reads *1961*. As Hugnet points out, it will not be possible to read a date upside down until 6009. However, we are concerned with the present, a form of eternity — at the moment, time seems to be marking time. Glancing through the book, I stop at a phrase; in France, the income tax man assesses one by what he calls exterior signs of wealth, a car, a maid, a house in the country. Hugnet says, *his* signs of wealth are all interior.

To no one could this apply more fittingly than to Marcel Duchamp. He owns nothing, collects nothing; a book given him is immediately passed on after he has skimmed through it. His few works are mostly in one private collection or in a couple of museums. Since he gave up painting forty years ago, one might say his principal activity is chess because his mind is alert and chess leaves no material traces of the most intense mental activity. And this has been his program. The competitive element of chess interests him less than its analytical and inventive aspects.

After my first installation in France and Duchamp's return to New York, I did not see him again for two years. When he returned, we renewed contact. It was the last year of the Dadaists' manifestations, involving new dissidences among the group, and the final break, leading into the Surrealist movement. Although held in a certain esteem by these groups, he was too little known; he never took part in their activities, nor frequented the cafés where their reunions were held. His earlier works were unknown in France — they had been sent to the States. As with Brancusi, only a few close friends were aware of his importance in contemporary art.

In 1923 Duchamp came back quietly, unheralded, to Paris for a prolonged stay. He was less of an expatriate from France than I from the States. I was now definitely established as a

photographer, but produced a painting now and then to keep myself in form and also in touch with the current art movements. Thus it was that I set about to do a portrait of him in oils, but, influenced by the many photographic portraits I had made of him, the work was in black and sepia, mimicking a photograph. I had him pose for me once or twice to verify some details in his features. I introduced some imagined motives in the black background so that the painting was not too factual. It was neither a painting nor a photograph; the confusion pleased me and I thought this should be the direction my future painting would take.

During his three years' stay in Paris this time, although he had forsworn painting, Duchamp did not remain inactive. Chess occupied him more and more; he spent much time studying the game and frequenting the chess world. I remained a third-rate player — a wood pusher, as he said: my interest was directed towards designing new forms for chess pieces, of not much interest to players but to me a fertile field for invention. Duchamp was sympathetic, having himself begun some projects in this direction, but abandoning them as his preoccupation with the game itself increased. One day he brought in Alekhine, then the world champion, to be photographed and to see my designs. The champion was interested, posed with my pieces before him and agreed to allow us to call them the Alekhine set if put into production. We had high hopes that it would supersede the present Staunton set in use, already an improvement on previous pieces. However, after inquiries and estimates, we found that a large capital was necessary to make molds, and with the uncertainty of a market, we abandoned the idea. I continued making individual sets for collectors and amateurs who could pay. At an exhibition where my set was shown, a visiting chess expert on seeing my pieces observed that he could see the advantage of playing blindfold.

Duchamp took a room in a small hotel next door to my studio, and came in frequently with various projects. Among these was a variation on the optical machine he had made in New York before 1920, but instead of setting flat plates of

glass behind one another to create a three-dimensional effect when revolving, he now mounted a hemisphere of black and white spirals framed in glass and copper bearing an onomato-poetic inscription, the whole mounted on a support with motor and 'rheostat to turn slowly. It was more effective than the first conception and the danger of its flying off its base was reduced. Besides, it could be viewed by several spectators in front — did not require to be seen from a fixed point by one person at a time. The meticulous application of Duchamp in the realization of this contraption fascinated me — it was not any love of mechanics on his part, but it was necessary to master the material to make his desires concrete. It seemed to me that he was working in an opposite direction to the scientists with their grandiose ideas which have their origin in atoms and molecules. Duchamp seemed to be trying to reduce all human striving to a self-sufficient entity — something that cannot and need not be justified.

He might have taken advantage of the legend that surrounded him; tried to do something in the art world that would have brought him comfortable material returns, but he avoided this with persistence. I was having dinner one night with a retired broker and the old art dealer Knoedler who expressed regret that Duchamp did not paint any more. The dealer appealed to me, asked me as his friend to speak to him and say that there was ten thousand dollars a year at his disposal if he would return to painting — all he need do was to paint one picture a year. When I broached the offer to Duchamp he smiled and said that he had accomplished what he had set out to do and did not care to repeat himself. Behind this refusal was, of course, an aversion to the trafficking of the art world, as well as the conviction that what he would produce would be something incomprehensible to the average mind, especially that of an art dealer. At least, this was my interpretation, based on my own experiences. Duchamp may have been very sensitive to adverse criticism, and he certainly had a profound contempt for others' opinions of his work. He could be more tolerant of a certain snobbism on the part of those who

professed to understand him. On the rare occasions when he did express some ideas on art, it was in the most impersonal manner as if he himself were not involved. Pride and humility went hand in hand.

Having finished his optical machine which stood in my studio covered with a cloth until an old friend offered to store it and possibly show it to a prospective collector, Duchamp now turned his attention to a different problem. In some of his previous creations the unknown and mysterious laws of chance and hazard had been the starting point. He wished to probe these more deeply — to master them so that the results of a premeditated action could be foreseen, controlled. And so he took up roulette. He studied the monthly sheets of all the numbers that came up, published by Monte Carlo, and worked out a system of placing his money that would infallibly bring in a return profit. But, to put his project into practice, capital was needed. He obtained a loan of about six hundred dollars from various friends, guaranteed by an issue of thirty bonds at twenty dollars, the form of which he designed. It was a lithograph of a green roulette table, bearing a red-and-black roulette wheel with its numbers, in the center of which was a portrait of himself. But this portrait, which I made for him, was taken while his hair and face were in a white lather during a shave and shampoo. Otherwise, the bond looked quite professional with complicated engraving and script, as well as interest-bearing tabs to be paid periodically. Armed with his capital, he installed himself in Monte Carlo and went regularly to the casino where he played his system carefully and according to plan. He won small sums, but never enough to reimburse his backers; for this a much larger capital was necessary. And the long, tiring seances in the stuffy casino were exhausting. The game wasn't worth the effort. Duchamp returned to Paris, satisfied that he had conquered the laws of chance. Nothing was said about payment to the investors, but the bonds are now collectors' items, very rare, and worth much more than the original investment. I have been offered two hundred dollars for my bond, but I treasure it enough not to

part with it. I consider it one of the best investments I have ever made. One thousand per cent profit. Only the most improbable luck at roulette could match this.

Our activities during this period were not limited only to these more or less intellectual occupations. Personal and sentimental factors ran a parallel current so that there was not a moment's lull in our lives. I had my hands full with Kiki of Montparnasse. There was a charming young widow of World War I who fell in love with Duchamp, and with his usual sang-froid and amiability he accepted the homage. About this time, the death of his old parents had left him a small legacy which enabled him to install himself comfortably. He rented a small studio on the seventh floor of an old building in an unfrequented quarter of Paris. There was a door in an angle that closed off the studio opening on his sleeping quarters, or closed off the bedroom opening on the studio, which proved that a door could be open and closed at the same time, demonstrating the fallacy of the old French adage that a door was either open or shut. Here Duchamp worked and slept in an atmosphere of austerity like a monk. There was no accessory that might indicate the penchants of an artist — the chess table was the principal piece of furniture.

We met often for lunch or at Mary Reynolds', the widow, for dinner. She was a sort of fairy godmother, receiving all who came to her, both of the French and American intellectual colonies. She was imposed on a good deal and solicited for aid. She worshiped Duchamp, but understood that he was determined to live alone. Mary and I were great frequenters of the night clubs at the time, she to fill in the times when she could not be with Duchamp, I for social and more practical reasons — for contacts. Duchamp seldom visited such places, just as he never went to an art exhibition. Mary, tall, slender and distinguished-looking, was very popular with the French, also because she was American, gullible and accommodating.

One day he confided to me that he had met a very nice young person, daughter of a well-known manufacturer of automobiles, and was going to marry her. Could he bring her around to be photographed? I could not help thinking this was

one of his self-contradictions — I could not imagine him married. I photographed Lydie, a buxom girl with pink and white skin. The date was set for the marriage; following the wishes of the family it was to take place in a church. It was suggested that I film the ceremony, or at least the arrival of the bride and groom. With my assistant we set up the camera in front of the church, ready to shoot. When the car arrived with the bridal couple, a voluminous form in white veils, like a cloud, stepped out, followed by Duchamp in striped trousers and cutaway. He looked spare and gaunt beside her. We cranked away, surrounded by a crowd who wondered who the notables were. Shortly after, the couple left for the South of France on their honeymoon. I had it from Picabia afterwards that things did not run too smoothly. After dinner, Duchamp would take the bus to Nice to play at a chess circle and return late with Lydie lying awake waiting for him. Even so, he did not go to bed immediately, but set up the chess pieces to study the position of a game he had been playing. First thing in the morning when he arose, he went to the chessboard to make a move he had thought out during the night. But the piece could not be moved — during the night Lydie had arisen and glued down all the pieces. When they returned to Paris, Duchamp told me that there was no change in his way of living; he kept his studio and slept there, while Lydie stayed with her family until they could find a suitable apartment. One night I was sitting at the bar of the Boeuf sur le Toit drinking my whisky; Mary Reynolds came in. She was desperate and began drinking heavily. A few months later Duchamp and Lydie divorced, and he returned to the States.

During this period there had been other diversions. Two events particularly impressed themselves on me. One was a trip to Rouen, Normandy, where Duchamp had been brought up. I went with him to see the house he had lived in, then walking down a street I was assailed by a most delicious odor of chocolate. Coming up to a confectioner's shop I saw in the window three steel cylinders turning in a tray grinding a huge mass of sticky chocolate. I thought at once of Duchamp's painting, the Chocolate Grinder; in effect, during his boyhood

he had passed the shop every morning on his way to school and had later used the forms as a subject for his painting. And it was still there — the picture might have been called Perpetual Motion.

During the Twenties Picabia had been commissioned to do a ballet for the Swedish Ballet Company, a rival of the Russian ballet, but more modern in spirit. Picabia had a free hand, could introduce all the fantasy he pleased. At one moment of the production the theater was in complete darkness, then a few flashes gave one the impression that he saw a living tableau of Adam and Eve in the garden of Eden, like a painting by Grünewald. It was Duchamp with a beard, in the nude, faced by a seductive Eve also completely nude, impersonated by a beautiful girl, the whole against a drop on which was painted a tree with a serpent twined around it. It was a strip-*tease* in the most literal sense — one would have liked to see a more prolonged vision of the tableau. I did, however, having photographed the scene at a rehearsal. During the ballet, I sat at one end of the stage like the property man in a Chinese play, but doing nothing, saying nothing, acting out Picabia's name for me: the silent one. Between the two acts, a film titled *Intermission,* also improvised by Picabia, was presented. This had been shot in studios and in the open air. In one scene Duchamp and I play a game of chess on the edge of the roof of the theater — a hose is directed upon us scattering the pieces and wetting us. The musical score was by Erik Satie, full of cacophonies and whimsicality.

Duchamp returned to Paris in the early Thirties for a much longer stay — taking up his abode in the studio he had kept. Mary Reynolds had a little house with a garden in a quiet part of Paris; she kept open house as usual and many evenings were spent sitting around in the garden with others who had been invited to dinner. Duchamp took an interest in fixing up the place, papering the walls of a room with maps and putting up curtains made of closely hung strings, all of which was carried out in his usual meticulous manner, without regard to the amount of work it involved. Mary took up bookbinding and he designed some original bindings for her collection of first edi-

tions, given her by English and French writers. He was solicited more and more by the Surrealists to aid in the organizing of exhibitions. When they opened a new gallery he designed the entrance consisting of a large pane of glass in which the silhouette of a couple was cut out, through which one had to pass to enter the gallery. This preoccupation with string and glass recurred time and again in many of his ideas. It may have been an effort to obtain transparency-invisibility. In the meantime he began assembling all documents pertaining to his earlier work, publishing them in facsimile in limited editions. (He composed also a book on chess dealing with problems of end games — of little interest to chess players, who foreseeing the end, generally resigned before this stage.) As much preliminary work as possible he did himself; preparation of photographs, diagrams and text, to reduce the cost of printing. He accumulated the individual sheets until the work was ready for publication, then had them bound or simply boxed the loose sheets, designing the covers and executing them by hand. He knew that no publisher would risk his capital in the production of such esoteric works, and he made little effort to secure backing. His object through the years was not to get money for his projects but to spend as little as possible. Subscriptions from friends and admirers were sufficient to cover the actual amounts invested.

Although accustomed to any inconsistencies in his life, I was intrigued by this preoccupation with putting his earlier work on record, making it permanent in the form of publication. He had foreseen that most of his work on glass would be broken, as it was, but spent much time piecing it together again. For many years, his other paintings were in a private collection, accessible to few, as he desired it. However, it was part of his renunciation of painting itself. And I realized that the time he spent in reconstituting his documents, time that might have been spent in the creation of new works, was proof of his determination not to continue to paint. Now and then he did produce a small object or, upon solicitation, a design for a publication of the Surrealists, but it was always in an anti-art spirit, in the manner of the old Dada days. When plans for

the big Surrealist show in Paris, 1938, were laid, he was invited to suggest ideas for its installation. This was in one of the smartest galleries in Paris. The red carpet and period furniture were removed. The daylight ceiling was blocked out with several hundred coal bags, stuffed with some lighter and less inflammable material than coal (recommendation of the insurance people). Sixteen nude mannequins — the kind used in window displays — were rented; each exhibiting painter was given one to dress up or modify as he pleased. We each outdid one another with bird cages, roosters' heads, etc. for headgear; veils, cotton wadding and kitchen utensils for clothes; I left mine nude with glass tears on the face and glass soap-bubbles in the hair, but Duchamp simply took off his coat and hat, putting it on his figure as if it were a coat rack. It was the least conspicuous of the mannequins, but most significant of his desire not to attract too much attention.

During the Thirties, Duchamp made several trips back and forth between Paris and New York — in the latter place he was repairing the broken glass, still in the possession of Miss Dreier, which afterwards was finally installed in the Philadelphia Museum. The last years before the war found him in Paris. I did not see so much of him; my reputation as a photographer was attracting advertising agencies and fashion magazines who gave me a great deal of work which involved travel in Europe and to New York. We were together in the summer of 1933 in Barcelona and Cadaqués, Spain, for a short while, seeing Dali in a fisherman's cottage nearby. Another summer, in the South of France where Mary Reynolds had taken a house in Villefranche. When war came and after the German occupation, I returned to the States, settling in California. Duchamp got out some time later settling in New York. France being arbitrarily divided into occupied and nonoccupied territory. Duchamp had traveled from one zone to another with his valise, as a cheese merchant, transporting the pages of his forthcoming reproductions of his work, culminating finally in the work called *Valise*, a limited edition published by himself. It was another desire on his part to be free of all outside contingencies in the pursuit of his ideas. His work, while not as world-

shaking as war, certainly has outlived the latter. The survival of inanimate objects, of works of art through great upheavals is one of my consolations. My justification, if need be. We do not know what significant works have been destroyed through the ages — we think those that have been spared are fully representative of their period. Suffice that a sketch made by a master five hundred years ago remains a greater source of inspiration than all the so-called progress produced by history and science. Fortunately, what we do not know we do not miss. And, fortunately, there is no progress in art — in the by-paths of human endeavor there is endless variety.

During these war years Duchamp was busy consolidating his earlier work, working with his collector Arensberg to assure a permanent home for it, accessible to any who cared to investigate it. While the old masters may have been concerned with the permanence of their individual works, Duchamp was concerned with the permanence of his ideas.

I happened to be in New York when the Germans surrendered; Duchamp and I met with André Breton, also an exile during the war. We went from restaurant to restaurant, everything was jammed, people were celebrating — we finally ended up at the old German restaurant, Lüchow's, on Fourteenth Street. This, too, was crowded — with Germans, subdued and weeping. The pianist played German tunes, all stood up reverently, but we had a table and remained seated. We managed to get served with Breton railing against the cooking — he always railed at any cooking but French. Anyhow, the Germans had produced some fine musicians, even some great chess players, I thought. I looked at Duchamp. His attitude was non-committal.

In 1951 when I returned to Paris, Duchamp remained in America, became a United States citizen and married. In the past few years he has been coming to Cadaqués for the summer and I have joined him a couple of times. We play a game of chess once in a while, but it is more a lesson for me — he points out my errors and lack of concentration. If I had given as much time to perfect myself in chess as I had devoted to my photography, I might have become a fair player. Duchamp is

a wonderful teacher — he gave chess lessons to earn money and he taught his wife Teeny to play. She is now one of the strong players among the women — beats me, which is fair play — I who have beaten women in other domains.

As we sit at the café in Cadaquès this summer of 1961, I look back upon a friendship that has not wavered since Duchamp first came to my shack in New Jersey in 1915. We are old men as far as years and vitality go, but we have our glass of manzanilla or Pernod before us while we watch and comment on the young women bronzed and almost nude in their bikinis, on their way to the beach. Even the little eight-year-olds wear a brassière on their flat chests. This combination of prudery and nudism sets us thinking of the reticences of earlier days, women with their boyishly bobbed hair and flattened chests. We also think of the naked women we have held in our arms. We speculate on the future — perhaps nudism will be integrated on the beaches and no one will bat an eyelash.

Being a spectator has its compensations: no risks nor disillusionments. After all, aren't artists and philosophers merely spectators? The world is full of busy bees, but there are also the drones for whom it can be said that they are likely to do the least harm, make the fewest mistakes.

I like to think of the two old Chinese sages who have ceased all activity and proselytism, who speak as little as necessary between themselves. They do go down to the river bank every morning to catch a fish for their dinner. Sitting one morning alongside one another, silently holding their lines, one feels a tug on his and begins gently to pull in his line, evidently a large catch, with the other watching. Presently a beautiful girl's head appears above the water, expressing fright, but she is hooked and cannot get away. The fisherman motions reassuringly to her to come nearer, bends down and lifts her out of the water. A long tail covered with fish scales terminates the body. Taking the mermaid on his lap, the sage gently disengages the hook, while she docilely holds on to him. Then he lifts her and places her back in the water. Meanwhile, the other sage has been quietly watching the operation; after a minute, he utters one word: WHY? To which his companion,

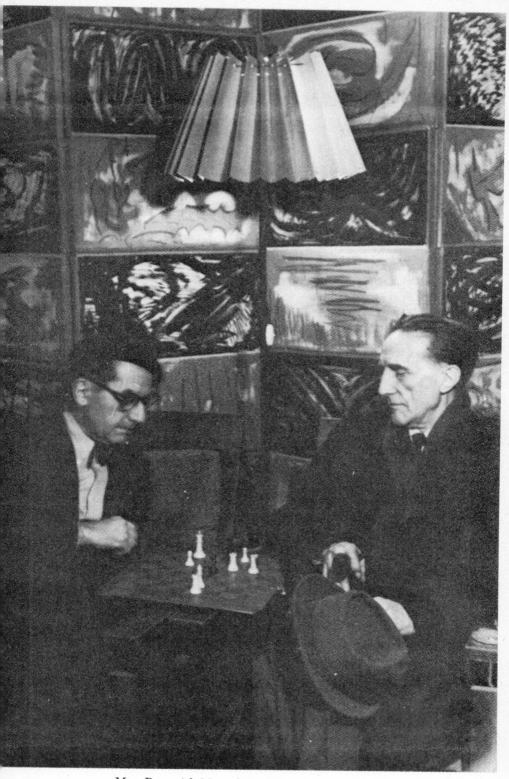

Man Ray with Marcel Duchamp, Paris, 1956

after a minute's reflection, replies: HOW? People are always asking *how* certain results are obtained, seldom *why*. The first query stems from the wish to do likewise, a feeling of necessity, a wish to emulate; the second wishes to understand the motive that has prompted the act — the desire behind it. If the desire is strong enough, it will find a way. In other words, inspiration, not information, is the force behind all creative acts.

Of the fifty other odd painters that passed through my studio during my first twenty years in Paris, I shall mention only those of my contemporaries with whom I had a more prolonged contact or with whom I associate some characteristic incident.

Jean Arp, one of the founders of the Dada movement in Europe, is a brilliant poet as well as a sensuous sculptor. Just before the war, when all Europe was on edge, he was having a show in London; on his arrival, he found the city plastered with posters bearing his name ARP, which impressed him no end until he discovered that the letters meant Air-Raid Protection, indicating the location of air-raid shelters.

Balthus, slightly precious, on the fringe of Surrealism, with a Lolita penchant as his mystical paintings of young girls indicated, reminded one of a Chopin, but his work breathed silence. A series of illustrations he made for *Wuthering Heights* had a Victorian quality.

Victor Brauner, of Rumanian origin, was at once accepted amongst us. His violent, irrational work at first purely Surrealistic afterwards drew its inspiration from Egyptian and other primitive sources, but the style is his own. There was a wild party one night in a studio where Oscar Dominguez, a painter from Teneriffe, who had joined the Surrealist group, became violent after too much drink and threw a bottle across the room, knocking out Brauner's eye. It was an accident — the handicapped painter did not hold too much of a grudge against his assailant but it did seem to affect the latter who continued to drink and engage in many other escapades in which he himself was the principal victim. The last time I saw him was a few days before his death. In a café, one night, very depressed

— his exhibition had been a flop, his love affairs had rendered life intolerable — he complained that whatever action he undertook resulted in harm to someone; he wished he could hurt himself first. The short periods he had spent in isolation in a sanatorium for disintoxication had produced no permanent results. I tried to console him, asked him to dinner for the following day but he did not show up, nor telephone, although he was very punctilious otherwise. Anyhow, we were to meet on New Year's Eve at our mutual friends, the Lyons', to celebrate. We waited for him throughout the night, his phone did not answer, and the next day he was found dead in his studio. Suicide. One more of the five or six of my friends who had taken this way out of an insoluble situation. Reflecting on this, I thought that perhaps if there was no solution, then there had been no problem — it was simply a matter of cause and effect. Just as night follows day.

One after another, the painters arrived in Paris to join the Surrealist group and were consecrated by my portraits. Giorgio de Chirico from Italy seemed to set the keynote with his early metaphysical works that were neither Cubist nor abstract, involving compositions of irrelevant objects precisely delineated. In time, relations with the group deteriorated, de Chirico changed his style to a more fluid, symbolical manner and disowned his earlier work which had already established itself on the picture market. Although the new paintings of horses with long flowing tails and manes had a certain success, they were not as much in demand as the works sponsored by the Surrealists. There was a rumor that he fabricated paintings of the first period for profit, which he denied; when confronted with them he said they were forgeries. If the accusation was true, the only forgery could be the date. Other painters had returned to earlier themes, myself as well, without incurring any disapproval. At one of his last exhibitions in Paris, with new subject matter, boycotted by the group, he explained to me that now he was painting for the man in the street. Standing in the doorway of the gallery, which opened on the street, he was alone; not a soul was inside and the passers-by did not even

glance at the painting in the window. I realized that his attitude was intended more to scoff at his former sponsors than to win a new public. Years later, in an exhibition of various periods of his work, the dealer called my attention to a still-life that might have been a Chardin and a self-portrait in an eighteenth-century costume, painted loosely like a Renoir. Pressed to give my opinion I observed that I did not understand them. In an estimate of various contemporary painters, Duchamp charitably remarked, referring to de Chirico's last manner, that posterity might have a word to say.

Soon after his arrival from Spain, Salvador Dali appeared in my studio, shoving a hundred-franc note in my hand asking me to pay the taxi outside — he was not familiar with the new currency. He was a slim young man with a timid little mustache like a penciled eyebrow but which later took on the more menacing proportions of a bull's horns. From then on, whenever we met, there was no small talk between us; he launched immediately into a voluble discourse on his latest preoccupations, limp watches, elongated spoons and skulls, this, no doubt, inspired by Holbein's painting of the Ambassadors, claiming that his manner of painting was a sort of color photography. He wished he could photograph his ideas instead and considered his own work as a form of anti-painting. His admiration of such meticulous painters as Vermeer and Meissonier (with such divergent ideas, however) indicated a genuine love of the medium itself. A Dali painting, on a wall behind a grand piano with a shaded lamp nearby, had all the qualities of an old master, if one did not look too closely for the subject matter. This contributed, no doubt, to its success. Hadn't the poet Eluard said that he spat upon those who admired the outward form of his poems, politely ignoring their subversive content? Perhaps a more or less classical technique was the best way of putting over otherwise unacceptable ideas. I never doubted Dali's integrity or sincerity. I cannot imagine a man devoting a lifetime of work to hoodwink a public for whose opinion he has no respect. If there is outrage, it is because the artist must needs outrage himself first — how could he know

in advance what would disturb others? If he succeeds, then he has identified himself with the spectator. One thing, he knew perfectly well that he would outrage the sensibilities of the Surrealists by his apology of fascism and later, by his adoption of religious themes, however unorthodox his virgins and crucifixions. Since he saw eye to eye with the group, it may have been a form of masochism on his part. And what greater triumph than to flout another Surrealist — to test the limit of his tolerance. It was simpler with the public — and more lucrative. I hold no brief against him if his extra-pictorial activities enabled him to sell his paintings. The world is full of unscrupulous businessmen publicizing more harmful products at much greater expense — I'd have to quarrel with the whole world. Working for advertising agencies and fashion editors, I was given to understand that they counted on me to help them sell the ephemeral products they sponsored. Teaching in an art school in California, I was often approached by pupils who asked me point-blank how one could become famous and successful. I advised them seriously to paint religious pictures — the critics would not be too hard on them, and the church was going in more and more for modern art and architecture. I knew a minister who bought Dalis — hung them in his private study where visitors were unlikely to see them. (I did not tell this to the pupils.) Even some of the best known moderns, working for the church, had thus received their final consecration.

I myself had been approached with the idea of designing stained glass windows. I thought at once of a luxurious brothel I frequented in Paris, when they were still tolerated; there were some stained glass windows — they were rather dirty. As in the case of cathedrals, they were invisible from the outside; I proposed a brilliant lighting system inside so that one could enjoy them from the exterior. But this was a step too far from tradition, however modern the designs might be. Or, was it too costly a project?

Speaking of brothels reminds me of another world or worlds that I frequented from time to time in which the dominant fig-

ure was Jules Pascin, the painter. He could have been some-
one who had stepped out of a Toulouse-Lautrec poster; his
tight-fitting black suit on a spare figure topped jauntily with a
bowler hat from which a lock of hair escaped, a cigarette butt
in the corner of his mouth, and a spotless white silk scarf
around his neck, indicated the tough guy at the turn of the
century. His nervous, delicate paintings of his models repre-
sented little women on short legs, and paintings of young girls
were also of little women. His studio was animated with these
models, both black and white, and their daughters. It was said
he'd been brought up by his parents who ran a brothel in Bul-
garia. I was often invited with Kiki to his parties, which some-
times ended in brawls among the women, but generally all got
along very well together. Pascin had prestige as a painter; one
of my wealthy American clients came along once to acquire
some of his work, selecting a dozen watercolors. Pascin in-
sisted on being paid in cash; the collector lacked a few francs
of ready money to make up the amount but promised to send
it around from his hotel. He forgot or had left Paris too hur-
riedly; Pascin reproached me with the unreliability of my
friends. But he was generous.

We were a group of about fifteen one night; he took us out
to dinner which became quite a boisterous affair with plenty
of wine. We adjourned to a brothel, one of those popular ones
that had a café on the ground floor. It was quite homey, with
the girls in négligée sitting around, some joining our party on
invitation. Pascin and I were quite drunk and, getting bored
with the jabbering around us, we invited a couple of the house
girls to come upstairs. We separated into different rooms. All
at once, I felt terribly sick, must have gotten green in the face,
for the girl began to scream, thinking I was dying. When the
madam came running up, she took me in hand, held me over
the wash bowl, then had me stretch out on the bed, undoing
my clothes in a very motherly fashion, saying I'd be all right
in a little while. The girl sat beside me smoothing my brow.
Presently the door opened with Pascin and his girl coming in.
Looking at me he asked if I was ready to go; as for himself he
could not do anything: too much to drink.

If from time to time I sought such distractions, it was to escape from the drudgery of my professional work and also from the high and exacting plane of my Surrealist activity. And in such adventures I was often joined by a member of the group, a poet or a painter. It was like playing truant. I regretted that a man like Pascin could not step out of his circle, enter another world for a moment. With all his gay and hectic surroundings, his success as a painter, there was a note of sadness in his manner as if the very freedom of his way of living prevented any escape. And so, one day he was found dead on the floor in his studio, his wrists slashed, his immaculate white silk scarf knotted around his neck and attached to a doorknob.

From time to time, after a suicide of someone close to us, the question was raised as to whether this was a solution to an unbearable situation. I recall my own particular case years ago when I was very ill, suffering from a complication of obesity, skin and liver diseases, brought on by too good living, eating and drinking. Doctors did not help me and a short stay in a hospital nearly killed me. I insisted on going home; a new complication set in, insomnia. The long nights awake made me desperate and I finally put a gun alongside my medicines, resolved to end it all if I did not fall asleep. From that night on, I slept like a log. Was it that taking fate into my own hands I became its master, or was it a perfect demonstration of self-preservation? When I woke up refreshed, my head cleared, I decided to survive. I still had no appetite and so ate little, drank a little water and recovered in a short time. Someone gave me a book on a new diet to follow. It was very Spartan, but it helped. What I learned, however, was that what I didn't do couldn't hurt me. Otherwise, like the others who had succumbed, I, too, would become a victim of the laws of cause and effect. Afterwards, I continued to lead a more sober life — it was not a question of will power but somehow I had lost the taste of indulging myself, or it may have been that my curiosity was dwindling. Just once in a while I'd go on a rampage — Brancusi had said one should create an upheaval within one's self now and then. But I did nothing as a matter of habit. I had

resolved never to get myself tied up with one woman for any length of time — continual change in love as well as in diet would keep my mind clear and my body well. Drink and permanent attachments had been the undoing of many of my friends.

Most of the younger painters who had come to Paris, intent on making good, seemed more circumspect in their behavior, more careful to preserve their identity — whatever extravagances they indulged in were interpreted as a manifestation of their artistic temperament. But their attitude towards me was respectful, I being older and a pioneer in my way, and my photography impressed them as it has many other painters, without their conceding that it should be taken as seriously as painting. In a way I agreed but in a different sense; painting for me was a very personal, intimate affair, photography was for everyone. There was no question for me of comparison or substitution between the two. Carrying this thought to its logical conclusion, how much painting can be taken seriously? It would be a great help if the word, serious, could be eliminated from the vocabulary. It must have been invented by critics not too sure of themselves, condemning all of the most exciting and profound works that have been produced through the ages.

It is impossible for me to speak of my encounters in their chronological order; I am not a historian. There are others who have set themselves this task — and their researches are bound to be punctuated with errors. Looking back so far in a lifetime, all the incidents seem to have happened simultaneously as in a well-ordered perspective — the farthest objects seem to be closely grouped. I can treat them only as groups, therefore, one incident suggesting another in the same group. First, of course, came the Surrealists with whom I was most closely associated.

Max Ernst, the painter, arrived in Paris about the same time as myself, but I did not make his acquaintance until later. With his pale eyes and thin beaked nose he gave one the impression of a bird — a bird of prey. The bird motive appears often in his extremely lyrical yet irrational painting — one of his earliest works, a combination of paint and glued objects,

bears the title: Two Children Menaced by a Nightingale. His full life with its many odysseys is paralleled by his varied techniques: collages, rubbings, sprayings, etc., without any concern for establishing a unique recognizable personality as evident in so many other painters. However, many of the later painters drew their inspiration from him, concentrating on one of his methods. We met often, sometimes at critical moments in our lives, and were helpful to one another. When his reputation was finally established, with retrospective exhibitions in museums, and publications devoted to his work, I received a copy of the fully documented story of Max Ernst by Patrick Waldberg. It bore the equivocal inscription: To my master, Man, from his faithful pupil Max. I could see his rare, sardonic smile behind this and thought that if ever a similar book were published on me I'd inscribe his copy with: to my faithful pupil, Max, from his master, Man. After all, I have no doubt that the procession of my contemporaries who filed through my studio could not help being inspired, at least stimulated by its atmosphere.

Joan Miró brought his first stylized, bucolic scenes from Spain, but very soon entered completely into the Dada and Surrealist spirit. His imagination ran riot covering large surfaces with splashes of color and delicately drawn caricature-like figures, sometimes embellished with irrelevant words and phrases, or with descriptive titles. Gradually, befitting his Spanish origin, his color became more intense, his forms more violent, yet always highly decorative to those who dismissed his drawing as rather infantile. He assembled heterogeneous objects, combining them with his painting. Sometimes a large coil of rope was attached to the composition. It reminded me of an episode when several of us were visiting Ernst's studio. Miró was very taciturn; it was difficult to get him to talk. A violent discussion was going on, he was pressed to give his opinion but remained obstinately mute. Max seized a coil of rope, threw it over a beam, tied a slip knot at the end, and, while the others pinioned his arms, put it around his neck and threatened to hang him if he did not speak. Miró did not strug-

gle but remained silent; he was ravished with being the center of so much attention. When he came to pose for me, I perfidiously hung a rope in back of him as an accessory. He did not comment on this, but the rope theme figured in his later works. At the same time that I did his portrait, Miró gave me a large painting in black, white and gray which I called Portrait of Man Ray — very fitting for a photographer.

Giacometti, the sculptor, gave one the impression of a tortured soul. Always dissatisfied with his work, feeling that he had carried it not far enough, or perhaps too far, he'd abandon it in his heaped-up little studio and start on an entirely new formula. When he turned to painting for a while, his colorless, line-searching figures seemed to express final resignation in a futile search of himself. Whatever the direction he took, the work was always a positive expression — a perfect reflection of the man. He could talk with lucid, voluble brilliance — on many subjects. I liked to sit with him in a café and watch as well as listen to him. His deeply marked face with a grayish complexion, like a medieval sculpture, was a fine subject for my photographic portraiture. During my period of fashion photography I disposed of a budget for backgrounds; I got him to make some bas-reliefs, units of birds and fishes which were repeated over a surface. One motif which he submitted, four legs radiating from a center, reminded me too much of the Nazi's swastika — when I pointed this out, he destroyed the work. The others were taken up by an interior decorator, and it helped him to attract attention. I did a series of pictures of his more Surrealistic work, for publication in an art magazine. He rewarded me with pieces of sculpture of the period.

One day, he introduced me to Meret Oppenheim, a beautiful young girl whose family had escaped from Germany to Switzerland, the country of Giacometti's origin. Whenever she could get to Paris, it was to sit with the Surrealists. She created a sensation with her fur-lined cup, saucer and spoon. Meret was one of the most uninhibited women I have ever met. She posed for

me in the nude, her hands and arms smeared with the black ink of an etching press in Marcoussis's studio. The latter, an early Cubist painter, wore a false beard to hide his identity as he posed with her in one of the pictures. This was a bit too scabrous for the deluxe art magazine for which it was intended; the one of Meret alone, leaning on the press, was used. Still, it was very disturbing, a perfect example of the Surrealist tendency toward scandal.

Yves Tanguy joined the group — his weird landscapes with their abstract archaeological forms were almost human in their shapes and attitudes. I could have applied to them a term used for some of my own inventions: non-abstractions.

Then there was René Magritte, the Belgian painter, who contributed a very personal note to our movement. His work was of a trompe-l'oeil nature, realistic, but with a crude quality, sufficient, however, to express his penchant for optical delusions. He admired a photographic enlargement I had made of a single eye, offered me a painting in exchange, which I received later: a large eye in which clouds and blue sky filled the whites.

There were other painters who passed momentarily through the Surrealist aura, retiring to pursue their own destiny, impatient with the movement's exacting ethics. Sometimes they were excommunicated for some deviation before they could make up their minds.

Painters outside of our circle came through my studio including Kandinsky, whose theories did not seem to be reflected in his painting; Fernand Léger, heavy, and striving to be understood by the public; Marie Laurencin, with a modernized eighteenth-century manner; Masson, superb draftsman, whether Cubist, massacre-bent, or decorative abstractionist; Vlaminck, spreading his paint like butter on bread; and Rouault with his Daumieresque message. These I photographed perfunctorily although they were more sympathetic than some of my paying sitters. I respected them, but, inwardly had my

opinion of them. Since they were interested in me only as a photographer at their service, I obligingly played the part — as in the case of certain writers and musicians.

In the early days Gertrude Stein brought Juan Gris to my studio. He came prepared to be photographed with a high white stiff collar, as if for a family portrait. I was curious about him, had seen some of his work in New York when it came up for auction from some collection. There was not much interest in him, he was considered a minor Cubist, as in France, and his work sold for a few dollars. I liked his painting for its simpler, starker quality in contrast with the works of the more famous innovators of Cubism whose works sometimes attained the patina of old walls. I had never been able to say whether a work was good or bad as so many others have done — it was sufficient for me to be attracted or repelled by the work, just as the personality of the painter whether as a photographic subject or an acquaintance was sympathetic to me or not. This was my only basis of judgment, uninfluenced by any aesthetic considerations.

It was inevitable that the continued contact with painters should keep smoldering in me my first passion — painting. Although the demands of my photographic work had increased, I was able to organize my schedule so that I could devote time to drawing and painting, if only as a relief from my daily routine. Ideas came to me that demanded a more flexible medium for their expression than the rigidity of the camera. To be sure, I had used photography as freely as I dared, or rather to the limits of my inventive capacities, but color was lacking. Not color for embellishment nor to attain greater realism. Progress in color photography was beginning to fill such needs, rendering its use in figurative painting rather lame, if not pointless. It gave an impetus to the development of abstract painting which resembled more and more an enlargement of a small, insignificant patch of nature. Some of the most effective photographs in black and white I had made were magnifications of a detail of the face and body. In a contemporary catalog of modern painters their portraits consisted only of

photographs of their eyes. I carried this idea further by giving such details a texture inherent in the medium itself, coarse grain, partial reversal of the negative and other technical variations; all frowned upon by straight photographers.

One of these enlargements of a pair of lips haunted me like a dream remembered; I decided to paint the subject on a scale of superhuman proportions. I placed a canvas about eight feet long over my bed and every morning, before going to my office and studio, I worked on it for an hour or two standing on the bed in my pajamas. If there had been a color process enabling me to make a photograph of such dimensions and showing the lips floating over a landscape, I would certainly have preferred to do it that way. However rapidly I could paint, it was still drudgery after the instantaneous act of photography. I did not take into account the meticulous preparation such a photograph would require nor its subsequent printing, which was the mechanical side, whereas in painting from the beginning to the end, every stroke required a high pitch of tension and interest. I was somewhat out of practice. Be that as it may, after two years I finished the painting, working only when my enthusiasm renewed itself. At one moment I did not like the angle of the lips in the sky, so redrew and repainted them on the same canvas, hoping the underpainting would not show through in time, as in the case of a Vermeer where a ghostlike figure appears in one of his interiors, a figure he had painted out. I consoled myself by thinking such a catastrophe might make the work more interesting to future generations as the Vermeer was for me, in spite of a critic's disparagement.

The painting when finished hung over my bed for a while like an open window into space. The red lips floated in a bluish gray sky over a twilit landscape with an observatory and its two domes like breasts dimly indicated on the horizon — an impression of my daily walks through the Luxembourg Gardens. The lips because of their scale, no doubt, suggested two closely joined bodies. Quite Freudian. I wrote the legend at the bottom of the canvas to anticipate subsequent interpretations: Observatory Time — The Lovers. As with other paintings I had made in my free time, the occasion for exhibiting this last

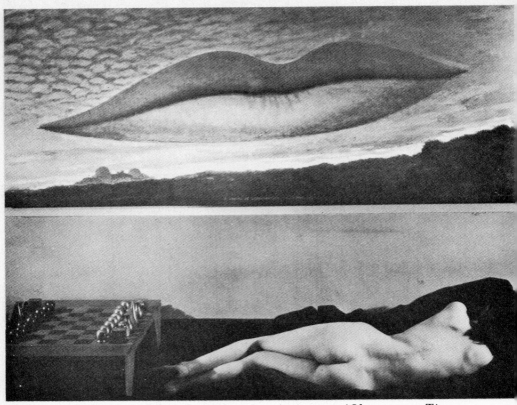

A l'Heure de l'Observatoire — Les Amoureux (Observatory Time — The Lovers), as it hung above the couch, rue de Val-de-Grace, 1934. One of the original chess sets appears at the left

work soon presented itself. First, I had a one-man show in Paris where it figured. It looked less important in the spacious gallery than in my bedroom — smaller. Some critic observed that it was an enlarged postcard, another remarked its erotic significance without analyzing the picture any further. Then the painting was sent to London where the Surrealists had organized a big exhibition. There, too, it was hung high and seemed to dwindle in size. I received a cable offering me a couple of hundred pounds for the work. I was tempted to have the picture placed in a collection, but fortunately turned down the offer.

The next year the Museum of Modern Art in New York held its exhibition of Dada, Surrealist and Fantastic Art, to which I sent The Lovers. I happened to be in New York on a photo-

graphic assignment for a fashion magazine and attended the opening which was a great social as well as artistic event. Streams of people in full dress were pouring in on the opening night. The museum was still the old converted brownstone building. The doors were wide open, so that the entrance flood-lit my Lovers, which seemed to strike the keynote of the ex-hibition. Here my painting stood out in all its scale and provocative intent. The following day I returned to the mu-seum to see my work again, but it was no longer there. Upon inquiry I was reassured — the painting had been hung inside the gallery among other Surrealist works. Later I learned that a member of the committee had objected to it, considering it rather obscene, so that it had been given a less conspicuous place.

My three month's stay in New York was a busy one, full of variety. I had an exhibition of some sixty drawings made dur-ing the past two years in my odd moments. The days were filled with sittings for the fashion magazines, photographing dresses, movie stars and actresses. My first wife Donna ap-peared on the scene — we had not been legally divorced — insisting on a settlement, demanding an indemnity for the sixteen years we had been separated. I consulted a well-known lawyer who took up the case and obtained the divorce papers rapidly, but advised me to return to Paris as Donna was not satisfied with the proceedings, threatening to make trouble, although she had been living with another man for a number of years. I wound up my affairs and went blithely back to Paris, taking with me a couple of charming mannequins whom I had recommended to the magazine to pose for me at French couturiers, to give an American accent to my photographs. One day I received a cable from New York — the exhibition at the museum was about to close and Helena Rubinstein asked to have the painting, The Lovers. I was overjoyed — with this windfall I'd be able to devote more time to painting in the future. After awhile, the painting carefully crated was returned to me followed by a letter of thanks from Madame Rubinstein. She had displayed it in her magnificent new beauty emporium on Fifth Avenue, featuring a new lipstick or some other beauty

product. This I was told by some outraged friends. However, I wasn't too upset; I was glad to have the painting back and showed it again in the Paris Surrealist show the next year. Then it hung in my studio, dominating the photographic activity, until the war came, when, under the threat of bombings, I rolled it up with a number of other larger paintings of various periods and stored them with my color dealer, Foinet.

During the war, while living in California, I was surprised to receive this roll, shipped from New York. My friend Mary Reynolds, who had been reluctant to leave Paris the first year of the German occupation, finally returned, crossing the Spanish border clandestinely, with my roll under her arm. Before I had returned, earlier, I had left some things with her, telling her of the storage of the larger paintings, and she had remembered. I put The Lovers back on a stretcher and had the opportunity of showing the painting in a new gallery opened in Beverly Hills by my friend William Copley. After the exhibition he added it to his collection; I thought it had found its final resting place. But friend Bill moved to France after the war, carrying The Lovers with him; its peregrinations are not finished for it has been in London again and to museums on the continent. I shall not be happy until I see it reproduced in full color across two pages in a book on Surrealism. Only then will I be assured of its permanence. I am much less concerned with the preservation of my own originals.

DADA FILMS AND SURREALISM

While investigating the various phases of photography in my early days in Paris, inevitably I turned my attention to moving pictures. Not that I had any desire to enter the field professionally, but my curiosity was aroused by the idea of putting into motion some of the results I had obtained in still photography. Having acquired a small automatic camera that held a few feet of standard movie film — there were no 16 or 8 mm cameras at the time — I made a few sporadic shots, unrelated to each other, as a field of daisies, a nude torso moving in front of a striped curtain with the sunlight coming through, one of my paper spirals hanging in the studio, a carton from an egg crate revolving on a string — mobiles before the invention of the word, but without any aesthetic implications nor as a preparation for future development: the true Dada spirit. Vaguely I thought that when I had produced enough material for a ten- or fifteen-minute projection, I'd add a few irrelevant captions — movies were still silent then, but not still — and regale my Dada friends, the only ones capable of appreciating such nonchalance. My neighbor and friend Tristan Tzara was the only one aware of this new diversion, followed it with interest saying this was one of the fields Dadaism hadn't touched; it was time to produce something in that direction to offset all the idiocies filling the screens.

I had put the camera aside, being occupied with more press-

ing demands, when, one Wednesday morning, Tzara appeared with a printed announcement of an important Dada manifestation to be held the following night in the Michel Theater. On the program my name figured as the producer of a Dada film, part of the program entitled *Le Coeur à Barbe:* The Bearded Heart. Knowing pretty well by now, from similar demonstrations, the group's habit of announcing the highly improbable appearance of a well-known personality, Charles Chaplin, for example, I humored Tzara, saying I'd like to be at the affair anyhow to lend my support to it. But Tzara was serious in this case; I had some movie sequences which could be projected, and an operator with a projector had already been hired. I explained that what I had would not last more than a minute; there was not sufficient time to add to it. Tzara insisted: what about my Rayographs, the compositions made without a camera directly on the paper; couldn't I do the same thing on movie film and have it ready for the performance? The idea struck me as possible and I promised to have something ready for the next day.

Acquiring a roll of a hundred feet of film, I went into my darkroom and cut up the material into short lengths, pinning them down on the work table. On some strips I sprinkled salt and pepper, like a cook preparing a roast, on other strips I threw pins and thumbtacks at random; then turned on the white light for a second or two, as I had done for my still Rayographs. Then I carefully lifted the film off the table, shaking off the debris, and developed it in my tanks. The next morning, when dry, I examined my work; the salt, pins and tacks were perfectly reproduced, white on a black ground as in X-ray films, but there was no separation into successive frames as in movie films. I had no idea what this would give on the screen. Also, I knew nothing about film mounting with cement, so I simply glued the strips together, adding the few shots first made with my camera to prolong the projection. The whole would not last more than about three minutes. Anyhow, I thought, it would be over before an audience could react; there would be other numbers on the program to try the spectators' patience, the principal aim of the Dadaists.

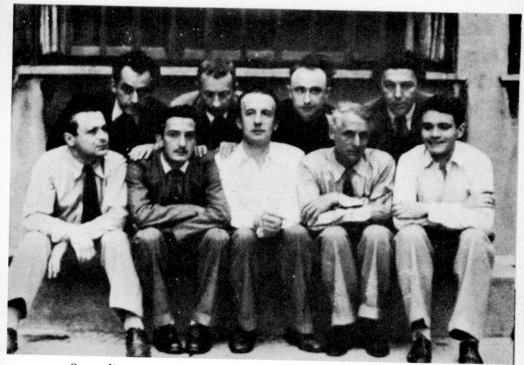

Surrealist group, 1930. *Above, l. to r.*: Man Ray, Arp, Tanguy, Breton. *Below, l. to r.*: Tzara, Dali, Eluard, Ernst, Crevel

I arrived at the theater a few minutes before the curtain went up, brought my film to Tzara and told him that he was to announce it, as there were no titles nor captions. I called the film: *The Return to Reason.*

The preliminaries consisted of the reading of some poetry, mostly gibberish, accompanied by a bit of clowning by the young poets: Aragon, Breton, Eluard, Peret, Ribemont-Dessaignes, Soupault, and Fraenkel, who sat in a corner reading a newspaper and ringing a bell. All of this the audience properly booed and whistled at. Then Tzara appeared on the stage and in a perfectly intelligible manner announced my film — *The Return to Reason,* a first showing, by that renowned artist, Man Ray, made in one of his lucid moments. The audience relaxed in their seats with an audible sigh of relief and a few handclaps. The theater went dark and the screen lit up. It looked like a snowstorm, with the flakes flying in all directions instead of falling, then suddenly becoming a field of daisies as

if the snow had crystallized into flowers. This was followed by another sequence of huge white pins crisscrossing and revolving in an epileptic dance, then again by a lone thumbtack making desperate efforts to leave the screen. There was some grumbling in the audience, punctuated by a whistle or two; but suddenly the film broke, due to my inexpert mounting. The theater remained dark while the film was being repaired. There were a few exchanges of opinion but nothing very serious: the audience was hopeful of some revelation to come. The next image was of the light-striped torso which called forth the applause of some connoisseurs, but when the spiral and egg-crate carton began to revolve on the screen, there was a catcall, taken up by the audience, as always happens in a gathering. But again the film broke, plunging the theater into darkness. One spectator loudly vented his dissatisfaction, the man behind, evidently a sympathizer of the Dadaists, answered him; the dialogue became more personal; finally a loud slap was heard, followed by the scuffling of feet and shouting. A cry for the lights arose, the theater lit up disclosing a group locked in a struggle preventing the participants from striking any blows. Small groups in other parts of the theater were seen, divided into two camps, engaged in similar activities. A group of police stationed outside in anticipation of trouble rushed in and succeeded in emptying the theater. There were still a few isolated battles on the sidewalk. The Dadaists were joyful — as for me, I knew it was near the end of my reel, so did not regret the interruption, on the contrary, it may have induced the public to imagine that there was much more to the film, and that they had missed the import of the *Return to Reason*. The episode gave me a new prestige; it was said that I had gone into the making of movies. But I put my camera aside.

I had no intention of following up the publicity, knowing that my approach to the movies was entirely at odds with what the industry and the public would expect of me. I recalled my first visit to Picabia, when, signing on his guest canvas I had added prophetically, Director of Bad Films — written in bad French — as a Dada gesture. Or was it in memory of my recent

abortive experience with Duchamp in New York? While helping him with his research, I had shot a sequence of myself as a barber shaving the pubic hairs of a nude model, a sequence which was also ruined in the process of developing and never saw the light. With my Dadaistic approach, I felt that whatever I might undertake in the way of films would be open to censorship either on moral or on aesthetic grounds, in short, bad.

Le Coeur-à-Barbe was one of the last public manifestations of the Dadaists, the group dividing into two camps over questions of personal leadership between Tzara and Breton. The death of Dada was announced with relief by the same critics who had announced it as still-born in the beginning. But Dada had accomplished its purpose of mocking the artistic and political futility of the day, offsetting it with irrationality and the destruction of all accepted values. It was as if the Dadaists were proposing to take over the affairs of this world, implying that they could not have made a worse mess than had the accredited leaders.

What Dada had accomplished was purely negative; its poems and paintings were illogical, irreverent, and irrelevant. To continue its propaganda a more constructive program was needed, at least as an adjunct to its criticism of society. And Breton came up with Surrealism, a word taken from the writings of the dead poet Apollinaire. Dada did not die; it was simply transformed, since the new movement was composed of all the original members of the Dada group. Tzara went along with the change for a while, until again personal rivalries caused him to withdraw. Breton took matters in hand, publishing his first Surrealist manifesto. The constructive element of this declaration was its advocacy of new sources for inspiration in writing and the other arts, such as the subconscious: automatic, that is, not logically controlled expression, and the dream world. Breton had visited Freud in Vienna a few years earlier, had kept up a correspondence with him, and had found in psychology a fertile field for his ideas. The combative and provocative spirit of Dadaism continued, directed

more and more to political society and its representatives. As in the days of Dada, there were frequent violent encounters: All this appeared in print, in publications brought out by the Surrealists. The new Surrealists were past masters in the use of words of attack and vituperation, leaving no doubt of the intent to wound in the minds of the most conservative.

Younger poets and painters joined up, eager to adopt the new formulas. A Surrealist gallery was opened; I was invited to have the first show, but aside from two or three works created since the birth of the new movement, I showed again my things of the Dada period. They fitted in just as well with the Surrealist idea, very few had remembered them from my first show in 1921 under the Dada sign. Breton once called me a Pre-Surrealist; I hoped it wasn't in the sense of a Pre-Raphaelite; but no, since he had pointed out that there had been Surrealists in all ages, whom he admired, such as Swift and Sade. With the movement firmly entrenched, we met nearly every day at each other's homes or in cafés chosen in the least artistic or bohemian quarters of Paris, to discuss future activities and publications. A good portion of these were politically slanted, but, tactfully, I was not required to sign the pronunciamentos, being a foreigner and liable to expulsion. Free speech was reserved for Frenchmen. If a couple of other foreigners in the movement signed, it was out of bravado, but passed unnoticed. There were sessions with questionnaires on various subjects: sex, love, what was the most fateful encounter in one's life, etc. Sometimes a poet would go into a trance and write automatically, producing astonishing phrases full of anagrams and puns. Or we would simply play games, everyone participating.

One night, in one of the studios, we were about twenty, men and women, playing forfeits. We were grouped around a table well supplied with wines and liquors to help us reply without inhibition to the very intimate and embarrassing questions that were propounded to each individual. I was asked pointblank whether I was a homosexual. Since such characters, as well as drug addicts and Lesbians were known to frequent my studio, there were lots of rumors about me, rumors which I

never protested. I refused to answer the question; at the end of the game I was condemned to strip completely. I asked jokingly whether they could judge from my nudity what my propensities were. Jumping up on the table I unbuttoned my shirt, I wore no undershirt, and, with a single gesture peeled off my clothes down to my shoes, till they lay in a pile at my feet. Being somewhat drunk, I performed a little dance, kicking glasses and bottles to right and left. It was the most embarrassing moment of the session. But it had psychological significance for the Surrealists. As did many other trivial incidents.

One Saturday afternoon eighteen of us including our wives and mistresses, piled into four cars and headed for Duclair in Normandy, a small town famous for its duck. Following each other closely, we were hampered by fog and I had trouble with my engine, so that we arrived late at the inn. Taking over the small establishment, we ordered lunch for the next day, and went to bed. We had a late breakfast; it was a lovely day and we wandered about the village. People were out, regarding us as if we were foreigners; I had Kiki with me, who, with her extravagant makeup, did not arouse the sympathy of the villagers. Lunch was served in the banquet room on the first floor, reserved for wedding feasts and other reunions. We were at the table for a couple of hours; there were nineteen empty bottles when we finished. The duck was delicious.

Benjamin Peret, the poet, became quite touchy, and rising, announced he would leave us if one or two of his neighbors did not cease tormenting him. It was easy to tease Peret; one had simply to mention the church and the priests to throw him into a violent rage. Like many famous writers of the eighteenth century, who had been thrown into prison or exile for anti-clerical activities, Peret made the church one of his pet aversions. Now, somewhat tipsy, he was led out on the balcony of the dining room, to cool off. A number of us joined him to watch the procession of the natives in their Sunday best, promenading along the principal village street. As a substantial-looking couple in black passed by, the fat woman leaning on the man's arm, on his other arm an umbrella, Peret called

down to him saying it was a beautiful Sunday and what was the umbrella for? The man looked up and scowled, then invited Peret to come down and be shown. The latter ran down and we all followed. As he approached, the good man lifted his umbrella and hit the poet over the head. Kiki rushed over, pulled the object out of his hand, broke it in two across her knee and threw it into a garden nearby. There was a loud outcry; then the whole village, it seemed, descended upon us as if they had been waiting for a signal. Huddled together, we were pushed against the window of the café, which finally gave way. Peret's assailant was shouting, demanding payment for his umbrella, the café owner ran out demanding indemnity for his window. No blows were actually struck and it was agreed to go to the police station to settle the matter. But there were no police, no constable, it was Sunday. They were away, fishing or picnicking, wouldn't be back till evening. We waited; when the officer appeared, each side told his version of the affair. Fortunately, one of the women with us was a relative of a former French president, which impressed the constable; he agreed with her that the broken window was the result of our being pushed into it by the villagers, but that the umbrella had been broken by one of us; therefore should be paid for. We departed, feeling we had won the case.

Although I had put my little movie camera aside, having satisfied my curiosity for the time being, in animating black and white stills, the rumors still went round that I was experimenting with films. One day a tall young man appeared with his beautiful blond wife, and introduced himself as a cameraman from Hollywood. His wife, Katherine, had been the oldest pupil at the Elizabeth Duncan Dance School, where my stepdaughter Esther had been the youngest. Dudley Murphy said some very flattering things about my work and suggested we do a film together. He had all the professional material, he said; with my ideas and his technique something new could be produced. We became quite friendly, spent a few days together discussing subject matter — I insisted on my Dada approach if we were to work together, to which he readily agreed after

I had explained it at some length. We took some walks together, I bringing out my little camera and shooting a few scenes without any attempt at careful choice of people or setting, emphasizing the idea of improvisation. For the more tricky effects we planned indoors, Dudley set up an old Pathé camera on its tripod, the kind used in the comic shorts of the day. He showed me some complicated lenses that could deform and multiply images, which we'd use for portraits and close-ups. The camera remained standing in my studio for a few days, which annoyed me, as I never liked to have my instruments in view. They were generally put away until used, or discreetly shoved into a corner under a cloth. When Dudley appeared again, he announced that he was ready to go to work and would I purchase the film. I was surprised, thinking this was included with his technical equipment — that I was to supply the ideas only. He packed up his camera, took it over to the painter Léger's studio, explaining that he himself had no money and that the painter had agreed to finance the film. I made no objection, was glad to see the black box go, and relieved that I hadn't gotten involved in a co-operative enterprise. And that is how Dudley realized the *Ballet Mécanique*, which had a certain success, with Léger's name. Dudley took the film back to Hollywood and got some work on big films as a result, made some money, and opened a charming restaurant and motel on the Pacific coast, which I myself frequented during my *séjour* in Hollywood in the Forties. He was a charming and generous host, but never referred to the movies again.

My life and work continued in Paris along its usual course, but I wasn't to get off so easily the next time. A couple came into the studio to arrange for a sitting. He was a retired broker, although still a young man; had sold his seat on the stock exchange and was planning to settle in Paris. He wished to have a portrait of his wife made. She was a dark little woman, smartly groomed; they radiated wealth. In due time, the pictures were delivered and received with great satisfaction. I was invited to dinner several times, and Arthur Wheeler became a frequent visitor, taking an interest in all my activities, al-

though the atmosphere was a bit incomprehensible to him. He wished he could do something in the art world. His father, a retired doctor, had begun to paint at the age of seventy-five and was having a wonderful time. We artists were lucky, he said, even if we made a lot of money, we did not have to worry about future boredom. One day during lunch, Arthur spoke to me frankly, hoping I wouldn't take it amiss; he thought I was wasting my time photographing any person that came in who could pay. With my imagination and talents I should be doing bigger things. At first I was about to blow up, give him a lecture on what creative work I had already done, tell of my literary and artistic affiliations, and explain that photography was a job which enabled me to remain free and pursue what was for me the most important aspects of living. Then I thought better of it, Arthur wouldn't understand, he'd consider it a lot of highbrow nonsense.

Instead, I asked what he did consider bigger things. The movies, he replied, that was the future for all art and money-making. True, I said to humor him along, but with my uncommercial ideas making films would be a catastrophe for any producer who invested his money. And I certainly wouldn't make any concessions to the industry, nor use my own capital for such a venture. Painting a picture did not involve any great effort nor outlay of funds, by comparison; I could put it aside and wait years for its acceptance, or even forget about it, but making a film was a banking operation as well as a work of art. Wheeler continued: he had every confidence in me and my ideas, was sure I could do something sensational and give the movies a new direction, in short, he would back me and be willing to lose his money. Although he had made money, he had lost plenty in speculations; the loss with me would be compensated by the conviction that it was in a good cause. I was quite pleased with his argument and agreed to accept his offer. How much money would I need, he asked. It being still the period of silent films, I replied that all I needed for the present was a camera, film, and some accessories. I'd investigate, and give him an estimate in a few days.

The finest professional camera available in France at the

time, with its accessories, cost about five thousand dollars. I told Wheeler I'd need ten to make a short film, as a beginning. He looked at me incredulously and laughed: he'd heard one couldn't do anything for less than fifty thousand in the movies. I explained again that this would be more in the nature of an experiment; I wouldn't want him to risk any more than what I was asking, even so he must be prepared to lose the money. Fine, he said, and took me to his lawyer to draw up a contract; he liked to do things in a businesslike way. After we explained our mission, the lawyer began writing out a draft of the contract, then turned to me and asked what guarantees I had to offer. None, I replied. Wheeler then confirmed me by saying that the only guarantee he asked of me was that I produce a film within a year. The lawyer shook his head, completed the draft and gave it to his girl to type. Wheeler wrote out a check for the sum agreed on and handed it to me.

Having assembled various accessories, deforming mirrors, an electric turntable, an assortment of crystals, and some special lamps, I went to work at once, neglecting other photographic commitments. After all, I considered this in line with my routine work, like any other order, with the advantage of being paid in advance. I might use people or their faces in the film, but no professional actors, a large item in all more conventional productions. There was no scenario, all would be improvised, along the lines of my first short for the *Coeur-à-Barbe*, the last Dada manifestation. And I was thrilled, more with the idea of doing what I pleased than with any technical and optical effects I planned to introduce. When I felt I had accumulated enough material for a short film, I'd mount the sequences in some sort of progression, consider the job finished. I'd even use the first strips from my Dada film: salt and pepper, pins and thumbtacks, but printed up professionally. This would emphasize my determination not to be seduced by any commercial considerations.

As in the previous summer, Wheeler had rented a large house near Biarritz, and invited me to come down with my material to do some of the work there, combining it with a vacation. This added to the feeling that making a picture

would be a holiday for me. Packing up my cameras — I had acquired a small automatic hand camera for special takes — I drove down and lived luxuriously for a few weeks, shooting whatever seemed interesting to me, working not more than an hour or two every day; the rest of the time spent on the beaches lolling in the sun, at elaborate dinners with other guests, and dancing in the night clubs. One of the most interesting shots I made was while being driven by Rose Wheeler in her Mercedes racing car; I was using my hand camera while she was driving eighty or ninety miles an hour, being pretty badly shaken up, when we came upon a herd of sheep on the road. She braked to within a few feet of the animals. This gave me an idea — why not show a collision? I stepped out of the car, followed the herd while winding up the camera and set it in movement, then threw it thirty feet up into the air, catching it again. The risk I was taking gave me the thrill that most movie makers must experience when doing a difficult shot. There were other more carefully planned sequences: a pair of lovely legs doing the popular Charleston dance of the day, the sea revolving so that it became sky and the sky sea, etc., all tricks that might annoy certain spectators. The Dada instinct was still very strong with me.

When I returned to Paris, I continued with other shots in the studio. I had now a hodge-podge of realistic shots and of sparkling crystals and abstract forms obtained in my deforming mirrors, almost enough for the film. I needed something now to finish it with some sort of climax, so that the spectators would not think I was being too arty. This was to be a satire on the movies. A visit from my friend Jacques Rigaut, the dandy of the Dadas, the handsome one who could have been a movie star if he wanted to, gave me the idea for the ending. As usual, he was impeccably dressed, with his well-cut clothes, a dark Homburg, and a starched white collar with a discreetly patterned tie. I sent out my assistant Boiffard to buy a dozen stiff white collars with which I filled a small attaché case. Then I had Rigaut go out with the case, find a taxi and drive back to the studio. The camera was set up in a window on the balcony overlooking the entrance to the studio; I filmed my man as he

Film strips, *Emak Bakia*, 1927

arrived in the taxi, stepped out and entered the building. In the studio I made a close-up of Rigaut's hands opening the case, taking the collars out one by one, tearing them in two and dropping them on the floor. (Later I had a reverse print made of the falling collars so that they appeared to jump up again.) I had Rigaut tear off the outside half of his collar, showing the tie around his neck. He looked more dressed up than ever, more formal. That was all for him. When he left I shot some sequences of the torn collars through the revolving deforming mirrors; they pirouetted and danced rhythmically. The entire sequence from the time of Rigaut's arrival was preceded by the only subtitle in the film: *The Reason for this Extravagance.* This was to reassure the spectator, like the title of my first Dada film: to let him think there would be an explanation of the previous disconnected images. To finish the film I did a close-up of Kiki. Her penchant for excessive makeup gave me the idea. On her closed eyelids I painted a pair of artificial eyes which I filmed, having her open her own eyes, gradually disclosing them. Her lips broke into a smile showing her even teeth. *Finis* — I added in dissolving letters.

The Vieux Colombier, formerly a legitimate highbrow theater that had not done very well, was now a movie theater where experimental and avant-garde films were shown. I approached the director and asked him to let me have the place in the afternoon to show my picture to an invited audience of friends and others interested in such efforts. As my film was very short, he combined it with another film — I think it was one of Jean Renoir's first productions. The theater would be filled with other guests and critics. As in all movie theaters in the silent days, there was a piano and sometimes several other musicians to furnish background music. Contrary to the general impression, I was not a purist concerning black and white photography. I liked the idea of a sound accompaniment, imagined a future with color and even relief — that is, a three-dimensional effect, not any other relief. We had a little rehearsal in which my film was projected, I instructing the musicians what numbers to play at which parts of the film. There was also a phonograph for which I provided some jazz

pieces of the day, which were beyond the house musicians' repertory. The director, Monsieur Tedesco, suggested that I give a little talk before the projection, setting forth my aims and motives, of which he himself seemed to be in doubt. All the films that he was showing, however experimental, had a story to tell. About fifty people came to the presentation, including, of course, my sponsors the Wheelers. The longer film was run off first and received warm applause.

Then I arose to make my speech. Among other remarks I said that my film was purely optical, made to appeal only to the eyes — there was no story, not even a scenario. Then, somewhat more truculently; this was not an experimental film — I never showed my experiments — what I offered to the public was final, the result of a way of thinking as well as of seeing. As for the strange title, *Emak Bakia*, it was simply the name of the villa in the Basque country where I had shot some of the more direct sequences. Like the audience, I continued, I was curious as to whether the words had a meaning; a native of the country told me it meant, Leave Me Alone. The audience laughed. I concluded in a more conciliatory tone: how many films had they sat through for hours and been bored? My film had one outstanding merit, it lasted not more than fifteen minutes. The audience applauded as I sat down. The phonograph began a popular jazz tune by the Django Reinhardt guitarists while the screen lit up with sparkling effects of revolving crystals and mirrors, interspersed with flashing lights out of focus and the more conventional shots taken at the Wheelers' summer place. Whenever the phonograph stopped, the piano and violin trio took up with a tango or some popular sentimental French tune. After about ten minutes — and I sensed the strain the audience was undergoing — the lone subtitle appeared on the screen: *The Reason for this Extravagance.* There was no music for a couple of minutes as Rigaut appeared on the screen and went through his act of tearing up the collars. It was a dramatic moment that might lead into some action with suspense. But when the collars began to gyrate into distorted forms, the orchestra broke out into a lilting rendering of Strauss's "Merry Widow Waltz." And the audi-

ence broke out into applause as the film ended with Kiki's double awakening.

People crowded around me to congratulate me, the Wheelers were very proud, and M. Tedesco booked the film for an indefinite run.

My Surrealist friends whom I had invited to the showing were not very enthusiastic, although I thought I had complied with all the principles of Surrealism: irrationality, automatism, psychological and dreamlike sequences without apparent logic, and complete disregard of conventional storytelling. At first I thought this coolness was due to my not having discussed the project with them beforehand, as we did in the publication of magazines and in the arrangement of exhibitions. It was not sufficient to call a work Surrealist, as some outsiders had done to gain attention — one had to collaborate closely and obtain a stamp of approval — present the work under the auspices of the movement to be recognized as Surrealist. I had neglected this, been somewhat too individualistic. True, I had used Jacques Rigaut in a sequence. He was looked upon with respect by the group, but had maintained a certain aloofness, and become involved in personal affairs which did not always meet with the approval of some. Only his suicide later brought them to his funeral to pay full homage to his personality. In his case, if one understood him, it was this personality without any other contribution that had impressed the group.

Robert Desnos, poet, one of the most brilliant exponents of Surrealism for a period, could go into a trance at a reunion in Breton's place, and reel off anagrammatic phrases, poetic sequences, even writing them down as he spoke. Some doubted the authenticity of such *séances,* but even so, they would have been miraculous if previously prepared and memorized. And there was something very disquieting at the end of the proceedings, for it took Robert a long time to come out of his trance. In his normal state he was unpredictable, one moment gentle and urbane, then again suddenly violent and vindictive towards some act of injustice or stupidity. He'd give free rein to

his passions in public gatherings, exposing himself to a beating by some outraged neighbor. Often, in my studio, he'd slump down in an armchair and doze peacefully for a half-hour. Opening his eyes, he continued an interrupted conversation as if there had been no time lapse. It was a perfect illustration of one of the Surrealist maxims: there was no dividing line between sleep and the state of being awake.

Desnos eked out a precarious living as a newspaperman; dramatic, literary and art critic. One evening he announced he was being sent to the West Indies on a reporting mission and would be away for a couple of months. We had a farewell dinner together, including Kiki and a friend of hers with whom Robert was in love. At the end of the meal he became very loquacious, reciting the poetry of Victor Hugo and others who were not particularly Surrealist favorites. Then he produced a crumpled sheet from his pocket; it was a poem he'd written that day. He read it aloud in his clear, well-modulated voice, giving it a significance which it could not have if one read it oneself in a book. I was impressed when a writer read his work himself. The poet Eluard always read his poems aloud to his friends before publication. It seemed to me that poetry should always be thus transmitted by the author. I could never read poetry in books, myself.

Desnos's poem was like a scenario for a film, consisting of fifteen or twenty lines, each line presenting a clear, detached image of a place or of a man and woman. There was no dramatic action, yet all the elements for a possible action. The title of the poem was "L'Etoile de Mer," Star of the Sea. A woman is selling newspapers in the street. On a small stand beside her is the pile of papers, held down with a glass jar containing a starfish. A man appears, he picks up the jar, she her pile of papers; they leave together. Entering a house, they go up a flight of stairs and into a room. A cot stands in a corner. Dropping her papers, the woman undresses in front of the man, lies down on the cot completely nude. He watches her, then rises from his chair, takes her hand and kisses it, saying adieu — farewell — and leaves taking the starfish with him. At home he examines the jar with its contents, carefully. There

follow images of a train in movement, a steamer docking, a prison wall, a river flowing under a bridge. There are images of the woman stretched out on the couch, nude, with a glass of wine in her hand, of her hands caressing a man's head in her lap, of her walking up the stairs with a dagger in her hand, of her standing wrapped in a sheet with a Phrygian bonnet on her head — symbol of liberty, an image of the woman sitting in front of a fireplace, suppressing a yawn. A phrase keeps recurring: *she is beautiful, she is beautiful.* Other phrases, irrelevant, as, *If only flowers were made of glass,* and, *One must beat the dead while they are cold,* appear in the poem. In one line the man picks up a newspaper lying in the street and scans a political headline. The poem ends with the man and woman meeting again in an alley. A newcomer appears, takes the woman by the arm and leads her away, leaving the first man standing in bewilderment. The woman's face appears again, alone, in front of a mirror, which cracks suddenly, and on which appears the word: *beautiful.*

My imagination may have been stimulated by the wine during our dinner, but the poem moved me very much, I saw it clearly as a film — a Surrealist film, and told Desnos that when he returned I'd have made a film with his poem. That night, in bed, I regretted my impetuous gesture — I was letting myself in for another wild goose chase, but I had given my word, and would go through with my promise. Not being able to sleep, I made some notes dealing with the more practical aspects of the realization. Of course, I would not employ professional actors, but choose from my friends those whom I thought suitable for the parts of the woman and the two men. It did not matter much as I was already figuring out a way to do the film so that I would not be dependent on the histrionic abilities of the characters. They would be mere puppets. Kiki was the most natural choice for the woman's part; for the first man, a tall blond boy we knew who lived in the same house as Desnos, would do. The second man who would appear only for a moment at the end of the film could be Robert himself.

The next day, I made my preparations quickly, deciding to shoot the last scene with the woman and the two men before

Robert's departure on his press assignment. Then I could plan and work more leisurely on the production. There were one or two rather delicate points to consider: the portrayal of absolute nudes would never get by the censors. I would not resort to the usual devices of partial concealment in such cases as practiced by movie directors. There would be no soft-focus, nor artistic silhouette effects. I prepared some pieces of gelatine by soaking, obtaining a mottled or cathedral-glass effect through which the photography would look like sketchy drawing or painting. This required some arduous experimenting, but I finally attained the desired result. After a few weeks of shooting, I had all my sequences in hand. I had enough for a film of about a half-hour's running time, but cut and rejected ruthlessly when a sequence seemed to drag, until the film lasted only half as long. Again I thought: its shortness would be one of its merits.

I waited until the return of Desnos, and then arranged for a projection in a small local cinema devoted to foreign and avant-garde films, whose director readily lent me the theater for an afternoon. He needed a short to prelude a showing of *The Blue Angel*, with Marlene Dietrich. He also allowed me to coach his trio of musicians, to play a musical accompaniment to my film, which was silent. I consulted with Desnos on the list of invitations. When Breton and the Surrealists were mentioned, a wild look came into his eyes; he began a violent tirade against the former. There had been a bitter falling out between them, of which I wasn't aware, as it was a period in which I hadn't been frequenting the group. Spying a photograph of Breton on my desk, he picked up a letter opener and jabbed at the print, as he had seen some of the voodoo sorcerers in the West Indies do to a wooden figure representing an enemy. Malediction on the man, he cried. It was calamitous, again I had done the wrong thing regarding the Surrealists. After seeing the film, the director was enthusiastic, as was the invited audience, and said he'd like to include the film in his next program. However, I had to get the visa of the film censors — he was doubtful about showing the nude shots to the general public. Accordingly, I trotted down to the offices of the censors,

located in the Palais Royal, and obtained a date to show them *The Star of the Sea.*

There were half a dozen men in the projection room, important-looking, some venerably bearded, with government ribbons in their lapels. There was some agitation during the showing, laughter when the young man bade the reclining nude adieu, then a long discussion among the jurors. The apparent incoherence of the film upset them more than the nudes, but they admitted that the latter were as artistic as any painting of a nude. They gave me the visa, but suggested the elimination of two short strips in the film, first, where the underwear of the woman undressing passed over her head — the act of undressing was slightly obscene, they thought; secondly, the elimination of the subtitle: *One must beat the dead while they are cold.*

Like my first film, *Emak Bakia,* the film ran for a couple of months and was shown by other houses all over Europe. But I never received enough to warrant continuing movie-making. I decided this would be my last film. However, I was solicited more and more from different quarters to continue. Half-heartedly, I discussed projects, rejecting them finally, as the conditions involved were too restricting for me with my ideas.

I wasn't interested in the art, really, had no desire to become a successful director. If I had unlimited funds to throw away, only then might I be tempted to make another film.

One day I received an invitation from the Vicomte de Noailles to dinner and the projection of a new film, unreleased as yet, in the private movie theater he had installed in the grand ballroom of his mansion in Paris. There were a dozen other guests, notables and society folk. After the film-showing he took me aside and told me he was leaving soon for his château in the South of France, as was his custom every mid-winter, to spend a few weeks away from the rigors of the Parisian climate. Would I like to come down for as long as I wished, be his guest with some others he was inviting? There would be Auric, the composer, and a couple of writers, so that I need not feel too isolated among a purely social group.

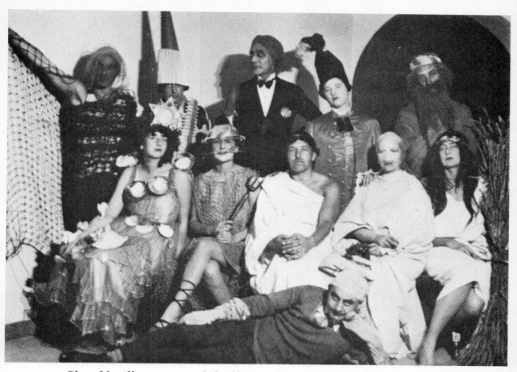

Chez Noailles, 1929, while filming *The Mysteries of the Chateau du Dé*. Man Ray at bottom

There was a reason in asking me, he said frankly, he wished me to bring down my camera and shoot some sequences showing the installations and art collections in his château which was very modern, as well as make some shots of his guests disporting themselves in the gymnasium and swimming pool. The film would be a purely personal affair to be shown later to his guests as a souvenir, and not released to the public. At first this struck me as a very uninteresting proposition, but when I hesitated, he assured me he would help me in every possible way, and pay me a fee. I was to regard the invitation as on the same footing as that of the other guests; could do what I pleased and whenever I pleased, and be comfortably housed in the château. As I had already enjoyed Noailles's hospitality and generosity on other occasions — photographing his family and the transformations in his Paris home, selling him one of my metal spirals, being invited to the sumptuous balls he gave, I accepted this new invitation. It would be in the nature

of a vacation, away from the chores of my studio, without any material loss to me. As I was given a completely free hand and the filming would be purely documentary, requiring no inventiveness on my part, it would be an easy, mechanical job and not change my resolution to do no more films. The thought of not showing it in public also reassured me.

Before leaving for the south to open up his château, Noailles gave me a photograph of it — a conglomeration of gray cement cubes built on the ruins of an old monastery on the top of a hill overlooking the town and the sea. Designed by a well-known architect of the day, Mallet-Stevens, it was severe and unobtrusive as if trying to hide the opulence that was housed in it. In spite of myself, my mind began to work, imagining various approaches to the subject; after all, it would be best to make some sort of plan if only not to waste effort. The cubic forms of the château brought to mind the title of a poem by Mallarmé: "A Throw of the Dice Can Never Do Away with Chance." This would be the theme of the film, and its title: *The Mystery of the Château of the Dice*. I acquired some accessories, nothing cumbersome, a pair of small and a pair of very large dice, also six pairs of silk stockings. The latter I intended to pull over the heads of any persons that appeared in the film to help create mystery and anonymity. According to the script I had prepared, I'd start filming from the moment I left Paris.

Two men, bundled up as if for travel in the open on a cold day are sitting at a bar (it is January in Paris). Their faces are blurred by the stockings pulled over them. They are throwing dice to decide whether or not they shall leave. Yes, say the dice, and they go out to a waiting car. The steam of their breaths comes through the stockings as they take off for an unknown destination. Leaving Paris, past the demolished fortifications, the car bounces along uneven roads until it comes upon the smooth national highways going south. There is snow on the ground, but the car travels at a good speed — the roads are free of any other traffic. A train in the distance or a rare truck are the only other signs of life. Further on south, poplar and olive trees begin to appear and along the road, leafless plane

trees whose branches have been brutally truncated, look like something out of early Cubistic paintings. Arriving at a small town, one perceives on a dominating hill a Cubistic château. Following a spiral path, the car reaches the château and drives through an opening in a wall without any gates. Inside is a spacious lawn surrounded by a wall with spaced rectangular openings that frame the surrounding landscapes. It is like a picture gallery with paintings on the walls. There is no sign of life anywhere.

This was the first part of the film. Although mostly improvised it fitted in with the script. After the start, not knowing what I was heading for, it seemed to me that I had successfully created an air of mystery. Our host received me and my assistant, Jacques Boiffard, who was now an accomplished cameraman. We had lunch and were installed in our quarters. The other guests retired to their rooms for a siesta. At cocktail time all came down to the bar, informally yet carefully dressed. Except for the Count de Beaumont, I hardly knew the others, but there was Georges Auric, the composer, who had come to my studio in the early days, and there was Marcel Raval who had devoted an issue of his avant-garde magazine, *Les Feuilles Libres,* to my drawings and Rayographs. So I wasn't too much out of my element. I explained what my host had requested of me, but that I had a little script, which required the appearance of characters at certain points, to break up the monotony of a purely documentary film. Would they give me an hour or so every day — there would be no tiring rehearsals nor exposure to blinding lights. The guests demurred; they did not consider themselves photogenic enough to face a camera. I told them I had solved the problem without resorting to tedious makeup. Then I ran up to my room, pulled a silk stocking over my head and appeared before them as an anonymity, although features were faintly visible. The guests were relieved, approved my idea and put themselves at my disposition. There was a little hitch, however; Noailles took me aside and said he had ordered a truck with generator and lights, which would arrive in a day or two. He thought it was indispensable in movie-making. I told him to cancel the order; it was unneces-

sary with the bright sunlight, and that I had the newest, fastest film and lenses. The filming should not take on a professional character, I added.

The next day I began conscientiously to shoot various aspects of the château, inside and out, panning the angles of the building, and running the camera on a small dolly for the interiors, to avoid too static sequences. Going down into the basement, I came upon a row of large wire mesh panels fitted into the wall. Pulling one out on its rollers I found it covered with paintings of all sizes. So were the dozen other panels. My host explained this was his surplus collection for which he had no room on his walls. He had befriended every painter he had met or who needed assistance. But the panels were originally part of the laundry installation, for drying the wash. I filmed them coming out one after the other, without the intervention of human hands; a simple movie trick. But I filmed them showing only the backs of the paintings. In mounting the film I added this caption: *The secrets of painting.* Whether the sequence was too short or badly filmed, I'm afraid I was the only one to appreciate the bit of satire.

Having obtained enough film for the documentary part, I turned my attention to the introduction of people, according to the rough script I had prepared. De Beaumont and one of the ladies played the sequence after my arrival on the lawn the first day. Dressed for traveling, their faces shrouded with stockings, they approach the middle of the lawn, stopping before the large pair of dice on the grass. Closeup of feet kicking the dice around for a moment. Shall we remain, they ask each other? Stay, say the dice. Then all becomes animated. The guests, faces shrouded, are on a terrace engaged in diverse gymnastics. Inanimate objects, hoops, dumbbells and medicine balls have a little spree of their own rolling back and forth on the terrace. The scene moves to the glass-enclosed swimming pool. All the guests come in, their faces anonymous, in black bathing suits, and disport themselves. Over the pool hang ropes and trapezes which are occupied by the more active ones. Some plunge into the water. The sunlight is over all, producing fantastic shadows on the tiled walls. All this was filmed

without any rehearsals. I was sure of my takes; it was easy work.

My host and his wife, Marie-Laure, were expert swimmers and I proposed shooting them individually. They deserved special sequences. I filmed her under water, juggling with three oranges; it is a slow motion shot. I had her vainly combing her hair under water — she could remain there quite a long time before surfacing. As for Noailles himself, he proposed to do a diving act. Jumping off the diving board he disappeared under water. I was cranking away, but he did not appear immediately. Then farther on I saw an arm come out of the water, groping in the air until it approached the bar around the edge of the pool and Noailles heaved himself out onto the ledge, trying to pull the stocking off his head. It had become waterlogged and he was choking. It might have turned into a tragedy. I apologized for my lack of foresight, but he laughed it off. Later, to obviate this too dramatic episode, I had a reverse print made of the sequence showing him rising out of the water and landing back on the springboard.

There were a couple of other shots of the guests, this time in repose, lying on the floor of the gymnasium, lazily throwing the dice, then falling asleep, and one by one fading out of the picture. Caption: *A throw of the dice can never do away with chance.* To finish the film I had de Beaumont and the lady meet on the terrace in the twilight against the sky. Their forms appear in silhouette against the fading light as they grapple and remain fixed like a statue. Gradually, the group turns white like marble against a dark sky. Then a closeup of an artificial hand holding a pair of dice. *Finis.* I completed the special effects in the laboratories in Paris, and the film was ready when Noailles returned. They gave a dinner inviting all those involved, and the projection followed. Everyone was highly amused, trying to identify the persons in the film. Noailles was delighted and at once proposed that I make a full length film with no strings attached, which he would finance. But I kept to my resolve not to go on with movie-making. Sound was now well established, and the amount of work involved, collaboration with technicians, and all the details of

production frightened me. I refused the offer and thanked my patron.

But Noailles had been infected with the movie bug; he made offers to Jean Cocteau and to Luis Bunuel who both produced films based on their own scenarios. There were certain subversive elements in these films which caused Noailles some trouble with the church and charitable organizations and threatened his standing in French society. However, this was ironed out, and Cocteau and Bunuel were launched on their careers as film-makers.

I was criticized for not having accepted such a rare offer as making a film on my own terms — I had missed the boat, it was said, as on some previous opportunities. I replied simply that I detested traveling. Unless some science fiction writer has already thought of it, I propose that in the future, in order to get somewhere, all one need do will be to turn a dial on his wrist watch, liberating him from the force of gravity, rise a certain height vertically and wait until the revolving world brings his destination to him. I leave to more fertile minds the problem of going north and south, that is, along the axis on which the world turns. The trip, in any case, should not take more than a few minutes. Fundamentally, I think I am lazy.

Several approaches were made from different sources to utilize my services as a cameraman, but I did not allow myself to become involved. There was General Kerensky whose abortive attempt to overcome the Bolsheviks brought him to Paris with his supporters, to prepare a comeback. I was asked to shoot some film of him in his headquarters. Obligingly, I sent my assistant around with a hand camera — the take would be anonymous — I wasn't getting myself mixed up in politics. About the same time Max Eastman came through Paris, collecting material for a film dealing with the Russian Revolution. I had known him in my early days in New Jersey, and had been impressed with his personality. Now, Trotsky was living in exile on the Island of Prinkipo in the Bosphorus. Would I get on the Orient Express to Constantinople and shoot a few feet of film of him in his retreat? Besides detesting travel, I felt this jaunt

might create some misunderstanding by leading people to think I was politically minded. I had already been taken to task in a book by a cameraman of the Russian director Eisenstein, pointing me out, or my work, as an example of bourgeois degeneracy. And I wasn't interested in politicians any more than they were interested in me: I considered my ideas and work as important as that of any of the world-shakers. However, to oblige Eastman, I had a solution. A young college man, an archaeologist, was on his way to the Orient, to participate in some excavations. I gave him my hand camera and the money Eastman had given me for the trip; he willingly accepted the assignment — it was a diversion for him — and brought back shots of the exiled man.

Before disposing of my professional movie material I used it once more in what might be called a sight-seeing, or slumming operation. At the instigation of the poet Jacques Prévert, a frequenter of the Surrealist group, we roamed about the more shady sections of Paris with my camera, shooting scenes haphazard and fraught with some hazard. With the permission of the proprietor of a dance hall frequented by ambiguous characters and their women, and with Prévert's consummate use of the local argot, as well as with several rounds of drinks, I was able to get a sequence of the goings-on. We even persuaded a couple of the apaches and their partners to enact a little scene on a deserted lot. They refused to accept any money for the trouble. For another sequence, I installed my camera in the window of a room on the top floor of a sordid hotel overlooking Place Pigalle in Montmartre, frequented by women plying their trade, cranking my camera whenever one accosted a passerby. As one man stopped to talk to a girl, she opened her bag and gave him some money. We planned other excursions, but ran out of film and funds, our backer having defaulted, and our work was shelved. Prévert later became a famous, successful scenario writer for French films.

One summer in the middle Thirties André Breton, Paul Eluard, their wives and I, were guests of a charming woman, a writer who was enthusiastic about Surrealism and its expo-

nents. Lise Deharme's country house in the south was a rambling affair, filled with strange objects and old rococo furniture. I had been given a small movie camera by a friend, which I brought along to make some souvenirs of our stay. To pass the time it was decided to do a Surrealist film. Although my material was inadequate for such an ambitious undertaking, I accepted the idea eagerly. Here was a chance to do something in close co-operation with the Surrealists, whom I had not consulted in my previous efforts. It was an opportunity to retrieve myself. Breton and Eluard spent a day mapping out a scenario in which all were to take part. There were sequences of the women, strangely attired, wandering through the house and in the garden. A farmer's daughter nearby, whom we'd seen galloping across the country on a white horse without a saddle, was persuaded to repeat the ride before my camera. I would have liked to have her nude for the act, but that was out of the question. She was given a one-piece white bathing suit, which, at a distance, and in movement, might produce the desired effect. In one scene, Breton sits at a window reading, a large dragonfly poised on his forehead. But André was a very bad actor, he lost patience, abandoned the role. I don't blame him, secretly I have always detested acting, making believe. The best part of the shot was the end, where he got into a temper. This was not acting. After a few more sessions, during which I was having trouble with my instrument — for it jammed often, losing half the takes, I abandoned the operation, to everyone's regret. On our return to Paris I salvaged what I could — it looked promising but there was not enough for a short. However, I had a few good stills which were reproduced in an art magazine announcing a Surrealist film by me. I was urged to continue, but my heart wasn't in it, besides, ·I no longer had my professional equipment, had renounced making films, and intended to abide by my resolution. Too bad, they said. Yes, too bad, I replied, with the afterthought: perhaps for the others. My curiosity had been satisfied — surfeited.

In reality, there was a deeper reason for this abandon. A book, a painting, a sculpture, a drawing, a photograph, and any concrete object are always at one's disposition, to be ap-

preciated or ignored, whereas a spectacle before an assemblage insists on the general attention, limited to the period of its presentation. Whatever appreciation and stimulation may result in the latter case is influenced by the mood of the moment and of the gathering. I prefer the permanent immobility of a static work which allows me to make my deductions at my leisure, without being distracted by attending circumstances. And so, the last few years before the war, in between my professional photographic activities, I concentrated on painting, drawing, and the making of Surrealist objects — a substitute for sculpture — which figured in magazines and exhibitions sponsored by the group. My work was accepted without criticism, never rejected. This, in itself, was a great satisfaction; I have never submitted a work where a jury functioned, nor in competition for a prize, unless it was announced that I was invited unconditionally, *hors-concours*.

The climax of Surrealist activity was without question the big exhibition in 1938. Besides the dressing up of store mannequins by the painters, several poets were entrusted with the task of providing other attractions or distractions. Thus it was that the poet Péret, who had lived in South America, installed a coffee-roasting machine, whose fumes assailed the nostrils of the visitors. There were recordings of hysterical laughter by inmates of an insane asylum, coming out of a hidden phonograph, which cut short any desire on the part of visitors to laugh and joke. There were other extravagances introduced by painters to bewilder them, and destroy the clean, clinical atmosphere generally seen in the most modern of exhibitions. It was quite natural that I should be appointed master of lighting. I had a ramp constructed several feet from the wall all around the gallery, with daylight bulbs hidden behind it, as in stage lighting. The paintings were beautifully lit. But for the opening night, when thousands of people came, there were no lights. An attendant sat at the entrance before a large box; as each visitor entered the dark gallery he or she was given a flashlight to find his way. Needless to say, the flashlights were directed more to people's faces than to the works themselves. As in every crowded opening, everyone wished to know who

else came, and paid little attention to the paintings. The paint-ers were quite angry with me, but I assured them that for the following weeks the gallery would be well lighted, when peo-ple came with the intention of seeing the works. Although a sign requested the visitors to replace the flashlights on leaving, many carried them off as souvenirs, making for a large indem-nity to be paid by the organizers — the lamps having been rented. If I had thought of it, I'd have had them marked and sold as souvenirs, of the Surrealist Exhibition of 1938, Paris.

OCCUPATIONS AND EVASIONS

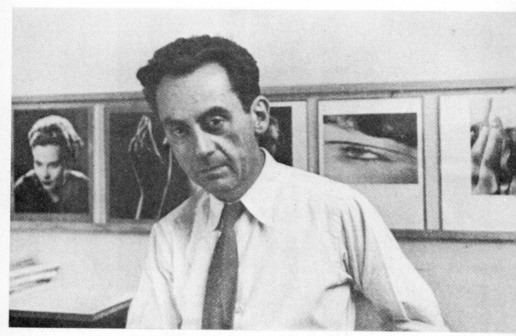

Man Ray, 1934 (photograph by Carl Van Vechten)

My reaction to the hectic Twenties began in 1929. My excursions into the film world had done me more harm than good. People were saying I had given up photography for the movies, few sitters presented themselves for portraits. The magazines shunned me. I decided to start all over again, invited people to sit for me, and arranged for an exhibition of my Rayographs to stir up interest.

My sponsor for the films, Wheeler, was still around, and I hoped to interest him in acquiring all the prints, although he had never bought a work of art, except one painting to give as a present to a friend. He was disappointed that I did not pursue the career of a movie-maker. Before I could use my persuasive powers, the crash hit Wall Street, and though Wheeler had invested all his assets in Europe, he acted as if he too had been hit. However, my exhibition created a new flurry of interest, and people began coming around to the studio.

But I had lost my original enthusiasm. It was time for a complete change in my life, as had happened about every ten years. I decided to help the transformation, whip up my disillusions with new interests. Having terminated a love affair, I felt ready for new adventures. I also had to get rid of the things that had taken up too much of my time and energy, especially mechanical things. I sold my professional movie camera and

my swank car which I had been a slave to for six years. These things no longer had the romantic appeal for me as in the beginning; they appeared just as prosaic to me as a sewing machine. It was a luxury to hop into a taxi and leave it forever at my destination. I no longer tried out new cameras, but did go into the darkroom now and then to make *solarizations,* since it was a deviation from the principles of good photography: to work in the dark. *Solarizations* were made comfortably with the bright lights turned on.

Walking along one day in a quiet street near the Luxembourg Gardens, I came upon a to-let sign for an apartment. I took it at once and spent a couple of months fixing it up according to my own ideas, designing the furniture, too. There was nothing in it that could have come out of a department store. It was very sober, yet a perfect love nest. And I would spend my mornings painting, away from the atmosphere of the photographic studio. My assistant, Natasha, could attend to calls, appointments and the work in the darkroom, until I came in the afternoon.

Often, in the evening, a woman would prepare a good dinner for some friends I had invited. The walls of the dining room were covered with paintings and objects of mine as well as of some of my Surrealist friends. Except for a few Rayographs, there was no sign of my photographic activity. If someone wanted a portrait, they came to the studio. There were more intimate little dinners, and when the concierge remarked on the number of unescorted ladies that came to the apartment, it was easily explained by my profession of photography. These visits were generally repeated only a few times, as I was being a bit too casual with my guests, keeping to my resolution not to get tied up with one alone. There was a girl who left in a huff, finding fault with my ideas on interior decoration. It is true that I told her she was not obliged to stay if my yellow curtains annoyed her.

By the middle of the Thirties I had re-established myself as a photographer, moving about more in social circles and being solicited by advertising agencies and fashion magazines. It was more irregular work, but better paying than portraits, leaving

me more time for painting. I found a large studio with an apartment, which I fixed up again according to my ideas. Here I could live and work. I gave up the other places, reducing my double life to a single one, still remaining single as far as amorous adventures were concerned. The studio was full of photographic paraphernalia, to impress my clients, but the walls were covered with paintings and a couple of easels stood among the lights. None except the Surrealists and some friends noticed the paintings. I was casual with my more commercial clients, getting all I could out of them. I acquired a little car, as I had to go out often on location, but still took taxis whenever possible. And I began to travel a bit, being sent all over Europe to get portraits of eminent doctors and scientists to sponsor American products.

Extraordinary results were expected of me, but I soon discovered that editors were more interested in using my name than in a new idea or presentation. If they expressed hesitation as to the advisability of using one of my far-fetched works, asking for a reduction in my fee, I replied to soothe my hurt vanity that in that case the fee would be double. My travels in the later Thirties took me to New York, for work for the fashion magazines, as has already been mentioned; also for the exhibition of Surrealism in the Museum of Modern Art. There were trips to the South of France in the summer by car, to join my friends, among them Paul Eluard, the poet, and Picasso. In spite of my resolution not to get involved again, I had at this time made the acquaintance of a beautiful young mulatto dancer, Adrienne, from the French colony of Guadeloupe. We were in love, and were received by the others in the south with open arms.

We met on the exclusive little beach, La Garoupe, in Antibes. Kodak had just put out their new color film; gave me a camera and supply of film to see what I could do with it. Only Adrienne with her coffee-and-cream skin looked as if she belonged, the rest of us in our new trunks and bikinis looked like white worms. Well, Picasso looked somewhat bronzed, (his native Spanish coloring). This would never do for color pictures, I thought. Taking an orange-colored filter from my black and

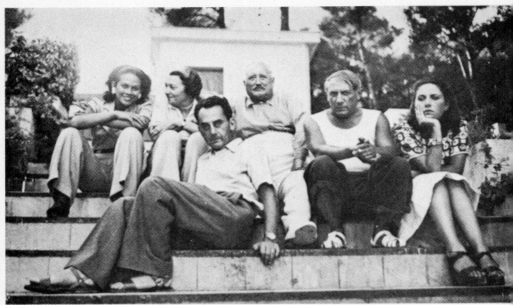

Antibes, 1937. *L. to r.:* Adrienne, Mrs. and Mr. Cuttoli, Picasso, Dora Maar, Man Ray

white outfit, I put it on the color camera, filmed the group, and sent the films to London for processing, since the material had come from there. I found the film when I returned to Paris with a printed note included, explaining that I had forgotten to remove a filter from the camera — the colors were all wrong. Upon projecting the film I was astonished and delighted at the result; the sky was green, the sea was brown, and everyone looked like a redskin or at least as having been exposed a month to the sun. I sent the camera back, disgusted with the technicians; they had probably never heard of Gauguin and Tahiti. And I never wanted to hear of moving pictures again, at least, never handle a camera.

It was at this point that I rented a sort of penthouse flat in Antibes, to spend as much time as possible painting. But there were ugly rumors in the air, and came the Munich pact in '38. I returned to Paris, decided that if worst came to worst, this is where I'd rather be. In Paris there was no visible anxiety, there was the usual round of parties and exhibitions, my work during the collections of fashions, and even an exhibition of some of the paintings I had made in the south.

The next year, at the end of the summer, Hitler invaded Po-

land, without declaring war, but fully prepared, while the more gentlemanly countries, France and England, to abide by their treaties, solemnly declared war, though unprepared. It was true, France had dug into its Maginot Line, like an ostrich with its head in the sand (I don't know whether this legend is authentic), but its behind stuck out before it reached the north coast. Methodically, the Nazis mopped up Belgium, Denmark, Norway, and Holland before turning their attention to the more serious business of invading France.

As everyone knows, in the first eight months nothing happened, although Paris had put on its battle dress; curfews, air-raid shelters, blackouts at night, with dim little blue lights at the street corners to show the way home after dark. Then there were the gas masks. Every schoolchild and French citizen was given one to wear, hanging from the shoulder in its tin can. I was stopped a couple of times by the police asking why I wasn't carrying one. I replied that I was not entitled to one, being a foreigner. But I could buy one, I was told. I promised to do so.

There were a few token intimidation raids on Paris, carefully planned to do damage to inconspicuous residential sections. When the sirens first sounded I went down with the others into an air-raid shelter, but after that, never again. I'd go to bed or to a park bench in the Luxembourg, with a book, until the all-clear sounded. Once in the park a policeman approached me to ask why I wasn't in the shelter. I explained I suffered from claustrophobia. He shook his head and let it go at that. Aside from these small air raids when all traffic had to stop, nothing much changed, the restaurants were full at lunchtime, at night people sat and ate behind blacked-out windows taped against concussion. They went to cinemas and the theater, got home as best they could, mostly on foot.

During the first few weeks after France's declaration of war, I was informed that Picasso had abandoned the flat I'd let him have the year before in Antibes. There were a lot of my things still in it which I wanted for my new little house acquired near Paris, at St.-Germain-en-Laye. To get down south I needed a military pass, as all roads and bridges were guarded. Through

an influential friend in the scientific research department, I obtained the pass. I offered my services to the government in any capacity it could use me, but was told that being of a neutral country, this was not possible; however, perhaps I could help in an unofficial way. My friend would keep in touch with me.

Hopping into my car, I started off at full speed for Antibes, about six hundred miles away. Except for a few stops by armed soldiers, I was making good time in a drizzling rain. But approaching a turn downhill towards a village, the car skidded, shot off the road and dropped about eight feet between two trees into a muddy turnip patch — on all four wheels. I sat for a while quietly, felt nothing amiss, and stepped out to see what damage had been done. The car did not have a scratch. A man came running out of a cottage and when he was assured that I and the car were none the worse for the accident, claimed damages to his turnips. I showed my insurance papers but to no avail — the car could not be removed until a settlement was made, in cash. I gave him a couple of hundred francs and asked if there was anyone around to pull me out. The nearest place was an undertaker's down the road, he had horses. There was a garage in the village a mile or so away. I went down to the undertaker, and persuaded him to come back with a horse and some planks. After two hours of work, the car was put back on the road and slowly towed to the garage. I asked for a checkup of the steering and rear, putting up at a small inn during the night.

Early the next morning I went back; the car was in perfect condition. Having already covered about a third of the distance, I drove steadily, arriving in Antibes before nightfall. The next day I found a shipping agent and gave instructions for emptying the flat, and sending my things to St.-Germain-en-Laye. Everything seemed to work normally — there was no sign that France was at war.

I loaded the back of my car with some small odds and ends, then went for a stroll in the town. This would probably be my last look at the place, so full of pleasant souvenirs. I sat down at the café, Place Macé, with its tall palm trees. Presently a

handsome, middle-aged, Japanese man sat down nearby. It was Sessue Hayakawa, a famous movie star of the silent days. I spoke to him in English and he replied in perfect English, with an American accent. He was glad to have someone to talk to, being alone and living quietly on the Riviera. Since the advent of the talkies, there wasn't much work for him.

My return to Paris was uneventful, except at one junction when the soldiers conducted me to the local constabulary for verification of my papers. A young American couple was being held; they had no military pass and spoke no French. I spoke to them; they were trying to get back to Paris, hitchhiking, from whence they hoped to be repatriated. The officer told me gruffly to speak in French. I said I was simply acting as interpreter, speaking English — didn't he know the difference between German and English — and weren't the English allies of the French? Besides, the couple had their American passports. I offered to vouch for them, take them with me back to Paris. No, they had to be held for further investigation, all spies were provided with passports, he said, then sent me on my way.

If there were no immediate signs of war during the fall and winter of 1939-1940, new restrictions and laws were being promulgated to make for greater austerity. Sugar, tobacco, coffee and gas were rationed, and, naturally, hoarded, with a black market developing at once. Lines formed in front of groceries and food shops whose windows were criss-crossed with strips of paper, some very artistically. This, I think, depressed me the most, but I followed suit with my studio windows, using, however, transparent tape. It was quite invisible.

I had almost no photographic work, so turned to painting, executing several large canvases. One of these was a composition of several dreams, done in brilliant colors and using all techniques, from Impressionist to Cubist and Surrealist. Now and then I'd drive out to my new little house in St.-Germain-en-Laye, where workmen were making some changes, and stay a couple of days. One night I heard distant guns, and when I fell asleep again, dreamed that two mythological animals were at each other's throats on my roof. I made a sketch of this and

incorporated it in the dream painting, which I called: *Le Beau Temps* (Fair Weather).

Strolling up to the open market in the town one morning, I met André Derain, the painter, whose house was a few miles out in the country. We chatted for a while, discussing the anticipated invasion of the Germans. He was of the opinion that nothing would happen to Paris, it would be like the First World War, when the Germans were repulsed as they approached Paris from the east. As for ourselves, personally, we had nothing to fear for our property, we were well to the west of Paris.

February and March were usually the months of the fashion openings for spring and summer clothes. The couturiers decided to make a supreme effort, to show that French morale was good. They put on elaborate shows of new clothes — American editors and buyers flocked to Paris and I was put to work on the collections for a couple of weeks. As usual, it was all rush work to meet the magazines' deadlines. Sittings were held day and night, in studios with specially prepared backgrounds and in the showrooms of interior decorators. There were frequent air-raid warnings when all work was stopped and we descended to the shelters until the all-clear. I made for the toilets with a book or paper. Sometimes, police whistles from the street at night warned us that our lights were showing through chinks in the curtains. There was an atmosphere of danger to make the work more exciting; we felt like soldiers in the front line. Some of the directors barked out short orders as would the captain of a company. It all ended with frayed nerves and exhortations to finish the work quickly, as the Germans increased their bombing and softening-up of the country. The buyers and editors returned to New York, crossing an Atlantic infested with U-boats.

We in Paris settled down impassively to face the future. There was every confidence in the army's ability to stave off the invader: the First World War slogan was taken up again: They shall not pass. There were no battles; the army sat in its nine-story Maginot Line, equipped for a long siege. Outside, all was turning green with the spring, the chestnut trees along the boulevards put out their multiple white and rose candles, the

gardeners were busy planting the flower beds in the parks with the first blooms taken from the hothouses. There was a little area in the Luxembourg Gardens fenced off, containing an artistically camouflaged anti-aircraft gun, which was used once or twice against some German planes, leisurely inspecting the city.

Camouflage was much discussed; new ideas had been born since the last war, but no one knew yet that green and brown paint photographed differently than natural greens and browns, which gave off infra-red rays, so that nature looked brown all over, while the painted surfaces were greener than nature. The most successful attempt at camouflage was the painter Léger's, on an American woman's little car. She had joined the Red Cross, and drove about the city like a butterfly, her car striped in all the primary colors, like Léger's paintings, flashing in the sunlight or adding a gayer note when the weather was gray. If the principal cities of France had been so decorated, with flags flying, perhaps the Nazis might have been less ruthless and come in as if on a holiday.

All in all, Paris in spring was paradise again; one could not help being optimistic, since nature was true to herself, ignoring all threats. In May the barometer had settled permanently on fair, like my last painting, Fair Weather, at least, like its title. I could not, like Whistler, say that nature was imitating me, as there were a few disquieting elements in my work which were not literally borne out by its title. The painting was less prophetic than it was a recording of the past, like a barometer with a chart in which one can read what has gone before, deducing the tendency for the future.

With the weather at its most perfect, the Nazis began to move, but not in the direction of Paris. They skirted around north of the Maginot Line, along the coast, disposing first of the British army at Dunkirk, then spread out over Normandy, preceded by their planes which blew up bridges and railroad stations. There was very little resistance, the Nazi machine moved and looked like a robot. The coast facing England was occupied and gradually fortified to repel any possible attempt to regain the continent. Other Nazi divisions turned east again,

approaching Paris from the rear: something no one seemed to have thought of. The French army was never where it was most needed. Despite the clamors to declare Paris an open city, it was decided that Paris would be defended to the last square foot.

Frantic preparations began, as much of the army as was immediately available was brought in, trenches were being dug all around the city, blimps hovered in the skies to warn of the arrival of the enemy. A smoke screen, comforting but ineffective, was thrown up around; it did not prevent the German planes from flying over the city. Finally, all civilians and those not connected with the army were ordered to leave Paris within twenty-four hours.

Streams of refugees were already jamming the roads from the northern towns, all heading south. There were also the luckier ones who had managed to get out of Belgium and Holland. The exodus from Paris took on a biblical character. There was no panicking, all was prepared with method, yet with a certain amount of fantasy. Cars were loaded with the more precious belongings, including bird cages, dogs and cats. On the tops were piled mattresses and bedding; (it had been announced on the radio that the enemy planes were swooping down on the long lines of exiles, machine-gunning them, although the planes also dropped leaflets, explaining that it was difficult from their position to distinguish between soldiers and civilians. All in line with the Nazis' policy of creating confusion). Trucks were loaded with machinery from the smaller manufacturers. The gas stations were besieged, each car-owner putting in reserves of gas in any sort of receptacle. Those who had no other means of transportation left on foot, some pushing bicycles and baby-carriages, loaded with a few objects, the bird cage or even a fish bowl topping the pile.

Being a good customer at my garage, I obtained a couple of ten-gallon cans of gas which I put in the trunk of my car. Looking around in the studio to decide what I should take with me, I was overcome with a feeling of helplessness. It was so full of objects I had collected over the years: paintings, drawings, books, photographic files and materials, that I could not make

a choice, even if I had room for them in my small car. I simply picked up some linen, a coat and a pair of heavy shoes. Adrienne had laid out all her finery to pack, which I promptly eliminated, allowing her only a few essentials. From the kitchen we filled a little basket with some cans of sardines, and fruit, and a bottle of champagne — Cordon Rouge, which was a brilliant idea, as it turned out, although at the time it put me in the same category as the bird fanciers. With a farewell look at my studio and the feeling that I would never see it again, that twenty years of work was being wiped out, I locked the door.

It was a perfect morning, mild and sunny, as we got into the car. Except for a small bag on the back seat and our basket of victuals, as if we were heading for a picnic or a weekend, the car looked empty, in contrast to our neighbors who were loaded until the tires disappeared under the fenders. I felt a bit guilty — I might have telephoned a couple of friends and offered to take them, too. On the other hand, one couldn't tell what the outcome of this odyssey would be. Since one could only go south, I'd head for Spain, I thought. Better not assume any more responsibilities. First I stopped at the bank to draw out some money, couldn't take it all they said. I was surprised not to see a rush on the bank. Then I drove to a tire dealer; although my tires were in good condition, I had a new set put on, including a new spare. Wasn't taking any chances. Then I headed west across Paris towards St.-Germain-en-Laye to close up my cottage in the country nearby. That part of Paris was completely deserted and I entered the Bois de Boulogne, leading out of the city. A lone policeman stopped me, asked where I was going. I explained. He said the Germans were coming from that direction. I replied I was an American, and neutral. I'd show them my passport. The officer shook his head sadly and let me go on.

Once out of the city, I put on speed, raced through the several villages along the Seine — not a soul was stirring, everything was closed down, everyone had left. At one point a company of French soldiers came down the road — I pulled over and they passed without paying any attention to us. It was noon when we arrived near our destination and I decided

to stop for lunch if something was open. Driving into the square in front of the château of St.-Germain-en-Laye, where all the restaurants were grouped, a strange sight confronted us. The restaurants were open, the terraces filled with tables and chairs all occupied by the refugees. Their cars were parked nearby with mattresses and bedding strapped to the tops; it had rained during the night, but now the sun was shining, and drying the wet things. I took an empty table near that occupied by a family. This group had spread out their wet things on an unoccupied table nearby. When they left, five francs were added to their bill for wetting the cloth on that table. There was quite an argument. Adrienne and I lingered over our lunch and finished a good bottle of wine.

Then I drove down to my little house, picked up a few small objects that did not add to our baggage, left a note with some money on the table for the maid who came in every day, carefully locked up doors and shutters, and went into the garage to shut off the water, gas, and electricity. Adrienne wanted to take her new bronze-gold finish bicycle; strap it to the front of the car as we had seen on some of the refugees' cars. But I refused, I was leaving so many other more valuable things behind; the bicycle would be the least missed.

I knew the surrounding country pretty well, and, while heading south, I kept to the smaller roads as much as possible; these were already pretty well filled with farmers' trucks carrying household goods and the families. Finally, I was obliged to get on a main road which was choked with the two-way traffic, refugees going away from Paris, and army reserves heading for the city. There were many stops, besides driving only in low gear whenever the car did move. Late in the afternoon, a cry was heard in the distance, swelling and getting louder as it approached us: the German planes were coming. Everyone dashed for the woods bordering the road, leaving all conveyances. We heard a few bursts of machine-gun fire through the noise of the motors, but no one was hurt. And there were leaflets on the ground, as had been rumored, apologizing for the attack.

We went through Rambouillet before nightfall, having driven

302

about thirty miles in seven hours. On the road again, I pulled into a path in the woods and we spent the night curled up in the car. In the morning, I took a less frequented road, leading to Chartres, whereas most of the refugees were heading due south towards Orléans. I decided to continue a more westerly course, towards Bordeaux. Presently the road became more crowded, but it was still possible to do fifteen or twenty miles an hour. Coming into a small town, we had lunch in the crowded dining room of the one hotel. A radio was blaring out the latest news. Things weren't going well at all; no direct news from Paris where the army was digging in, but wherever the Nazis met opposition along the roads, they sent in planes that wiped out the points of resistance with a few bombs. At one point a group of French tanks had stood their ground, but were soon reduced. Gradually the dining room emptied, we got back into our cars and started leisurely on our way.

The next big city on the road was Tours, where all were heading to fill up on gas. I had used one of my reserve ten-gallon cans on the road, but decided to fill it up, too, to be on the safe side. I took my place in a long line in front of one of the gas stations, sitting on the empty can; as it looked like a long wait. Everyone was very jittery, there were rumors that the Germans were going to bomb Tours. With the slow progress in front of the gas stations, tempers became shorter. A fight broke out between two refugees ahead of me about their place in the line. After half an hour, I gave up my place and returned to the car with the empty can. Crowds always nauseated me; people jammed together, whether in a street demonstration, or applauding in unison in a concert hall, filled me with apprehension. I knew from my experiences of the Dada period manifestations, that any contrary action on the part of a lone individual would expose him to the fury of the mob.

I drove out of Tours, down to the Loire River, and followed a quiet country road along its banks. After twilight, I drove into a wooded lane where we made ourselves as comfortable as possible for the night. Adrienne was a perfect traveling companion, her good humor and self-effacement sustained my spirits, prevented me from giving way to a feeling of despair.

And it was a relief not to see other people. With the break of day, I got out on the road again to catch the first rays of the sun — it had been chilly and damp in the woods. I drove for a couple of hours, arriving at a village called Montaigu, with a gas station at its entrance. Not a soul in sight but the elderly attendant sitting at a little table dipping a croissant in his bowl of coffee. I asked whether he had gas; he shook his head in the affirmative, then I inquired if there was a café nearby where we could get breakfast, while he filled the tank and checked the oil and water. He invited us to have coffee with him, brought out a couple of cracked bowls, a coffee pot and a few croissants. While we ate he attended to the car, filling up the empty can also. I asked for the bill, bringing out my gas-rationing tickets, but he waved it all aside; the Germans would soon be in, he said, and take over — money and tickets would be useless then. I thanked him profusely, could not help saying that if the French had been as generous with one another as he was with strangers, had stood by one another, they might not have come to this pass. With this remark, I drove off. I was more convinced than ever that people were at their best when alone.

My objective now was to get to the Atlantic coast, then down to Bordeaux which was still some distance away, so I headed for the nearest town, Sables d'Olonne, a summer beach resort, hoping to find a comfortable hotel where we could stay a couple of days and rest up. The road was deserted, but I drove slowly, enjoying the emptiness of the surrounding country. We passed a military airfield which was a shambles, with the hangar leveled and a few smashed planes lying around. The Germans had bombed it the day before. The war still seemed far away; until now, I had seen no action, and very little of its consequences.

Arriving at Sables, I made the rounds of the three or four hotels listed in my guidebook, but they were all filled up. The last one offered me an attic room without windows but with a small casement in the ceiling showing a blue patch of sky. I took this, carried up my bag, and returned to the car to see

about putting it in a garage; in those days, no one left his car in the street overnight, and not a single car was visible in the town. The nearest garage was jammed to the doors with cars, they could not take another one; two other places also refused to take me. Then I had some trouble starting the motor, the battery was showing the strain of the trip from Paris. The mechanic at the last garage told me to leave the battery overnight, he'd have it charged. But where to leave the car? I drove back to the hotel, parked the car at the curb, removed the battery and carried it to the garage. The law would be lenient with me, leaving the car outdoors in the present emergency.

It was a relief, once in our little room, to undress, after two days and nights on the road, and to stretch out full length on a mattress that was not of the best quality; we slept until morning. Arising, I shaved and washed in the room while Adrienne lolled luxuriously for half an hour in the bathroom down the hallway. Twice the maid came to knock at her door to see if she hadn't drowned. Then we went down to see about breakfast. The dining room was jammed with refugees, Dutch, Belgians, as well as French from the northern towns, who had come down earlier in the week. The radio was blaring patriotic music, then a voice announced that General Pétain had an important communication to make to the people of France. He said an armistice had been declared. The Germans had come into Paris which had been declared an open city. While every French soldier was ready to shed his last drop of blood for his country, there were the priceless historic monuments of Paris which had to be spared. But the cease-fire Pétain had obtained from the Germans was not without honor. A line had been agreed upon from east to west, dividing France into occupied and unoccupied zones. The Germans would remain north of this line. Refugees were exhorted to remain where they were until further notice, not to clog the roads which were being kept open for the necessary military operations. In time we could all return home again and resume our usual way of life. The war was over. Let us be dignified and do nothing to provoke the invaders who are showing the utmost leniency as

from conqueror to conquered. His speech ended, and the strains of *La Marseillaise* followed. Everyone stood up; men and women wept freely.

So, I thought, all this scramble to get out of Paris was useless, we would have been better off if we had stayed put. And we settled down to wait for further instructions. The dividing line was south of us; the Nazis would come in any day, no doubt.

I went down later to the garage to pick up my battery, install it and test it, to be ready for the departure as soon as the roads were declared open again. In the meantime, leaving the car in the street was risky; I lifted the hood and pulled out the distribution plug, putting it in my pocket. No one could steal the car now. Days passed by without any news, except from discreetly controlled broadcasts announcing the Germans' taking over of towns and putting them back on a pre-war footing — getting France back to its normal life. There were still isolated resistance nests held by a few hot-headed die-hards, working against the interests of their country, it was said, but these were quickly reduced.

I'd been told when I had closed up my flat in Antibes that Picasso had gone to Royan, on the coast between Les Sables and Bordeaux. This would be my next destination on my way south — I had no intention of returning to Paris, a Paris occupied by the Nazis. Before leaving Paris, I'd also had a letter from Duchamp who had gone to Arcachon, south of Bordeaux, where, with Mary Reynolds, he hoped to be able to get on a boat for New York. I sent him a wire now giving my whereabouts, and received a letter in a couple of days, saying, among other things, that he hoped I wouldn't return to Paris, but to come on down to Arcachon.

I'd been in the hotel for a week now, and things were getting more austere every day. The coffee became weaker; there was no milk. For lunch and dinner it was potato soup and boiled beans, or a slice of cold ham, although the bills remained the same as for full pension. I did see the proprietor and his little family sit down to lunch (after the dining room was empty), with chicken or lobster on the table. Nobody dared complain

openly. One or two observations were met with a short reply — one could leave if not satisfied.

Coming down into the dining room on the morning of the eleventh day of our stay in Les Sables, we found a greatly excited gathering around the radio. It had been announced that the Germans were in the vicinity and would come into the town during the day. Also, it had been recommended to the townsfolk and refugees to refrain from any demonstration. Before noon the sidewalks around the central square were filled with people. Others filled the windows of all the houses facing the place. The bank building and the little city hall were locked up, trucks having carried off all money and documents earlier. As if at a given signal, the first cars bearing the German staff rolled into the square, followed by trucks filled with soldiers. A couple of tanks took up strategic positions in the square, with cannons lowered. Everything, cars, soldiers, uniforms, tanks, were of the same dismal gray-green color, as if the army had passed through a paint shop and been sprayed with it. Some men jumped out of the trucks and ran to the bank and the mayor's buildings, pounding on the doors. Not receiving any reply, they drew their revolvers and shot open the locks. Other soldiers followed with machine-guns, ran into the buildings and appeared on the roofs where they installed their guns, pointing down on us.

The crowd watched silently and motionless. A man in his fifties next to me, looked at me frowning. There must have been something about my appearance which made him sense that I was not a Frenchman. He spoke, saying he did not know who I was and didn't care, but in his day, that is, during the First World War, things would not have come off so easily. He said it loudly enough for the surrounding bystanders to hear. Several looked at me frowning and I realized I was in one of those dreaded situations where a mob was ready to pounce on anyone who might serve as a goat on whom to vent its frustration. I could be taken for a fifth columnist, receive a knife in my back. Adrienne was about to say something, but I pushed her ahead of me, saying out loud, as I left, that I was an American, and saying it with a strong American accent. A loud-

speaker blared from a truck telling the people to return to their homes and attend to their affairs. This announcement was made in good French. The crowd broke up silently.

The Germans set up their headquarters in the city hall, sent out squads to take over houses for billeting their men, and visited the garages, withdrawing the best-looking cars for their use. The next day posters appeared on the walls throughout the town, telling all refugees and others who were not residents of the town to appear before the staff with their papers. I was congratulating myself on not having put my car in a garage, when a German officer appeared at the hotel accompanied by a Frenchman as interpreter, inquiring for the owner of the car that was parked in the street. I came down — we walked to the car. The officer was in an elegant new uniform and he had a monocle in his eye. Through the interpreter I was requested to drive the officer to a certain place outside of the town, and to be at his disposal. In other words, I and my car were being requisitioned. I replied that the car had broken down, otherwise it would have been put in a garage. After the interpreter had translated, the officer made a movement of impatience telling me in German to quit stalling. I pretended not to understand, although I knew some German, and after the Frenchman had translated again, I declared I was an American — of a neutral country — and brought out my passport. The officer brushed it aside with some uncomplimentary remark about Americans, and ordered me to get behind the wheel. I took out my ignition key, offering it to him and saying he was welcome to the car if he could make it run — this in English. He motioned to the interpreter to leave, saying they'd look for another car. As I watched them walk away, I patted my pocket in which lay the distribution plug whose withdrawal had given me the assurance to bluff the Nazi so successfully.

In the morning I appeared at headquarters and showed my papers and passport. Seeing my Paris address they told me to return to where I came from; when I expressed my intention of going south and asked for a pass, I was told politely that no one could cross the line that divided France into occupied and

non-occupied zones. Then I asked about getting gas to return to Paris. I was told to stop at the next large town north, that is, Nantes, where there were plenty of garages.

After a meager snack at the hotel, I paid up, making a silent wish that the proprietor would come to grief with the Nazis, that his hotel would be requisitioned, that he would be put on the most austere rations and we took off in the car. Nantes was due north, not quite on the road to Paris, a detour of about fifty miles, but I figured I had enough gas to get me halfway to Paris, two hundred and fifty miles back. But arriving at the town, I ran into a similar situation as at Tours, a couple of weeks ago. Long lines in front of all the gas stations and people trying to get back to their homes. I continued my way east to the next town, Angers, with its impressive walled fortress, but here, too, the same situation faced me. So I drove on to Le Mans, another fifty-five miles. It was late afternoon as I pulled into the public square in the center of the town. Grim sights and sounds met my eyes and ears. All kinds of cars were parked fender to fender. On the sidewalks refugees had laid out bedding and blankets, on which families had installed themselves as if for a long stay. A gray-green Nazi truck with a loudspeaker was blaring out Wagnerian music. Twilight of the Gods — *Götterdämmerung*. A scene from Dante's Inferno with sound.

Finding a place between two cars, I took a walk around the square. All the cafés and restaurants were filled with the gray-green uniforms — a woman here and there among them. Out of the question to try to sit with these, even if there had been an empty table. Walking back to the car I passed a bakery and was able to get a last loaf of bread. The store had been cleaned out by the refugees and soldiers. There were still a couple of cans of sardines in our little basket; we made sandwiches and gave some to our neighbor who was installed on the ground with his wife, mother and a child. They had no food, but produced a bottle of ordinary red wine which was passed around. It was still daylight around eight o'clock, but all the refugees prepared to make themselves comfortable for the night, either

in their cars or on the sidewalks with bedding and blankets. They did not have enough gas to risk being stranded on the roads.

Presently two Germans came by, stopping to speak with the French people. They bore the insignia of interpreters on their uniforms. I spoke to them in English, declaring my identity, and they replied in the same language. My coming from Paris aroused their interest — they hadn't visited the city yet, and plied me with questions. Changing the subject, I asked them why they did not give all these refugees gas to get back to their homes; the garages had plenty but were closed by the invading army. The older one replied that they had just finished an exhausting campaign and were resting; to distribute gas would require the setting up of some system of fair allotment and checking which would take several days. They would get around to it soon. Couldn't he, I asked, do something for me at once — who was a neutral? He thought awhile, then asked if I had enough gas to do a few miles; he was billeted in a house in the woods outside the town on the northern road. If I drove out the next morning early, I'd come to a side road on the right with a sign bearing the words Le Château Bleu. A hundred yards inside this road, I'd come upon a sentry to whom I'd give the password: *Dolmetscher*, German for interpreter, and who would lead me to him. Above all, I was not to say anything to the other refugees, nor attract their attention to my errand.

Accordingly, in the morning, I took my French neighbor into my confidence, saying we'd pretend we were tipped off on getting a room in a hotel outside the town to put up his family, which was in bad shape. I told him I might get gas and if he helped me, we'd share it. Also, I had him put an extra blanket in the back of my car to cover up any cans of gas we might obtain.

Leaving Adrienne on the place with the French family, I pulled out my car and drove north through the town, some refugees watching us with curiosity. After about ten minutes on the road, we came upon the sign, as indicated, and I drove into a narrow lane. At the end was a clearing with a cottage and a sentry with bayoneted gun in front. I drove up and gave the

password. The sentry knocked on the door and my interpreter came out in his shirtsleeves pulling his suspenders over his shoulders. Getting into the car alongside of me, he asked about the man in the back seat. I reassured him, the man was to help me if necessary. He shook his head saying, yes, I might need help, then told me to drive along another path to a large clearing. Here, in an open space, stood four huge tanks with their cannons, British tanks captured at Dunkirk. The German engineers were studying them, said the interpreter. Then adding that they were full of gas, to help myself, he left me.

My companion and I began examining the monsters with their half-inch armor, but could find no indication of an opening to the gas tanks. Axes and crowbars were strapped to the outsides, but it was futile trying to pry open any apparent cleft. I climbed up on top to a turret and found the entrance. Letting myself in, I dropped down to a seat in front of the wheel. The inside was beautifully padded with foam rubber. In front of the wheel was a horizontal slit about four by twelve inches filled with layers of bullet-proof glass. An extra block of this glass lay on the floor beside the seat. It had bullet marks and was cracked. I made a mental note to take this with me as a souvenir. Alongside the seat lay a helmet with ear pieces, also lined with foam rubber. I put this on, as if it were going to help me solve my problem. Trying out different switches on the dashboard, I found the contact and the motor started. There was gas, all right. I shut off the motor, turned around and saw a heavy catch in an angle of the armor. Pulling it, there was a click. I climbed out and told my companion to try different panels again; one plate lifted up easily, disclosing the reservoir with its cap, which he opened and smelled the fumes. Finest aviation gasoline, he said. But how to get it out? Then I remembered — with my jack and tools in the back of my car was a length of rubber tubing from an old douche bag. I'd used it on the road once when I ran out of gas and an obliging motorist had let me siphon some from his car into my tank. Backing up my car as close as possible to the reservoir, my man lowered one end of the tube into it and started the flow by sucking, spitting out a mouthful of the liquid. It took some time, and when

the tank overflowed, we transferred the tube to my empty cans. The gas continued to pour — there must have been a hundred gallons in that tank. A dozen empty five-quart oil cans lay around on the ground, which we filled up — fortunately the caps lay around, too. We piled it all onto the back seat and covered our hoard with the blanket. Driving back to the cottage, I thanked the interpreter asking if I could pay him. No, nothing, he said. I took out the bottle of champagne I'd brought from Paris and gave it to him. His eyes sparkled; ah, Paris, he said. He expected to be on furlough in a few weeks — could he look me up and have me show him some of the high spots of Paris? I gave him a false name and address, then departed for Le Mans.

Our people were waiting for us full of anxiety. It was almost noon. They had been afraid we'd never come back. Some of the other refugees were standing around sharing the anxiety. I said we could not find any rooms in a hotel, but an old couple in a cottage offered us a spare room. I started off, followed by my neighbor, close behind. When we got away from the town, we went into a side road and divided the gas between us. My man watched me closely during the operation, claiming another small can at its completion. I gave him two, since he had a larger family, I said; shook hands with him and was off.

The car was running beautifully, and I kept my foot down on the pedal. After an hour's driving on a deserted road, I heard an imperious klaxon behind me. Looking into my mirror, I saw an open gray-green car approaching with four men in uniform sitting upright. The guns of the two in the back were sticking up. I pulled over to the side of the road and they whizzed by me. Feeling reckless and a bit exhilarated with my morning's achievement, I put on speed until I caught up with the Nazis, then kept my hand on the klaxon. They in turn moved over to the side of the road and I passed them, waving one hand in token of thanks or of triumph. I wouldn't have been surprised if a couple of bullets had whizzed by. Unfortunately, a few miles further there was a train barrier across the road, and I had to stop. The guardian came out slowly to lift the gate, taking his time, while the other car drew up along-

side me. An officer, with a monocle in his eye, looked us over, fixing his gaze on Adrienne, then complimented me in French on my driving. Was it an American car, he asked? No, I replied, it is a French car. He laughed; I let him get ahead of me, reducing my speed.

At one point, a crossroads in a village, we were halted by a long line of bedraggled French war prisoners slowly shuffling along with a German soldier every thirty feet alongside holding a tommy-gun. While waiting for the procession to pass, a few other returning refugees' cars drew up. Presently a German guard came up and looked inside the waiting cars. Except for some cans of gas, covered with a blanket, the back of my car was empty. The guard returned to the line, selected two prisoners and motioned to them to get in the back seat of my car. I could not figure whether it was a humanitarian act or was he reducing the number of men that had to be taken care of? There must have been a couple of thousand in the line; when it ended I drove on. My new passengers were farm laborers from the surrounding country; they asked to be dropped off anywhere, they could get back home easily. Had they eaten, I asked? Not for the past twenty-four hours, they replied. I still had a can of sardines, and some bread from the day before, which I gave them and let them off. They thanked me profusely and awkwardly in a strange patois of French; they must have been Polish or Czechs.

I headed for St.-Germain-en-Laye, expecting to see my house full of Germans. Arriving before nightfall, we found the place as we left it — not a soul was around. I realized that the invaders were busy with occupying more important-looking places, of which there were plenty in and around the town. I went through the house — all was intact. But, going to the garage, I found the door forced and the bicycle missing. Adrienne was inconsolable; I tried to tell her how lucky we had been; I promised her a bicycle in solid gold, ornamented with mink. She laughed, threw her arms around me, her temper was the result of the long strain, she said. And she had never given the slightest indication during our adventure.

Back in Paris, I found the studio exactly as we had left it.

Adrienne busied herself putting new sheets on the bed, taking a bath, and going to sleep. I walked around the studio, putting an object in place here and there, just for the pleasure of touching things which I thought I'd never see again.

Many shops including my garage were still closed, the owners evidently hadn't been able to return yet, or had gone beyond the occupied line of demarcation, and were loath to come back to an occupied Paris. Opening the old carriage doors of the building where my studio was, I could drive my car into the courtyard. I still had a large supply of gas, and intended to use my car for an occasional trip to my place in the country. No civilians' cars were circulating in the city, except some luxurious vehicles requisitioned by the Nazis, these, and their own military vehicles. A few food shops opened at specified hours; one could obtain provisions by queuing up. Some restaurants were open, one could eat if he didn't mind sitting amongst the gray-green uniforms. Neither the food nor the sight was appetizing. Now and then a column of soldiers marched, their heavy boots thudding out the rhythm as they sang their German songs. I thought that they should each have had a can of gray-green paint with a brush in it strapped to their belts, to touch up the color now and then.

One of my first errands was a trip to the American Embassy, to report my whereabouts, and to see about repatriation. The building at a corner of the Place de la Concorde flanked the smart Crillon Hotel, occupied by the German chief staff. Hitler and Goering had made it their headquarters when they had driven triumphantly into Paris. A huge Nazi flag hung from the balcony. On its terraces and the roof, machine-guns bristled. French police in front stopped me as I tried to pass and made me go around a back street to reach the embassy. I went up to the information desk and made some inquiries. First, I wished to send a cable to New York to inform friends that I was safe and sound. I was told there were no direct communications with the States, all wires had to go through Berlin for censorship. The American ambassador had returned to Washington, he being *persona non grata* to the Germans. I

told of my attempted escape to Bordeaux, having heard that American ships were taking on citizens for repatriation. The embassy knew nothing about this. All the clerks working there were completely isolated. I left with a request to be notified if any new developments or facilities came up.

Coming out, and skirting the Place de la Concorde, I noticed a group of French workmen, probably war prisoners, supervised by a couple of German soldiers, demolishing balustrades on the place, and removing bronze ship-prows on columns. A couple of days later a photograph appeared in a Nazi-controlled French paper showing German soldiers at work on the same place, with the caption explaining that the appearance of the place was being improved. Everyone knew, of course, that many bronze pieces were being sent to German factories to be melted down for war supplies. Many cafés, especially in the Latin quarter where students of all races gathered, began to sprout signs saying the cafés were for Aryans only. This was soon changed, the signs saying the cafés were for non-Aryans only — out of bounds for the Germans. The Nazis were trying to be more conciliatory with the French than they had been with the conquered northern countries, Poland, Denmark, Belgium, etc.

Posters appeared on the walls, urging the population to regard the invaders as friends. One showed a Nazi carrying a child in his arms, with a little boy following him, holding a piece of candy. The legend said that the Germans loved children. One of the posters the next day bore an added legend scrawled across saying the French, too, loved children. In a small square of a popular quarter, an army truck drew up with a loudspeaker calling the inhabitants to come around and get some rations. When a sufficient crowd of women and children had gathered, the speaker asked who would like chocolates; to raise their hands. The next day a photograph appeared in the paper showing the French giving the Nazi salute. Theaters and movies were ordered to be opened, the programs carefully censored, to be sure, and well-known entertainers who had fled south to the unoccupied zone were requested to return to maintain the morale of the people, with the hint that if they did not,

their relatives or families would be taken as hostages. Ship-
ments were already being made to the east of able-bodied men
to work in the factories, later to be followed by indiscriminate
roundups for concentration camps.

In such a climate, it was impossible for me to do any work;
besides no one came to the studio — all my friends had disap-
peared. A resistance movement had not yet been organized.
The people were still dazed. One afternoon Adrienne, who had
been visiting her relatives, came in trembling and breathing
heavily as if she had been running. She had been followed by
a couple of officers in a large black convertible, who offered her
money, jewels, the car, a mansion, if she would come along
with them. At first she paid no attention, but when they in-
sisted she turned on them and asked what about their super-
race principles — she was not of their kind. Oh, that was
nothing but politics, one replied, intelligent Germans liked
everything that was exotic. She ran as fast as she could.

The next day I was walking down the Boulevard Montpar-
nasse, and, passing a lingerie shop that was open, I stepped in
with the idea of getting her some stockings — she had men-
tioned that she was running out of them. Two soldiers were
looking over the stock which the salesgirl had placed on the
counter. There were about six dozen pairs of stockings spread
out. Putting them back in the boxes, one asked the price for the
lot. The girl looked shocked, and said it would be a lot of
money. He picked up the boxes while the other produced a
wad of bills and threw it on the counter. They walked out. The
girl picked up the money, then looked at her fingers. They were
covered with fresh ink. It was the money the army was print-
ing and imposing on the French as legal currency. I commis-
erated with her; did not try to make a purchase.

Before my attempted escape from Paris, an English friend
had been stopping at a first-class hotel not far from my studio.
I had worried about him since my return and went around to
see if he had been able to get away before the occupation. For
years I had been going there to meet friends; I knew the man
at the desk quite well. He was still there but in a brand-new

Nazi uniform with the insignia of a captain. He did not or pretended not to recognize me. He spoke several languages, I knew, but all with an accent. It was said he was Alsatian. The hotel was now occupied entirely by a German staff. I inquired about my friend without mentioning his nationality. The captain looked through his books and said the man had left before the occupation. Later I heard he'd gotten safely back to England.

I now made up my mind to get out of Paris for good. Returning to the embassy, I was informed that I could apply to the German headquarters for permission to get on a train that went down to Spain, and from there to Lisbon, Portugal, where American boats were taking on passengers for New York. Appearing at the headquarters with my passport and French papers, I stated my desire to leave the country and requested a pass for myself and my wife. Looking at my identity card which listed me as a permanent resident of Paris, the officer asked why I wished to leave; the war was over and I could continue to live and work as before. I said I had certain commitments to fulfill in New York as a photographer. He knew about me, he said; the Germans could give me plenty of work and would even pay me as well if not better than the Americans. I replied I was under contract and had to leave. He gave me the pass.

It took me several days to put things in order as well as possible. I removed the large canvases from their stretchers, rolled them up (this was the batch that Mary Reynolds brought back to America the next year), and, with other works, stored them at René Foinet's my color dealer, to whom I gave a power-of-attorney for all my belongings, including the house at St.-Germain-en-Laye. He promised to watch over my things.

I drove the car out there to put it away in the garage. Since no civilian cars were permitted on the road, I kept an old mattress strapped to the top so that if I were stopped I could say I was a returning refugee. In the garage I jacked up the car on blocks to ease the tires and drained the battery, with the vague idea that I might come back in a few months. With another

last look at the house, locking all up carefully, I walked up the hill to the station at St.-Germain-en-Laye where I took the local train back to Paris.

I explained to Adrienne that once we were in Portugal, we'd decide the next step to be taken. At the last minute she declared she'd remain in Paris, with her family who needed her help. At first I was angry, then thought perhaps it was for the best; I couldn't foresee what this new departure might lead to. Our previous attempt to escape had been futile but harmless, but this time we might not be so lucky. Best for her to remain. I made out checks for her to use up my bank account. I could only take some hand luggage with me, and again looked around the studio, unable to decide what to pack. Finally, I filled a couple of valises with a batch of Rayographs, drawings and watercolors — what I considered my representative work in painting and photography. Then I packed my dinner suit, a few of my favorite pipes, my patent leather shoes and some linen, again with a feeling of despair. The train was leaving in the evening for the Spanish border. Adrienne was in bed, feeling ill. I took a walk in the afternoon to my old stamping ground, Montparnasse, for a last look.

The terraces of the cafés were filled this summer day, late in July. Many German soldiers, some French women, very few French men. Walking up and down, I met Giacometti, the sculptor. He had left Paris on foot during the exodus, heading straight south on the encumbered roads, witnessing tragedies including the machine-gunning by planes of the civilians. Paris, he said, was too depressing a sight, he'd return to his native Switzerland. I said I too was leaving that day for my country. As we walked past a café a voice hailed us. It was Kiki with another girl sitting at a table by themselves among the soldiers. We joined her and discussed the situation for some minutes. She hadn't joined in the general flight, had remained in Paris which was occupied quietly as an open city. She was lucky, I told her. Presently she turned to a nearby table where a girl sat with a Nazi soldier. In a loud voice and in insulting slang terms which could be understood only by a Frenchman, she upbraided the girl — wasn't she ashamed of herself sitting

with a boche? This was the Frenchman's term for the invader. The girl replied saying the man was an old friend who had come every year to Paris for the past five years, not, of course, in uniform.

Assuring one another that we would soon meet under happier circumstances, I returned to the studio for final farewells. Adrienne was still in bed, refused to get up; she couldn't face the ordeal of seeing me to the station, but she had summoned a brother to help me with my valises. There were no taxis and we had to take a bus. I promised to write and wire as often as possible, advising her to go out only when necessary. With my pass I was let through the gates guarded by two soldiers at the station. Carrying my two bags I boarded the train. It was full of soldiers, I was the only civilian. I found a compartment with one empty seat and a number of Germans in uniform. They looked at me with curiosity but said nothing. I simply declared that I was an American. I understood one to say to another that these Americans were all over the place, and was tempted to reply, yes, like the Nazis, but I kept my peace; better pretend I did not understand their language. The trip to the Spanish border would last through the night and I made myself as comfortable as possible, taking out a book I had brought along, trying to read it as if I were indifferent to my surroundings. The soldiers slept through the night, leaning on one another in their seats, while I dozed off and awoke repeatedly. It was a sunny morning as we pulled into a town near Biarritz. There were soldiers everywhere which surprised me; I thought this was the unoccupied part of France, but soon learned that the Germans were occupying and fortifying the entire Atlantic coast in anticipation of any attempt by the British to try a comeback, also in preparation for the invasion of England, as soon as the Germans had rested awhile from their labors and were ready to make their next move. All the soldiers got off at the stop, leaving me alone as the train continued a few miles to the border town, Hendaye.

Here I put up at a hotel to get a night's rest in a bed, with the intention of going across the border to Irún where the Spanish train left for Lisbon. The hotel was full of refugees

also headed for the same destination, but the frontier was closed and guarded on the French side by the Germans, on the Spanish side by the Franco soldiers. No one could cross. In the small railroad station families were camped on the floors of the waiting room. Those in authority were indifferent, or powerless to help them. I wandered about the town trying to get some information and returned to the hotel for dinner. In the dining room I met Virgil Thomson the composer, and we discussed ways and means of getting out. I knew the country around Biarritz pretty well from my having been a guest of the Wheelers' in previous years; remembered a cocktail party at the American consul's, Roy McWilliams. We decided to go to him the next day. There was a bus or a tram which took us to Biarritz. The consul was there and received us cordially. He had a letter written out in German to the authorities in Hendaye. He warned us we could take no foreign money into Spain, after we had paid our train fare. Besides some French money I had a couple of hundred dollars. The consul took it and gave me his check for the amount, on his New York bank.

Back in Hendaye, we found a man with a handcart to take our baggage across the border. Virgil had fourteen bags, with which he had left Paris in the general exodus, putting up with some friends in the South of France and gradually making his way to Hendaye. We were held up at the little bridge connecting the two countries. A Belgian ahead of us was being searched. Although he had a letter from someone high up, the Germans felt something unusually hard along the seams of his coat. It was lined with unmounted diamonds. He was taken away to a building nearby. The soldiers then turned to our handcart, eyeing it suspiciously. Virgil was ordered to open a designated bag. It was full of musical scores: Beethoven, Mozart, Bach and Brahms. The inspector shook his head approvingly, commenting on Thomson's good taste. Without looking any further, he waved the cart across the bridge. My bags hadn't been touched and I regretted not having put in a couple of my favorite lenses.

Once on the Spanish side things were more difficult. The soldiers took our passports and ordered us into a car. We were

driven down the road to a building and taken into an office where we were kept an hour. A clerk with our passports in hand went through the files. We understood that they were checking to see if we had been associated with the Loyalists during the civil war in '36. I remembered coming back from New York that year after a short visit and on the boat there had been a number of young men who were crossing as volunteers to fight against Franco. Weren't they called the Lincoln Brigade? Even Hemingway was involved. However, Thomson and I were cleared and taken back to our baggage. It was wheeled to the railroad station; we bought our tickets with French francs at a wretched rate of exchange. There was some money left in change and the ticket seller indicated a little black box for charity on the counter in which to place the money. I made a gesture with my finger in my mouth indicating I was going to buy some food at the buffet. We paid off the man with the handcart and with some of the change bought a bottle of liquor, cheating the Spanish government: a little, at least.

The night trip to Lisbon was uncomfortable, but the train wasn't crowded; we stretched out on the benches. Arriving late the next day, I was filled with a sense of great well-being — I was free and would no longer see those dreadful gray-green uniforms. We changed what money we had left into Portuguese currency.

Piling our bags into a taxi we directed the chauffeur to take us to a hotel. It was a filthy place and we were given a room with two cots. However, we were too tired to change. We had a good dinner in a restaurant, took a walk on the principal thoroughfare and drank some delicious coffee at a café terrace. That night we were devoured by vermin in our beds. The next day we moved to a first-class hotel. This was full of refugees from all over Europe — they seemed well-to-do. We hadn't a penny left.

The dining room was crowded, in fact, there were so many people in the hotel that there had to be two services. But food was abundant, with fish and two courses of meat, a Portuguese custom, no doubt. And wine, too; no more restrictions, none of

the austerity we had left behind. Some old friends appeared at the tables: the Salvador Dalis, the René Clairs, an editor of one of the French magazines I had worked for, all heading for the States as soon as they could book passage.

There was much to do the next day. First, to appear before the local police to have our papers verified and be granted temporary visas, being told to appear every day during our stay for this same checking. Then a visit to the American embassy to register our presence. Next, standing in line at the steamship office to get passage on whatever boat would be available. There was one about every week and as an American I was entitled to priority. Many of the foreigners hadn't the necessary visas, it took weeks to get one. Finally, I went to the bank, and only upon showing them my checkbook on a New York bank, my passport and the check from the American consul in Biarritz, did the bank agree to send a cable with reversed charges requesting a draft for enough money to pay my hotel bill and the boat passage. A lot of red tape was involved in this operation; only after a week was I notified that the draft had come through. There was nothing to do now but to wait.

The time was passed sitting at cafés, visiting the local museum, and some cabarets where singers accompanied by guitarists gave forth with the national popular tunes. It did not sound like anything Spanish — seemed to me to have Russian overtones. A musical comedy we went to one night was a satire on the Spanish mood. There was a resort nearby where one bathed and gambled. We visited a fair with the booths tended by pretty girls in native costumes. On leaving Paris, I had put in my valise a small camera with color film with which I took some pictures. One of the young girls was especially charming in her bridal outfit, a white satin dress, and a white satin pillbox on her head. She spoke some French and gave me her address so I could send her a print. Unfortunately, the camera was stolen on the boat later, and despite the purser's assurance that it would be recovered on landing, I never saw it again. If the thief had only left me the film, I would have pardoned him.

After two weeks in Lisbon I was notified that I had passage on the next boat, leaving in a couple of days. It was a one-class

boat, partly freight, but advertised as ideal for traveling tourists. I followed my porter carrying my two bags and on board he led me into the grand salon. The floor was covered with mattresses on which sat many young men, with their baggage alongside. They were American students repatriated from various universities throughout Europe. The porter placed my bags near an unoccupied mattress. I threw my hat and coat on it, returning to the boarding plank to see who else was coming aboard. Thomson appeared and joined me after having disposed of his voluminous baggage in the hold. We had been assigned to the salon because we were unattached. Couples were given berths, as in the case of the Dalis and the Clairs, who had been able to obtain their visas. Back to austerity, I thought, after the respite in Portugal.

The crossing was uneventful and uncomfortable. The weather was calm and sunny. There were one or two alarms sounded — submarines had been sighted, but after an exchange of radio signals we proceeded unmolested. At night the ship was brilliantly lighted and we met a couple of ships, neutral, no doubt, similarly illuminated. As a precaution we were instructed in putting on life-preservers. With the number of people on board, it did not look as if the few life-boats could hold all of us.

The landing in New York was exciting and thrilling, especially for the European refugees. I was overcome with a feeling of intense depression. Leaving twenty years of progressive effort behind me, I felt it was a return to the days of my early struggles, when I had left the country under a cloud of misunderstanding and distrust. Although now I was well known as a photographer, with all doors open to me and the possibility of a new life, it meant joining the ranks whose greatest thrill consisted of selling and buying, if I wished to survive. I'd go into hiding, I thought, until I could return to my accustomed haunts: to the easy, leisurely life of Paris, where one could accomplish just as much and of a more satisfying nature — where individuality was still appreciated and work of a permanent quality gave the creator increasing prestige.

Such vague thoughts were crossing my mind when Dali

came up to me and asked me to be his interpreter. The usual swarm of reporters and photographers had come aboard seeking out celebrities. Fortunately, my name was listed under the letter R which meant nothing to the press. Statisticians and bureaucrats had always had trouble with my name, not knowing whether to list it under M or under R. The French had no trouble, treating it simply as one word, classifying me under M. As with many who would not accept me both as a photographer and a painter; I had to be one or the other, to the detriment of one of the forms of expression. Great photographer, lousy painter, they must say, or great painter, lousy photographer. As if any critic was great enough to decide this matter.

I excused myself to Dali, saying simply that I did not wish to attract attention to myself. He managed pretty well with the press anyway. In the States it often gives added prestige to speak a foreign language, or English with a strong foreign accent.

Disembarking, I took a cab to a hotel in the Fifties, wallowed in the bathtub for some time and climbed into the large bed, feeling as if I had just escaped from a concentration camp. Later, I put in some calls to a few close friends announcing my arrival, made an appointment for the evening, and fell asleep. I dreamt I was still on the boat in a heavy sea, walking along the deck balancing myself with the rolling motion. A siren began to sound and passengers came running in all directions, shouting, U-boats. I rushed to the gunwale to scan the sea; my head met a hard, invisible obstacle with a tremendous thwack, throwing me back on the deck. I awoke with a start, looked around the room to reassure myself, got up slowly and prepared to go out.

As soon as the news of my return got around, I was solicited by magazines to go to work at once. Advertising agencies offered me a studio and all facilities. I begged off, saying that I had been through a war and needed a rest for a couple of weeks. I'd look into the propositions after my return to the city. I had some money in the bank and thought, secretly, I'd take a trip to the west coast, perhaps from there to Tahiti, and disappear for a year or two.

I DISCOVER
HOLLYWOOD

Except for the few intimate friends I had contacted and the magazines I had worked for, no one was aware of my presence in New York. I visited no galleries, did not seek out anyone in the art world, except my old friend Stieglitz, with whom I had lunch one day. I hadn't seen him for years; he looked old but was as talkative as ever about his mission in life. Jokingly, I said he was still an idealist. He had called me an idealist in my younger days.

One day, through my devoted sister, I met a young businessman who was planning a trip to the west in his car, with stops at the principal cities to obtain orders for his product, men's ties. I told him I was planning to go to California for a short rest. Harry admired some of my paintings at my sister's and invited me to accompany him. He had never been in an art gallery, but respected artists. He was interested in music and hoped someday to be able to devote time to it. I accepted his invitation and we left, first for Chicago. I had never been west of New York but some of my earlier work, paintings, had been shown, and figured in the Eddy collection in Chicago. I had also been a guest exhibitor at the Arts Club of the city, between the wars. While Harry attended to his affairs for a few days, I visited the art circles and was given a warm welcome, with luncheons and interviews by the press. Did I bring any of my

recent work, I was asked? I explained my situation, saying I hoped soon to settle down and begin to paint again.

We headed southwest, St. Louis, Kansas City, and Oklahoma City. The cities, the endless fields of wheat, nothing made any impression on me. I might just as well have been crossing the Sahara. By contrast, I thought of the quaint villages of France, its lush green gardenlike landscapes with here and there a noble château or castle, beautifully preserved or in ruins. Only when we entered Arizona on a straight hundred-mile road on the Painted Desert in a violently colored sunset, did I react. It may have been because I was at the wheel, while Harry dozed. I felt a desire to overtake that sunset as if it were a rainbow, before it faded. Suddenly my companion awoke with a start and looked at the speedometer. The needle was at ninety. He howled — it was a new car, hadn't been broken in yet. Used as I was to the noisy nervous little French cars which seemed to be going fast at thirty-five, I hadn't gauged the power and silence of the larger American car. I braked slowly, fortunately, for we were approaching a narrow bridge over a creek. At the same time a truck appeared at the other end of the bridge. I continued, passing the truck with about half an inch to spare. Harry's eyes were closed, his hands clasped tightly together.

Then he took the wheel until we got into Los Angeles at nightfall. The ride through the downtown section with its dark, shapeless office buildings alternating with parking lots, railroad tracks and grimy streets was short; we entered Hollywood which gave me the impression of a frontier town. No buildings seemed to be higher than two stories, the sky was visible everywhere, pierced occasionally by shafts from searchlights as in Paris during the war, to spot enemy planes; here it heralded the presentation of a new film or the opening of a supermarket.

We had dinner at a drive-in, off trays attached to the doors of the car, a new experience for me, and put up at a nearby hotel. The spacious lobby was done in Spanish Mission style, although the name of the hotel was Italian. I felt that we and the people in it should have been in costume of the period. It was later that I realized what gave Hollywood its distinction was its anachronisms.

In the morning Harry phoned a girl whom he had known in New York, now staying with a friend, and told me we'd all have dinner together that evening. He left me to my own devices during the day; I explored the town. It was like some place in the South of France with its palm-bordered streets and low stucco dwellings. Somewhat more prim, less rambling, but the same radiant sunshine. More cars, of course, yet they seemed to whiz past apologetically so as not to obstruct the scene. And I seemed to be the only one on foot, sauntering along leisurely, avoiding the more populated districts. One might retire here, I thought, live and work quietly — why go any farther?

Georgia, of Greek extraction, was a dress designer, originally from New York and familiar with the art world. Her guest, Juliet, with faun-like features and slanted eyes also had something exotic about her; she had also moved in art circles, she knew about me and my painting. I was highly flattered. After dinner we went to a night club where some of the best jazz of the period was being played. We danced. Juliet was like a feather in my arms, she had studied modern dancing with Martha Graham.

Harry left in a couple of days to continue his rounds; I said I'd stay and rest awhile, being in no hurry to return to New York. I promised to look him up when I came back. He made me a present of half a dozen superb silk ties. Very seldom did I see anyone wearing a tie — the Byronic collar was the fashion in this warm climate. I discarded my hat and more formal clothes. In New York I had acquired a brilliant blue tweed coat which held its own against any of the sartorial fantasies of the better-dressed man in Hollywood, even the sport coats with suede patches on the elbows, that pretended indigence. (When the sleeves of my coat began to fray, I considered having suede cuffs put on.)

The idea of being a hermit had often seduced me, but one or two experiments in this direction had convinced me that I had none of the makings of a recluse. The most attractive part of any temporary retirement was the anticipation of the next face I would meet. The day after Harry's departure I phoned

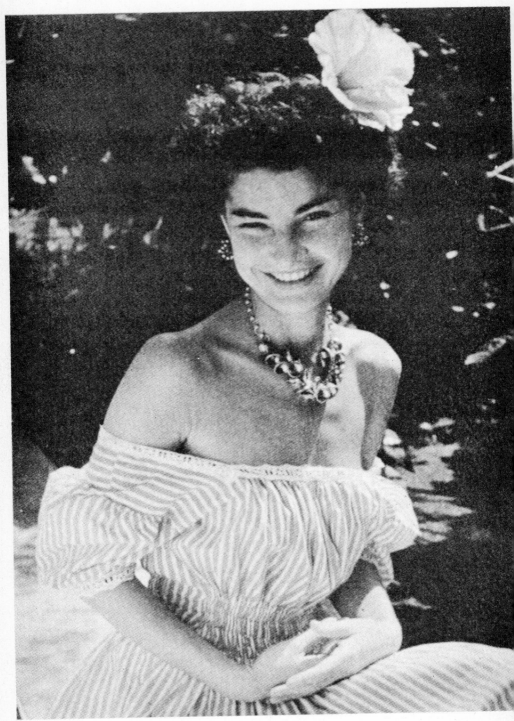

Juliet, 1946

Juliet asking her to have lunch and explore the town further with me. We walked and talked. Entering a park with a lake, I hired a rowboat. I hadn't touched a pair of oars since my boyhood; I splashed about clumsily, but it brought back the romantic days when I rowed a teen-ager around, imagining myself the master of our destinies. Juliet was passive and thoughtful. Walking her back to Georgia's flat, I questioned her about her plans. She supposed she'd be returning to the east soon; the atmosphere at her friend's was rather tense and distracting — a child, a defaulting husband, and the struggle for existence.

I told her of the adventures I'd been through, of my interrupted life, but that I would make a new start, return if possible, to my first love, painting. It was an activity that could be practiced under any circumstances — had been, by many others before me. She said I ought to have a show to begin with, it would give me new courage. Had I brought some of my work with me? I said I had a number of early things which were in storage in New York — might have them sent out. I spoke of the portfolio of drawings, watercolors and Rayographs I had brought with me. She expressed the desire to see them. I took her to my hotel and went through the collection.

There was also a small package of photographs of paintings I had left in Paris. Things I never expected to see again. It occurred to me that as soon as I got myself settled, I'd reconstruct some of them while the memory of their colors was still fresh in my mind. Then, looking at Juliet, I suggested that she move into the hotel and keep me company while I got on my feet again. I'd reserve a room for her at once; she could move in the same day. She accepted without any formalities. During the next two weeks we consolidated our relationship, although observing the proprieties of the hotel irked me. I wasn't accustomed to such hypocrisy and set about looking for more domestic quarters.

In my search I came upon a hotel with housekeeping facilities. It was called the Château des Fleurs. Aside from its French name which attracted me, it had complete little suites for living, well-furnished; we moved in. Juliet went marketing and

prepared what she said was the first meal she had ever cooked. It was the first meal I had eaten at home in a long time. I loved it.

Meanwhile, I looked up Walter Arensberg, the wealthy poet and collector, who had moved to Hollywood from New York; whom I hadn't seen since I first left for France twenty years ago. He received me warmly amid his collection of modern and primitive art. There were other people present, among them a teacher at the local art school who at once attached himself to me, telling me how inspiring a show of my work some years ago had been for his pupils. In effect, the director had visited me in Paris in the Thirties and borrowed a number of things for an exhibition. The teacher spread the news of my presence and I was invited to the school to give a talk and possibly join the faculty to teach. There followed luncheons and dinners, but I was reserved, said I was there for a short stay only. The truth was that I had resolved never to become involved with schools, did not believe in teaching, and felt that the worthwhile things could only be done alone.

I also explained that I had a great deal of work to do to make up for what I considered lost in Europe. I was going to concentrate on my own painting. The enthusiastic teacher continued to befriend me, inviting me to Sunday barbecues on his rustic property — where I met his pupils informally. One day, I received an easel and a box of paint materials and brushes from him, since I was going to paint. Set up in my flat these gave me added incentive to begin work at once. I acquired some canvases, picked out a photograph of one of the paintings I'd left behind and studied it, trying to recall the original colors. Then I changed my mind. Why make copies simply, which would be drudgery? Within the general outlines and composition, I began to improvise freely. Other painters had made many variations of the one subject — I'd do something entirely different each time to maintain my interest and enthusiasm.

After a few weeks, sitting at my easel near a window in the small flat I began to feel cramped. I had always had high studios with large windows and plenty of elbow room. Deciding to

look for a painter's studio, I made inquiries at several agencies, but was told there were no such places in Hollywood. One agent remarked that painters were not desirable tenants — likely to mess up the walls with their paints. I said I'd never heard of such extravagance — paints were expensive. My teacher friend told me of an apartment hotel that had duplexes, inhabited mostly by musicians and movie folk. I hastened to the place on Vine Street, a four-story brick building. All around were car dealers' lots and markets, not very prepossessing surroundings. But going into the courtyard, I saw palm trees, ivy-covered walls and hibiscus bushes in flower. Inquiring at the desk, I was taken to the end of the court and shown a beautiful apartment on the ground floor, a high-ceilinged studio, den, dining room, kitchen, and loggia with bedroom and bath, completely furnished. I couldn't have imagined anything more perfect. Paying my first month's rent, I moved in as soon as possible. I bought a roll of canvas in preparation for big things.

This was the original heart of Hollywood, surrounded by the first movie studios, and a few blocks from the principal thoroughfares: Sunset and Hollywood Boulevards. Right across the street was the Film-art Theater devoted to imported films. Whenever a French film was playing, I sat through absorbing the dialogue, ignoring the English subtitles, translating to Juliet as if she could not read the latter. Awaking mornings, I'd forget where I was, and consider going down to the corner café for a strong black coffee and a croissant, as I did sometimes in Paris. I explored the district thoroughly, taking long walks at night when few people were out, except for the cars that rolled by. I still seemed to be the only pedestrian. Once a policeman eyed me suspiciously as I stopped to look in a shop window. It was inconvenient, not having a car. Transport by buses or taxis was not easy — the distances to any point were great, whether for shopping or visiting.

I decided to get a car. It should be a new one — the signs of secondhand dealers were too glib; I had no confidence in them. Going downtown to Flower Street where most of the showrooms of new cars were grouped, I did some window

shopping. Then I saw my car, discreetly advertised. It was a low, closed body, four-seater, completely streamlined without any excess chrome trimmings, the finish, metallic blue, the interior blue, my favorite color. I could see myself in it with my bright blue tweed jacket livening up the color. The sign in the window gave technical details saying something about a built-in supercharger. I sensed the old excitement when I had acquired my first car. Going in, I told the man at the desk I was interested in the car and could I have a trial of it. He offered no blandishing sales talk, went back and returned with a stocky mechanic. Double doors were opened and the car rolled out into the street. This was only the demonstration model — deliveries were made a couple of weeks after the order, I was told.

I took my seat alongside the chauffeur, he touched the pedals and the car leaped forward as if he had gone directly into high gear. We were out on Cahuenga Pass in a few minutes. After half an hour's drive we returned to the store. I said I'd take the car. No, I couldn't wait for another, I said, I was leaving at once. But the car was used, had already done a thousand miles, said the man. No matter, I wanted this car and no other. He agreed, even gave me a slight rebate because of the thousand miles already showing on the speedometer. I wrote out a check. When all formalities were terminated, I got behind the wheel and drove off. I had that feeling of power which I see in the face of every driver who handles his car. Forgotten were all my resolutions never to bother with automobiles. This was something alive, like a thoroughbred horse. I barely touched the pedal, wondered how fast I could go if I pushed down? I'd soon find out, I promised myself. After the rickety contraptions I had driven in France, this was like holding a feather in my hands — like dancing with Juliet. I drove up to the curb in front of my studio. Getting out, I stepped back for a good look at the car. It had whitewall tires, too, very smart. A small crowd gathered, youngsters — the best authorities on cars. A man stopped and asked me what foreign make it was. American, I replied disdainfully, in the same tone that I had answered the Germans when they had asked if my car was Amer-

ican and I had replied, French. I brought out Juliet to look at my acquisition. She was incredulous. Probably I had never appeared to her as one who could drive a car, besides his other accomplishments.

Well, now I had everything again, a woman, a studio, a car. The renewal of my existence every ten years, as predicted by an astrologer, was running true to form. Having provided for my immediate material needs, I could now concentrate on the long-range project of re-establishing myself as a painter. There was plenty to do. Besides the reconstruction of apparently lost works, I had sketches and notes for new ones which I hadn't had time to realize in Paris. When finished, I could truthfully use one of my favorite expressions: I had never painted a recent picture.

With the car I began to circulate, visiting a couple of galleries between Hollywood and Beverly Hills, and the Arensbergs more often, where I met new faces. One dealer offered me his gallery for a show. This was a good beginning, I thought. I had my old paintings, which were in storage in New York, sent out. The opening was well attended — many movie people came; nothing was sold. I was not listed on the art market, and I think my prices were too low to impress collectors. Critics in the papers were prudent if not hostile — as if my works were new, as if they did not date twenty-five years back. New York was always twenty years behind Paris in its appreciation of contemporary art, and California was twenty years behind New York. But my name got around. I received invitations from directors of museums to show my work: San Francisco, Santa Barbara, and locally, Pasadena and the Los Angeles museum.

For the show in San Francisco I was invited to come up personally for the opening. I accepted — the five hundred odd miles from Hollywood would give me a chance to see some of the country and gauge the qualities of my new car. Once on the highway I kept a steady pace for a while, within the speed limit. Presently a big black sedan passed me, going about seventy. I pressed down the pedal until I overtook the car and

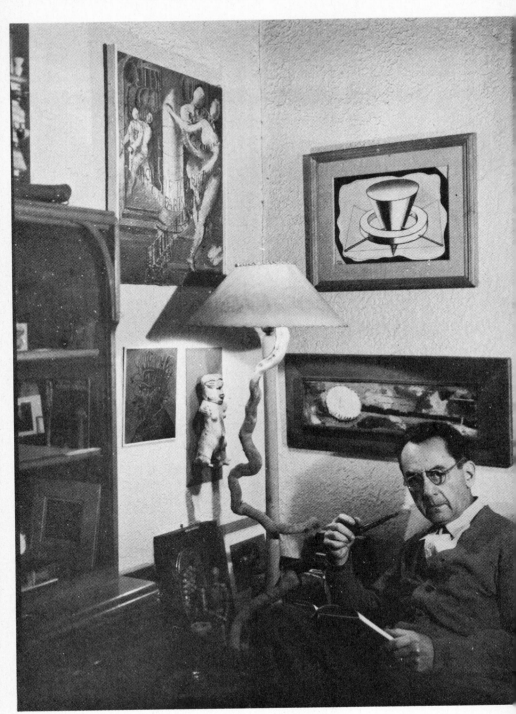

Man Ray, 1948

passed it easily. The needle of the speedometer wavered between eighty and ninety; the accelerator wasn't all the way down. This was like the good old days in France when there was no speed limit on the roads, when it was a matter of pride never to let a car pass one. Driving was a serious sport, not merely a means of getting somewhere. After a while I perceived a motorcycle in my mirror coming up. I slowed down and was motioned to pull over. The cop asked me if I was trying to commit suicide and — looking at Juliet — murder. He took a long time examining my papers. (Fortunately, before leaving New York, I had applied for a driving license, so I could relieve Harry at the wheel. The examiner at the desk had been impressed with my French and English driving licenses. He pulled out a card from under the desk and held it up, asking what it signified. It bore the word, *detour*, as in French. This was up my alley — I translated — deviation. The examiner gave me my license without more ado.)

I apologized to the officer saying I was a stranger, unfamiliar with the local rules, also that I was hurrying to a sick-bed. Juliet gave him a sweet sad smile. He let me go with the admonition to get a California permit, study the code.

The exhibition in San Francisco was impressively hung; one gallery with paintings, another with Rayographs and drawings. Many people came on invitation to the opening; I was introduced to local society. There followed a series of cocktails and dinners at the houses of people who were interested in art, eager to show me their acquisitions. The view from their windows of the Golden Gate was magnificent.

The most important critic wrote up my show in the local paper; he considered my painting a feeble attempt to imitate the European avant-garde production. I recalled the reception I had met in France — hailed by the Dadaists and Surrealists as a precursor. However, the said critic thought my Rayographs were important innovations, a serious contribution to the modern trend. He followed the usual procedure of critics — a thing could be good only if something else was not so good.

I had never paid much attention to criticisms: if I had taken them at their word I would probably never have accomplished

anything. In fact, if I had any doubts about my work, adverse criticism convinced me I was on the right track.

Except for a few isolated talks, I felt an increasing urge to state my ideas in words, despite the opinion in some quarters that a painter should paint only. The statements of Delacroix and of Cézanne have more significance than the words of any of their critics, have finally obliterated the latter. A phrase dropped casually by Picasso could silence any argument. Such statements are not merely attempts at justification; they are reserve arrows for the same target. They crystallize and confirm the painter's intentions; incidentally are an aid to those who cannot see and understand at once.

Opportunities to speak and to write presented themselves during my prolonged stay in Hollywood. Once I was invited to explain and defend modern art before an audience of teachers, students and others interested in the subject. A well-known portrait painter would also speak in favor of traditional painting. The organizer of the evening took the two of us aside, asking us each to stick to his subject as assigned — painters, he said, had a tendency to wander off on irrelevant matters when speaking. The portrait painter had a sheaf of papers in his hand, he had prepared his talk. I hadn't. Would I begin? I said I'd rather speak after the other, it would give me time to assemble my thoughts. The portrait painter began to read — it lasted about three quarters of an hour — mostly a diatribe against modern painting. He ended by explaining that painting a good picture was like making a good cocktail; the ingredients had to be carefully measured, based on knowledge and experience. I was already annoyed with the organizer; if I needed further provocation in order to talk, I had it there. After being introduced, I began by saying I'd been asked to speak on the subject of modern art; then turning to my sponsor, I added that I had been requested to stick to my subject — it seemed painters had a tendency to digress. However, I added, since my predecessor had diverged from his subject, had not been very informative on the subject of traditional art, I felt entitled to take some liberties myself. But, I assured my audience, it

would always be on the subject of painting, for years the old masters had been a source of inspiration for me as a student: Uccello and Leonardo, the investigators; Breughel and Bosch, the Surrealists of their day; and many others through the nineteenth century, when painting was left to its own devices and sources of inspiration, less patronized by the church and state. I spoke of my enthusiasm for the Impressionists — the calvary they had suffered, then touched on the movements of the twentieth century: Cubism, Futurism, all natural products of their times, their freedom confirmed by their variety. There was no progress in art, as there is in science — one could not do better than the old masters, one could only be different. I gave a short description of my association with the Dadaists and the Surrealists. Finally I ended by saying I wasn't much of an authority on cocktails — I had never mixed my paints with alcohol. (Laughter and applause.) I sat down. For another hour there were questions, all directed to me.

This problem of progress, of good and bad in art, dominated all discussions. Never, as in eating and drinking, did the idea of enjoyment arise. Of course, there was the oft-repeated phrase: I don't know anything about art but I know what I like; meaning in reality, I like only what I know. The conclusion being, I'm afraid to like what I don't know — I may be wrong. Once, in exasperation, I accused an interlocutor of being an art critic.

One of my most comprehensive exhibitions took place in Pasadena. There were five galleries filled with paintings, drawings, watercolors and Rayographs. My sponsor was a professor at Cal Tech, Antonin Heythum, a Czech painter and designer who had been stranded while building the pavilion for his government at the World's Fair in New York in '39. His authority and enthusiasm led me to imagine that the local community would show a similar interest. There had been many pleasant gatherings in his garden on Sundays, with his wife Charlotta, and prominent neighbors. A large attendance came to the opening — I had hopes of selling something to the retired wealthy residents. During the show I gave several impromptu talks to visitors and students. The local art critic wrote a long

column. A more formal lecture was arranged in the library's auditorium. The art critic presiding introduced me to a respectable and solid-looking audience. As usual, I hadn't prepared my talk, had made no notes. Looking over the gathering, I apologized for not having written down my ideas; my real excuse was the fear that any prepared speech might be boring — I had myself been the victim of long-winded lectures — I would rely on the indulgence of my listeners, if I stuttered somewhat or even became silent. To speak off-hand, I said, I needed some provocation. Looking over the kindly faces of my listeners, I realized I could expect none from them. But, foreseeing this, I had brought the provocation with me. I then produced the clipping of the art critic's review of my show. Mr. R——, I continued, says he spent four hours at my exhibition and came out more bewildered than when he went in. I do not know whether this was intended as a criticism of my work or a confession of his own lack of perception. In either case, the statement is flattering. Myself, I have never been able to spend more than an hour in a museum without getting tired and dizzy. As for a one-man exhibition, generally a look at one of his works can give me an idea of the painter's production. Mr. R—— was probably disturbed by the variety of subject matter and techniques emanating from a single artist; could not arrive at an appraisal. I had run into similar difficulties with dealers who were unable to keep up with my diversions from year to year. Perhaps I wasn't as interested in painting itself as in the development of ideas, and had resorted to the graphic arts as the most direct presentation of them; each new approach demanded its particular technique which had to be invented on the spot. Whatever the variations and contradictions, one or rather two motives directed my efforts: the pursuit of liberty, and the pursuit of pleasure. I was terribly afraid of being recognized by a fixed style to which I would be obliged to adhere. Painting would become a bore. Wasn't it sufficient that I signed my name to all my works, as had so many other painters who had also varied their styles through the years?

I continued my talk for some time, expressing thoughts similar to those in previous dissertations, then suddenly my mind

went blank. I said I had said my say, it was still early and if there were any questions, I'd be glad to continue. Mr. R——— rose and spoke with deliberation: was I more interested in being different, original, in enjoying myself, than in being profound? I confessed I hadn't considered this aspect — I had never heard or read of any other painter who was concerned with his profundity. We had taken for granted that if we were of a profound nature, every stroke would proclaim the depth and significance of our work; on the other hand, if a painter was a superficial person, all his efforts to appear profound would fail, would show in his brushstrokes. After all, I added, wasn't it the critic's job to decide this matter, which he did with so much assurance in his weekly column, collecting his weekly salary and jeopardizing the chances of some hopeful artist? There is a question of ethics as well as of aesthetics . . .

I was interrupted by several raised hands and voices in the audience, demanding to be heard. It seemed I was now being more provocative than provoked. I indicated a woman up in front wearing an intellectual pair of spectacles with a gold chain attached, an imposing hat covered with flowers. She had seen my work and, referring to one of my paintings by its title, wished to know what was beautiful about it. Looking at her, I restrained myself from paying her a compliment, which might have helped matters, but I no longer cared. I said that if she told me what was beautiful about her hat, I'd tell her what was beautiful about my painting. She replied she liked to have flowers the year round. That, I replied, is more a practical consideration than an aesthetic reason; I, too, liked flowers, especially flowers that smelled — what could she do about that with her artificial blossoms? Was I any more exacting than she? Painters were like other human beings, subject to depression, rages, feelings of aggression, and chose to express their moods in their medium — had to do so to relieve themselves. There was plenty of work around made to please and arouse the admiration of those who sought to satisfy their own desire for pleasure.

I thought I was being sincere and conciliatory in my answers, but now came the fully loaded question: one elderly person

asked, didn't I think this modern art could have a bad influence on the younger generation? Perhaps, I replied. I knew of a young person who had one of my works hanging in her room. One day, returning home, the painting was missing. Her mother had destroyed it, saying it was having a bad effect on the daughter. So, it must be the older generation only which thinks so. There is, I continued, your high bridge in Pasadena from which every once in a while someone jumps off, committing suicide. There is no question of removing the bridge. Poems have been written by well-known authors that are supposed to have driven love-sick young people to suicide. These works are not banned. Thousands lose their lives in automobile accidents, yet nothing is done to restrain manufacturers from building lethal instruments that can do more than thirty miles an hour. To me, a painter, if not the most useful, is the least harmful member of our society. An unskilled cook or doctor can put our lives in danger. I have tried, I concluded, pointing my finger at the interlocutor, to paint a picture that would be like the beautiful head of Medusa, turn the spectator to stone, (I really said: so that certain ones who looked at it would drop dead), but I have not yet succeeded!

People gathered around me to shake my hand, compliment me — they hadn't been bored. Other talks were marked by the same general pattern — my sincerely trying to convey thoughts that had crystallized through the years, in as simple a language as possible, without the mystifying, abstruse words that preface contemporary art. When an instructor once asked me if I spoke seriously (that word again), with his pupils watching to see what repartee would follow, I said I hoped I was addressing a serious gathering, many a truth is said in jest, and if some of my observations seemed trite, they were a confirmation of what other thinkers had said before me. Not always did I try to be original; this was just as hard work as trying to be profound. One student remarked that I contradicted many of the ideas he had been brought up with. I reassured him by saying that tomorrow I'd contradict myself — don't we all sometimes? Speaking gave me a certain exhilaration, it was a sort

of communing with myself, in keeping with my determination to do only a one-man job: paint. Putting my ideas into words was like preparing canvases and paints for a new work. With my aversion to crowds — gatherings of any kind — I often fixed my attention on one person sitting near me, as if in a heart-to-heart talk, saying I regarded the assembly as one individual. Talking to a sea of faces was too intimidating, too abstract.

Attempts to bring me back into a world of greater public activity were made from time to time, due to my reputation as a photographer. Editors of fashion magazines came out west and tried to put me to work again. Appointments were made to photograph life in Hollywood: movie stars in their homes and on the sets, local couturiers profiting from the dearth of fashions from Paris. I went along with this for a while, more out of curiosity than any desire to return to my profitable occupation, but soon lost interest and discouraged the editors. Besides, after my life abroad with its more personal contacts, the spirit of Hollywood was too formal, trying to be distinguished, too fearful of being undignified. If I had put my mind to it I might have produced some imaginative work in spite of the conservatism I felt around me, but I knew it would have been accepted with reserves.

At cocktail parties I had nothing to say to the others, sat in a corner nursing my highball. One such affair in some writer's house took on a more intellectual turn. The walls were hung with modern paintings acquired in Europe, of which the host was very proud. He asked my opinion on one painting for which he had just paid a fabulous sum. I made some evasive reply. The other guests were all engaged in shop talk — the movies. A record of a Beethoven symphony was put on the phono. My host asked if I liked Beethoven. I'd had a couple of drinks which made me reckless. I said the composer always had the same effect on me. Getting down on the thick carpet, I put my head between my knees and turned a somersault. Some standing around turned their backs to me and continued

their professional conversation. I asked my host to play something of Bach — my favorite composer. I promised not to perform.

One day an agent phoned me. With my talents, he said, he could get me a job in the movies. A luncheon was arranged with a producer from one of the big studios. The agent suggested that I bring along a portfolio with some of my work; very likely the producer did not know who I was nor of my accomplishments. I had none of the original prints of work I had done for the fashion magazines, which would be the things to show, not my more creative work. Making the rounds of secondhand bookshops, I went through back numbers, but most of my photographs had been cut out, evidently by students. This was very interesting; it confirmed my efforts to produce work that would have more than a transitory interest in contrast to the policy of the magazines which were interested in immediate news values, to be forgotten with the following issues. However, I managed to assemble a number of reproductions of fashion photographs, and portraits of celebrities in which their faces dominated the clothes they wore, such as Gertrude Lawrence and Paulette Goddard.

The luncheon took place at Mike Romanoff's, rendezvous of the movie folk. When Mike saw me, we fell into each other's arms. In his wanderings about Europe, calling himself the illegitimate son of the czar and, without a passport, he'd often been thrown into jail, then been ordered to leave the country. He'd appear at my studio and show me some roughly molded chess pieces, made from bread crumbs, with which he would pass his time in prison, just like the character in Stefan Zweig's book, *The Royal Game.* The agent and producer must have been impressed with my reception. It helped to establish me.

During a sumptuous lunch, with a bottle of champagne sent in by Mike, we discussed my capabilities and prospects of employment. Would I like to be a cameraman; a good one could make $750 a week. I replied that I was interested in doing something more creative. The producer then asked, how about being a special effects man? I said I wanted to be a general effects man. He looked at me, asking whether I'd like to direct

a picture, if that was what I meant; he had a nice little scenario ready to shoot. Again I replied that if I directed a film, it would be with my own scenario. The producer looked puzzled, asked if I wrote as well.

We were near the end of our lunch; I drank some more wine and lit a cigar. I was putting on an act — too bad there wasn't a camera to record the event. Then I began to speak, as if I were giving a lecture, a lecture that was not improvised but carefully prepared. First, I reassured the producer: my scenario was a simple love story, like most films, but I had a new technique, oh, nothing elaborate; in fact I could do a film for half the amount they spent in the studios (here the agent looked at me with disapproval and I realized my mistake; I should have said for only twice the amount). But to make this film, I continued, certain modifications would be necessary in the process: optical changes on the cameras, different arrangement of the lighting, slight modifications of the developing and printing of the negatives and finally, the makeup and costumes of the actors would require special attention. As for myself, I'd be in front of the camera, not behind it, playing the principal part. Oh, said the producer, Orson Welles and Charlie Chaplin — I still sounded like a technician — why did I want to act? I reminded him of the salary paid to a first-class cameraman, then asked how much he paid a star. Wasn't that a better-paid job? Needless to say, I wasn't hired.

Another big producer of musical films came to my studio. He looked at some of my paintings and asked the price of one. I mentioned a modest figure; he didn't buy. Then he told me of a starving young painter he'd brought out west, of whom he had made an important director. As I was neither young nor starving, I showed no interest in what I took to be a hint.

An important public relations man who handled the publicity for political campaigns, came to my studio one day, and asked me to do a portrait of him. I photographed him with his derby hat, blond mustache and gold cuff-links — like someone out of a 1900 play. He was quite enthusiastic about the pictures, my paintings, myself, and suggested a big exhibition in New York which he would promote without charge. In the mean-

time he brought around some movie nabobs to see my paintings. They were quite bored. One asked me if I was a Cubist.

All these encounters were helping me to attain my desire for isolation, perhaps indirectly, but I was amused and entertained, satisfying my undeniable social instincts. Had I followed my original intention of exiling myself to Tahiti or some Pacific island, I might not have been so happy — forced isolation could be deceptive, depressing. Here, in a big city, I could choose my world. My personality took care of the rejections. And my need for communion was gradually filled — I made friends.

First, there was a handsome young couple, Gilbert, a writer, and his wife Margaret. They lived downtown in Los Angeles in a poor section near the funicular tramway called Angel's Flight (with the Château des Fleurs, one of the few poetic names in the region). They had lived some years in Mexico, had absorbed some of the Latin spirit, radiated an atmosphere of cosmopolitanism and Américanism. We spent many an evening together discussing French, Spanish and American literature, or making improvised recordings on my phono attachment which were played back while we sat fascinated as if at a play put on by others. I painted papier-mâché masks for the girls who put them on and danced weirdly, completely abandoned, secure in their anonymity. One evening, my friends brought around a friend of theirs, a quiet-looking man with a high forehead and eyes that seemed diminished in size by his glasses. Although we had been neighbors for many years in Paris, frequented the same cafés, I had never met Henry Miller. Later, he told me he had expressed a desire to meet me but had been discouraged by the English-speaking clique who considered me a phony. Without exchanging many words, we accepted each other or rather took each other for granted. I had read one or two of his books — cornucopias of language but lacking the introspective mood I was accustomed to with the Surrealists. However, in speaking his eyes took on a faraway look as if a turmoil of ideas were being generated. Then he looked like a sage of the Orient, which he had expressed the desire to be-

Henry Miller at Big Sur, 1945

come one day. The so-called pornography of his books reminded me of the banned writings of the Marquis de Sade, banned even in France, although Sade had declared that his books would bore seekers of erotic sensations — taken as a whole they were an obscene outcry against the injustice and skulduggery of his time — that it would take a century for him to be understood.

In our conversation, Miller and I never used any of the words for which he was notorious; I for a definite reason: in a violent argument one day I could only express myself with profanity and was told quietly that it was not becoming to my personality. This had a greater effect on me than any retort. One day, standing on the corner of Hollywood Boulevard and Vine Street, we commented on the seething, shopping crowd around us, trying to catch the eye of any attractive woman, but were met with a cold stare or head turned away to the shop windows. Not like Paris, we agreed, and if the crowd really knew who we were and what we represented, we'd probably be lynched. When Miller settled on the palisades of Big Sur, I drove up to spend a few days with him in his eagle's nest. A colony was forming in abandoned houses and shacks which were rented cheaply, the country being useless for any exploitation. Gilbert and Margaret settled in a large abandoned barrack on the coast, where he finished his book: *There Is a Tyrant in Every Country*, a story with scenes laid in Chicago and Mexico. I thought it a marvelous piece of writing; Gilbert had high hopes it would launch him. Unfortunately, there was some trouble at the time between the States and Mexico and the book was not pushed.

The visits to the colony were some of the most satisfying during my stay in California. We wrote, read and painted, Margaret grew fresh greens in her garden patch and cooked wonderful meals. Back in the cool forest on the hillside was a deep pool with a waterfall where we went to bathe. About a mile up the road on the palisades was an abandoned installation for hot sulphur baths. Half a dozen white bathtubs stood out in the sunshine against the cliffs from which one pulled a wooden plug to let the hot, pungent water pour into the tubs.

We all bathed in the nude, with no one else around; the sense of freedom was complete. And this open-air plumbing made a perfectly Surrealistic picture.

Another agreeable encounter was with a small, white-haired, immaculately dressed man whom I first met at the Arensbergs. He was a producer-director in one of the big studios, although I did not know it at the time. Al Lewin was fond of painting and invited me to his house on the beach in Santa Monica, to see his collection. His place was the last word in modern architecture. But inside it was crammed with old furniture, books, deep-cushioned seats and primitive art, both painting and sculpture. He told me later he'd had some trouble with his architect who disapproved of this cluttering — found it out of harmony with his conception. This was the new trend with modern architects who considered themselves interior decorators as well, whereas traditionally they were concerned mostly with exterior design. Among the more conventional furnishings there were, however, a couple of ankle-high armless chairs and a low cocktail table against which one barked his shins. A decorator explained these were designed so as not to obstruct the view of the sea or landscape through the picture windows. It seemed to me that it would have been appropriate for those who entered to come in on all fours. When I sat in one of the low chairs without arms, in order to get up I had to fall on my knees first. Al made up for this; he had a luxurious bar, elbow-high. And the dinners, organized by his wife Millie, held their own with anything produced in Paris by Maxim's or Véfour.

At one of the more elaborate dinners, with about thirty guests, the cream of Hollywood, I sat next to Eric von Stroheim, the actor-director, notorious for his lengthy and costly productions, his faithful impersonation of the haughty Prussian type. I told him how much I liked his acting, that I did not feel that he was playing a part, but was himself as he might be in real life. Especially in the film, *The Grand Illusion*, by Jean Renoir (who was present at the table). Von Stroheim listened to me with condescension, then asked politely, what did I do? I said I was a painter. A modern painter? he inquired. He hated modern painting. I said that I did not like the word, modern, I

considered myself simply of my time. I added, we do not like many things we do not know, and certain aspects of things we do know, as in the movies. He agreed with me without knowing that we agreed for different reasons. And how different he was from a man like Jean Renoir who also lived in another world than mine, with the background of his father's painting, with his fame as a film director — yet who treated me with tact, came to my exhibitions, and like Lewin, tried to find a place for me in his productions.

Allie, as everyone called him, invited me not only to his house, but to luncheons, tête-à-tête, to the studios when he was directing, or just to his suite of offices, as if he were trying to find something for me to do — to fit me into his world. As I got to know him better and the films he had produced and directed, I remarked a certain continuity in his work. Whether it was *The Moon and Sixpence, Picture of Dorian Gray,* or *Bel Ami,* in every picture a painter figured. He prepared his own scenarios, was regarded somewhat as a high-brow by the rest of the community, but, as one of the pioneers of the industry and discoverer of new stars, with a certain respect. I pointed out to him that what we two had in common was our interest in painting. However, most of his collection was composed of primitive or what is sometimes called Sunday painters, which he bought because he liked them without any thought of what one should collect, as in the case of many art patrons. This might be a reaction against his own sophistication, I suggested — although young, the movies were certainly not primitive art. My statement could have influenced him, for he soon began to acquire works of a more cerebral nature, like those of some of the Surrealists.

One of the last films he made while still in Hollywood was based on the legend of the Flying Dutchman, with Ava Gardner as Pandora. As in his other films, the leading man, besides being condemned to wander over the globe for eternity, is a painter who paints Pandora's portrait before he has met her — quite a Surrealist idea. Allie needed a color portrait of Ava for one of the shots, as she looked in a period costume. I offered to do it and he sent her to my studio. She was absolutely ravish-

Man Ray with Ava Gardner, 1950

ing — no film, I thought, had ever done her justice. And as a model, no one in my experience with mannequins and professionals surpassed her. She acted for stills as if before the movie camera. My picture appeared in the film as if it were a painting. He also used a chess set I had designed in one of the sequences and confessed to me later that the producer had tried to eliminate it, but it was retained and some fan traced me to order a similar set. A creator needs only one enthusiast to justify him, I thought. Allie showed his enthusiasm by adding some of my works to his collection, which I considered more important than any job he could have gotten me in the movies, even if it were in front of the camera.

With the realization through the years that California was a wilderness for me — that there could be no general acceptance of my ideas and my work since I had no talent for ingratiating myself — I withdrew into my personal shell, maintaining contact with the few friends whom I could talk to without wasting my breath, or those who sought me out and made the first advances. Among these were several women, wives of successful movie people, or those engaged in some more prosaic occupation, who came to me as pupils in photography and painting. I accepted them willingly as it permitted me to continue expounding my thoughts without having to face a crowd. One of the pupils, wife of a famous actor and daughter of a weathy newspaper family, collectors of important art works, had an unbounded admiration for me as a photographer and was totally blind to my painting. My pride suffered somewhat but I was accustomed to this sort of appreciation, and limited my instruction to purely technical matters, as in the case of other pupils in photography.

They had their own definite ideas — were more concerned with how than with why. The painting student, however, was of an entirely different breed. In the first place, Dolly moved in other worlds — she was a waitress in a restaurant and was consumed with the passion for painting. Having acquired sufficient technique to put distinct colors and forms on canvas, she came to me with her work whenever she had an afternoon off,

seeking not so much criticism, as she pretended, but inspiration. I talked, expressing my general ideas as if addressing an audience, hardly referring to the work in hand. Now and then I did point out a wavering or blurred passage in her painting, advising her to leave blank any area if she was not too sure of her intentions. Cézanne had painted in this manner; for a long period his works were considered unfinished, but now the unfinished areas seem as valid as the rest — like the rests in music. I do not know whether Dolly followed my observations, some of which may have appeared whimsical or far-fetched, but it did have an effect on her work which became firmer, more self-assured. I knew a painter who could not paint on canvas — his emotions overcame him to such an extent that he'd tear the linen — had to resort to more resistant surfaces. He had missed his vocation, should have been a sculptor.

Like my lecturing, my teaching was quite unorthodox, would have been frowned upon by academic faculties. In both cases, however, the goal was the same: to make people think. I have made some of my listeners think, and it has sometimes made them angry, but I have also made others angry and it has made them think.

(This end of the year 1961 I am sitting in the house of Bill Copley, outside Paris, forgetting where I am, rather imagining myself back in Hollywood, fifteen years ago when my host first appeared in my studio, recently out of college, looking like a typical product of such institutions, inarticulate in certain respects but without the usual expression of one determined to make a respected position for himself in the world. Later, he did express himself, maintaining that my reception of him on this first meeting was anything but cordial. If true, it is in line with the impression I have given others on their first visit to my studio. And why shouldn't this first contact be forbidding? I had never cultivated the social amenities; it was more fitting that I receive this newcomer with a frown than with a frozen smile which might disappear later. After relations were established, new friends often confessed they hadn't dared to approach me at first — my reputation was intimidating. They probably expected to see someone six feet tall with a beard and heavily rimmed glasses. My long confrontation with faces had taught me that no one looks like what he really is, whereas many rely on a first impression.

After a few more encounters I realized that Bill had been bitten by the painting bug. But unlike others with means, whom I had known and who wished to justify their existence

354

by engaging at once in creative work, his approach was more tentative. He began to collect paintings at the same time that he began to paint discreetly, without being influenced by the works of others, except by a general iconoclastic quality of the Dadaists and Surrealists. His undisciplined technique and harsh humor were too disrespectful of any school. It conformed to my repeated declaration that art was the pursuit of liberty and of pleasure.

Then Bill opened an art gallery in the heart of Beverly Hills. There were half a dozen exhibitions of Surrealist painters over a period of six months. The openings were attended by all Hollywood. Much whisky was consumed, very few works sold. Bill was the best customer, retaining a work of each painter. For the opening of my show, I had a typical French café installed in the garden, run by Stravinsky's daughter-in-law, Françoise, serving onion soup, red wine and black coffee. People carried their whisky from another room to the little tables and sat listening to popular French records played on the phono. Stravinsky himself patted me on the shoulder and called me *maître* (master). Besides the large painting, The Lovers, which Bill reserved for himself, one other was sold to Al Lewin. The party lasted late into the night, until all the whisky was consumed. I had composed an elaborate catalog for my show entitled: *To Be Continued Unnoticed,* the last page devoted to criticisms both favorable and derogatory from previous exhibitions. One of the write-ups was in the style of Lewis Carroll's jabberwocky language, supposed to reflect the impression my show had had on the critic. It was probably the nearest approach he had made to creative writing.)

Shortly after the end of the war, having written to a number of old friends in Paris, I received word that everything was intact, untouched by the Nazis, even my little house in St.-Germain-en-Laye. Only the studio had been abandoned, my things had been moved into an attic in an old house nearby. But life in Paris was very difficult, food scarce and still rationed. I was thrilled and on the point of taking off immediately for Paris. But I now had almost as much material accumulated in my

studio in Hollywood as I had left over there. Besides there were commitments, exhibitions planned; it was impossible to leave at once. I reasoned that now that my things were safe, I need not hurry, but would plan carefully my return for a more permanent stay. Circumstances had forced me to abandon, during the past five years, a way of life I had known for twenty years, circumstances could now wait a while longer, until I got good and ready.

With war restrictions lifted in California, I relaxed mentally, realizing I had been subconsciously under a strain through the years, although one would not have thought so watching my various activities. I made more frequent excursions with my car, with or to friends — a memorable trip across the Mexican border to a bullfight in Tijuana, with Gilbert and Margaret, visits to Henry Miller, definitely settled in Big Sur, Bill Copley in San Diego, Max Ernst in Arizona. Any sight-seeing was purely incidental, serving as a background for contacts with friends.

Except in one instance, when I visited the giant sequoia trees. Wishing to record my impressions, I spent a day photographing them. The result was disappointing. They looked like ordinary trees. A cabin, a car, a person alongside one, put in to show the scale, became items out of a Lilliputian world. There was only one way to indicate the dimensions: to make a photograph as large as the tree itself. But even a photograph could not show the most important aspect of these giants. They are the oldest living things in nature, going back to Egyptian antiquity, their warm-colored, tender bark seems soft as flesh. Their silence is more eloquent than the roaring torrents and Niagaras, than the reverberating thunder in Grand Canyon, than the bursting of bombs; and is without menace. The gossiping leaves of the sequoias, one hundred yards above one's head, are too far away to be heard. I recalled a stroll in the Luxembourg Gardens during the first months of the outbreak of war, stopping under an old chestnut tree that had probably survived the French Revolution, a mere pygmy, wishing I could be transformed into a tree until peace came again. Trees, I know, are cut down in times of peace, even sequoias. And

men; from Christ to Gandhi, workers for peace have been assassinated. These were thoughts that flitted through my mind as I fumbled with the inarticulate camera before the five-thousand-year-old, living patriarchs.

Having finished a series of paintings, I turned my attention, for the sake of variety, to the fabrication of objects out of materials picked up by chance, without modifying the original shapes, in the manner of earlier years, like the jar containing steel ball bearings in oil instead of olives, or the flatiron with a row of tacks on its smooth surface. Assemblages, they have since been called — and imitated, at least in spirit. I named them, Objects of my Affection. A new gallery offered me the opportunity of showing them. The more or less indifferent reception of my shows of paintings was an incentive to present something more provocative. About thirty of the objects were tastefully hung or placed on pedestals. I wrote a few lines for the catalog explaining that they were made to amuse, bewilder or inspire reflection, but were not to be confused with the aesthetic pretentions or plastic virtuosity usually expected of works of art. Visitors were certainly bewildered, afraid to be amused — due, without doubt, to the fact that a gallery is considered a sanctum where art is not to be trifled with. There were a couple of children, however, at the opening who were not at all impressed nor repulsed. In the center of the gallery stood a billiard table on which rested a steering wheel mounted on casters; from its hub a spring with a rubber ball at its end waved idly back and forth as the wheel was pushed about. The kids played with the object until dragged away by their parent. The title of this object: Auto-mobile, did not help to mend matters.

Some enthusiastic collectors sponsored the founding of a Modern Museum of Art. There were some lively exhibitions of the younger painters, with a show now and then of better-known moderns. Lectures and concerts were given. I was invited to give a talk on Surrealism. The only preparation I made for this was to construct an object that would demonstrate a Surrealist act. It consisted of a cardboard lottery wheel with its

numbered segments and fixed arrow, mounted on a vertical board with a roll of toilet paper at the base. As the members filed into the gallery, each one was given a slip of folded toilet paper, bearing a number: there were, of course, many blanks as the number of people exceeded the figures on the wheel. The object stood on the table alongside which I gave my talk. I began as usual with an apology for not having prepared a lecture — I knew my subject well enough, I said, to speak extemporaneously, but there might be moments of hesitation while I assembled my thoughts. In reward for the audience's patient attention, at the end of my conference I would turn the wheel of my contraption, and whoever possessed the number indicated by the arrow would win a fortune.

I spoke for about half an hour, described some of my activities in the movement in Paris, related several anecdotes that illustrated the tendencies of Surrealism and its influence on contemporary thought, and concluded by saying that brevity was one of its virtues, whatever other reservations one might have on the subject. This I had now illustrated, I added, and would proceed to give a more concrete example. I gave a flip to the wheel of my object, it made a few revolutions and stopped with the arrow pointing to 15. A hand shot up in the audience holding the piece of paper with the number; I requested the bearer to step up front. He stood beside me while I spoke again for another minute, saying that after this dramatic moment for which everyone had been waiting, I'd be glad to answer any questions. Then, lifting my object with the lottery wheel, I handed it to the winner, saying this was a concrete example of Surrealism. The object bore the title: *La Fortune.*

Speaking of lotteries brings to mind another incident connected with the organizers of local exhibitions. The Modern Museum closed down after a year or so for lack of sufficient support, but interest in contemporary art was growing and there were many young painters who had no place to show. There was the local museum with plenty of unoccupied wall space, but the curator's interest went no further than eighteenth-century art, having received a priceless donation from

the Hearst collection which filled the most important galleries. His other interest was ornithology; walls were lined with glass cases filled with examples of the taxidermist's art. However, one of his younger assistants persuaded him to allot a couple of unused rooms for a modern show, and invitations were sent out to painters to submit their works to a jury.

I ignored my invitation — it was one of my principles never to submit my work to a jury nor in competition for a prize, an attitude which I realized had been to my detriment as a painter, as far as recognition went. When the organizer came to me to insist on my participation, I replied that if it were an invitation *hors concours* and so announced, I'd send in something. Further, I questioned the authority of his jury — of any jury. Some of the most renowned painters of today had been rejected for years by juries. I had exhibited only in independent salons where anyone could exhibit. In France there had even been a Salon des Refusés of now famous painters rejected by the established organizations. Why couldn't one have an independent show here? The young man replied that it was primarily a question of wall space — there were too many painters for the space at his disposal. I offered an alternative solution: why not give a number to each painter desiring to exhibit, and draw duplicates out of a bowl until all the space was accounted for? The same procedure could be followed for the next exhibition, giving the same opportunity to those who had been unlucky in the first drawing, and so on. And suppose, the organizer objected, the worst paintings got into this first show? Now, I said, he was acting as a lone judge, as bad as a jury if not worse — just as liable to make mistakes: the so-called worst paintings in non-juried shows sometimes became the most significant ones. My interlocutor did not seem convinced, but pursued the discussion, evidently with the idea of reducing my proposal to an absurdity. Suppose, he said, there were prizes to be awarded — how would I replace a jury? In the same manner, I replied: by a drawing; and if the so-called worst painting got the first prize, what an act of generosity it would be — the poor dauber would be compensated for his unfortunate effort, whereas the so-called best painter did not need

such recognition. People would flock to see the anomaly; might even buy it. It had often happened with prize-winners chosen by juries, that such works quickly fell into oblivion.

Years later, back in Paris, I was allowed to put my theory into practice with very satisfactory results. And there was no criticism nor grumbling over the outcome. No one could dispute the workings of chance.

Speaking of juries brings up another aspect of their function: that of censorship. Jurors generally have the power of eliminating at once any works that might be considered of a subversive nature or simply obscene. Although tolerance in such matters has increased with time, the objections of a puritanical minority suffice to create an atmosphere of distrust resulting in the banning of a work — to be on the safe side. A just course would be to create a second jury composed of prominent figures who had come under the opprobrium of the puritans. This jury in turn would censor all suggestive works that kept within the law, on the grounds of hypocrisy — that they were a form of subversion in which concealment was the most potent form of obscenity — the only approach that the puritanical mind could enjoy. With the support of medical authority it could be proven that sex, where obscenity was most likely to manifest itself, was healthier when not dressed up with circumlocution and insinuation.

Many of my Parisian friends had sought refuge in New York during the war, but with them I made no effort to maintain contact. They existed in a hopeful spirit of anticipation, like myself who felt that it might have added to my inward depression had I sought them out. But I did receive various invitations and visits from old acquaintances in the city. Julien Levy, who years back had started a gallery devoted to photography with the idea of making it as salable as painting, and had given me the first exhibition of my photographs, soon discovered that he had made a mistake and could not maintain such an enterprise. He turned to the handling of paintings, like other dealers, although devoting his gallery mostly to the Sur-

realists. Faithful to me, he now gave a show of whatever work I had accumulated in my retreat. There was as little reaction to it as to my exhibitions in the west. New York was just as backward as California as far as I was concerned, perhaps more so since it knew me as the photographer, had forgotten that I was one of the pioneer Surrealist painters. A number of the Objects of my Affection were included in the exhibition, but the art world was not yet ready for them. It is really unfortunate to be a pioneer; it pays off to be the last, not the first.

I did some writing, also, invited by an old friend, Charles Henri Ford, who published the magazine *View* in New York. Two stories were printed, both of an irrational nature as in dream sequences; one called "Photography is Not Art," the other "Ruth, Roses, and Revolvers." They were favorably received in certain quarters. Another old friend, Hans Richter, painter and movie-maker of the Dada period (who should have beaten me up because I tried to seduce his pretty wife in the early days in Paris), wrote me, asking me to do a sequence for the film he was preparing, to which several other artists each contributed a part. With the title "Ruth, Roses, and Revolvers," I prepared a scenario which I sent him, telling him to do it himself as I was loath to involve myself in movie-making. Richter used my script which was of a satirical nature, but he gave it a psychological twist in keeping with the rest of the film which he entitled: *Dreams That Money Can Buy*. Except for a couple of slight modifications, less than any a script would suffer in Hollywood, I was very pleased with the realization. It was a miracle to see many concrete images formed out of a few words, without any fuss on my part over technical details, reversing the old Chinese proverb that an image was worth a thousand words: in this case, a word produced a thousand images.

One afternoon, Max Ernst appeared at my studio with his fiancée, Dorothea Tanning the painter, with the intention of getting married in Hollywood, and asked me to act as witness. I had now been with Juliet for six years and thought it about time to get married also. So we agreed to act as mutual witnesses, and drove down to the city hall for licenses. Some pho-

tographers and reporters were hanging about on the lookout for people of note who might be bent on a similar errand. Max had recently been divorced from Peggy Guggenheim with a certain amount of notoriety and wished to avoid any further notice. The woman at the desk directed us to a doctor across the street to obtain health certificates.

We returned with the necessary documents the next day and stood around, rather nervous — the room was filled with people including the newspapermen. While the clerk was making out the licenses, Max made polite conversation. He commented on a pretty calendar on the wall behind the clerk. She observed that he could probably do something better, evidently suspecting he was the painter whose name had been in the papers. Max said he didn't think he could do better. The clerk's suspicions seemed to be confirmed and she must have pointed us out to the newspapermen who followed us as we left. A photographer aimed his camera at Max — I interposed announcing myself, but he wouldn't have me — he wanted the man hiding behind me.

With our licenses we drove to the local justice of the peace, but he was out, it being Saturday afternoon, and we were directed to Beverly Hills where we found a qualified official still in his office, who performed the ceremony.

We celebrated our wedding that night with a fine dinner and champagne. For the next few days the Lewins and the Arensbergs gave lunches and dinners for us. I photographed Dorothea who made a beautiful painting of Juliet with a fantastic white headdress like a bridal veil; later Max painted a large canvas called Double Wedding in Beverly Hills.

Time passed; the idea of returning to Paris lay dormant in the back of my mind. I was very comfortable in California, hated to make a major move, and detested traveling. Once installed I stayed put, as on previous occasions, until forced by circumstances beyond my control to change my surroundings.

I had kept up my correspondence with Paris until I received a letter one day from a friend who had intended moving into my little house in the country. He informed me it had been

broken into and every movable object taken out. Besides, local authorities were installing families in all unoccupied habitations. He would have taken it but the heating and plumbing installations needed repair, with materials and workmen available only on a priority basis involving lengthy formalities. I decided to make a quick trip and put my affairs in order, holding on to the Hollywood studio for the time being. Taking Juliet with me — she had never been abroad — we went all the way by plane, the latest and fastest models, and due to a twelve-hour delay in Kansas City, caused by engine trouble, and a day in New York, arrived three days later in Paris. Accustomed as I was to boat and train travel, except for the same annoying formalities with passports and customs, I found this magic, if unromantic — it consoled me for my distaste for traveling. It could be improved upon, I thought, if one were put under an anesthetic and into a box for the duration of the flight. And, what a relief from fear of not arriving at one's destination.

Once installed in a hotel, I contacted friends who were still around — some had disappeared during the war. I had brought little gifts for everyone, things that I was told were lacking, among them a quantity of cans of instant coffee, which had no success with the French.

Adrienne was married to a young Frenchman who had looked after her during the occupation and had protected her. It was the two of them who had saved most of my affairs, which I found stacked in an attic of an old house. When I unlocked the door, I could hardly enter, so full was it with files, furniture, pictures and various objects. Negatives and prints were scattered on the floor and trampled upon — the concierge told me someone had carried off a number of things — with my authorization, she had said. A number of my paintings, as well as those of my collection, appeared in galleries, acquired with "my authorization," I was told. But on the whole, I was lucky; found most things which I thought I'd never see again.

I spent days in the attic classifying, destroying prints and negatives, putting aside paintings and books to be shipped to the States. A couple of boxes with books and objects were confided to Mary Reynolds who had returned to her little house in

the rue Hallé. One of my first acts was a visit to the house in St.-Germain-en-Laye. The locks on the garden gate and of the house were broken, the rose bushes gone, three feet of grass and weeds covered the grounds. The inside of the house was bare of any furniture, with traces of water from a leaking roof, and cracked radiators and pipes which I had carefully emptied before the war. The garage was empty, an oil stain marking the spot above which my car had been jacked up. I felt a pang as had Adrienne when she missed her bicycle. Later I was told it had been sold to pay my taxes during the occupation. I could not help admiring the efficiency of governments which even in times of greatest stress, held one to his obligations without guaranteeing his security. There was no recourse for war damages, my property not having been occupied or destroyed by the armies. With the shortage of labor and materials, the place could not be put back in shape for a long time. I decided to sell and placed the house with an agent. Shortly, an officer stationed with the English army in France took the house as it was. Within a few weeks the place was put back in shape, and a new car occupied the garage, all of which the Englishman proudly showed me when he invited me to tea.

Outwardly, nothing seemed to be changed in Paris, except here and there where the city seemed to be licking its wounds. There were many bare pedestals, from which the Germans had removed bronze statues. Flowers were planted in the Luxembourg Gardens, the trees cared for, but around the Senate building which was roped off, trenches were being carefully dug to remove mines planted by the invaders. All the public buildings had thus been mined and it needed only the pressure of a button to blow up the city. Somehow at the last minute, the German governor had hesitated — Paris was saved again. Twice in one war. We visited the Louvre, where some of my favorite paintings had not yet been taken out of their hideout during the war, grimy Montmartre topped by its phallic, sugar-loaf church, trying to look like a cathedral; and I took Juliet up the Eiffel Tower which I had never visited during my previous twenty years in Paris. The view is more impressive than from the Empire State Building, if less hallucinating. We

364

had a few dinners in famous restaurants like Lapérouse, which seemed to be exempt from the rationing in less expensive establishments.

A marked change was most evident in the relations of my former friends, both in and out of the Surrealist movement. The bickerings and dissensions of the old days had ended in a complete dissociation of interests. By the Thirties, Aragon and Eluard who, with Breton, were the leading figures in the movement, had already veered towards a more political attitude and had joined the Communists. Most of their writings were slanted accordingly; they became engaged, as it is said. Breton too, had tried at one time to participate, but without renouncing his Surrealist ideas or making any concessions to the average mind; he was regarded with a certain suspicion, and so remained aloof, maintaining his domination over younger adherents as he had over the earlier group.

Having been most intimate with Eluard whom I found to be the most human and simple of the poets, I contacted him at once. During the occupation I had received pamphlets in California, published and circulated by the underground resistance movement, containing his soul-stirring poems on liberty and love. The recent death of his wife, Nusch, had transformed him into a moody person; now and then he forced himself to put on a gay front, as in the old days. We never discussed politics although he intimated that he would continue to be a mouthpiece — that he was needed, and was trying to work for a better world. Poor Paul, I thought, enmeshed in the cogwheels of ruthless intrigues. Only a simple nature could have been so misled. He thought he could maintain his status as a poet at the same time as he was actively concerned with social problems, which inevitably become economic ones, completely incompatible with poetry. Pure poets have generally succumbed to economic pressure, unable to adjust themselves personally. Paul Eluard, fortunately long before his political commitments, had been passionately fond of painting, had helped young painters to become known, had formed a collection of his own from which — not from his poetry — he was able to meet his needs. But the painting he was interested in was closely allied to poetry

— any gains accruing from the former were justified. Both he and the painter profited. He continued publishing his poetry in limited editions, now accompanied with illustrations by painter friends, including Picasso. It was probably this close association that induced the latter to join the Communist party. This was a mystery for all; Picasso's work could never be accepted by members of the party — hadn't his paintings been dragged out of the cellars in Russia and exhibited as examples of bourgeois degeneracy?

For me the explanation was simple. At political or artistic reunions, the speakers generally say everything expected of them, are duly applauded. The most effective propaganda, it seems to me, would be to go into the enemy's camp and continue to preach apparent subversion. Of course, this, too, has happened in history, has produced martyrs.

During the German occupation of France, in spite of their destruction of so-called degenerate art, they were quite considerate of Picasso, as if to show they were not entirely barbarians, and offered him coal in exchange for paintings (which he refused), but he was the goose that laid golden eggs. In the same way, it is a feather in the cap for the Communist party in France who are partial to caps in the first place. When Stalin died, Picasso was asked to make a portrait of him for the party's daily. Aragon, the editor, and admirer of Picasso, was responsible for this and used Picasso's drawing. When the moon face with its mustache appeared, there was consternation, threats of excommunication. I do not think he intended any desecration nor was he being funny, it was purely poet's license, perhaps prophetic. Later, with the process of de-Stalinization, it might have been more acceptable. Anyhow, Picasso has continued his individualistic, poetic career despite the condemnation both of the bourgeosie and the communists; strange to say, it has solved his economic problems. If the destiny of nations had been guided by poets and painters instead of by politicians, war and waste might have been eliminated.

Having attended to my personal affairs during this short stay in Paris, I had nothing more to do but return to Hollywood. I had made some inquiries about getting a studio, but

there was a housing shortage. My former Paris home was now occupied by the family of a well-known art critic and I could not recover it, the lease having expired, besides I had not been in a position to pay rent through the years. I should have come back on Liberation day with the American army, I was told; then I could have had anything.

Before leaving, I had a farewell dinner with the painter Oscar Dominguez, who suggested that I send a painting to the next Salon d'Automne. I told him I never submitted my work to a jury, would not risk rejection. He explained that he was a permanent associate, once admitted by the jury, he did not have to pass it in subsequent exhibitions, but that this year he intended to send in a work that the committee might find objectionable. Several other painters, members, would support him, and he would see that anything I sent in would be hung. In that case, I said, I accepted, the experiment would amuse me. Accordingly, I had my large canvas, *Le Beau Temps,* which had been rolled up, put back on its stretcher, and left it with Dominguez. It was in the fall, back in Hollywood, that I received the details of what had happened. As he expected, Oscar's canvas was rejected, as well as mine, but he made such a scandal that both were finally admitted, and I received my card as permanent member, not having to submit to a jury in the future. If I had departed from my principles in this case — submitting a work to a jury — they were vindicated by the results: we had been passed over the heads of the jury.

Having distributed most of our personal effects among friends, we went to the Paris airport with very little baggage. I carried a portfolio with some drawings, photographs, and a beautiful antique ebony cane given to me by Dominguez. But I had arranged for an important shipment to follow me by boat. It was forbidden to take any capital out of France; my pockets were stuffed with French francs, proceeds left from the sale of my house. The customs officials relieved me of this money, saying it would be at my disposal when I returned — they'd give me a receipt. But the receipt book could not be found, and for twenty minutes the whole office hunted high and low before it was found. Meanwhile, a couple of the staff from the plane,

which was being held up, appeared and made a row. Finally, we were escorted to our seats amid curious looks from the other passengers who wondered who the notables could be, who always arrived the last minute, for whom planes were always waiting.

After a few days in New York, we took the train west and with us my young niece Naomi just out of Bennington, who had decided to follow a photographic career and wished me to guide her. She was a slim dark beauty, a replica of my sister whom I'd been in love with in the early days. Looking at her, my mind wandered back, but would be recalled at once when I was addressed as uncle, one of the most insipid words in the English language.

The stopover at Chicago to change trains was marked by a visit to the Art Institute to see Seurat's *La Grande Jatte*. In spite of the huge white bathroom frame which threw its dimming colors out of key, the calm majesty of the painting was unperturbed.

Among the photographs I brought back to Hollywood was a batch of prints I had made in the Thirties as a basis for a series of paintings. These were of objects in wood, metal, plaster and wire made to illustrate algebraic equations, which lay in dusty cases at the Poincaré Institute. The formulas accompanying them meant nothing to me, but the forms themselves were as varied and authentic as any in nature. The fact that they were man-made was of added importance to me and they could not be considered abstract as Breton feared when I first showed them to him — all abstract art appeared to me as fragments: enlargements of details in nature and art, whereas these objects were complete microcosms. In painting them, I did not copy them literally but composed a picture in each case, varying the proportions, adding color, ignoring the mathematical intent and introducing an irrelevant form sometimes, as a butterfly or the leg of a table. When about fifteen were completed, I gave the series the general title: *Shakespearean Equations,* and for individual identification the title of one of Shakespeare's plays, quite arbitrarily or the first that occurred to

me. Thus, the last one was called *All's Well That Ends Well.* Some saw a symbolical relation between the subject and the title.

These paintings formed part of my exhibition at the Copley Gallery. The elaborate catalog I had prepared: *To Be Continued Unnoticed* (an anagram) was prophetic; no mention was made of the show by the critics and it was by-passed by collectors, except by a couple who knew me personally. Al Lewin acquired *The Taming of the Shrew,* the Weschers another picture I painted for them specially as an afterthought, without a Shakespearean title.

The pace of what was to be my last two years in Hollywood became accelerated, as if a crisis was approaching. Households broke up and familiar faces disappeared, new faces came upon the scene in quick succession. Jean Renoir was shooting a film based on Mirabeau's *Diary of a Chambermaid,* a tragic story, but transformed by the studio into an all's well that ends well affair. He built himself a lovely house on the nearby hills, where we enjoyed charcoal-broiled steaks from a grill built into the wall of the dining room, on the eye level. Nearby, he installed Gabrielle, his father's favorite model, with her American husband, Slade, a tall, bearded old man of great distinction. He waltzed with Juliet in the French manner, like someone out of a painting by Renoir.

My old friend Donald married M.F.K. Fisher, living out in Bare Acres, where we spent weekends. She could tell one how to cook a wolf, and made a Burgundy beef stew like in Dijon. Her book of California stories was entrancing. There was Galka Scheyer, one-time friend of Paul Klee, her house perched on no man's land at the top of the Hollywood hills, crammed with the painter's works. There was the indefatigable Kate Steinitz, one-time friend of Kurt Schwitters, the painter, now directing the Elmer Belt foundation devoted exclusively to the works of Leonardo da Vinci, my favorite old master. And Dr. and Mary Wescher who kept open house for us, interested in all my activities, although he supervised Paul Getty's museum of antiques. There were parties at Clifford Odets's and Stravinsky's always filled with people from the studios, where as usual

I received little attention and felt like a black sheep. I played chess with Bertolt Brecht, the author, and with Von Sternberg who had launched Marlene Dietrich, losing my games as usual. My designs for chess pieces were successful — movie stars bought them, mostly as conversation pieces, I imagine.

But those I had seen most often left the scene one by one as in that symphony by Haydn in which the musicians leave one by one at the end, snuffing out their candles. There were earth-quake tremors occasionally, nature was being as unreliable as the institutions of men. An invisible acrid pall hung over the city; one went about with red-rimmed, watering eyes. Upon outcries from the newspapers and the public, committees were formed to investigate the causes, but experts could not agree whether the rubber-producing factories or the fumes from au-tomobiles were to blame for the smog. It seemed the only solu-tion was to abolish the automobile, the consumer of gasoline and rubber.

Although necessary implements, I began to conceive a dis-like for all cars including my own. Mine had served me well for ten years. I'd held on to it despite efforts to persuade me to trade it in for a new one. It ran beautifully, its only weakness being that the muffler burnt out four or five times. I was rather pleased when it happened as it seemed to increase the power of the motor — also the noise, as several traffic cops observed. I had even raced some kids in a souped-up, whittled-down ja-lopy and left them behind. I decided to get rid of the car as my trips were less frequent and I had become more sedentary. With the other happenings, Hollywood began to lose its glamour.

Then a new landlord appeared, raising the rents appreciably. I figured that, with the increase, a year's rent would pay my way to Paris. By now things must have gotten back to normal in France, from what I was hearing. Bill Copley, too, was rest-less, involved as he was in domestic problems. We decided to leave at once. Within a few days most of my belongings were packed and put away in storage — the work of ten years. I thought that once in Paris I'd soon produce a batch of new work for an exhibition. Besides, a number of things were still

stored there. As we were leaving for the airport, the landlord came out to bid me goodbye, telling me that if I came back he'd have a studio for me any time. Then he asked what I was doing with my car which stood in front of the door. I told him a friend would take care of it, probably sell it for me. The man offered to buy it, he liked the looks of it, and gave me a check for half the price I had paid for it ten years ago. Something unheard of in auto deals. Now that it wasn't mine any longer, I gave it a fond farewell look, reading the discreet lettering on the hood: *Hollywood Supercharger.*

PARIS AGAIN

During the short stopover in New York, I hesitated, wondering if, after all, it wouldn't be just as well to settle down there. In the big city I could choose my contacts as I had in the West, without getting involved in more demanding activities. In a few days, however, my mind was made up. Had I continued immediately with the voyage, the problem would not have presented itself. With my usual sociable instinct, I made some friends aware of my presence; cocktails and dinners followed. An editor of a smart magazine asked me to do an article on photography. I promised, as soon as I got settled. The Museum of Modern Art had just put up an exhibition of American Pioneers of Modern Painting; had unearthed my large painting, The Rope Dancer Accompanies Herself with Her Shadows, which had figured in the Independents show of 1917. I could take up my painting, exclusively, in New York, I thought, where there was a growing appreciation for work that had been previously condemned. It was dangerous, though; a painter who becomes a photographer is easily forgiven, but a well-known photographer like myself, who turns to painting, even if he is known by some as a pioneer, would be looked upon with suspicion. I had known a couple of such instances. I decided against New York. Perhaps it was also the stronger attraction of Paris,

like the scene of his crime to a criminal. Besides, I was surer of my reception in Europe.

We took passage on the *DeGrasse*, a slow boat — we were in no hurry, and there were few passengers in March. When I entered the cabin, my old friend Marcel Duchamp was sitting there with a little parcel on his knees, to bid me farewell. The object he gave me was an abstract galvanized plaster model entitled *Feuille de Vigne Femelle*. One of the few mysterious creations he produced from time to time.

During the leisurely trip, the dining room was the principal distraction. It was to be the last voyage of the boat before being retired and it seemed that the kitchen was trying to have us consume their reserves. The chefs made special dishes for us — there was a birthday cake every day, and champagne to end the meals. In between times we walked the decks or sat in the salon playing chess. One portly South American challenged me to a game which began after lunch and lasted beyond the dinner bell. Neither one would resign, until his wife and two pretty daughters stood around impatiently, so that he made a mistake and lost. He was quite angry from the way he spoke to his family in Spanish.

With time on my hands, I decided to write that article on photography I had promised the editor in New York. I asked the steward for a cabin to set up my typewriter. He gave me an unoccupied suite, generally reserved for a millionaire or movie star. I should have been inspired by my surroundings: golden drapes, two beds, tiled bathroom. I should have had a party or two, invited some of the more interesting passengers. Instead, I plugged away alone until I had covered about four pages. It was a very abstruse article on art in general, the word photography not being mentioned. Purposely. When I landed, I mailed the article at once, but never heard from the editor, nor was the manuscript returned. I realized my mistake; what was expected of me was a story of my contacts with the stars in Hollywood during the Forties. I should have told how I photographed Paulette Goddard, Tilly Losch, Ava Gardner, Gypsy Rose Lee, played chess with Hedy Lamarr, dined at Janet Gaynor's, and at Kathleen Winsor's with Artie Shaw; spent Christ-

mas at the Stotharts with Benny Goodman, and Easter with the Stravinskys; drank with John Barrymore and Errol Flynn; argued at Clifford Odets's with Chaplin and Dudley Nichols; met a host of others at Renoir's and Lewin's. But in this article I was not being a name dropper (as in the present case) — if I couldn't stand on my own merits, so much the worse for me. Anyhow, I had expressed my own ideas; in one line I had said that the world really detests ideas, it loves tricks. Sometimes, under the guise of trickery, ideas have been put over. Unfortunately, there was nothing tricky about my writing, just naïve sincerity.

We docked at Le Havre amid great confusion. There was a general strike in France — no trains were running. The steamship company provided buses to take the passengers to Paris, followed by trucks with the baggage. The trip was twice as long as by train; we arrived in front of the closed railroad station, like homing pigeons. It was already dark, no taxis, only a few private cars stood by. Two people came running from one of them; it was my niece, Naomi, and her husband David, who were studying and working here. They knew we were due on the *DeGrasse* and also the situation. There was another wait for the trucks with the baggage. When they arrived, everything was dumped pell-mell on the sidewalk, allowing passengers to sort out their respective pieces. We finally got our half-dozen bags, then Juliet discovered her violin was missing — she hadn't used it for years except once when I photographed her holding it in playing position. Naomi ran to the empty truck, climbed in and came out with the precious case. We drove to the hotel where rooms had been reserved, then to the Coupole in Montparnasse for dinner. The owner, Monsieur F——, walking among the tables, spotted me, gave me a hearty welcome with a bottle of champagne; after dinner we went below to the night club and danced until closing time.

Next morning I awoke to face a typical, gray, dismal March day in Paris. It was cold in the room although the hotel was considered first class. As usual in French houses, the radiators were at the other end of the room, as far away from the win-

dows as possible, as if they might catch cold. There was still a shortage of coal or it was too expensive. Some Americans I met later shook their heads sadly, saying France was no longer the same. I pointed out that it was we who had changed during the past twenty years, besides facing a new generation. I found the country just the same, with its gardens and outward aspects intact; inwardly, even, the French mentality was the same as always. It still regarded all necessities of life as luxuries, and luxuries as indispensable necessities. Very normal for a people who had been the victim of so many invasions and revolutions, to try to maintain its morale.

My first concern was to find a place of my own; I investigated every possible lead in newspapers or from friends, but all places were rented furnished for limited periods and at high rentals, the occupants planning to go off on vacations. I couldn't understand this situation, it seemed to me that after the war with all its casualties more room would have been available. But rent controls were still in force; landlords could not make ends meet and offered unoccupied premises for sale outright, also at prohibitive prices.

After a couple of weeks, I moved to a more modest hotel in the Montparnasse district where I preferred to live again, and continued my search. Before starting out on my quest in the morning, I went into the old Rotonde, now a plush café-restaurant with neon lights, but serving the same strong black coffee as in early days — what I had missed in my first days in Hollywood.

After about two months of fruitless efforts, we were having dinner one night with June, a friend from California passing through. She told me of some official from abroad who was looking for a comfortable, well-furnished flat and who had been offered an old sculptor's studio in a little street near the church of St. Sulpice. She gave me the number, too. In the morning I went down to the address, a little door at the end of a high wall enclosing an old seminary facing the square in front of the church. Getting no reply to my repeated ringing of the doorbell, I slipped a note with my name and the telephone number of my hotel under the threshold. Then I took a

walk around the neighborhood, which was familiar to me. It was one of the older quarters of Paris, quiet and almost provincial, halfway between Montparnasse and the St.-Germain-des-Près sections, the latter place with its cafés was now the stamping ground of intellectuals, existential riffraff and tourists. The huge church itself was considered one of the ugliest in Paris — perhaps because it wasn't Gothic, but a product of the return to classicism in the eighteenth century. All the orders of Greek architecture were superposed one on top of another: the church was three temples in one, Doric, Ionic, and Corinthian, topped by two round towers of a more hybrid style trying to be graceful, although one was unfinished since the days when the last architect had committed suicide by jumping off it. This church brought back to my mind my own investigations and partiality for the more pagan creations when I was a student of architecture. I had preferred their invisible subtleties to the more obvious, flamboyant Western productions.

I walked back to my hotel through the Luxembourg Gardens, passing the museum, closed since the war, which had housed paintings acquired by the government — works that could not be hung in the Louvre itself either because the painters were still alive or because these works were considered of secondary importance, like Whistler's Mother. This museum had been an official Salon des Refusés.

Two or three days later I received a telephone call from the old sculptor; I rushed down and was admitted to the studio. It was a huge whitewashed place flooded with light from skylights and windows on three sides, twenty feet above. An ideal studio for a sculptor of monumental projects, but I could see why one would hesitate to make it his living quarters. Perhaps Brancusi with his austere cot in a corner of a balcony, a sink in another corner and a stove in the middle would have been in his element here. But I was no celibate; Juliet had to be consulted and I brought her around to see the studio. It depressed her; it seemed too enormous to do anything with. However, my mind was made up. Having had experience in transforming other studios into comfortable living quarters, I already en-

visaged installations, and took the studio, paying, in guise of key money, the price demanded for the few pieces of period furniture that went with it. These I eventually got rid of except a large wardrobe — there were no closets — and an eight-foot, five-fold screen of white canvas on which I would paint something when I had the inspiration. In the meantime, I put a bed in a corner with the screen hiding it, and we moved in, being fed up with hotels. It was a hot summer but the studio was delightfully cool.

I engaged plumbers, electricians and carpenters who finished their work within a month — quite a tour de force when one considers their usual dawdling, with time out for trips to the cafés, or a recess with a bottle of wine. I did no work myself that summer, but busied myself with the finishing touches to make the studio as comfortable as possible for the winter. I congratulated myself that there were radiators and steam pipes, the studio connected with the four-story eighteenth-century building next door. But when the days became chilly, I discovered that there was no heat; the furnace had gone to pot during the war and tenants were heating individually. Then I installed a pot-bellied coal stove which heated the five hundred cubic yards quite well.

One day a group of tourists rang the doorbell, asking to visit the place. The guide informed me it was the home of the ancestors of one of the Three Musketeers — did I have any postcards to sell? I had heard that the neighborhood was classified as a historical one — its outside aspects could not be modified, nor any shops permitted in my street. However, it occurred to me that I might have kept the pieces of antique furniture, given the studio an eighteenth-century character, dressed myself up as a D'Artagnan with plumed hat, doublet and a sword, and sold souvenirs and postcards of the quaint street and myself. But it might also have incurred the displeasure of the authorities — I was tolerated as an artist, my profession being listed as non-commercial and my existence a mystery, as expected of painters.

Impressed with my location, I made a rather academic painting of the street as I might have photographed it, including the

Rue Férou, 1952, painting

work in an exhibition of my more imaginative work, much to the surprise of some friends. Why had I painted such a picture? they asked. I explained that I did this simply because I was not supposed to — that some of my contemporaries feel the urge also to do such a work but do not dare — and I enjoyed contradicting myself.

Not always did I have the ready word to answer an observation on my work. It took a ten-year-old to leave me speechless once. I had just finished painting a still-life, a trompe-l'oeil or literal rendering of a composition of objects on the table which had intrigued me. The child stood before the easel looking at the work and then at the original objects, as if verifying it. When I asked her how she liked it, she replied that it was very nice, but why did I want two of the same thing?

I knew a confirmed abstract painter who had suddenly switched completely to figurative painting; when he asked my opinion I replied I could see he was enjoying himself, although he had aesthetic and philosophical reasons to justify the change. All this pseudo-profound wordiness to cover up a simple human urge and desire, in contrast to myself who was suspected of flippancy and superficiality when speaking of my work in answer to a collector who had found it rather austere. One critic read motives in the painting of the street which I had never been conscious of — no doubt he was an adversary of abstract painting, using my work to make his point. It was a consolation to know that whatever interpretation was given to a painting, whatever criticism, they could not change the work which was fixed once for all; in fact, the more varied the opinions expressed, the more successful I considered the work. As for any attempt at evaluation of the work, since there was no criterion to go by, the appraisal was arbitrary and futile.

Once comfortably installed with immediate material problems solved, I entered upon an intensive period of painting. Although I had given up professional photography, my curiosity in the medium continued; at odd moments, I turned my attention to color photography. As a distraction, I made some color portraits with the materials available, which gave satis-

factory results as far as the diapositives against light were concerned, but any process involving the transfer to paper left much to be desired. The results smacked of the chromo with the colors deadened or falsified. After a series of trials I managed to transform the original transparency into a beautiful print, retaining the brilliance of the colors with the quality of a painting added. To be sure, the choice of subject, lighting and color were the prime factors, as in a painting, reflecting the personality of the operator. But the process itself was simple and required no great technical skill. With the aid of some well-placed and well-meaning friends, I was able to submit my idea to the heads of important manufacturers of color film in various countries, avoiding technicians where possible. It was rejected with the argument that the process could not be protected, that it could not be patented — that everyone could use it.

Which was exactly my idea; I did not consider myself an inventor, wishing simply to add a new interest to color photography, whatever the basic materials employed. For this I hoped to receive a modest sum without any thought of the profits the manufacturers would derive from increased sales of color film. When Daguerre through influential contacts received a subsidy from the French government for his improvements in black and white photography — he was not the inventor, Nièpce having preceded him without receiving anything — the process was given to the world and all were free to use it. My attitude was that of a painter who develops a personal style which cannot be patented but may be imitated with impunity. Once understood, there is no secret about it — one does not ask a painter what materials he uses. I had an opportunity of applying my process when a magazine asked me to make some color shots of a well-known personality. I used my new method proudly, but the editor was quite bewildered — he said it was impossible to reproduce my work with the setup to reproduce transparencies to which he was accustomed. I realized it could be of interest only as an original and for amateurs who wished to play with it.

This experience strengthened my resolve to continue paint-

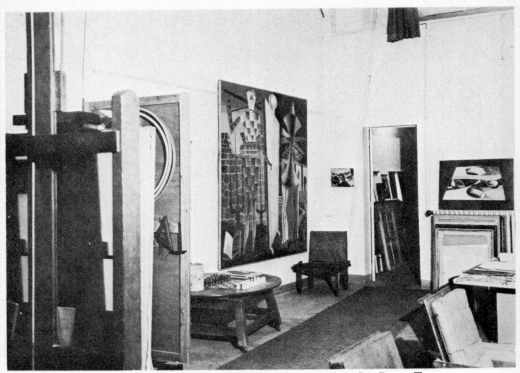

The studio at rue Férou, 1951. With painting, *Le Beau Temps,*
1939

ing, produce originals: one-man creations, and leave the prob-
lems of reproduction to the technicians. The days spent in
puttering around the studio, seeking a diversion in photo-
graphic experiments, putting off the tackling of a canvas until
there was no longer any excuse for delay, were due in reality to
a certain anxiety I felt, as for instance, before getting behind
the wheel of my car, or in anticipation of a love-tryst. This
emotional state had always bothered me — a sort of misgiving
of the outcome of my enterprises. But once engaged in the act,
all uncertainty disappeared and I carried on with confidence,
with complete assurance.

Whereas photography was simply a matter of calculation,
obtaining what had been figured out beforehand, painting was
an adventure in which some unknown force might suddenly
change the whole aspect of things. The result could be as much
a surprise to myself as to a spectator. The surprises produced
by a badly regulated mechanical instrument have no value, but
the aberrations of a brain that feels at the same time that it

thinks are always interesting. All modern psychology is based on this, as is art. One well-known painter said, I do not seek, I find; another, There are no problems, therefore no solutions; and myself: I have no problems, I have only solutions. Examples of the brain working in perfect harmony with one's feelings; attitudes, however, which might be considered cases for a psychiatrist. Once launched in my painting I could understand other painters who continued to work until their last breath, whether honored and recognized in their lifetime, or ignored and desperate. Even repeating themselves, it became a sort of intoxication with a lifetime habit. Not as in other walks where one retired after years of a more or less interesting occupation to enjoy a well-earned rest.

In my case it was also the illusion of finding a bit of my youth again — one completely non-figurative painting was given an arbitrary title: My First Love, suggested probably by the use of an earlier technique. At the same time I sought a new technique that would be more automatic as when a seed or a sapling is planted and the forces of nature are counted on to do the rest. By spreading the colors according to the impulse of the moment, I abandoned brushes and palette knives, and applied pressure with other surfaces, withdrawing them to produce a variation of the Rorschach test. The results were astonishing, with details that could have been obtained only through long and meticulous labor by hand. I gave these productions the general title of Natural Paintings.

Among the objects and paintings that accumulated there stood always in the studio the large blank screen, no longer serving any purpose since there were more permanent partitions for kitchen, bath and bedroom. It seemed to challenge me to attack it, but I bided my time. Not until an inspiration came or an event that might prod me, would I tackle this virgin surface. Other prepared canvases had stood around for years, patiently waiting for my attention. Ideas were not lacking, many were put aside. When they recurred for the third or fourth time I thought it worthwhile to do something about them. If not, it was just as well, or better even — the forgotten idea did not merit realization.

We had been almost a year in the studio, without any vacation or change of scene. I did not mind, feeling as if I were always on vacation — but Juliet was longing to get down to a beach, sun-bathe and swim. A young couple was driving down south, inviting us to join them. I preferred to stay home and sent Juliet on without me. Alone now in the vast studio, it seemed to me that I had twice as much time on my hands. And the white screen accentuated the emptiness. I began by dividing it up into forty rectangles, like a chessboard. One of the first assignments I'd give a pupil in painting was to lay out a chessboard. I explained that this was the basis of all art: a picture was a surface cut up into smaller areas whose shapes could be modified as dictated by the subject, maintaining the contrasts of light and dark patterns, or blending them as required.

On the screen I followed my theory, but conserved the chessboard effect, filling in each panel with an improvised motif that was neither abstract nor figurative. One could see anything one wished in these panels. I alternated their values, light and dark, as in a chessboard. The screen now became a part of the studio.

When Juliet returned, she was quite pleased and impressed, probably feeling I hadn't had much time to profit by her absence, had been faithful to her. And how was her trip? I asked. Wonderful, she replied, except that there had been a moment of tension; the man had made a pass at her, the woman had sensed something, and there had been a coolness between them towards the end. Juliet had a beautiful tan and looked radiant. The next day I painted in the title on one of the panels of the screen: *Les Vingt Jours et Nuits de Juliette* (The Twenty Days and Nights of Juliet).

As in California when I had completed a new series of paintings, invitations to exhibit followed. Retrospective shows were organized in various cities, especially of works of the Dada and Surrealist periods, which were now being taken more seriously. I was well represented in these, having had a number of my older works sent back to me from storage. A couple of galleries in Paris gave one-man shows of my more recent work and al-

though they were well attended, the sales were meager. Paint-
ers, sculptors, and writers were the most appreciative — the
most complimentary. However, soon collectors and dealers be-
gan to come to the studio asking for the earlier works, looking
carefully at the dates and flattering me with the word *pioneer*.
One would think they were interested in what was considered
the best vintage years of wines. Although this annoyed me, I
willingly gave up the older things until there were almost none
left and looked forward with pleasure to when I could say
there were no more. Perhaps then they would pay some atten-
tion to the later works; or would I have to wait for the next
generation? It was too late, now. Had I been of a less self-
reliant nature, this state of affairs might have depressed me,
but I had been hardened by many exhibitions which had
brought no immediate returns. Besides, I had less to complain
of than many of my predecessors. I comforted myself with the
resolve to follow the inscription of the catalog in my last show
in Hollywood: *To Be Continued Unnoticed*. After all, I was in
good health, free and enjoying myself. I could even give up
painting as I had given up professional photography — as in
my youth I had walked out of an office with the determination
never again to be at the beck and call of another man. The
exhilaration had compensated for all the hardships. Now I had
enough work accomplished to assure my future.

Without becoming bitter, my conversation and talks took on
a more bantering tone, laying me open to the accusation of
joking. Thus it was when my old friend Roland Penrose, who
ran the Institute of Contemporary Art in London, put the gal-
lery at my disposal for an exhibition, I selected works from the
earliest period to the present — a most comprehensive choice,
quite austere, as some would say — and then composed the
catalog carefully, including a transcription of an article by
that delightful, profound and enigmatic composer, Erik Satie.
I had come across it in a musical review of 1912, written by
him in answer to attacks by critics. I changed a few words in
the article, to suit my case: when he speaks of music, I speak
of painting, when he says, sound, I say color. The title: *What
I Am:*

Everyone will tell you that I am not a painter. That is true. At the beginning of my career, I at once classed myself among the photometrographers. My works are purely photometric. Take *Revolving Doors* or *Seguidilla, Le Beau Temps* or the *Shakespearean Equations,* you will notice that no plastic idea entered into the creation of these works. It is scientific thought which dominates.

Besides, I take greater pleasure in measuring a color than looking at it. Holding a photometer I work joyfully and surely.

What have I not weighed or measured? All Uccello, all Leonardo, etc. It is very strange.

The first time I used a photoscope I examined a pear of medium size. I assure you I have never seen anything more repulsive. I called my servant and showed it to her.

On the photoscale a common ordinary nude weighed two hundred pounds. She was sent by a very fat painter whom I weighed also.

Are you familiar with the cleaning of colors? It is quite filthy.

Spinning is cleaner. Knowing how to classify them is very delicate and requires good sight. Here we enter phototechnicology.

As for color explosions so often disagreeable, cotton wool placed on the eyes will attenuate them suitably for one. Here we arrive at pyrophotology.

To draw my *Mains Libres* I used a caleidophoto-recorder. This took seven minutes. I called my servant and showed it to her.

I think I may say that photology is superior to painting. It is more varied. The pecuniary yield is greater. I owe to it my fortune.

Anyhow, with a monodymanophote, a barely trained photo-measurer can record in the same time and with the same effort more colors than the most adept painter. It is thanks to this that I have painted so much.

The future belongs to philophotology.

Thus, also when the big retrospective show of Dada in Düsseldorf was organized, I was asked among others to write a few lines for the catalogue. I was vacationing in the south of France, doing nothing, but dashed off the following without thinking nor changing a word:

DADAMADE

Who made Dada? Nobody and everybody. I made Dada when I was a baby and I was roundly spanked by my mother. Now everyone claims to be the author of Dada. For the past thirty years. In Zurich, in Cologne, in Paris, in London, in Tokyo, in San Francisco, in New York. I might claim to be the author of Dada in New York. In 1912 before Dada. In 1919, with the permission and with the approval of other Dadaists I legalized Dada in New York. Just once. That was enough. The times did not deserve more. That was a Dadadate. The one issue of New York Dada did not even bear the names of the authors. How unusual for Dada. Of course, there were a certain number of collaborators. Both willing and unwilling. Both trusting and suspicious. What did it matter? Only one issue. Forgotten — not even seen by most Dadaists or anti-Dadaists. Now we are trying to revive Dada. Why? Who cares? Who does not care? Dada is dead. Or is Dada still alive?

We cannot revive something that is alive just as we cannot revive anything that is dead.

Is Dadadead? Is Dadalive? Dada is. Dadaism.

A retrospective show of early Dada works was held in Paris and the object called Boardwalk was borrowed from its owner for the occasion. The show looked respectable — almost conservative by present standards. I had added another object I had conceived in the early years: simply a metronome to the oscillating stem of which I had attached a photograph of an eye that moved with the ticking as it swung back and forth. The title was, Object To Be Destroyed. I really intended to destroy it one day, but before witnesses or an audience in the course of a lecture.

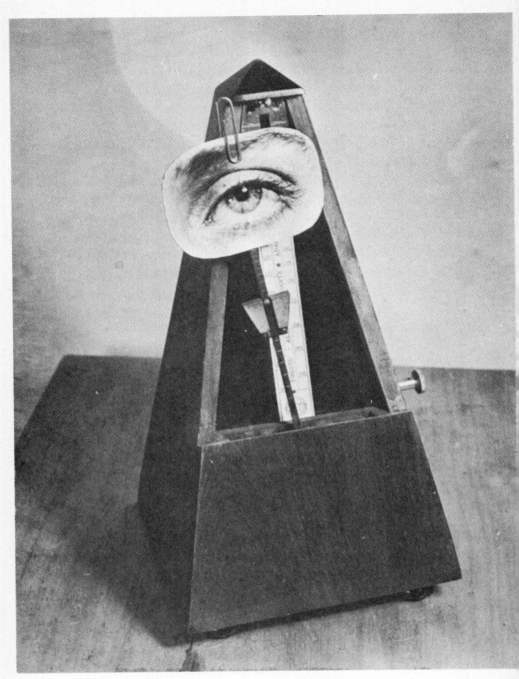

Object To Be Destroyed, 1923 (destroyed in 1957)

Be that as it may, I was in the gallery one day with my old friend Tzara who had helped organize the show, when a group of youngsters, boy and girls, filed in, some carrying portfolios, evidently coming from the Beaux Arts Academy. Suddenly, handfuls of green handbills filled the air and a voice announced to the other visitors present that this was a protest against the Dadaists and Surrealists. Then the students began taking down the works and laying them carefully on the floor so as not to damage those under glass. After which they filed out in an orderly manner.

But on the way one grabbed the metronome and disappeared with it. My Boardwalk hung near the door; a second member grabbed it, carrying it with him. I ran after him and seized him by the collar, but someone tripped me and I fell on the sidewalk. Getting up, I was about to follow him, but two girls across the street were already holding the Boardwalk up high while a boy pulled out a pistol and began shooting holes into it. I did not insist any further.

Fortunately, the secretary of the gallery had phoned the police at the beginning of the demonstration, which brought a patrol wagon, and the leaders were rounded up. The police also took a couple of innocent bystanders with them. I picked up the Boardwalk, taking it back to the gallery. Aside from the neat bullet holes it hadn't suffered much except for some footprints. The girls had tried to destroy it, but it was solid plywood, quite indestructible. I picked up one of the handbills to read: it was a vilification of all Dadaists and Surrealists, holding up the good old traditions as a goal, citing the poet Villon of the fifteenth century as an idol, ignoring that he had been condemned to hang for stealing. I was summoned to the police station the next day and asked if I wished to prosecute, but I refused, saying it was their affair: wasn't it forbidden to carry arms? The captain opened the drawer and showed me the pistol. Yes, they would take care of that. The papers quoted me as saying I would have done the same at their age.

Afterwards I had an interesting session with the insurance expert; the gallery had insured the exhibition. First he offered to replace the cost of the metronome, a trifle. I pointed out

that one did not replace a work of art, a painting, with brushes, paints and canvas. He conceded the point: since I was a well-known artist, he would pay the full value of the insurance. Then, assuming a more intimate tone, he voiced his suspicion that I might, with this money, buy a whole stock of metronomes. That was my intention, I replied; however, I assured him of one thing — I'd change the title — instead of Object To Be Destroyed I'd call it Indestructible Object. As for the Boardwalk — he offered to repair it — fill up the bullet holes and clean it up. On the contrary, I said, as a Dada object, it was more valuable than before, and should not be touched. Then why did I insist on collecting insurance, he asked. Thinking of the owner, I suggested that the company pay the full value now, and keep the work, as is specified in the contract. He demurred, said the company did not collect works of art, and finally agreed to pay half of the value. I was quite pleased with this tilt — I had succeeded in making what was not considered a work of art as valid as any legitimate painting or sculpture.

Despite reiterated announcements that Surrealism was dead — there had been certain ones who had declared it from its very beginning as stillborn, or an abortive movement — there was a recrudescence now and then in the form of a gallery devoted to Surrealism, a publication that lasted through several issues: and always a group of new adherents formed around its founder, André Breton. Like previous movements, it was entering its final phase — the public domain.

One of the most recent manifestations was an exhibition called E-xposition inte-R-nati-O-nale du S-urrealisme, with eroticism as its theme. Besides contributing a painting, I was invited to write an article for the catalog. The exhibition itself was a disappointment to many seekers of pornographic thrills — it was on a poetic level and rather symbolical. My painting of a nude must have been considered one of the most erotic for it was inconspicuously placed on the ceiling where few noticed it. I myself did not see it at first and thought it had been censored. My article, however, was well featured in the catalog

and aroused much favorable comment. It was translated into French; I liked it much better so: It was called "Inventory of a Woman's Head."

In spite of all restrictions and camouflage, whether for purposes of concealment or merely suggestiveness of her body, most races have unwittingly and fortunately left the head or part of the head of woman naked. Even if it were only to allow the eyes to peep through a veil, our society has committed a breach of its moral code, a laxity for which poets through the ages have been grateful.

The more daring poets who have seen in a woman's eyes her sex, have realized that the head contains more orifices than does all of the rest of the body; so many added invitations for poetic, that is, sensual exploration. One may kiss an eye or provoke it to wetness without offending decency.

With the complete exposure of the head a veritable orgy is invited. Either in its natural state or with its embellishments of makeup, jewels, and elaborate hairdos, nothing can restrain the imagination from the most riotous speculations. All the senses are concentrated in this one head: eyes, ears, nose, lips, tongue and the skin which covers all with its network of vibrating nerves. One imagines the senses, the counterpart of our own, ready to respond in complete agreement.

The eyes not only receive an outward image but give forth an image of an invisible thought; the nose breathes invisible odors that may affect all the other senses; arabesque and impenetrable ears, receptive only to invisible sounds that can inflame the brain, become stereauditory, just as the eyes are stereoscopic, the nose stereolfactory, and the mouth stereosculatory for greater intensity and for surer receptivity. The voice is always monophonic; it need not be stereophonic.

And the hair, except in a few extreme cases, has fortunately escaped the usual sex taboos (pubic hairs), so that the eyes, hands and nose can explore and caress this head crown, yielding like a consenting body. Finally, when the lips, two bodies fitting together in perfect harmony, when these lips break into a smile, they dis-

close the menacing barrier of the teeth, which nevertheless invites further exploration.

When I hold this head in my hands I do not ask whether it is a portrait of the woman's body; I only know that without the head all bodies are alike in that they serve one purpose. My first view of a naked body in a life-class where I was a student was a total disappointment, and my first drawing of a nude brought down on my head the most violent criticism by the art instructor: This is not a woman, it is a horse. Silently, I agreed.

Oh, I know, there is the well-turned leg, the perfect breast, the inviting rump, but it is first through the eyes in the head that the final, the sexual sense is aroused. I speak now of my own head which contains the same senses as does that of the woman. My first object is to arouse the same desires in these two heads through their similar openings. It is only by bringing together the heads that any real understanding and acquiescence can be attained, and consent given for further exploration. In most places, the kiss has become the password for this unison; in some places it is frowned upon, as would be a public sexual gesture. Since the nakedness of the head is tolerated, so is the junction of two heads tolerated; at least *our* society observes a certain superficial logic. Fortunately, again!

The head of a woman is her complete physical portrait, but, whatever its fascination, *"Le portrait d'un être qu'on aime doit pouvoir être non seulement une image à laquelle on sourit mais un oracle qu'on interroge,"* * says André Breton.

So, for all purposes, let us first ask of a woman: has she a head?

* "The portrait of a loved one should be not only an image at which one smiles, but an oracle one interrogates."

Having to give a talk one day on the value of the image, before a group of newspapermen and reporters, I arrived as usual without any fixed idea of what I was going to say. The chairman suggested that I take as my theme the old Chinese adage: An image is worth a thousand words. Somehow I got the words mixed up, perhaps subconsciously intentionally, and announced that an image could produce a thousand words. Had one ever seen a picture that was not accompanied by a caption or a paragraph? Even when the work was self-evident, as the portrait of a young man holding a flower, by an old master — looking it up in the catalog I read: Portrait of a Young Man Holding a Flower.

In a life devoted to the graphic arts, I have felt more and more a desire to supplement my work with words. Not always literally, to be sure, but as an identification — as one's name, which has no relation to one, in no way describes one. The most popular music is music accompanied with words. The introduction of a word in the early Cubist paintings gave intensity to the work. It was not explanatory. It also introduced a time element lacking in the plastic arts, no matter how much preparation went into their realization. The impact of an image is instantaneous whereas reading and listening are in time. It has been said that a drowning man sees his whole life pass be-

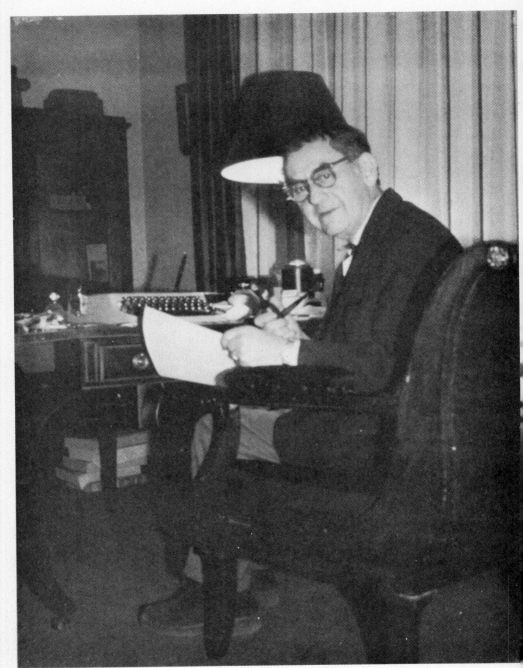

Man Ray, Paris, 1962

fore him in an instant. Even the longest, most complicated dream is supposed to occur in a flash.

In painting, with skill and new techniques, I sought to keep up with the rapidity of thought, but the execution still lags behind the mind as it does behind perception. The Chinese and Japanese artists had attained this almost instantaneous quality centuries ago. There is the story of the artist commissioned by the emperor to paint a dragon on a screen. For years the order languished until one day the emperor visited the studio of the artist to investigate the reason for the delay. The place was full of studies of dragons, one more detailed and magnificent than the other. The artist said he was making studies and would soon be ready to come to the palace to execute the final image. When he arrived with a pot of paint and a brush, he started at one end of the surface with the tip of the brush, making a swirl with varying pressure until he had reached the other end in a few seconds. It was the synthesis of all his studies.

This was the opposite of all Western ideas of painting, especially with the primitive and their laborious, detailed productions. Perhaps today painters are striving to recapture the Oriental conception. Perhaps, also, the very act of painting is primitive and will disappear in the future, be replaced by a creative activity that can in no way be related to our conception of art today, just as the art of today would be incomprehensible as art to former generations. After all, the abstract painters, the collagists, the drippers and dribblers, are the primitives of today. With the feeling of satisfaction that came in putting down my ideas and reactions in words as well as in paint, the graphic spirit in me was impatient at the time element involved — never have I engaged in such a sustained effort over one work as in the writing of this book.

There was a certain compensation, however; many of the incidents had been repeatedly told to friends who had urged me to put them down in writing. Besides giving them a permanent form, I felt that I need never again tell them — I would free myself from the past and the risk of boring my hearers if I should forget that I had already told the same story.

And so, to guard against repetition, for a recent talk before a very serious audience, on the occasion of the opening of an exhibition, I did prepare my discourse. Many in the audience were standing — there weren't enough seats. I wore evening clothes as there was to be a formal dinner afterwards. Stepping up on the platform with a sheaf of paper in my hands, I noticed a look of resignation on many faces. Solemnly and slowly I read the first page, then paused to look at my hearers. Some shifted in their seats or from one foot to another to a more comfortable position. Turning to the second page, I accelerated my reading, then to the third page, which I went through almost breathlessly. Turning to the next page, I paused again, then held it up to the audience, saying, that was all. The page was blank as was the rest of the sheaf.

DATE DUE

JUL 0 3 1981		
APR 1 2 1988		
APR 2 7 1988		
MAY 1 0 1988		
MAY 1 1 1988		
MAR 1 8 1989		
OCT 0 3 2001		
OCT 2 4 200?		
GAYLORD		PRINTED IN U.S A